The Art and Archaeology of Ancient Greece

This richly illustrated, color
archaeology of ancient Gree
Roman conquest. Suitable for students with no prior knowledge of
ancient art, this book reviews the main objects and monuments of
the ancient Greek world, emphasizing the context and function of
these artefacts in their particular place and time. Students are led
to a rich understanding of how objects were meant to be perceived,
what "messages" they transmitted, and how the surrounding
environment shaped their meaning. The book includes more
than 500 illustrations (with over 400 in color), including specially
commissioned photographs, maps, floorplans, and reconstructions.
Judith Barringer examines a variety of media, including marble and
bronze sculpture, public and domestic architecture, painted vases,
coins, mosaics, terracotta figurines, reliefs, jewelry, armor, and wall
paintings. Numerous text boxes, chapter summaries, and timelines,
complemented by a detailed glossary, support student learning.

- More than 500 illustrations, with over 400 in color, including
 specially commissioned photographs, maps, plans, and
 reconstructions
- Includes text boxes, chapter summaries and timelines, and
 detailed glossary
- Looks at Greek art from the perspectives of both art history and
 archaeology, giving students an understanding of the historical
 and everyday context of art objects

Judith M. Barringer is Professor of Greek Art and Archaeology in
Classics at the University of Edinburgh. Her areas of specialization
are Greek art and archaeology and Greek history, myth, and
religion. Professor Barringer is the author of *Art, Myth, and Ritual
in Classical Greece* (Cambridge University Press, 2008), *The Hunt
in Ancient Greece* (2001), and *Divine Escorts: Nereids in Archaic and
Classical Greek Art* (1995), and co-editor (with Jeffrey M. Hurwit)
of *Periklean Athens and Its Legacy: Problems and Perspectives* (2005).
She has been awarded grants from the National Endowment for
the Humanities at the American School of Classical Studies in
Athens and the British Academy, among others. She was a Blegen
Research Fellow at Vassar College and a Senior Fellow at the
Internationales Forschungszentrum Kulturwissenschaften in Vienna,
and she currently holds a Marie Curie Fellowship at the Institut
für Klassische Archäologie at the Freie Universität Berlin from the
M4Human Programme of the Gerda Henkel Stiftung.

The Art and Archaeology of Ancient Greece

Judith M. Barringer

CAMBRIDGE
UNIVERSITY PRESS

CAMBRIDGE
UNIVERSITY PRESS

University Printing House, Cambridge CB2 8BS, United Kingdom

Cambridge University Press is part of the University of Cambridge.

It furthers the University's mission by disseminating knowledge in the pursuit of education, learning and research at the highest international levels of excellence.

www.cambridge.org
Information on this title: www.cambridge.org/9780521171809

© Judith M. Barringer 2014

First published 2014

Printed in Singapore by C.O.S. Printers Pte Ltd

A catalogue record for this publication is available from the British Library

Library of Congress Cataloguing in Publication data
Barringer, Judith M., 1959– author.
The art and archaeology of ancient Greece / Judith M. Barringer.
pages cm
Includes bibliographical references and index.
ISBN 978-1-107-00123-7 (hardback)
1. Art, Greek. 2. Art, Mycenaean. 3. Greece – Antiquities. I. Title.
N5630.B27 2014
709.38–dc23 2014007608

ISBN 978-1-107-00123-7 Hardback
ISBN 978-0-521-17180-9 Paperback

Contents

List of Figures

Front cover image: Munich, Glyptothek, detail of warrior from east pediment of the temple of Aphaia on Aigina, c. 470s B.C. marble. Photo: Hans R. Goette. Back cover images, left to right: Florence, Museo Archeologico 4209 ("François Vase") from Chiusi, Attic black-figure volute krater signed by Kleitias and Ergotimos, c. 570 BC, terracotta; Pella, Museum, pebble mosaic of lion hunt from Pella, 4.90m × 3.20m; Didyma, temple of Apollo, east façade.

List of Boxes

Acknowledgments

Many people have influenced this project and helped me in numerous ways, sometimes without knowing that they have been helpful. I began this project with my friend and colleague Eve D'Ambra. Kara Hattersley-Smith and Lee Ripley-Greenfield encouraged us to write a textbook of Greek and Roman art. Our project eventually changed, and I proceeded on my own with a different aim and with Cambridge University Press, but that initial work with Eve – our discussions, exchange of ideas, and of texts – stimulated my thinking and have contributed to the focus of the present book. I am grateful to her for this and for our friendship, which means a great deal to me.

It is a pleasure to thank Iphigeneia Leventis and Jerry Rutter, who generously gave of their time to read and comment on portions of this text; I am especially grateful to the latter, who saved me from many mistakes about the Bronze Age material.

Discussions about the subject, as well as textbook presentation of the same, with Aileen Ajootian, Nancy Bookides, Leda Costaki, Sheila Dillon, Jeff Hurwit, Jenifer Neils, Jerry Pollitt, Carola Reinsberg, David Scahill, Andy Stewart, Marek Węcowski, and Mark Wilson-Jones shaped and improved this text considerably. Nicola Nenci helped me to obtain materials, and the University of Edinburgh kindly supported me with finances for research, travel, and photographs. The staff of Cambridge University Press was helpful in obtaining photos and dealing with paperwork matters. Beatrice Rehl offered wise counsel, enthusiasm, and support from beginning to end. My thanks to them all.

For their help in obtaining or providing photos and permission to publish them, I thank Art Resource (New York), Anton Bammer (Technische Universität Wien), Valentina Bandelloni (SCALA Picture Library, Florence), Immo Beyer (Freiburg), Mark Bloomfield (London), Alexander Cambitoglou (University of Sydney and Australian Archaeological Institute at Athens), Angela Carbonaro (Archivio Fotografico dei Musei Capitolini, Rome), Arcangela Carbone Gross (Martin-von-Wagner Museum, Würzburg), Allyson Carless (British Museum Company, London), P. J. Chatzidakis (Archaeological Museum of Delos, Mykonos), Maria Chidiroglou (National Museum, Athens), Guffi Chohdri (Oxford University Press), Kalliopi Christophi (École française d'Athènes), Amanda Claridge (Royal Holloway, University of London), Charles Crowther

(Centre for the Study of Ancient Documents, Oxford University),
Sylvie Dumont (Athenian Agora excavations, Athens), Yolande
Ferreira (British Museum, London), Marta Fodor (Museum of Fine
Arts, Boston), Reinhard Förtsch (Deutsches Archäologisches Institut,
Cologne), M. Gkioni (ΛΖ΄Εφορεία Προϊστορικών και Κλασικών
Αρχαιοτήτων, Corinth), Guillaume Grandgeorge (Picard Editions,
Paris), Joachim Heiden (Deutsches Archäologisches Institut,
Athens), the late Frederick Hemans (Isthmia excavations, University
of Chicago), Klaus Herrmann (Athens), Carol Hershenson
(University of Cincinnati), Angelika Hildenbrand (Badisches
Landesmuseum Karlsruhe), Wolfram Hoepfner (Freie Universität
Berlin), Ralf von den Hoff (Albert-Ludwigs-Universität Freiburg),
Mario Iozzo (Museo Archeologico Nazionale, Florence), Shannon
Jackson (The Johns Hopkins University Press, Baltimore), Paula
James (Panos Pictures, London), Amalia Kakissis (British School
at Athens), Michael Kerschner (Österreichisches Archäologisches
Institut, Vienna), Manolis Korres (National Technical University,
Athens), Daria Lanzuolo (Deutsches Archäologisches Institut,
Rome), Guy Lecuyot (Centre national de la recherche scientifique,
Paris), Maria Liston (University of Waterloo), Craig Mauzy
(Athenian Agora excavations, Athens), Alexander Mazarakis Ainian
(University of Thessaly, Volos), Katerina Nikolaidou (17th Ephorate,
Hellenic Ministry of Culture, Aigai), Naomi Norman (University
of Georgia, Athens), Hakan Öge (Istanbul), Antonio Paolucci
(Musei Vaticani, Vatican City), Ingo Pini (Corpus der minoischen
und mykenischen Siegel, Marburg), Felix Pirson (Deutsches
Archäologisches Institut, Istanbul), Claude Rapin (Centre national
de la recherche scientifique, Paris), Giorgos Rethemiotakis
(Heraklion Archaeological Museum), Andrew Rheinhard (American
School of Classical Studies Publications Office, Princeton), Alfonsina
Russo (Soprintendenza per I Beni Archeologici dell'Etruria
Meridionale, Rome), Maurizio Sannibale (Museo Gregoriano
Etrusco dei Musei Vaticani, Vatican City), Florian Seiler (Deutsches
Archäologisches Institut, Berlin), Candace Smith, Matthias Steinhart
(Julius-Maximilians-Universität Würzburg), Andrew Stewart
(University of California, Berkeley), Jutta Stroszeck (Deutsches
Archäologisches Institut, Kerameikos, Athens), Thierry Theurillat
(École suisse d'archéologie en Grèce, Athens), Natalia Vogeikoff-
Brogan (American School of Classical Studies at Athens), Christiane

Vorster (Universität Bonn), Angeliki Voskaki (Archaeological Receipts Fund, Hellenic Ministry of Culture, Athens), Rebecca Wells (University of California Press, Berkeley), Bonna Wescoat (American excavations on Samothrace and Emory University), Saskia Wetzig (Albertinum, Dresden), and Astrid Winde (BPK Images, Berlin).

Most of all, my greatest debt is to Hans Rupprecht Goette, whose magnificent photographs, maps, plans, and drawings grace the pages of this book. He read and commented on the entire text, patiently discussed the text and its structure, and entertained questions and photo requests again and again. I thank him for his support and generosity.

Note on the text

Abbreviations of ancient authors and texts are those used in *The Oxford Classical Dictionary*, 3rd edition, edited by S. Hornblower and A. Spawforth. Abbreviations of modern journals are those used by the *American Journal of Archaeology*, http://www.ajaonline.org/submissions/abbreviations.

For the numbers for the Parthenon frieze slabs, this text follows those used by I. Jenkins, *The Parthenon Frieze* (London 1994).

I have not aimed for consistency of transliteration of Greek into English, but have instead used spellings most commonly found or recognizable, so, e.g., "Corinth," but "Nikopolis," "Bassai," but "Cumae."

Introduction

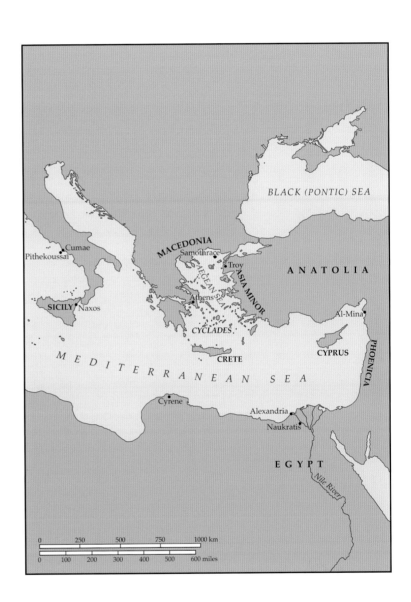

Map of the Mediterranean area

When someone referred to "Greek Art" in the nineteenth century, the meaning was clear: the Classical period of Greek art, *c.* 480–323 BC, usually objects or buildings from Athens. The image that sprang to mind was of marble sculptures and temples, preferably in ruins to convey the romantic notion of a lost past. The passion for antiquity, particularly ancient Greece, inspired innumerable examples of Neoclassical architecture and Neoclassical ornamentation on nearly every continent, Neoclassical painting and sculpture in Europe and North America, enthusiastic borrowing of Greek myth in every artistic medium, including literature, drama, music, and so on. Ancient Greek or classical styles (as opposed to the Classical period) were not only aesthetically favored but also bestowed intellectual cachet (e.g., the façade of the British Museum) or advanced political ideals (e.g., civic buildings and monuments in Washington, DC).

But times have changed, and so have our definitions of Greek art, specifically ancient Greek art (for there is modern and contemporary Greek art, as well). The idea of ancient Greece and its cultural outpouring is very much still with us, but in our multicultural world of global economies, the internet, social networking, and global travel made easily accessible, we have, unwittingly, redefined ancient Greek culture as stretching throughout the region where the ancient Greeks once trod, from Spain to the Hindu Kush, from the earliest Paleolithic "Greeks" to the Byzantine Greeks or even later. What was once clear has become obfuscated because of a plethora of information, as well as the professionalization of the academic fields of art and archaeology and the consequent push to justify budgetary expenditure through publication. What was once of supreme importance to the education of young gentlemen has become the province of anyone and everyone and, ironically, has become obscure and apparently disconnected from the lives of even the well educated.

This book cannot correct this situation and does not aim to do so. But it does try to inform, enliven, and offer new perspectives. Designed for students, the book also aims at the interested layperson, and scholars also may find something of interest here. Many introductory books on Greek art and archaeology already exist, and one justifiably may ask why another is needed or wanted. While this text traces changes in interests, motivations, and appearance of the visual output

of Greek culture over time, it is chiefly concerned with context and function: the purpose and use of buildings and objects, and how these, as well as city planning, infrastructure, and so on, operated within their time and place. How were these things meant to be perceived, what "messages" did they transmit, and how did the surrounding environment – both physical and sociohistorical – shape their meaning for viewers, visitors, and inhabitants? In the case of the prehistoric period, where far less evidence exists to guide us, we can ask how physical objects and buildings were shaped by, and are products of, the larger Mediterranean milieu, by trade, by settlement in distant places, or by the development of technologies. By necessity, the range of materials discussed and the treatment offered here are selective; I have chosen representative examples, including the "usual suspects," but have endeavored to enliven and enrich this study with anomalies and lesser-known objects and monuments in the hope that these choices will stimulate the reader to "see" more and pursue further study. Text boxes offer amplification of various subjects.

Although we regard much of the material production (sculpture, architecture, vase painting) of ancient Greece as "art," this term is an anachronism; until the Hellenistic period, sculpture and architecture were entirely functional: sculpture served religious purposes – as votives, cult statues, and tombstones – and architecture was religious, civic, or domestic no matter how aesthetically pleasing it was and is. Vase painting is a trickier category: the vessels themselves were functional, actually used for dining, drinking, and storage, and/or as grave gifts. But decoration is often not clearly linked to use and is entirely non-functional; one might call it "decorative," but the content of the imagery often has cultural meaning that can be extracted with careful study. Small, portable, private objects of costly materials – carved gemstones, gold jewelry, cameos, for example – also existed, but some of these, such as amulets, also had a religious or, at least, magical purpose.

Likewise, the modern idea of artist is largely inapplicable to the ancient Greek world, and the idea of artist as creative genius was conceived during the Renaissance in Europe. Ancient sculptors, painters, gem carvers, and architects might be more accurately described as having the status of "craftsmen" in the modern sense of the word; they created works of *techne*, of artful skill. In addition, our modern

divisions of sculptors, architects, and so on are probably inaccurate with respect to ancient categories of craftsmen, who are more likely to have been divided by medium: stone masons who could work on sculpture or on architecture, which often was treated as sculpture; ceramicists who made pots and sculpture; metalworkers who created sculpture, perhaps coins and armor, as well, and so on.

Ancient Greek written sources never discuss vase painters (the only mention of vase painters is by the second-century AD writer Pollux 7.108) so everything we know about them must be deduced from the vases themselves, some of which show potters and painters at work. Rivalries clearly existed as we know from *dipinti* on vases, and painters and potters both sign their works – at least that is how we usually interpret the two verbs used in such signatures: γράφω (to write or draw) and ποιέω (to make or shape). There is one instance known to us when a vase painter received the benefit of citizenship in return for a public commission.

Sculptors signed their works starting from an early date, and these signatures usually appear on the base supporting a free-standing sculpture. Our evidence for sculptors increases as time progresses, as seems to be the case with the status of sculptors. Ancient writers mention prominent sculptors and architects, their works, sometimes public reaction to them, or the reputation of these craftsmen, some of whom received tremendous honors from their hometowns (for example, Damophon of Messene was accorded heroic worship), although such instances of exalted honors are relatively rare. Some were wealthy enough to make dedications of vases and sculpture, even large-scale sculpture, as we know from dedicatory inscriptions. And a few were extraordinarily rich: Kephisodotos the Younger, son of the famous fourth-century BC sculptor Praxiteles, took on the liturgy of a trireme – the full equipping of a warship – for Athens thrice in ten years! Sculptors in the fourth century BC began to work on speculation, i.e., making works first, then finding a buyer, rather than working exclusively on commission, and this yielded greater autonomy and price control for the sculptors. Ancient written sources mention more and more treatises written by sculptors and architects from that century onward, though we certainly know of earlier such writings (only one survives).

Architects and wall painters were usually employed by a polis or sanctuary. These were business transactions with contracts, deadlines, financial penalties for tardiness or unsatisfactory work; their work was

evaluated, and accounts were scrutinized, as we know from ancient building accounts inscribed on stone, which served as copies of archival material. Later Roman writers mention the renowned wall painter Polygnotos, who was celebrated for his civic benefactions and praised for his refusal of payment rather than for his painterly skill.

Ancient Greece was a culture highly sensitive to visual stimuli in the form of buildings, sculpture, etc. and to some degree, highly dependent upon these physical means to shape the environment and to define and give significance to space. In these ways, ancient Greece is very much like the modern western world, but even more so: we are bombarded by visual stimuli – all kinds of stimuli, in fact – that were never available in the ancient world: books, newspapers, magazines, film, television, computers, video games, advertising, and so on. In urban centers, there is little empty space either in the built environment or on blank surfaces, such as walls or the sides of buses or streetcars. Everywhere we look, there is something manmade to see, read, watch. Our problem most often is distraction – too much stimulation, too much to see and hear, too much to absorb. This was not usually the case for ancient Greeks, whose visual stimuli were far more limited and consequently, far more observed, discussed, and impressive, literally speaking. When mass spectacles, such as the Olympic games or a religious procession, occurred, they surely were sensational and visually arresting. One can imagine masses of people on foot, traveling in the hot, dry summer through miles and miles of rural landscape, some of it cultivated, and mostly monochromatic, toward a sanctuary like Olympia: from a distance, they could espy the sun glinting off gilt statues placed atop high columns, and as they neared, a vast complex of brilliantly colored buildings appeared. Within the sanctuary was a dazzling array of objects made of costly and rare materials – ivory, gold, silver, jewels, textiles, bronze – not to mention the hundreds of lustrous bronze and brightly painted marble and terracotta sculptures. Inscriptions everywhere – on statue bases, temple façades, altars, objects themselves – were meant to be read aloud in praise of deities, cities, and mortals. In sharp contrast to what people, particularly rural inhabitants, encountered in their daily lives, these colorful, sumptuously decorated sanctuaries must have been intoxicating, mesmerizing, otherworldly spectacles. So when considering the Greek manmade world, the impact of even small details must be borne in mind. They "saw" with fresh eyes and rapt attention a great deal of the time;

we do not. And because so much of Greek sculpture and architecture is devoted to religion, this viewing was imbued with a special vibrancy.

The study of the physical remains of the ancient Greeks is much more than the study of objects, what some scholars deem "art history." Another group of scholars focus on what they define as "archaeology," such as the organization of land and use of terrain for agriculture, settlements, fortifications, burial, and religion, and the products and tools of trade, studies that are rooted in excavation, underwater archaeology, surface survey, or that employ technology, such as radiocarbon dating, aerial photography mapping, dendrochronology, magnetometer survey, remote sensing, resistivity survey, archaeozoology, osteoarchaeology, archaeobotany, to name just a few. Such techniques are especially (though by no means exclusively) useful in periods when written documentation is lacking or highly limited.

Many scholars draw a sharp distinction between those studying objects, art historians, and those doing "archaeology," archaeologists, with the latter often regarding the former with condescension, even disdain; this may be because they mistakenly consider art history as the study of style or of individual objects when, in fact, art history is much broader than this. Similarly, art historians often find the archaeologists' approach to be bloodless and lacking human interest. But the modern division of the study of Greek culture into art and archaeology – in spite of this book's title – is misguided and misleading: "classical archaeology" in its original nineteenth-century sense (particularly among Germans, who were pivotal in the development and study of Greek culture) encompasses *all* areas concerning Greek and Roman physical remains in an effort to understand and "reconstruct" Greek and Roman culture in all its dimensions: religion, politics, history, aesthetics, social relations, labor, agriculture, and so on. This book seeks to revive this vision and to promote a greater unity of approaches in the united effort to understand the ancient Greek world. Thus, it investigates Greek culture through its physical remains, both those deemed "art" and those that are deemed pragmatic or immobile. The questions asked of the evidence can differ, but the goal remains the same. Because of the volume's chronological arrangement, the earlier portions will deal more heavily with questions that can be answered through technical means, while the latter portion focuses on different types of evidence and questions.

It is important to state at the outset that I use the terms Greece and Greek entirely anachronistically in most of this book. The ancient

Greeks never thought of themselves as Greeks but rather as Hellenes, and the region of the world where they resided was Hellas. Ancient Hellas was not a unified nation (nationhood is a nineteenth-century AD invention), but a series of poleis that shared a similar "culture," and were sometimes allied into federations or leagues by common interests or common enemies; I am keenly aware of the ambiguous nature of the term "culture," but simplifying here for the sake of brevity, by "culture" I mean religious practices, burial practices, and language (although there were regional dialects).

The land that constituted ancient Hellas varied over time: the physical extent of the Bronze Age cultures is discussed in Chapter 1. After this time, ancient Hellas included the area of modern Greece (mainland and islands), parts of the Balkans, the western coast of modern Turkey (Asia Minor), and by the eighth century BC, colonies in south Italy and Sicily. Colonies existed elsewhere in the Mediterranean, as discussed in the text, but tended to be singular in a region dominated by another culture. The area corresponding to modern Greece has geography and topography that made agriculture and animal husbandry challenging for the ancient inhabitants. It is a mountainous country with very hot, dry summers, mild winters, and relatively little rain, which yields scrubby vegetation in the lowlands and covered mountainous areas; forests were – and are – common in the north, although for architectural construction suitable wood, especially cedar from the area of modern Lebanon, was often imported in the historical period. This is a terrain ideally suited to sure-footed goats and inhospitable to cattle. Areas around well-watered rivers are green, even lush in some places, where frogs, turtles, snakes, and mosquitoes flourish. The mountains and islands posed an impediment for travel and communications, but the islands, together with the coastline of the mainland, naturally promoted the development of seafaring early on, and the mountains offered natural borders between territories. Marble of various colors and granular quality and various kinds of limestone were – and are – abundant, and silver was accessible in some locations, such as Laurion in Attika. Greece is – and was – an earthquake zone, and we have abundant archaeological and written evidence attesting to earthquakes in the ancient period.

Where to begin this narrative (and it *is* a narrative), and where to end? There was human settlement in the area we now call Greece already in the Paleolithic period, and people have always occupied this

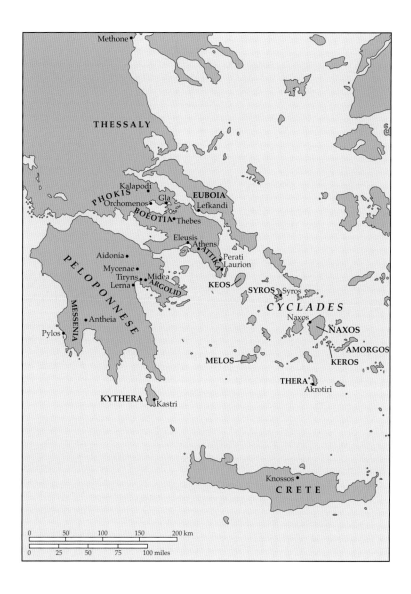

Map of Bronze Age Greece

same region since then. But prehistoric culture in Greece, that is, those cultures that existed before *c.* 1100 BC, really begins in the Neolithic period when we see organized trade, and settlements and fortifications in several areas. Ancient Greek culture experienced changes after the Romans asserted full control and redistributed the region into several provinces of the empire. With the introduction of Christianity and the split into western and eastern portions of the Roman empire, the latter of which became the Byzantine empire, we are dealing with a very different culture – form of governance, role of religion, burial customs, etc. So this book concentrates on the period from the Bronze Age (post-Neolithic) until the conquest by the Romans, with some overlap at the far end of this chronological spectrum.

Those familiar with the field know this span of time includes an overwhelming amount of material, especially if one considers the geography of ancient Greece in its broadest extent. Ironically, however, most of Greek art and archaeology is lost to us or has never been found. Not only was much destroyed in antiquity by warfare, pillaging, and natural disaster, but the post-antique period saw massive destruction of monuments and objects by Christians determined to eradicate the pagan past by destroying, rebuilding, or converting buildings, then later by armies traversing these regions and either destroying or pillaging (the use of the Parthenon metopes for target practice is a well-known example), and by the removal of objects for royal, civic, and personal collections, building, and warfare in more modern periods. The destruction continues now: from air pollution, vandalism, lack of conservation and neglect, new construction, illegal "excavation" and collecting, and, in some parts of the ancient Greek world, by warfare. How much is lost? We will never know it all, but many sculptures, buildings, wall paintings, and cities mentioned in extant ancient written sources (which themselves constitute a small fraction of what once existed) no longer survive. For archaeologists, the limits of our knowledge are humbling, sometimes truly depressing, especially as we witness more and more slipping away, but this quest for the past is also thrilling and endlessly fascinating.

Were I writing this book a century ago or a century hence, my focus surely would be very different, and I am aware that my interpretation is shaped by my own time and place. But the resilience of ancient Greek culture, its ability to speak to us still – in spite of efforts to silence it and its seeming disconnectedness from our contemporary existence – is a marvelous testament to its centrality to western culture throughout its history. Contemporary students may find that ancient Greek culture is remote and hard to comprehend, and this is partially true. The ancient Greeks are not like us in most respects; their beliefs, their values, their cultural priorities, their religious practices are largely alien. Nonetheless, ancient Greek culture is, in fact, deeply, sometimes strangely, familiar in some ways: the architectural visual vocabulary is immediately recognizable, the names of gods and heroes – even some myths – are known, and the Classical sculptural style from the Classical period – its seeming naturalism – is easily identifiable. We may no longer prize education about the ancient Greek world as we once did, but we cannot eradicate it from our cultural consciousness. The ancient Greeks are here to stay.

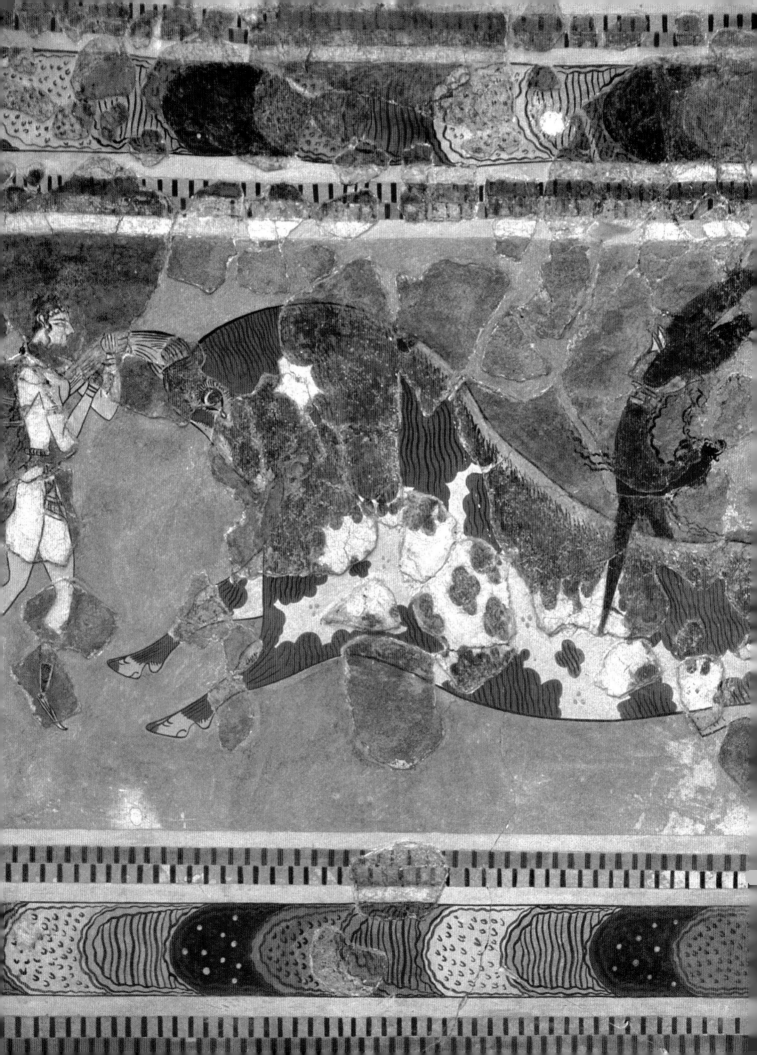

1 The Bronze Age and Early Iron Age in Greece

CONTENTS

TIMELINE – all dates in BC

c. 2800–2200	Egyptian Old Kingdom
c. 2500	Helladic corridor houses on mainland, e.g., House of the Tiles at Lerna
c. 2400–2300	Introduction of bronzeworking from Anatolia to western Aegean
c. 1930–1750/1700	First Palace (Protopalatial) period on Minoan Crete
c. 1792–1750	Law Code of Hammurabi
c. 1650–1530	Volcanic eruption on Thera
c. 1500	Gournia town
c. 1550–1450	Second (New) Palace period on Minoan Crete
c. 1550–1100	Mycenaean period of Helladic culture
c. 1450–1375	Knossos reoccupied under Mycenaean control
c. 1350	Pylos and other Mycenaean centers burned
c. 1300	Uluburun shipwreck
c. 1260–1200	Trojan War?
c. 1250	Rebuilding of Cyclopean Wall at Mycenae to include Grave Circle A
c. 1125	Destruction of Mycenaean centers, end of Linear B
c. 1125–1050	Submycenaean
c. 1000–700	Early Iron Age ("Dark Age")
c. 1050–900	Protogeometric
c. 950	Lefkandi "Heroon"

Map of the Mediterranean area

Bronze Age Greece

The entire Mediterranean was thriving in the Bronze Age (*c.* 3000–
1100 BC): the Egyptian Old Kingdom (*c.* 2800–2200 BC) and vari-
ous Near Eastern cultures, such as the Sumerians and Akkadians, were
already highly developed with written language, mathematics, sophis-
ticated construction techniques (of stone in Egypt, predominantly
mudbrick in the Near East), trade, seafaring, metals, and even writ-
ten law codes, such as that of Hammurabi of *c.* 1792–1750 BC. The
region now called Greece is the latecomer in this part of the world;
with its abundant sources of marble and islands to facilitate seafaring
and trade, which brought technologies and materials, the Bronze Age

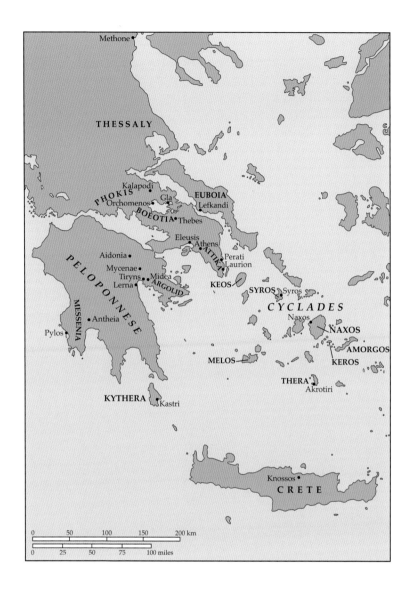

Map of Bronze Age Greece

cultures of Greece rapidly developed. These peoples initially differed from each other not only in geography, but also in funerary customs, architecture, pottery, sculpture (although nearly all of it was small-scale), and, when they occurred, writing systems.

Although regions later inhabited by Greeks – western Anatolia (the western coast of modern-day Turkey), the northern mainland and the eastern Aegean islands – were all occupied in the Bronze Age, our focus here will be the Bronze Age in the western Aegean where three cultures flourished – the Cycladic on the Cycladic islands, the Minoan on the island of Crete, and the Helladic on the southern mainland of Greece. The richest phases of Minoan and Helladic culture come in the Middle Minoan and Late Helladic periods (Fig. 1.1). One key

Approximate Date BC	Cycladic	Minoan	Helladic
3100	ECI	EMI	EHI
2500	ECII	EMII	EHII
2400	ECII	EMII	EHII
2300	ECII	EMII	EHII
2200	ECIII		
2100		EMIII	EHIII
2000	MCI	EMIII	
1900	MCI	MMI	
1875		MMI	
1850		MMII	MH
1825		MMII	MH
1800	MCII	MMII	MH
1775	MCII	MMII	MH
1750		MMIII	MH
1725		MMIII	MH
1700			
1675			
1650	LCI		LHI
1625	LCI		LHI
1600			
1575			
1550		LMI	
1525		LMI	
1500		LMI	LHII
1475	LCII		LHII
1450	LCII	LMII	LHII
1425		LMII	
1400			
1375			
1350			LHIIIA
1325	LCIII	LMIII	LHIIIA
1300			LHIIIB
1200			LHIIIB
1100			LHIIIC
1075			

Time Periods: Cultures:
E = Early C = Cycladic
M = Middle M = Minoan
L = Late H = Helladic
so, e.g., LH = Late Helladic, EM = Early Minoan, MC = Middle Cycladic, etc.

Fig 1.1 Bronze Age chronology.

factor in this acceleration is the acquisition of copper and tin, which were melted together to produce bronze, a technique introduced from northwestern Anatolia (the Troad) into the western Aegean in *c.* 2400–2300 BC. This "tin bronze" was used for tools, including the plough, and led to great advances in construction, farming, such as olive cultivation, and shipbuilding.

The brief overview of Bronze Age Greece presented here offers the background for an understanding of later Greece. Key developments and practices at this time had a profound effect, either directly or indirectly, on the later, historical period when we have literary and historical written documents: these developments include the exploitation of abundant marble supplies, especially in the Cyclades; stone architecture and fortifications; painted terracotta vessels; metalworking; trade, including non-indigenous materials (e.g., hippopotamus ivory and gold), throughout the Mediterranean and Near East with the resulting cultural interchange; worship of deities, who can be identified with later Olympian deities; and, perhaps most critically, the development of a writing system, Linear B, which is the predecessor of later Classical Greek.

Cycladic culture

Agriculture, boats, and trade appeared in the early Bronze Age when a new population, perhaps from mainland Greece to judge from their pottery, settled on a circle of islands, the Cyclades, in the Aegean. The chain of Cycladic islands has two tremendous natural advantages: geography and marble. The islands' central location in the Aegean and close proximity to each other offer ideal stopping-off points for trade and transportation among the islands and on east/west and north/ south routes across the Mediterranean Sea. The abundant marble of varying kinds (fine-grained, large-grained, various colors) in the Cyclades was already exploited in the Bronze Age, and not surprisingly, the Cyclades were instrumental in producing the earliest large-scale stone sculpture in Greece later on, as we shall see.

Box 1.1 Dating

Unlike the case with later periods of Greek archaeology, our knowledge of much of the Greek Bronze Age is heavily dependent on our interpretation of archaeological finds without the aid of contemporary written accounts. Without these, archaeologists must rely on a variety of other means to establish dates. Stratigraphy (the study of the layers or "strata" of excavations) in controlled excavations and typologies (ordering the development of a "type," for example, bronze daggers, over time) enable us to produce relative chronologies, that is, sequences that distinguish between earlier and later objects or periods without using numerical dates (Box 1.1 Fig. 1). Major breaks between periods, for example, when Middle Minoan II ends and Middle Minoan III begins, are usually declared when major changes, e.g., fire destruction, new pottery types, or earthquake damage, appear in excavations, but establishing the time of these transitions, especially from site to site, is often contentious.

Numerical dates are then mapped on to these relative chronologies using correspondences of events, e.g., we know that a particular event occurred in a particular year from its mention in Egyptian texts, which are continuous from the early Pharaonic period onwards, and archaeological findings indicate that this event occurred at one specific point in the relative chronology of Bronze Age Greece. Thus, we can match the latter to the firm dates of the former. Natural phenomena, such as the volcanic eruption of Thera and eclipses mentioned in ancient written sources from elsewhere (e.g., Egyptian texts), also provide scientifically measured events, but, in the case of these, of course, the interpretation of the latter scientific evidence is disputed, and the matching of Egyptian chronology to Greek events also depends on subjective interpretations.

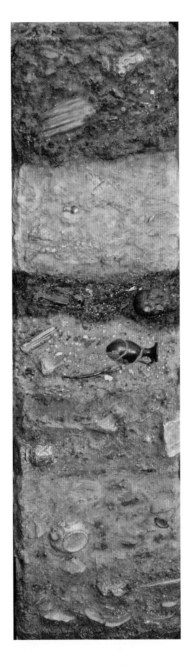

ash layer with remnants of burnt buildings and works of art (destruction layer)

volcanic ash (lapilli) covers a settlement with all daily life remains

destruction layer with ashes

layer with marble chips, tools, vase fragments, and coins (construction fill)

layer with offerings of imported material in an "international" sanctuary

volcanic ashes cover the remnants of a prehistoric city

hand-made pots and stone tools remain from farming and herding settlements

Box 1.1 Fig 1 Stratigraphy.

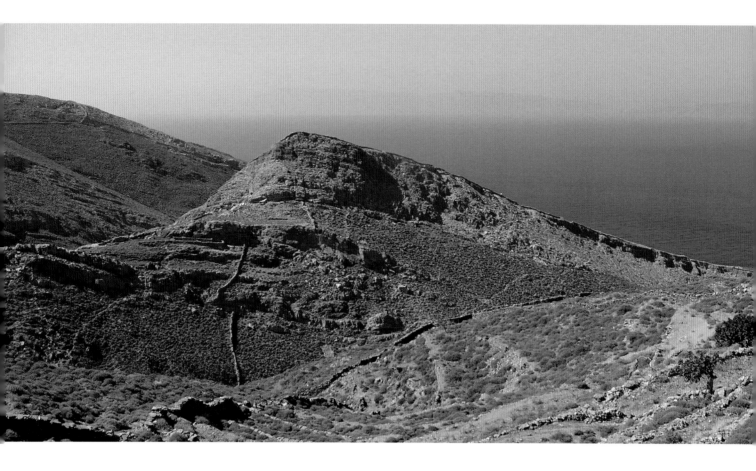

Fig 1.2 Chalandriani, Syros, general topography, looking west

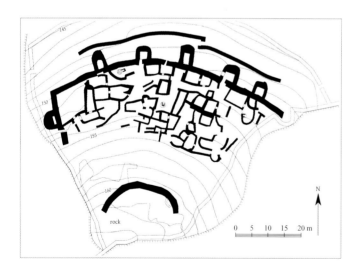

Fig 1.3 Chalandriani, plan.

The Bronze Age Cyclades, particularly in the Early Cyclad-ic II (ECII) period, left behind villages, fortifications, cem-eteries, and painted objects and pottery that provide a vivid picture of early Bronze Age life in the western Aegean islands. The village of Chalandriani-Kastri on the island of Syros was strategically perched on the coast with a commanding view of surrounding seafaring activity (Fig. 1.2). A stone fortress (a length of 70m remains) with five towers enclosed rectangu-lar or curved stone houses with thatched roofs (Fig. 1.3). The large cemetery (600–1,000 graves) consisted of single graves, which was normal burial practice in this period, together with grave goods. Among the grave goods were "frying pans," a characteristic Cycladic terracotta object named because of its resemblance to a modern frying pan, often with incised decoration that is sometimes filled with white coloring. Sev-eral from Chalandriani are incised with the profile view of an

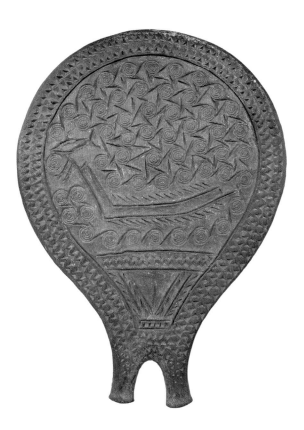

Fig 1.4 Athens, National Museum P4974 from Chalandriani, ECII, terracotta, D 28cm.

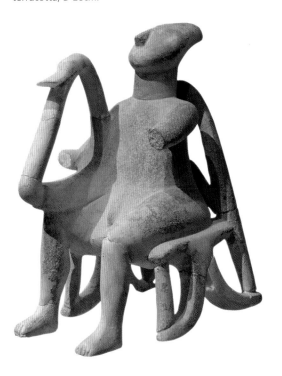

Fig 1.5 Athens, National Museum P3908 from Keros, ECII, marble, H 22.5cm.

oared ship, a fish at the prow, and surrounded by spirals to signify water (Fig. 1.4), references to the seafaring in which the inhabitants engaged. A "ground line" distinguishes the central composition from a nearly triangular area at the point where the pan's circular shape tapers toward the handle. The triangular area of the frying pans is sometimes incised with a vertical line at its center, interpreted by some scholars as the depiction of a vulva, as if this portion of the pan were conceived of as mimicking human female form. Yet this interpretation founders in cases when plant-like decoration also occurs in this zone. This type of object could have served as a shallow container but for what is unknown; most were found in cemeteries, and the form exists elsewhere in a few marble and bronze examples.

Marble sculpture is the best-known product today from the ancient Cyclades (Figs. 1.6–7). The simplified forms and smooth white marble make the figures appear modern to current sensibilities, but ironically, they are among the very oldest works of Greek sculpture remaining to us. In fact, they were originally painted so they once were not so stark as they now appear, and the marble is not all white, but of a variety of shades, including light grey. The marble derives from the abundant quarries in the Cyclades islands, primarily Keros and Naxos. It was shaped with copper and obsidian tools into figures varying in height from *c.* 20cm to lifesize (1.52m), and sculptors used abrasive emery to smooth the finished sculptures before painting eyes, hair, parts of the anatomy, and adornment in primary colors; substantial traces of the paint survive.

The human forms are abstractly rendered: flat bodies with heads tapered slightly back, arms often folded across their torsos, the legs separated or divided by a groove, and usually with toes pointed downward so that the figures cannot stand on their feet. Most are generic figures, chiefly females, while a few signify particular types – pregnant females, seated figures, musicians (two were found together on Keros), or warriors as indicated by a dagger and baldric or helmet (Fig. 1.5). Some are abbreviated, consisting

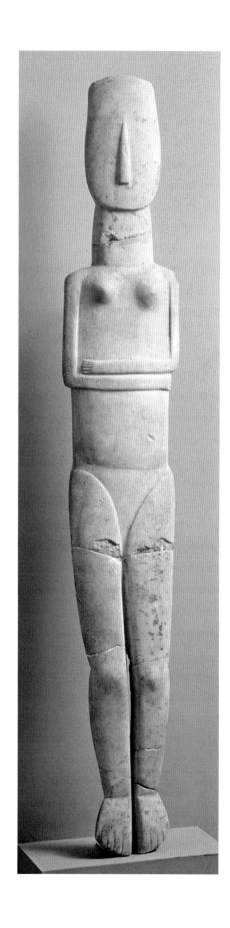

Fig 1.6 Athens, National Museum P3978 from Amorgos, ECII, marble, H 1.485m.

only of a head and long neck or a fiddle-form body and stem-like head.

Why were these objects made, and what function did they serve? The sculptures occur only on some islands, on Crete, and on the mainland; like the frying pans, most were found in graves (some were deliberately broken), though some derive from domestic contexts. It is noteworthy that some examples were considered significant enough to repair in antiquity though *why* they were important is a question: were they heirlooms, or expensive items, or did they have sentimental value? Scholars propose a religious purpose for some of the figures, but with no written evidence from the Cycladic culture to inform us about religious belief or practice, this must remain speculation.

In addition to the frying pans from Chalandriani, terracotta pottery from the Middle Cycladic (MC) period is notable for its colorful painted figural decoration (compare the use of paint on the marble sculpture discussed above), both animal and human (birds and flowers are favorite motifs; Fig. 1.7), treated in broad, bold compositions with ample open space. Some was exported to the Middle Helladic/ Late Helladic I (MH/LHI) mainland and to Late Minoan IA (LMIA) Crete, where natural motifs are commonly used in LM pottery, sculpture, and wall painting.

Minoan culture

Minoan culture existed simultaneously with the Cycladic culture of the Cyclades islands but was centered on the island of Crete, the largest island in the Aegean Sea, to the south. Chiefly known now for their "palaces," the Minoans have fired the imagination of westerners because of, among other things, the apparently prominent role of women and bulls in Minoan religion, and the Minoans' "peaceful" nature as suggested by the lack of fortifications around their settlements. But one reason why they are so well–known to us now is because of what later Greeks of the historical period wrote about them. These writers describe earlier Minoan culture and the roles of King Minos, the Minotaur, and the labyrinth. Later Greeks – specifically Athenians – wove together

Map of Crete

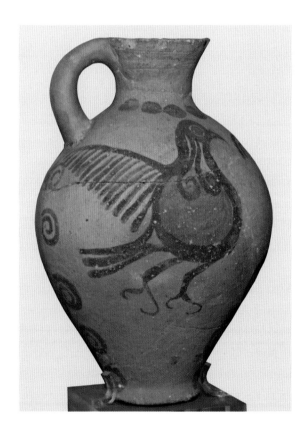

Fig 1.7 Athens, National Museum P5762 from Melos, MCIII, terracotta, H 26cm.

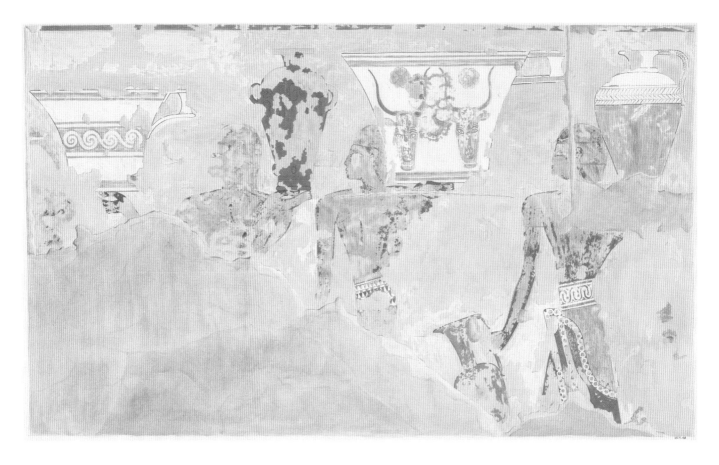

Fig 1.8 New York, Metropolitan Museum of Art 30.4.49 (Roger Fund 1930), drawing made by Nina de Garis Davies of fresco in the tomb of Senenmout in Thebes, 18th Dynasty, *c.* 1479–1458 BC.

the myth of the Minotaur with that of their hometown hero, Theseus, to describe how Theseus became king of Athens. For our purposes, the Minoans are especially important because of the instrumental role they played in the formation of certain aspects of Late Helladic culture (in spite of the many ways in which Minoans and the Helladic peoples differed) and thus, indirectly, of Greek culture of the later historical period.

The Minoans traded and had contacts throughout the Mediterranean. Numerous Cretan polities, as well as Akrotiri on Thera, traded with coastal Asia Minor, Cyprus, the Levant, and Egypt, as we know from archaeological finds. Egyptian texts mention Crete, Egyptian objects have been found on the island, and Minoan-style paintings have been discovered in Egypt (Fig. 1.8). Lacking silver, tin, and copper, Crete imported these crucial metals from Cyprus and the Near East, silver from Laurion in Attika, and also other rarities, such as ivory and gold (Figs. 1.9–10). The Minoans established the colony of Kastri (with even a religious sanctuary on a mountain top, a "peak

Fig 1.9 Herakleion Museum MA 3 from palace at Knossos, MMIII–LMIA, ivory, L 29.5cm.

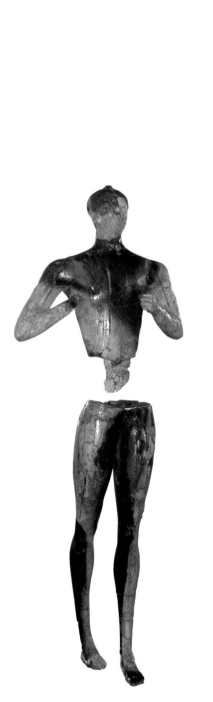

Fig 1.10 Sitia Museum MA 8506 from Palaikastro, LMIB, gold, ivory, serpentine, rock crystal, H 50cm.

sanctuary") on the island of Kythera, and created ports, constructed sailing ships, and built rural farmsteads, watchtowers, and roads on Crete.

Two writing systems have been found on Minoan Crete, and both remain undeciphered. Therefore, our interpretations of Minoan life and the power structure of Minoan society are sharply limited to what can be known from archaeology and what can be gleaned from later objects and textual references. It appears that writing was used for administrative purposes in the palaces, where storage areas – sometimes vast – attest to the economic importance of these centers. Our knowledge of Minoan religion is gleaned from objects whose context, material, and/or iconography suggest ritual function: figurines, stone and terracotta vessels, seals, and gold objects within the palaces and outside them, especially on mountain peaks (Fig. 1.11) and in caves.

Excavations at the Minoan "palace" of Knossos began in AD 1900 under the direction of the Englishman Arthur Evans (Figs. 1.12–13). His discoveries and documentation greatly shaped our picture of Minoan culture, and his reconstruction of the archaeological evidence and of Minoan culture – its governance, religion, and social structure – have strongly flavored both current and later perceptions of the Minoans, even when newer discoveries vitiated or challenged

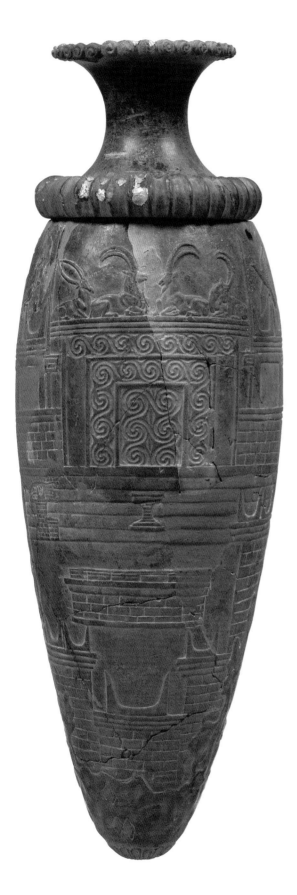

Fig 1.11 Herakleion Museum MA 2764 ("peak sanctuary rhyton") from Zakro, LMI, gilt steatite, H 31cm.

his interpretations. His nomenclature for his discoveries persists as a lingua franca among archaeologists, although the descriptive terms are now known to be inaccurate and can seem fanciful. While our knowledge has expanded greatly and been corrected and refined by extensive exploration, Evans' discoveries at Knossos opened up the world of Minoan archaeology and laid the foundation for all later work.

The term "palace" is used to describe the large, sprawling architectural complexes that dot the Cretan landscape (Figs. 1.14–15). These structures have domestic quarters as well as large storage and work areas, a combination that suggests that they served as central governing and distribution centers. The palaces of Minoan Crete were built in two phases. The First Palace (or Protopalatial) period occurred in the period between MMIB and MMIIB, *c.* 1930–1750/1700 BC, when the palaces of Knossos and Mallia in the north, and Phaistos in the south, as well as smaller, more modest palaces in eastern Crete (e.g., Petras), were constructed. The palace complexes signaled a shift from scattered rural communities to a centralized area of control. After a great fire that destroyed the first palaces, an event that marks the end of MMII in *c.* 1700, they were quickly rebuilt at Knossos (Fig. 1.13) and Mallia, and at Phaistos in LMIB (Fig. 1.15).

This Second (or New) Palace period is the richest phase of Minoan culture and a great period of expanded settlement throughout Crete, including many smaller palaces, for example, at Kommos on the south coast, which is still quite sizable. The new palaces were unfortified multi-storey structures. Our knowledge of their appearance and materials comes not only from the remains on the ground but from contemporary depictions of Minoan architecture in Minoan frescoes (Fig. 1.16), in modeled form (Fig. 1.18), in faience (façades only, Fig. 1.17), and on stone vessels (Fig. 1.11). Plastered mudbrick or rubble walls stood on stone foundations, and wooden beams provided structural supports. The new palaces had façades built of dressed blocks arranged in multiple vertical planes (setbacks and projections), the largest palaces have open terraces flanked by stairs or "theatral areas" in the west, and generally these palaces followed the plans of the old palaces: a large rectangular central court oriented north–south

dominated the structure, with other rooms clustered around this core. The central court was thus a large, open focal point and a good size for public activities. The palaces vary in the placement of their storage magazines, administrative areas (identified by clay sealings, the impressions left by stone seals in clay), and reception rooms, but are remarkably similar in many respects, including the maze-like arrangement of rooms and in having areas devoted to separate functions. Light shafts offered illumination in lower areas of the structures and facilitated drainage (Fig. 1.19), and some rooms had tapering wooden columns on stone bases as supports and were equipped with folding doors that permitted control of ventilation and lighting. One peculiar feature of the new palaces is the lustral basin – a small, sunken room, usually lined with stone slabs, accessible by a staircase (Fig. 1.20). The shape and structure of lustral basins suggest that water was used in these rooms, yet there is no capacity for drainage in them. We are ignorant of the power structure at the palaces, in both the Protopalatial and New Palace periods; Linear A is used in both, but hieroglyphic script only appears in the Protopalatial structures.

Knossos is the largest and most impressive of the new palaces, in part because of Arthur Evans' imaginative reconstructions, which, in spite of many "errors," particularly with regard to decoration and room "furnishings," help the visitor to visualize the past structure. The population of the palace and surrounding town probably numbered around 17,000 (Fig. 1.13). As is the other palaces, one could gain access to the large complex at Knossos from several entrances – in this case, one on each façade – with the primary access on the west. From here, an entry corridor winds along a circuitous route and deposits the visitor in either the central court or the second-floor reception area. Numerous storage corridors with huge pithoi lie at right angles to the western façade (Fig. 1.21), public reception rooms, together with "pillar crypts," line the area immediately to the west of the central court, while a large staircase at the southeast leads down to a residential area (Fig. 1.13). Workshops were located in the east of the palace at Knossos.

The lustral basins and pillar crypts at Knossos and Mallia seem closely connected to religion and to whomever governed the palaces: the "pillar crypts" receive their name from twin pillars, which are

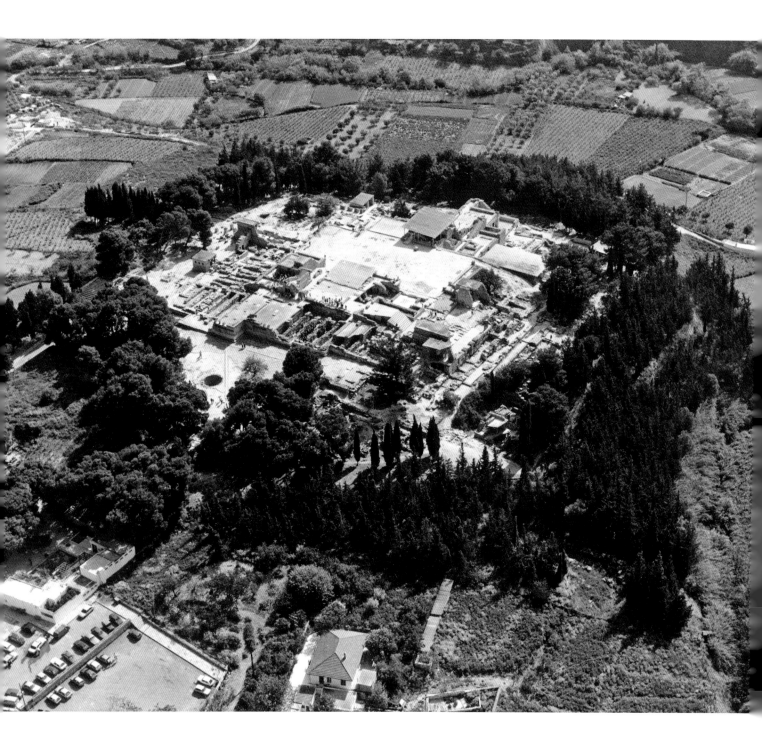

Fig 1.12 Knossos, palace, aerial view, looking northeast.

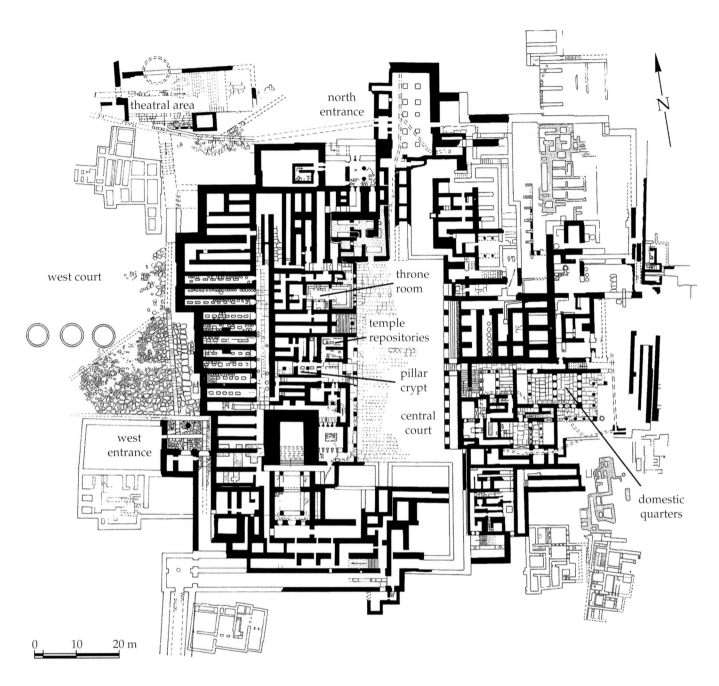

theatral area

north entrance

west court

throne room

temple repositories

pillar crypt

central court

west entrance

domestic quarters

N

0 10 20 m

Fig 1.13 Knossos, MMII, plan.

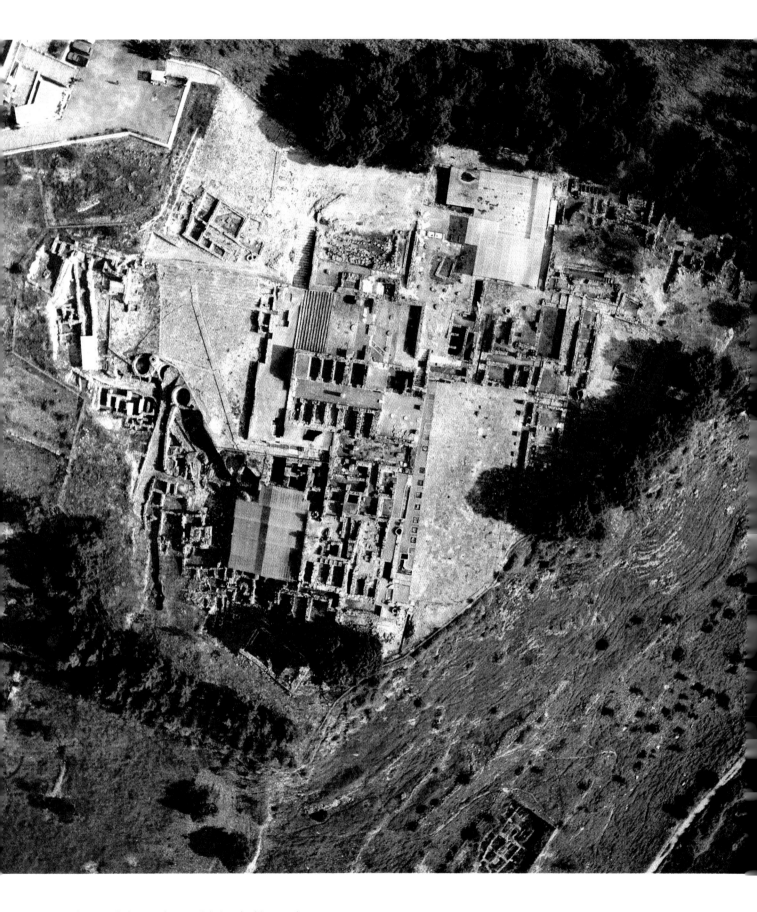

Fig 1.14 Phaistos, palace, aerial view, looking north.

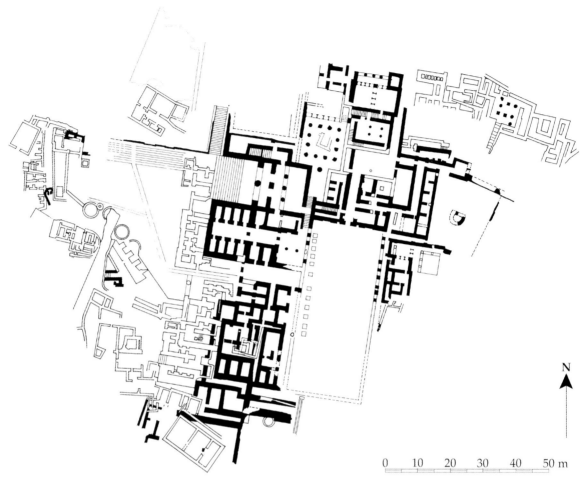

Fig 1.15 Phaistos, plan, LMIB.

Fig 1.16 Oxford, Ashmolean Museum, twentieth century, watercolor reproduction of the Grandstand fresco from Knossos, H (of fresco) 32cm.

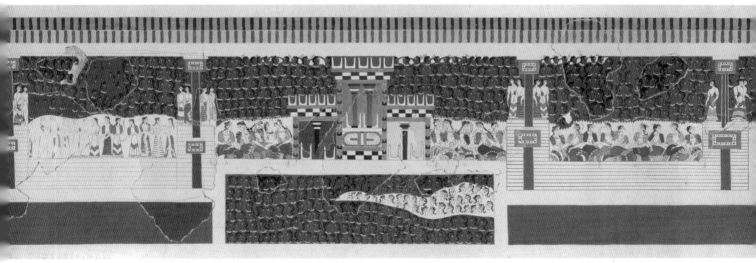

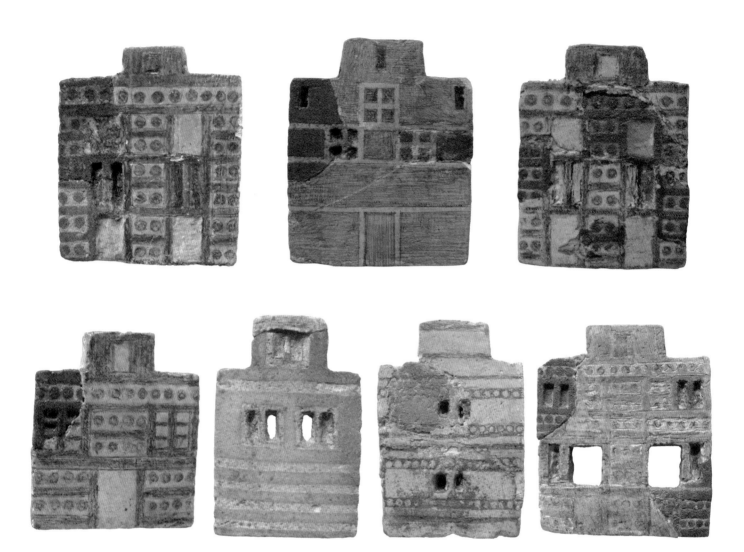

Fig 1.17 Herakleion Museum MA 1, 9, 18 ("Town Mosaic"),
MMIIIA, faience, H 4.1–4.7cm.

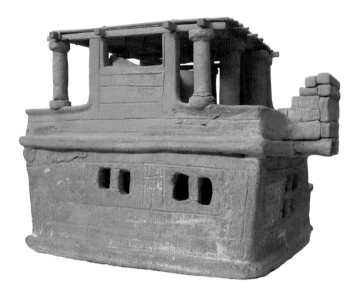

Fig 1.18 Herakleion Museum MA 19410 from Archanes, MMIIIA, terracotta, H 31.3cm.

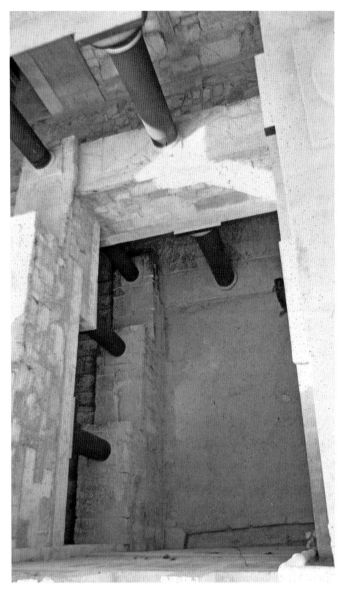

Fig 1.19 Knossos, palace, staircase and lightwell.

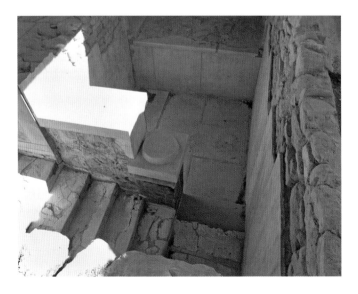

Fig 1.20 Phaistos, palace, lustral basin.

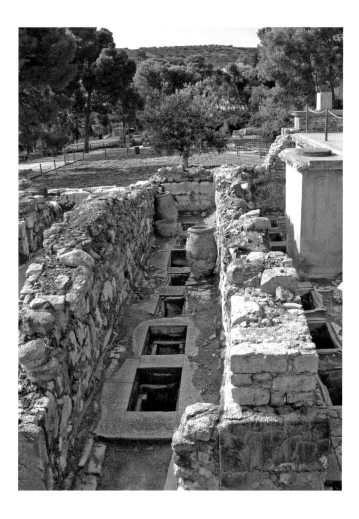

Fig 1.21 Knossos, palace, storage magazines with pithoi.

Fig 1.22 Knossos, palace, pillar crypt.

incised with symbols – at Knossos, double axes (Fig. 1.22), and at Mallia, the double axe, star, and tridents. Stone-lined pits at Knossos (Evans' "temple repositories") contained many objects, including female figurines of faience, the so-called "snake goddesses," who wear flounced skirts, sleeved bodices that reveal ample breasts, and hats; they stand with their arms outstretched or raised, holding snakes in their hands or wound round their arms (Fig. 1.23).

That the snake goddesses may represent Minoan divinities receives support from images of similarly attired females honored by others. A gold ring bezel from the Isopata necropolis at Knossos portrays just such a figure at the right. Two females at the left raise their arms, as if in reverence or greeting, either to the figure at the right or to the figure above, another female of the same type, who stands on a higher

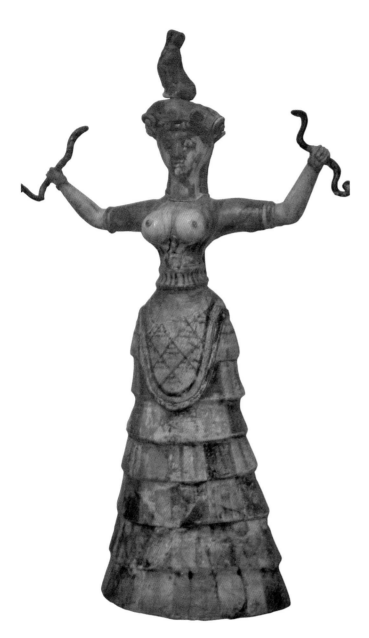

Fig 1.23 Herakleion Museum MA 65 ("snake goddess") from Knossos, palace, MMIIIB, faience, H 29.5cm.

ground level (Fig. 1.24). Minoan animal sacrifice is suggested by images of trussed bulls on tables, sometimes with a human nearby, which appear on LM seal stones. Evidence for human sacrifice comes, most notably, from four human skeletons from a shrine of MMIII date on Mt. Iuktas and from a cache of bones of children (comprising at least four individuals), who, some scholars believe, were butchered and eaten, together with other animals, in an LMIB house at Knossos.

Bull imagery is also prevalent at Minoan sites and is of special interest because of later myths about the Minotaur. According to these traditions, King Minos ruled over a vast thalassocracy from his palace in Knossos. His wife, Pasiphae, developed an unnatural longing to have sex with a bull. The court sculptor, Daidalos (the earliest "artist" in Greek mythology), created a device or apparel for the queen so that she could attract a bull. She succeeded in her goal and conceived a child: the Minotaur, a half-bull/half-human monster, posed such a threat that Minos had a labyrinth created to house it. As part of a settlement over an earlier war, Athens had to "pay reparations" to Knossos annually with a tithe of seven youths and seven maidens, who were sent to Minos; these sacrifices were placed in the inescapable labyrinth as food for the Minotaur. One year, the Athenian king's son, Theseus, volunteered as one of the sacrifices. When he arrived at Knossos, he met Minos'

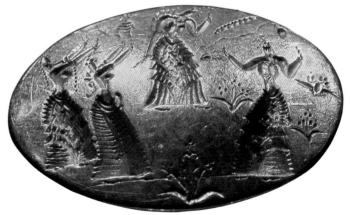

Fig 1.24 Herakleion Museum MA 424 from the Isopata necropolis at Knossos, LMIA, gold, L 2.25cm, H 1.6cm.

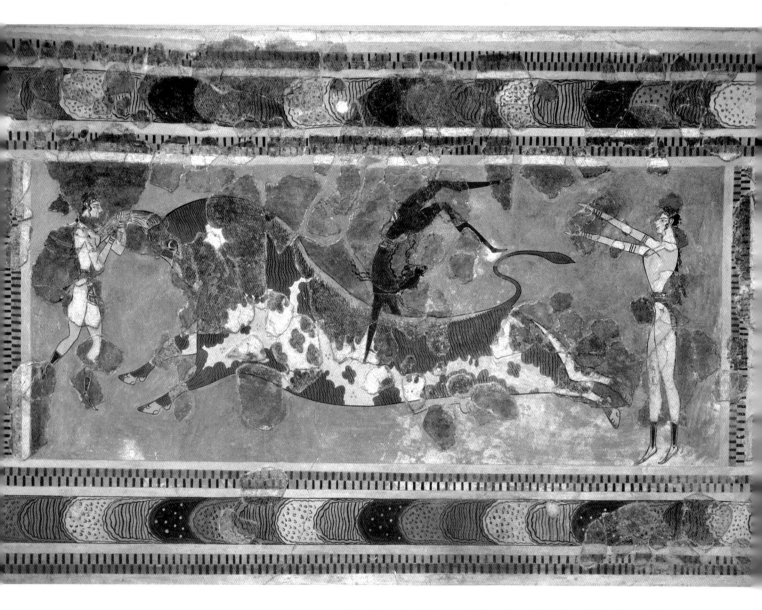

Fig 1.25 Herakleion Museum, bull-leaping fresco from Knossos, palace, H 62.3cm.

daughter, Ariadne, and (predictably) they fell in love. She gave him a ball of wool to take with him into the labyrinth (this object is apt since woolworking was the hallmark of domesticity and the ideal wife in ancient Greece), which he unwound behind him so that he could find his way out. He killed the Minotaur, left the labyrinth, then married Ariadne (he later abandoned her, but that's another story).

This later mythological tradition of a labyrinth for the Minotaur at Knossos seems to be an echo of the palace at Knossos with its intricate groundplan and ubiquitous bull imagery. For example, the bull-leaper fresco from Knossos depicts a figure holding the horns of an enormous

Fig 1.26 London, British Museum 1966.0328.1 LMIA, bronze, L 15.5cm.

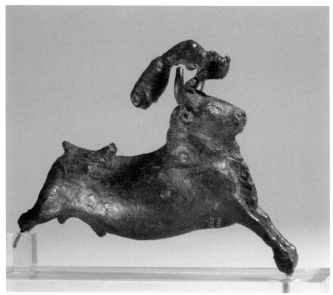

Fig 1.27 Herakleion Museum 1368 from the Little Palace at Knossos, steatite, limestone, rock crystal, shell, gilt wood, H 20.6cm.

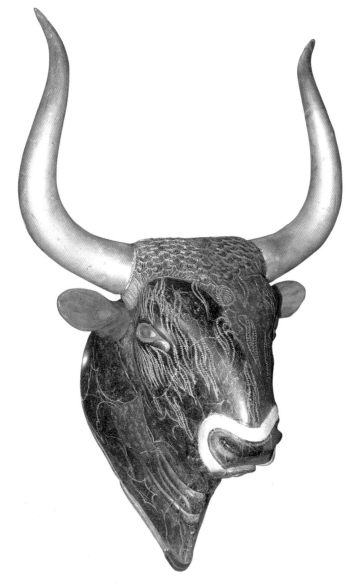

bull, while a second springs over the animal's back, as a third "spots" behind the bull, or perhaps we see the same figure in three stages of action (Fig. 1.25). It is difficult to be sure of the sex of the figure: in Minoan art, white is usually used to delineate females, brown for males (and this convention recurs in later Greek vase painting), but females usually appear bare-breasted, and human figures can also be shown as red (Fig. 1.16). The bull-leaping motif is repeated in a variety of media (Fig. 1.26) and may reflect actual activities that took place in the central courts at Knossos and other Minoan palaces; but while there was ample space for the bull and participants, some scholars have rightly pointed out that the stone paving would have offered little traction for the animal, and there would have been inadequate space for spectators. A carefully worked bull's head rhyton was found at Knossos (though not in the palace); its impracticality suggests limited, ritual use (Fig. 1.27). The motif of bull's horns, which Evans dubbed "horns of consecration," appears as architectural decoration on numerous objects, such as the serpentine rhyton that depicts a peak sanctuary (Fig. 1.11), and also exists in three dimensions (Fig. 1.28).

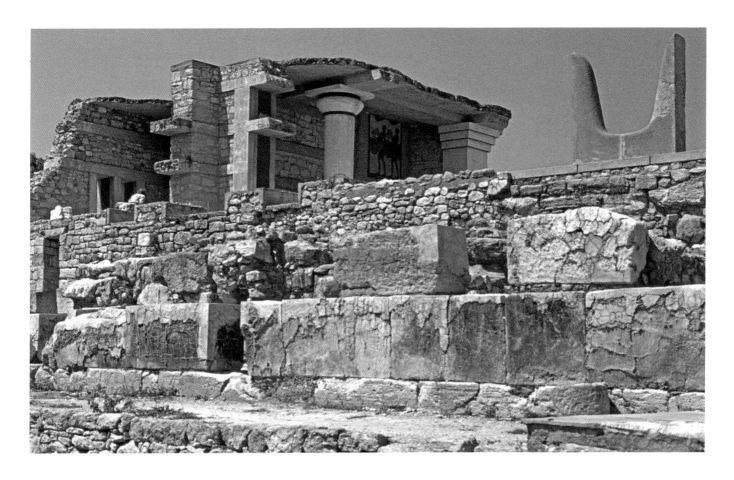

Fig 1.28 Knossos, palace, sculpted horns of consecration.

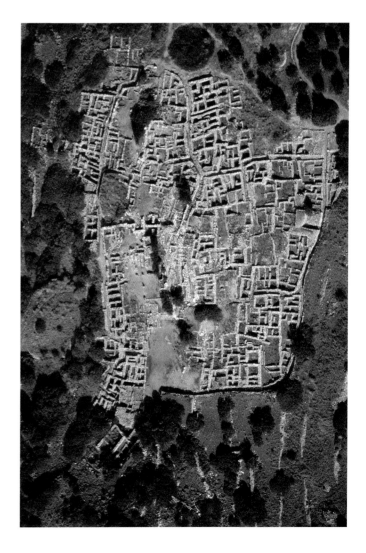

Fig 1.29 Gournia, aerial view, looking north.

Lesser palaces or villas, such as Zakro and Ayia Triada, together with the tablets and clay seals found in them, suggest a dispersal of economic and political power over greater areas in the Second Palace period. And while this chapter has been considering palaces thus far, the hill-top town of Gournia near the northern coast provides a good example of an LMI (*c.* 1500) town plan: rectilinear buildings in blocks divided by narrow, winding, paved streets that encircle the town (Figs. 1.29–30). Gournia possesses a small palace distinguished by its ashlar masonry (regularly dressed blocks of stone arranged in successive layers), and influenced by larger palaces in the form of pillared halls, a lustral basin in the south west, and a "theatral area" with steps.

Akrotiri

A tremendous volcanic eruption on the island of Thera (modern Santorini) plays a key role in the chronology for the Aegean Bronze Age. The volcano spewed ash and pumice as far away as Asia Minor, the Near East, and Egypt. The presence of this material in Egypt is significant: the excellent chronology established for Egypt, together with scientific data and Syro-Palestinian objects, enables scholars to deduce that the eruption occurred sometime between the seventeenth century BC (maybe mid-century) and *c.* 1550–1530 BC. As an added archaeological bonus, Minoan objects found on pre-eruption Thera can be assigned a *terminus ante quem*, a latest possible date, which helps to establish Minoan chronology. As is the case with Pompeii and Mt. Vesuvius in Italy many centuries later, the eruption of the volcano on Thera was a benefit to archaeologists because it buried the Theran city of Akrotiri, which dates to MMIII–LMIA (though it is clear that the city was there long before: remains dating from the period of transition from the late Neolithic to the early Bronze Age exist). Although only a small area of the town has been excavated, its well-preserved finds have excited great interest (Fig. 1.31). Unlike Crete, where it is common

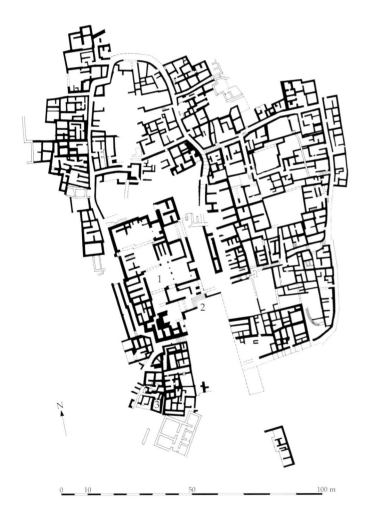

0 10 50 100 m

Fig 1.30 Gournia, plan 1. pillared halls; 2. theatral area; 3. lustral basin.

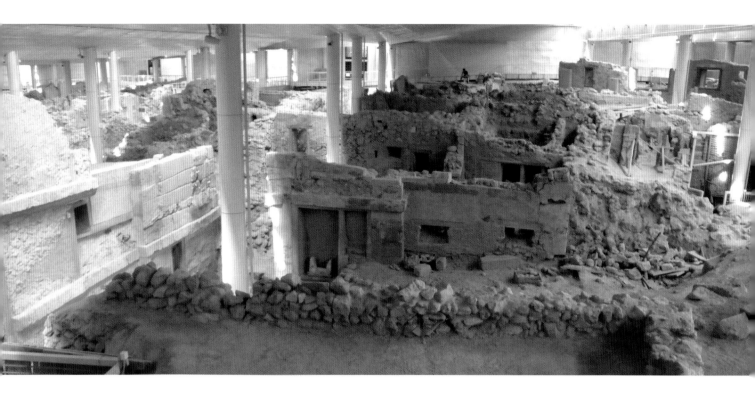

Fig 1.31 Akrotiri.

to find only foundation levels of building, the structures at Akrotiri survive up to a second or third level with internal staircases. The size of many dwellings – three to four rooms and 300–400 sq. m – their numerous windows, fine ashlar masonry construction, and sumptuous decoration are remarkable.

There is a strong Minoan flavor to Akrotiri. Linear A incised on pottery and clay tablets in the city suggests a similar type of administration. Architectural features, such as a lustral basin and pillared halls, recall Minoan architecture, and many motifs and the style of Minoan frescoes (Fig. 1.32) are similar to those found at Akrotiri, where they are better preserved (Figs. 1.33–34).

For those familiar with later Greek vase painting from the Archaic and Classical periods, perhaps one of the most striking aspects of the Minoan and Akrotiri painting (fresco and pottery) is the emphasis on the natural world: on landscape or seascape, on animals and their behaviors (Fig. 1.11), flowers, plants, mountains, and sky. A Minoan "pilgrim's flask" – a term that refers to the oval, two-handled shape – is decorated in the Marine Style (Fig. 1.35): an octopus with large eyes wriggles across the surface, its tentacles carefully delineated and writhing freely, while the area around the animal is filled with plant and mollusk motifs.

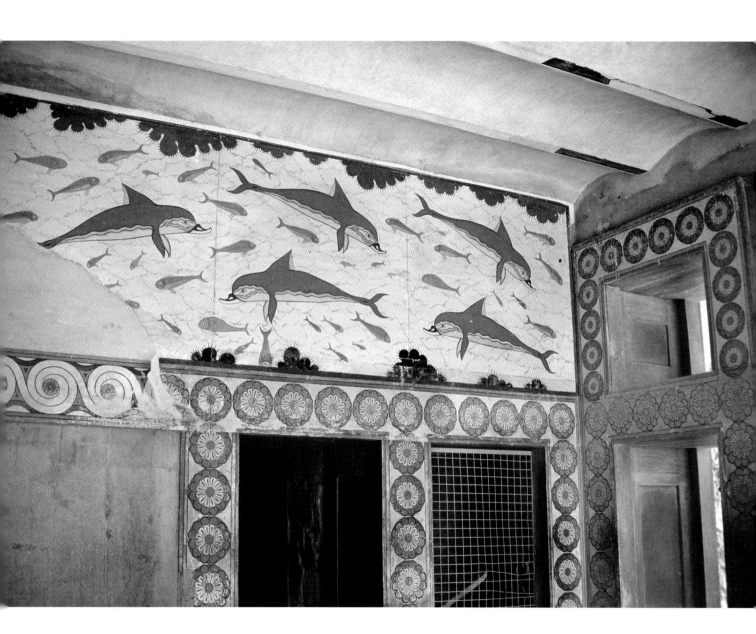

Fig 1.32 Knossos, palace, dolphin fresco from Queen's Megaron, LMII, H 70cm.

Change

The Minoan palaces and other important sites on Crete were destroyed in LMIB, *c.* 1450, but the cause of their destruction is debated. Outside invasion and earthquake, either separately or together, have been proposed. Of the palaces, only Knossos was repaired and reoccupied until *c.* 1375, although building activity and cities flourished elsewhere on the island, especially in coastal towns, such as Kommos and Palaikastro. Dramatic changes appear at Knossos in this post-1450 period: new pottery shapes and styles, new forms of burial and grave goods, new types of

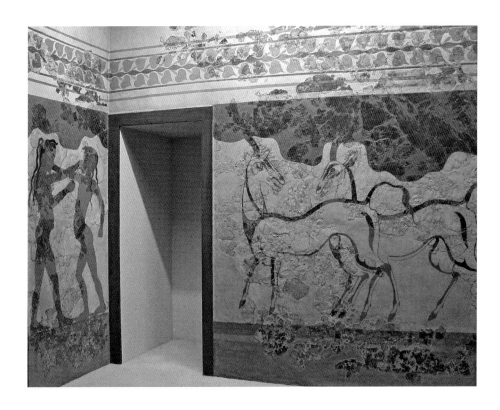

Fig 1.33 Athens, National Museum, boxers, antelope frescos from Room Beta 1 at Akrotiri, LMIA, H 2.75m, W 2m.

Fig 1.34 Athens, National Museum, "Spring fresco" from Room Delta 2 at Akrotiri, LMIA, H 2.75m, W 2m.

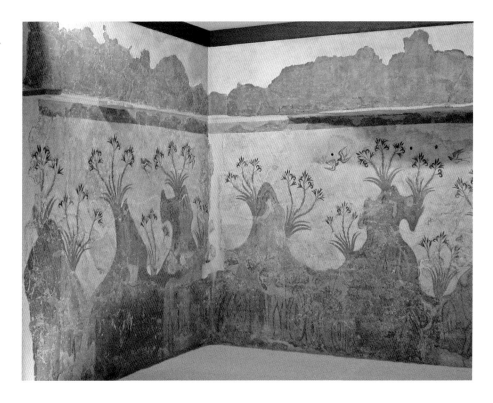

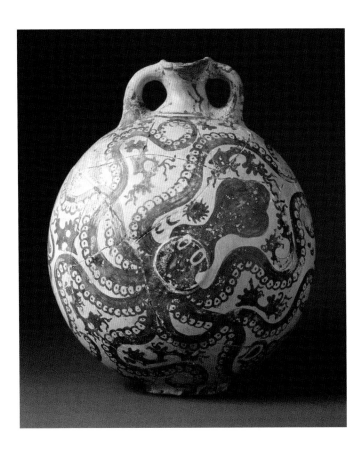

Fig 1.35 Herakleion Museum MA 3383, Marine Style "pilgrim's flask" from Palaikastro, LMIB, terracotta, H 28cm.

objects, and, perhaps most dramatically, a new writing system, Linear B in place of Linear A. What happened? It appears that new people with their own script arrived at Knossos and took control. These invaders seem to have been the Mycenaeans.

Helladic culture: architectural achievements in EHII (Early Helladic II)

"Mycenaean" is a term applied to the late Bronze Age period of Helladic culture, which was concentrated in the Peloponnese, the southern portion of Greece, although sites appear in Thessaly, Boeotia, Attika, and on the nearby island of Euboia, as well. The Mycenaean writing system, Linear B, reveals that the Mycenaeans were pre-Greeks in both their language and their religion.

Whether this was true earlier in the Bronze Age is unclear. But the Early Helladic II period is noteworthy for other, architectural achievements. Large "corridor houses," buildings with long corridors flanking central rooms, were erected at major sites on the mainland beginning in *c.* 2500 BC. These structures were roofed with terracotta and schist tiles, the first appearance of roof tiles in the Mediterranean, which allow for wider, gabled roofs. The House of the Tiles at Lerna takes its name from a large deposit of such tiles (Fig. 1.36a–b). The rectangular building, of mudbrick walls on stone foundations with packed clay floors, was extraordinarily large for a corridor house (25 × 12m) and had unusually thick walls (about 1m wide). An antechamber preceded four main rooms, and staircases ran from the corridors to an upper storey, where wooden posts supported windows and doors. The function of corridor houses is unknown but they likely served a public function, perhaps regional distribution centers, because of their multiple points of access: entrances on three sides of the House of the Tiles, for example, gave access to the interior, but the entrance on the fourth side leads only to one room, which is accessible *only* from outside the building. Curiously, this room contained many clay

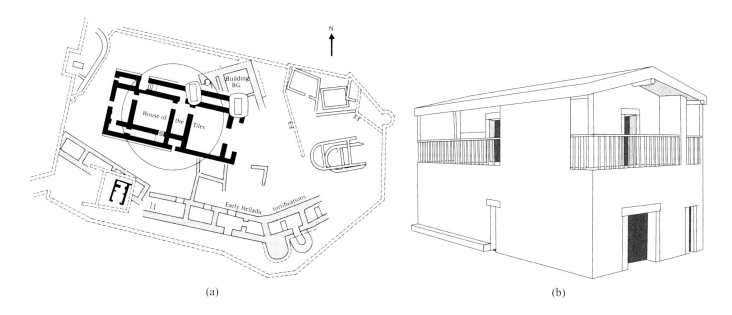

(a) (b)

Fig 1.36a–b Lerna, House of the Tiles, plan and reconstruction.

sealings used to secure containers and items; the great variety of their designs (seventy different motifs) suggests many people using this room, each possessing his own seal.

A comparison of the Helladic corridor houses and the Minoan palaces on Crete is instructive: the Helladic peoples built at large scale much earlier, and their structures are roughly regular in plan, symmetrical with respect to a central axis, as compared with the maze-like, asymmetrical architecture of Minoan palaces. Both seem to be regional distribution centers with multiple entry points, but conceived in very different ways.

In addition to its scale, function, and roofing, the location of the House of the Tiles was also significant. The building partly stands on the site of an earlier structure (Building BG). When the House of the Tiles suffered a massive destruction and fire, key events that mark the end of the EHII at Lerna, the remaining debris was piled up over the destroyed building to form a tumulus, which remained there throughout most of EHIII. Building over a previous structure occurred repeatedly in the Greek world – Minoan new palaces built atop old palaces, for example – but the memorialization of an earlier structure was more unusual; we will observe this phenomenon again (see Fig. 1.63a–c).

Helladic culture: the late Bronze Age

The term "Mycenaean" derives from the site of Mycenae (Figs. 1.37–38) in the Argolid, which Heinrich Schliemann, a wealthy German

THE BRONZE AGE AND EARLY IRON AGE IN GREECE 41

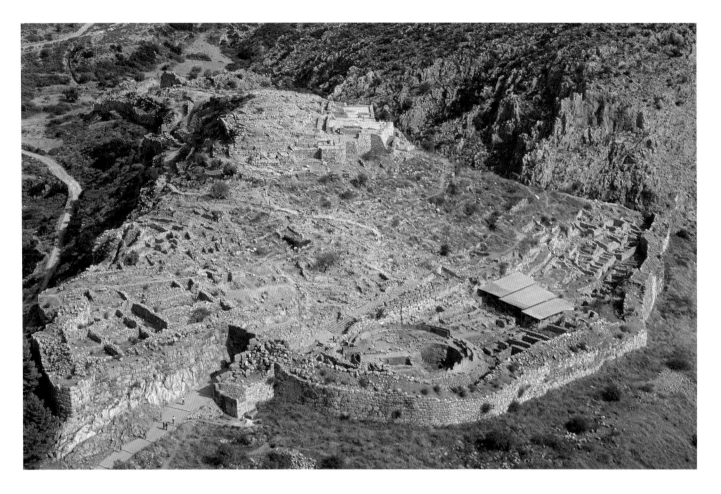

Fig 1.37 Mycenae, aerial view.

entrepreneur, excavated in 1876 (although excavation of the site had already begun in 1841). Schliemann is a remarkable personality in Greek archaeology; he was seeking the home of the Achaians, those warriors who invaded Troy (another site excavated by Schliemann) and destroyed the city after a ten-year struggle as described in the Homeric poems. According to the *Iliad*, Mycenae was the home of Agamemnon, and Schliemann set out to find this place. He succeeded in finding Grave Circle A (see below), although he was mistaken in interpreting artefacts found there as contemporary with the Trojan War, which we estimate to have occurred later (if at all). Likewise, he excavated Troy but misidentified Troy II as the level of the city that fought the Trojan War (scholars now think Troy VI and Troy VIIa are the most likely candidates among the numerous superimposed cities).

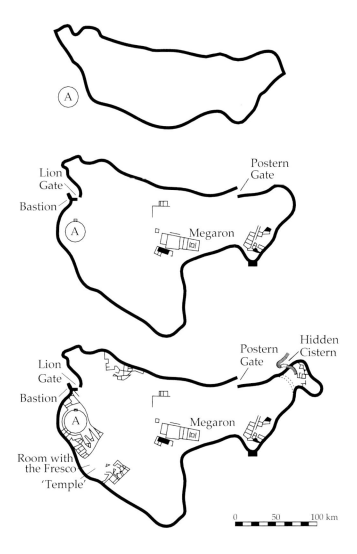

Fig 1.38 Mycenae, three-phase plan.

Mycenae and other sites, such as Tiryns (Fig. 1.39), Thebes, Pylos, Athens, Eleusis, Gla, and Midea, later received more systematic excavation. Several were strongly fortified citadels, although fortifications are not found at all sites, such as the palaces of Pylos or Orchomenos; this, however, may be due to accidents of survival: recent geophysical study of the palace at Pylos revealed a 60m long lineament below ground that may have been a terrace or wall.

The palaces were governed by a *wanax* ("leader, king"), a term recorded in Linear B on clay tablets, which survive because they were baked in the fires that finally destroyed the Mycenaean palaces (Fig. 1.40). The importance of the Linear B tablets can scarcely be overestimated. They preserve accounts, not literature or poetry, yet have yielded valuable information about the Mycenaean economy (for example, exports of textiles and perfumed oils), exchange among Mycenaean polities, and ships, although they do not reveal personal thoughts or beliefs, and offer no information about contemporary philosophy or cultural norms. Linear B is also exceedingly important for its linguistic significance: it is an early form of the later, historical Greek language using a different writing system from later Greek. Finally, the Linear B tablets record the names of the deities worshipped by the Mycenaeans, and these are, in some cases, precisely the same deities worshipped in the later historical period. For example, vessels were sent to Potnia (the female with the power), Zeus, and Hera. Athena, Poseidon, and Dionysos also are clearly attested in the tablets, and there is linguistic evidence for Mycenaean worship of Artemis. In other words, the Mycenaeans were direct ancestors of the later historical Greeks to whom the following chapters are dedicated.

Mycenaean palaces: Mycenae and Pylos

The citadel of Mycenae, constructed in three phases, was protected by massive fortification walls (*c.* 6m thick) of Cyclopean masonry, huge limestone boulders that could only have been moved by the giant Cyclopes, according to

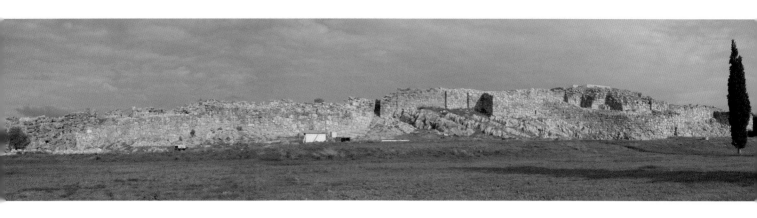

Fig 1.39 Tiryns, view.

Fig 1.40 Athens, National Museum 7668, Linear B tablet.

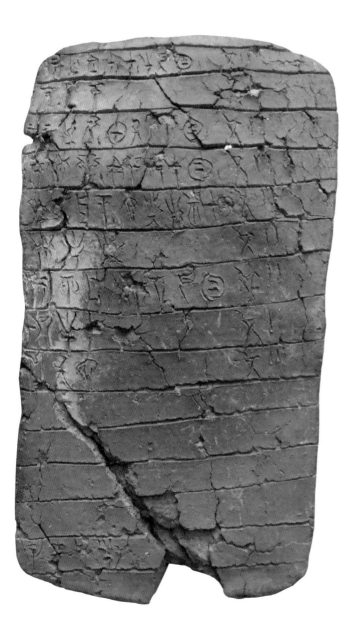

later Greeks. These boulders were fitted together and the interstices filled with smaller stones. The Lion Gate was added to the fortifications in the second phase (Fig. 1.41a) and was surrounded by ashlar masonry. The Lion Gate's enormous lintel block is estimated to weigh 20 tons; to reduce the weight on the block, which spans a wide, unsupported space, the area above the lintel was topped by a thin (70cm thick, 3m high) limestone relief sculpture, a "relieving triangle" (Fig. 1.41b); this construction technique was already used in Egyptian stone construction a millennium earlier. On this relief, standing lions (heads, now missing, were attached separately with dowels) flank a column, their front legs resting on an altar. The choice of images reflects contact with other cultures: the column is of Minoan type, tapering downward with a bulbous capital, and the lion is familiar from Near Eastern palatial art, long used by rulers to denote power and virility. However, the lion may also reflect a memory of the distant past. Lion bones have been recovered in Neolithic and Bronze Age contexts in the Balkans and various locations in Greece, including as far south as Kalapodi and Tiryns, suggesting that lions inhabited Greece into the early Bronze Age period; the bones usually show marks of butchering, suggesting that the meat was

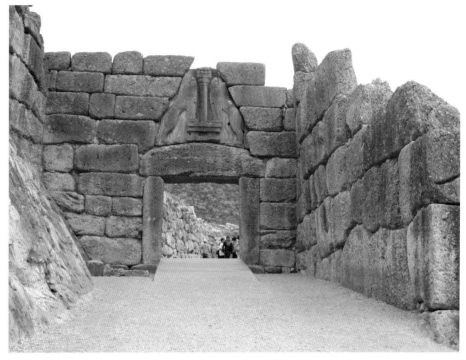

(a)

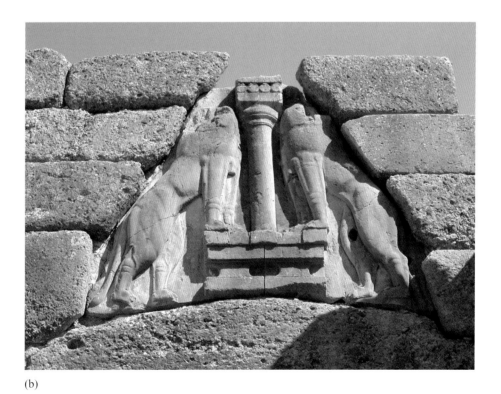

(b)

Fig 1.41a–b Mycenae, Lion Gate.

Box 1.2 Writing in the Bronze Age

Bronze Age Greece produced four writing systems: a
hieroglyphic script and Linear A belonging to the Minoans,
Linear B (see Fig. 1.40) of the Helladic culture, and a
unique instance of writing on the terracotta Phaistos
disk, a Minoan object of MMIII/LMI found at the palace
at Phaistos. Of these scripts, only Linear B has been
deciphered, thanks to the brilliant work of Michael
Ventris in 1952. In spite of the many Linear B texts
existing (mostly inventory lists, instructions,

distributions, lists of received goods), the range of
information they offer is restricted. They were found in a
limited number of areas in palaces, and all of them were
written on clay. There are basic facts we do not yet
know about these societies (for example, whether any
of them were slave societies). Admittedly, however, our
knowledge would be far poorer without the Linear B
tablets, which tell us a great deal about the economy
and religion.

consumed. Rather than solely being the product of Near Eastern
influence, the lions depicted in the LH period might reflect a memory of the past, perhaps passed down through oral accounts. However, the artistic motif of confronted lions, a heraldic device, is familiar from earlier Near Eastern art and may have been one influence on this device at Mycenae.

To return to Mycenae's defense system, the bastion of the Lion Gate juts forward 14m as a defensive strategy: invaders were tunneled into this narrow passage and their exposed right sides were vulnerable to guards posted on the adjacent projection. In the last phase of construction at Mycenae, the wall was extended to include access to an underground cistern, an emergency water supply, in the northeast of the citadel, a signal of concern or anxiety over the accessibility of the water supply; the same phenomenon occurs on the Mycenaean Athenian Akropolis.

Within the walls were buildings and areas devoted to different functions, a layout also used at other Mycenaean palaces; for example, rooms of the well-preserved palace at Pylos were devoted to a single commodity: some were filled with pottery or storage jars or wine, one was devoted to perfumed oil. In addition, the extraordinarily large number of Linear B tablets recovered at the palace at Pylos gives us insight into its functioning and economy that included authority over the surrounding region (most of modern Messenia); from these tablets and those found elsewhere, we also learn that Mycenaean palaces were centers for gathering commodities

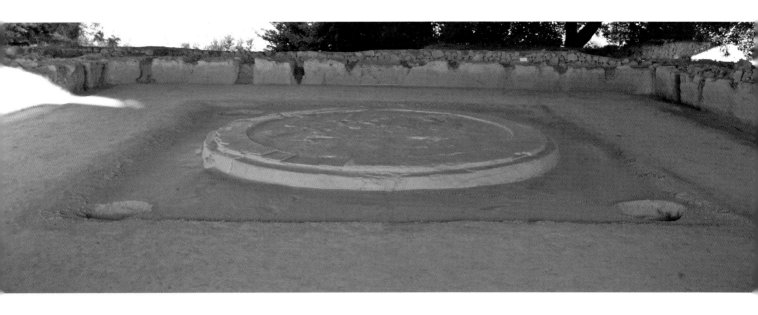

Fig 1.42 Pylos, megaron, view.

from the surrounding region, which were stored, then dispensed as offerings or payments.

Mycenae's walls enclosed houses, a religious area, and a *megaron*, a feature common to Mycenaean palaces. The megaron at Mycenae and elsewhere constituted the central room of the palace and served as the primary reception area for the wanax (Figs. 1.38, 1.42–43). Axial design, symmetry, and clarity characterize the megaron form, and its features are remarkably consistent in Mycenaean citadels: two small antechambers preceding a large, nearly square room with a large, central, circular hearth. The outermost antechamber serves as a porch with two columns between the walls or *antae* (this arrangement is expressed in architectural terms as "two columns *in antis*"). The megaron's walls often were ornamented with frescoes, and a throne stood against one wall. An opening in the ceiling corresponded to the shape of the hearth below in order to allow smoke to escape, and four columns supported the ceiling around the aperture. The megaron at Pylos adheres to the type described above and includes a hearth and throne (Figs. 1.42–43), as well as an offering table with a drainage channel near the hearth, suggesting religious powers vested in the wanax.

Religious activity seems to have taken place in several structures in the southwest of the citadel at Mycenae. "The Temple" and the "Room with the Fresco" complex both had rooms with platforms on which female terracotta figurines were found *in situ* (in their original position; Fig. 1.44a–c), and more figurines, including terracotta snakes,

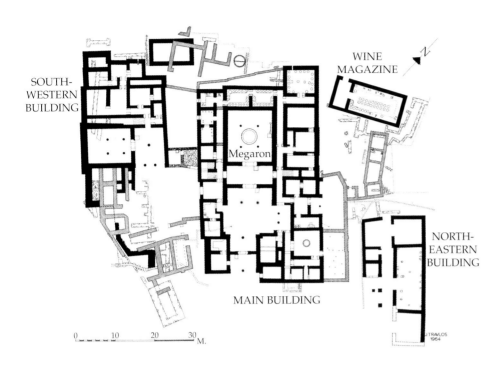

SOUTH-
WESTERN
BUILDING

Megaron

WINE
MAGAZINE

NORTH-
EASTERN
BUILDING

MAIN BUILDING

0 10 20 30
M.

J. TRAVLOS
1954

Fig 1.43 Pylos, plan.

pottery, some imported and luxury items – a scarab, ivory objects, lapis lazuli, glass beads – were found nearby. "The Temple" seems to have been particularly important: thirty female figurines and fifteen terracotta snakes, as well terracotta "offering tables," were found within. The painting in the eponymous "Room with the Fresco" depicts two confronted female figures (one holds a sword, the other a staff or spear) standing near columns, and two diminutive males stand between the females; at a lower level, another female figure next to a column holds sheaves of wheat in her upraised hands while a griffin prances nearby (Fig. 1.45a–b). Women, snakes, plants, and columns are the featured, significant elements. The "horns of consecration" on the adjacent surface and column recall Minoan motifs discussed above, and the snakes and female figures with upraised arms bring to mind the Minoan faience snake goddesses. Such figurines are not unique to Mycenae and are known from other Mycenaean sites, as well. With no apparent practical use, the figures, platforms, paintings, and objects, as well as the prominent placement of the statues and expensive small items, suggest religious activity in these rooms.

Further information about Mycenaean religion derives from the Linear B tablets from the palace at Pylos in their mention of animal offerings to Poseidon and "Peleia," suggesting animal sacrifice. As more tangible evidence, animal bones from Pylos show evidence of

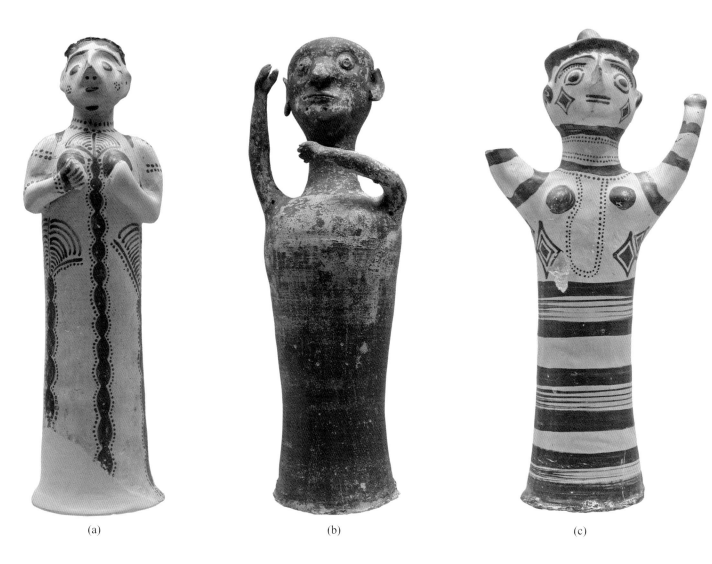

(a) (b) (c)

Fig 1.44a–c Mycenae, Museum 68–1577 (holding breasts,
LHIIIA, H 33cm), 68–1572 (gesticulating, H 57cm), 69–1221
(arms up, LHIIIB, H 29cm), terracotta.

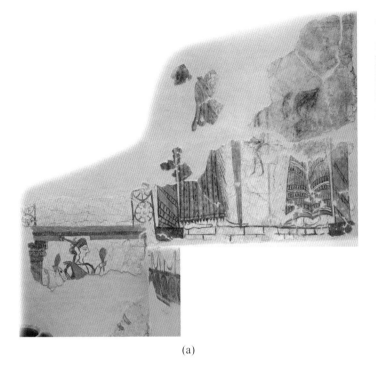

(a)

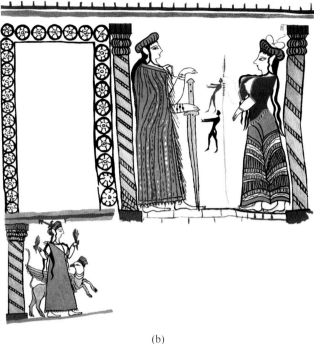

(b)

Fig 1.45a Mycenae, "Room with the Fresco," painting, LHIIIB.

Fig 1.45b Mycenae, "Room with the Fresco," reconstruction of painting.

butchering, then burning after meat was removed, and the quantity and deposition of archaeological evidence suggests communal banqueting (crowds of perhaps more than a thousand people), which is also attested at Kalapodi in Phokis. Butchering does not imply sacrifice, but, given what we know from the Linear B tablets of Poseidon's importance at Pylos and his having received sacrificial offerings, the physical evidence is suggestive.

Burial at Mycenae and elsewhere

From the MH and LHIA periods come some of the most spectacular finds from Mycenae, the grave goods from Grave Circles A (*c.* 1600–1500) and B (*c.* 1650–1550). Both burial areas initially were outside the Cyclopean fortification walls, but Grave Circle A was

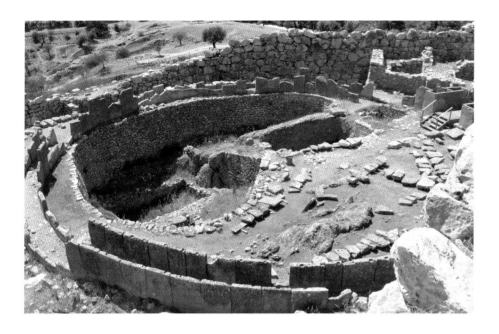

Fig 1.46 Mycenae, Grave Circle A, view.

Fig 1.47 Mycenae, Grave Circle A, reconstruction.

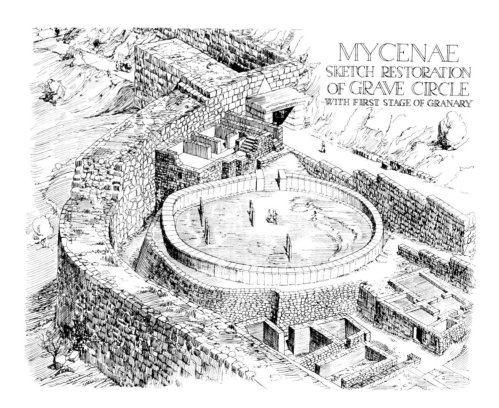

Fig 1.48 Athens, National Museum P1428, stele from shaft grave V in Grave Circle A at Mycenae, LHI, limestone, H 1.35m, W 1.06m.

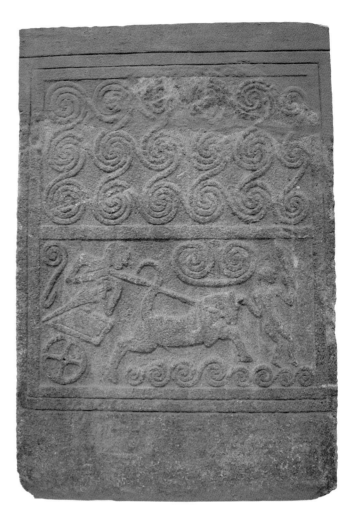

Fig 1.49 Athens, National Museum P624a ("mask of Agamemnon") from shaft grave V in Grave Circle A at Mycenae, LHI, gold, H 26cm.

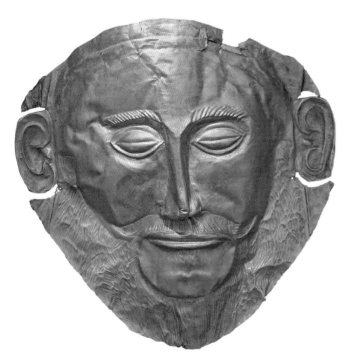

included within an extension of the wall around *c.* 1250 BC (Figs. 1.38, 1.46–47), suggesting the special importance attached to these tombs. Nearly all the graves in both circles were shaft graves, which were unusual in Mycenaean Greece – rectangular shafts dug deep into the earth with the body placed at the bottom in a stone-lined pit, which was then covered – while the remainder were cist graves, a shallow version of the same; both types of graves were reused over time. Stone stelai, some decorated with relief sculpture of hunting or warfare themes, marked the graves (Fig. 1.48). The grave goods provide information about wealth, status, and cultural values; those from Grave Circle A are extraordinarily rich in terms of material and decoration: bronze, imported pottery, ivory, silver, and an abundance of gold dominated by seals, jewelry, five face masks, and diadems (Figs. 1.49–51). The imagery emphasizes warfare, hunting, lions, and bulls (Figs. 1.51–53),

Fig 1.50 Athens, National Museum P412 ("Nestor's cup") from shaft grave IV in Grave Circle A at Mycenae, LHI, gold, H 14.50cm.

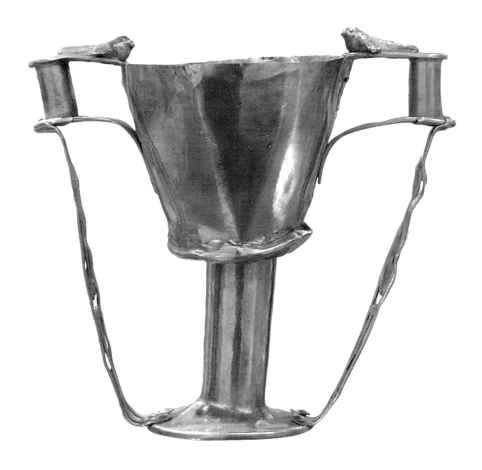

Fig 1.51 Athens, National Museum P811 from shaft grave V in Grave Circle A at Mycenae, pyxis, LHI, gold, wood, W 8.5cm.

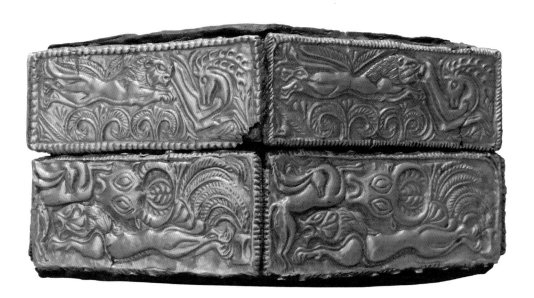

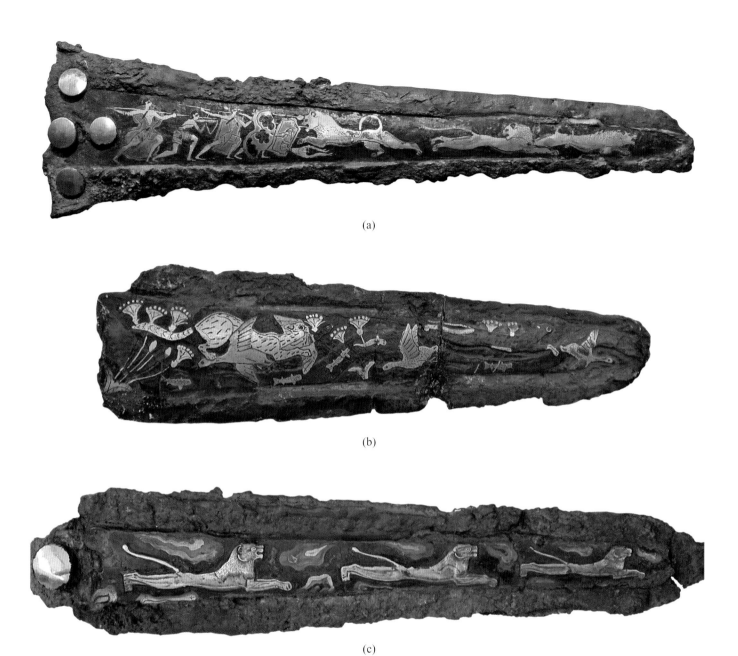

(a)

(b)

(c)

Fig 1.52a Athens, National Museum P394 (hunt) from shaft grave IV in Grave Circle A at Mycenae, inlaid dagger, LHI, gold, silver, niello, L 23.8cm.

Fig 1.52b Athens, National Museum P765 (cat and bird) from shaft grave V in Grave Circle A at Mycenae, inlaid dagger, LHI, gold, silver, niello, L 16.3cm.

Fig 1.52c Athens, National Museum P395 (lions) from shaft grave IV in Grave Circle A at Mycenae, inlaid dagger, LHI, gold, silver, niello, L 21.4cm.

sometimes rendered in Minoan style (cf. the wasp-waisted figures). It has been suggested that Minoan craftsmen traveled to the mainland and produced their wares there; in any case, it is clear that the Mycenaeans were trading with the Near East in order to obtain some of these highly prized materials.

As grand as these grave goods are, even more elaborate forms of commemorating the dead existed at Mycenae and at other LH sites. These are stone *tholoi* or beehive tombs (all robbed long ago), a construction type already existing on the mainland in the MH, but the LH examples exceed their MH predecessors in size. Perhaps the most

Fig 1.53 Athens, National Museum P384 from shaft grave IV in Grave Circle A at Mycenae, LHI, silver, gold, H (without horns) 15.5cm.

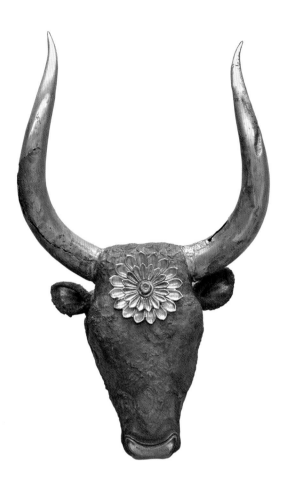

Box 1.3 The Uluburun shipwreck

Unfortunately, the extant Linear B tablets have not revealed details about trade in the Mycenaean period, but our knowledge advanced greatly with the 1982 discovery of the Uluburun shipwreck near southern Turkey. The ship sank shortly before 1300 BC (LHIIIA), as we know from dendrochronological analysis of the wood used for the ship's dunnage (packing material). The cargo comprised a vast range of raw materials (especially copper, tin, resin, ebony, and glass) and finished goods, materials that derived from Cyprus, the Near East, Mycenae, Egypt, and Nubia. Items for shipboard use help in identifying the home port (its last port of call seems to have been Cyprus), and numerous Canaanite objects, including pan-balance weights, lamps, scales, and dining vessels, suggest a crew of Canaanite sailors and merchants. In addition, personal items, including Mycenaean sealstones, weapons, and fine dining ware, attest to the presence of Mycenaeans onboard. The shipwreck expands our idea of trade as derived from the Linear B tablets and allows us to envision Mycenaean objects and Mycenaean tradesmen plying the Mediterranean waters.

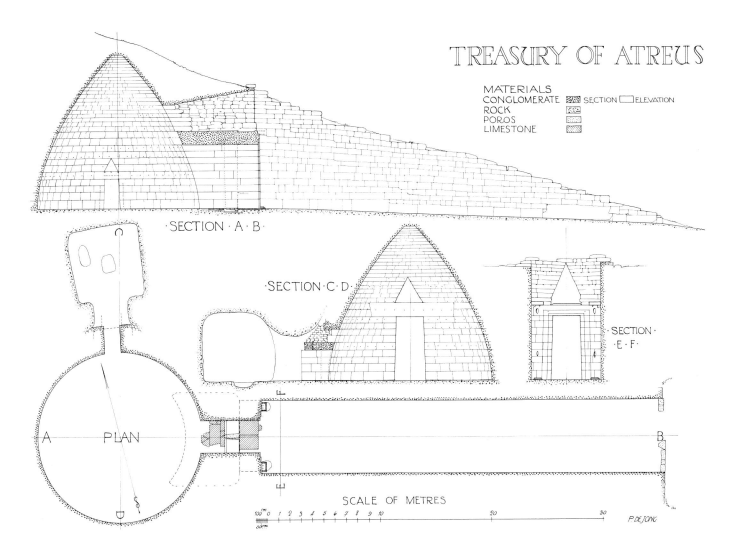

Fig 1.54 Mycenae, "Treasury of Atreus," LHIIIB, cross-section.

impressive example, the "Treasury of Atreus," is at Mycenae, where this is one of nine tholoi. The name is a misnomer reported by the ancient travel writer Pausanias (2.16.6), who lived in the second century AD. The tomb itself (interior dimensions: 14.5m diameter, 13.2m high) is cut into a hillside, which serves to buttress the construction of ever-diminishing rings of dressed stones (corbel vaulting; Fig. 1.54). A *dromos* (path), 35m long and 6m wide and framed by conglomerate

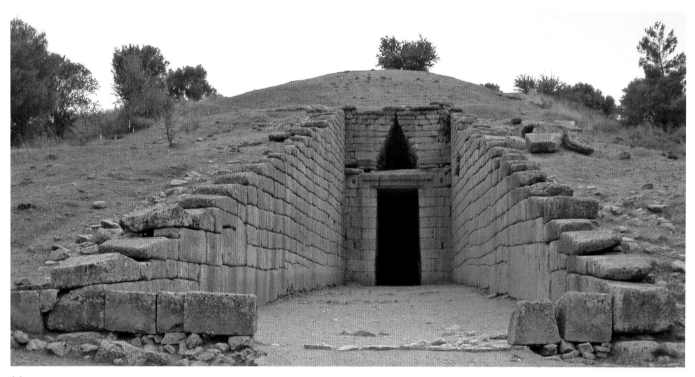

(a)

Fig 1.55a Mycenae, "Treasury of Atreus," LHIIIB, view of doorway.

ashlar walls, leads to the doorway that, at 5m high, forms an enormous cavity in the structure (Figs. 1.55–56). A relieving triangle surmounts two adjacent lintel blocks, and another relieving triangle is also used over the secondary, smaller room within, which is a technique employed elsewhere (e.g., Orchomenos) to alleviate weight on the lintel. Adornment enlivened the doorway, which once had doors: two engaged columns of green stone flanked the opening; smaller, downward-tapering red stone columns stood above; and the relieving triangle also had stone decoration. Like the Lion Gate, the shape of the upper columns, the column capitals, and the decorative motifs borrow from Minoan precedents. Embellishment to the doorway is highly unusual for Mycenaean tholoi and signifies the extravagance of this particular tomb.

The various kinds of tomb structures in the Mycenaean world exhibit a social hierarchy. In addition to the grand tholoi at Mycenae, tholos tombs were built elsewhere but usually at smaller scale, seemingly in imitation of the grander forms. Chamber tombs are another common form of burial. These rock-cut tombs were not vaulted, but like the tholos tombs, have a dromos leading to an underground chamber and were used repeatedly for later burials. These are especially common in

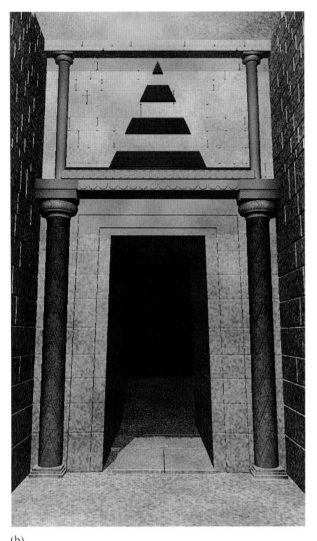

(b)

Fig 1.55b Mycenae, "Treasury of Atreus," LHIIIB, reconstruction of doorway.

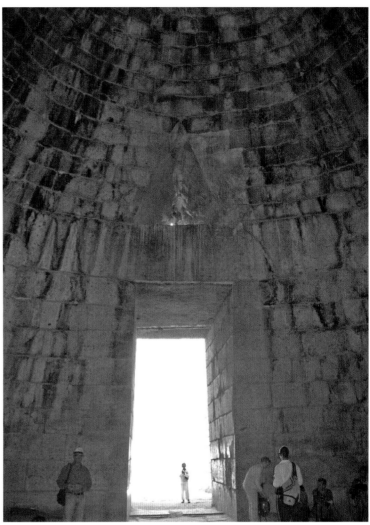

Fig 1.56 Mycenae, "Treasury of Atreus," LHIIIB, interior.

the Argolid; for example, Mycenae has more than 250 chamber tombs in 27 different cemeteries.

Pottery: Minoan and Mycenaean

Mycenaean pottery employs shapes native to the mainland, such as the stirrup jar, the two-handled drinking cup, and tall *kylix* (cup), but was clearly influenced by Minoan painted motifs after the conquest of Knossos in *c.* 1450. A stirrup jar of LHIIIC found in a cemetery at Perati in Attika is ornamented with an octopus, a typical Minoan motif

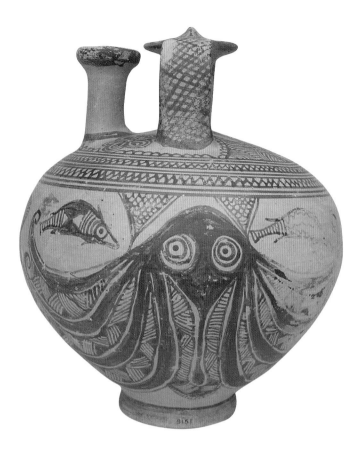

but highly unusual for Mycenaean pottery (Fig. 1.57). Unlike its Minoan counterpart (Fig. 1.35), the Mycenaean rendering of the animal is very abstract and symmetrically aligned with the vertical axis of the pot: the motif has traveled but has also been adapted to differing tastes. The Mycenaeans also borrowed other Minoan motifs, such as bull-leaping and groups of women with their arms outstretched upwards, but whether the meaning, perhaps religious, attached to the original motif was retained in its reuse in another context is unknown (Figs. 1.58–59; cf. Figs. 1.24–26).

Abstract ornament and horizontal bands, as well as highly stylized warriors, hunters, and chariot scenes, are common on Mycenaean pottery (and one also sees the occasional oared ship). Large human figures filling the height of the vessel, however, are not. One of the latest examples of Mycenaean pottery offers just this. The Warrior Vase of LHIIIB–LHIIIC receives its appellation from the file of infantry who process away from a woman, who

Fig 1.57 Athens, National Museum P9151 from Perati cemetery in Attika, Mycenaean stirrup jar with octopus, LHIIIC.

Fig 1.58 Kalamata, Benakeion Museum (ex-Olympia), from chamber tomb 4 Antheia, ring found in LHIIIA context, bull-leaping, gold.

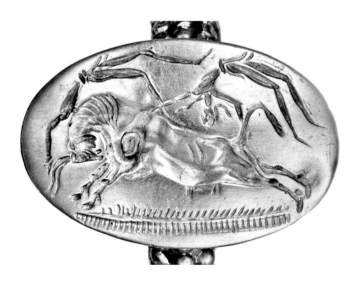

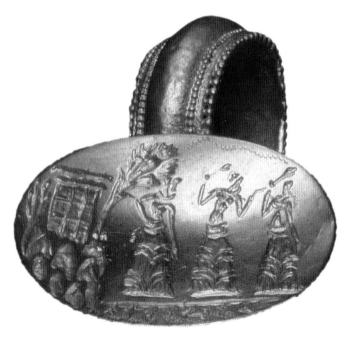

Fig 1.59 Nemea, Museum 549, chamber tomb 7 from Aidonia, ring from context of LHII–IIIB, gold.

misnomer since there is no evidence of worship after the burial of the couple, yet it is clear that this space was treated with special significance. To return to the point made earlier about Euboia's pivotal role in the Early Iron Age Mediterranean, we might note that, in addition to the eastern imports in the Heroon, the Toumba cemetery includes a great quantity of Egyptian and Phoenician objects and materials, indicative of trade. Furthermore, Lefkandi was producing its own objects: clay moulds offer evidence of the local production *c.* 900 BC of bronze tripods, highly prized objects, as will be discussed in the next chapter.

Pottery of *c.* 1050–900, the Protogeometric phase of the Early Iron Age, offers a new range of crisply articulated, wheel-thrown shapes painted with mostly abstract decoration on the shoulder and between the handles; a multiple brush, already in use in the late Bronze Age to decorate pottery from the island of Naxos in the Cyclades, was employed to render half-concentric circles (Fig. 1.64). In Attika, the new technology of firing painted pottery in a three-stage process (discussed at greater length in Chapter 2) created a glossy black slip for its painted ornament, and significantly, figural decoration reappeared here around 900 BC on a handful of amphorae used as cinerary urns (Fig. 1.65). Non-Attic imitations of this new pottery quickly followed in other areas on the mainland, in west Greece, and on the islands, although late Protogeometric pottery on Crete exhibits eastern motifs and compositions, perhaps inspired by Cypriot imports.

As we have seen, the Bronze Age witnessed enormous developments in Greece, many stimulated by imports from the east, but others generated from within. By the end of the Early Iron Age, Greece again experienced a surge of population and productivity, and it was another eastern import, the alphabet from Phoenicia, that dramatically changed Greece in the Geometric period.

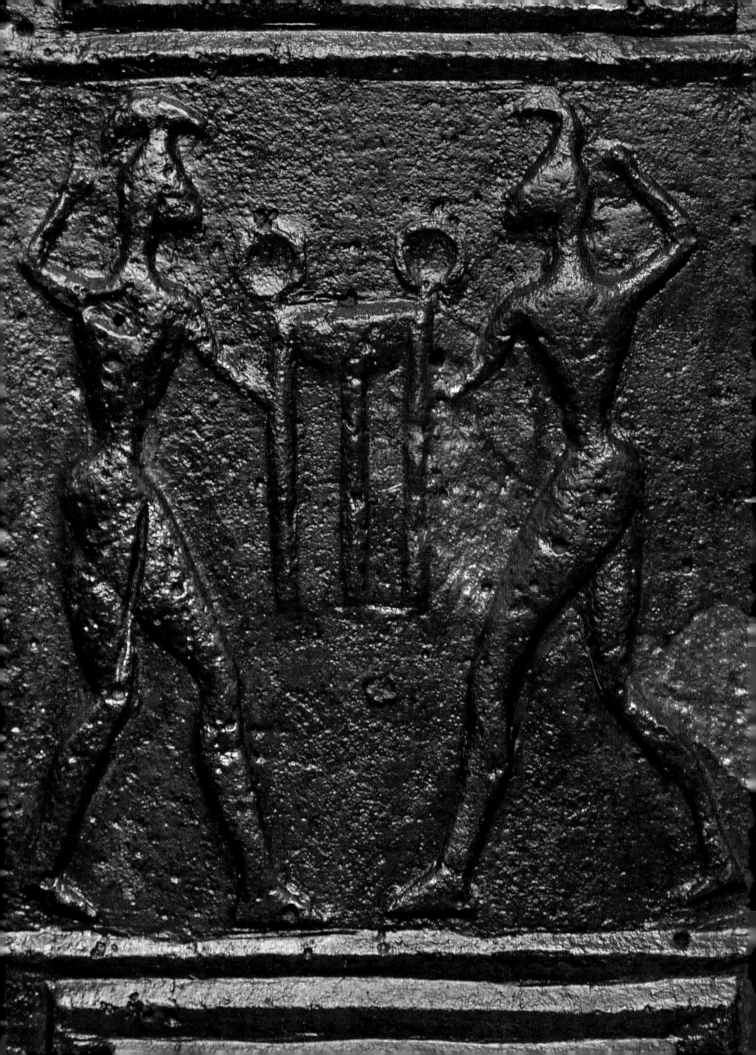

2 The Geometric period (*c.* 900–700 BC) and the seventh century BC

CONTENTS

TIMELINE – all dates in BC

c. 900–700	Geometric period
c. 900	Earliest Phoenician inscription found in Greece (Knossos)
c. 825	Greek emporion founded at Al Mina
c. 800	Temple of Hera, Perachora
c. 800–750	First Heraion on Samos
c. 776	Legendary date for the inception of the Olympic games
c. 775–750	First examples of Greek writing
c. 750	Homeric poems composed, Dipylon amphora
c. 725	Hoplite armor appears
c. 700–600	"Orientalizing" period, Daidalic style, Protocorinthian and Protoattic pottery
c. 690–650	Doric temple of Poseidon, Isthmia
c. 650	Law code from Dreros
c. 640–630	Temple of Apollo at Thermon
c. 632	Greek colony founded at Cyrene
c. 600	Attic black-figure pottery begins

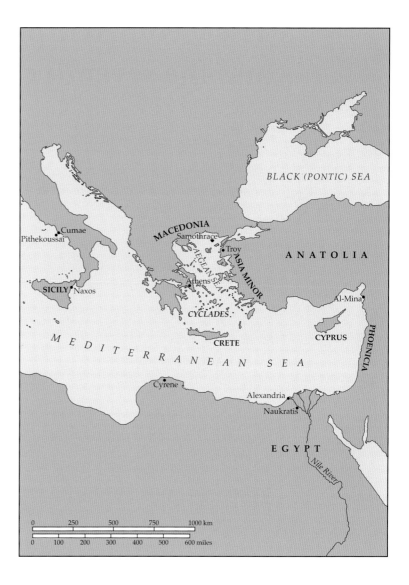

Map of the Mediterranean area

The Geometric period

Because our knowledge of the Early Iron Age of Greece has advanced substantially in recent years, the dramatic developments of *c.* 900–700 BC, the Geometric period, no longer seem as abrupt as they once did. Rather than a sudden increase in the tempo of culture, it is now more accurate to talk about a slow and steady growth of activity and an expansion of settlements throughout Greece. This is not to diminish the importance of the changes during the Geometric period, which include the reappearance of literacy, but to re-contextualize them in the larger history of ancient Greece. Contact with others through colonization and trade brought dramatic changes, including the

Map of southern Greece and the Peloponnese

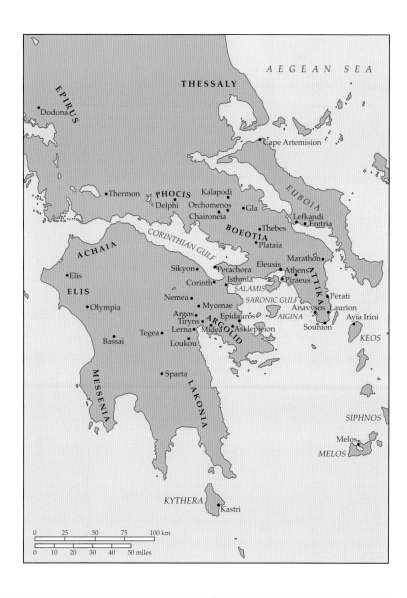

Fig 2.5 Villa Arbusto, Archeologico di Pithecusae, Rhodian cup from Pithekoussai with Nestor inscription, *c.* 730 BC, terracotta.

Fig 2.6 Boston, Museum of Fine Arts 03.997 ("Mantiklos Apollo"), Francis Bartlett Donation of 1900, from Thebes, *c.* 700–675 BC, bronze, H 20.3cm.

Fig 2.7 Olympia, Museum Br 14064, Br 219, inscribed sauroter from Olympia, fifth century BC, bronze, L 31cm.

(a)

(b)

Fig 2.8a–b Dreros, law code.

island of Keos was used almost continuously to the Hellenistic period. In the eighth-century BC sanctuary, a painted terracotta head that once belonged to a female figure created in the mid-to late Bronze Age was found far from its corresponding body fragments and *in situ* in its eighth-century context: re-erected on a ring stand on the floor. In other words, the head once belonged to a full-bodied statue, but when detached (from an unknown cause), was reused on the stand. Dionysos was worshipped in this sanctuary by *c.* 500 BC and this seems likely to have been the case since at least the eighth century BC to judge from other objects found at the site. Thus, the site and the statue seem to have retained their sacred character from the Bronze Age into the Geometric period, when this earlier object was reused in the same location, perhaps in honor of Dionysos.

Similarly, Greek artists in the Geometric period portray themselves at work for the first time (Fig. 2.9), signaling a greater artistic self-consciousness than previously detectable. These objects are not high art,

Fig 2.9 New York, Metropolitan Museum of Art 42.11.42, helmet maker, *c.* 700 BC, bronze, H 5.1cm.

not necessarily designed for sale (we do not know), but nevertheless indicate an interest in recording one's craft and were considered worthy of dedication to the gods: an impressively large and detailed series of votive plaques detailing processes in the pottery trade were inscribed and dedicated as gifts from their painters (some are signed by the painters) in a sanctuary to Poseidon and Amphitrite (Fig. 2.10a–c).

The Greek sanctuary

Among the most striking developments during the Geometric period in Greece is the flourishing of sanctuaries and the construction of temples within them. To understand Greek temple architecture, one must begin with some fundamentals about Greek religion. The sanctuary or *temenos* was a sacred area designed for worship, which could be delimited by something as simple as a line on the ground, or by more elaborate means – a fence, wall, inscribed boundary stones, or permanent, tangible border of some kind. Ancient Greek religion was remarkably flexible and varied in its practices and rituals, and there was no single written authority about religious practice or belief. Neither a statue nor a temple was *necessary* for worship; all that was needed was an altar, and these could be small and simple or enormous and of fine material, such as marble. But worship often focused on a sacred object, such as a tree (the famous oak tree of Zeus at the oracular site of Dodona is a good example), some other natural feature (such as the mark from "Zeus' thunderbolt" on the ground), or a cult statue, whose presence often was explained by supernatural means, such as dropping from the sky. Ancient written accounts indicate that the "old" cult statues (*xoana*), the most highly venerated of all statues, were of wood – often a simple, unworked plank, sometimes enveloped in bronze sheets. Wooden statues require protection from the elements and thus arose the need for roofed structures: temples.

Whether early examples made of wood and mudbrick, or later ones of more durable stone, temples provided protection not only for the cult statue but also for valuable objects dedicated to the deity; therefore, the buildings were usually equipped with metal or wooden gates, which could be shut

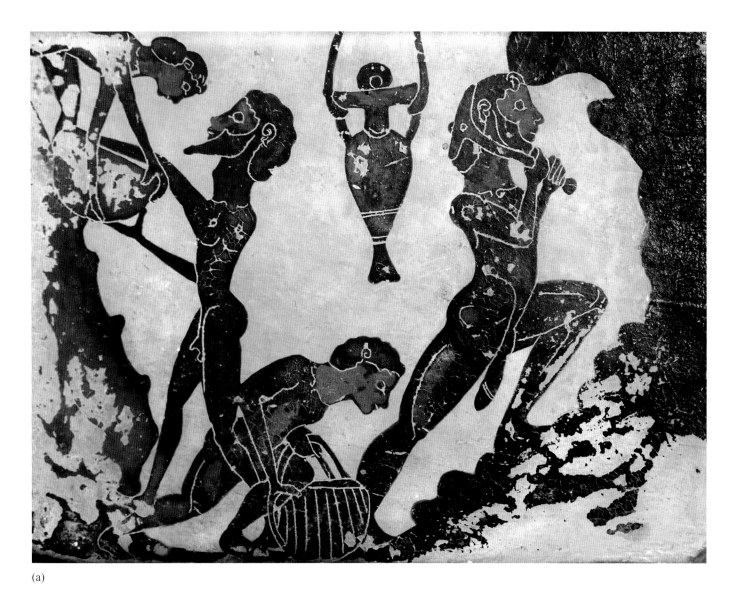

(a)

Fig 2.10a Berlin, Antikensammlungen F871 from Penteskoufia, Corinthian votive plaques depicting (a) clay extraction.

and locked. In some instances, additional small buildings were built in a sanctuary to serve as treasuries, either superseding or supplementing the temple in this respect.

In spite of the importance and proliferation of temples, the focal point of Greek religion and its most essential act – sacrifice – was an altar. The offerings could be liquid, cereal or grain, or, most involved of all, the sacrifice and roasting of an animal or animals; consequently, most altars – though not all (especially in this early period) – were outdoors. Animal sacrifice was of primary importance to the Greeks because it not only established a link between human and god, but also distinguished them: the gods received the smoke and bones, and the human beings were able to enjoy the roasted meat, which was distributed in varying portions to the assembled crowd. (Like almost

(b) (c)

Fig 2.10b–c Berlin, Antikensammlungen F868, F893
from Penteskoufia, Corinthian votive plaques depicting
(b) throwing a clay vessel on a potter's wheel. and
(c) firing clay objects in a kiln, sixth century BC,
terracotta, H 10.3cm, 9.5cm.

everything in Greek culture, class distinctions were enforced even in
this way: those of higher status received the choicest cuts.) For a peo-
ple whose daily diet was largely vegetarian, this was a joyous occasion
greeted with anticipation and celebration.

Early temples

On Crete, Delos, Samos, Naxos, and Euboia, and on the mainland at
Argos and elsewhere in the Geometric period, large-scale temples were
of perishable materials – mudbrick, wood – raised on stone founda-
tions. The earliest temples seem to have been apsidal in shape and over
the course of the seventh century, rectangular (or nearly so) temples

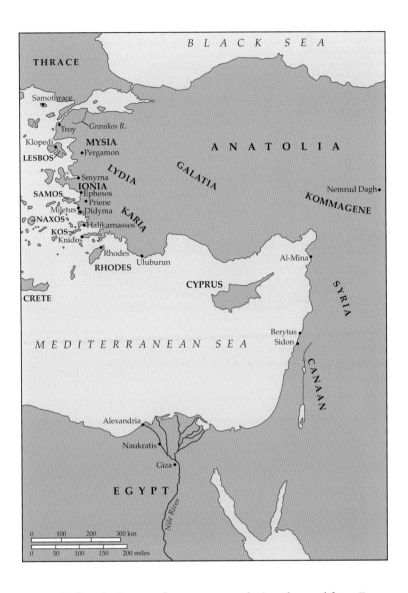

Map of the eastern Mediterranean

were rebuilt or built anew from stone, a technique learned from Egypt, where stone architecture had existed for millennia; think, for example, of the Old Kingdom pyramids at Giza (*c.* 2500 BC). The progression to stone, however, is not linear; regional variation seems to have played a part, and stone wall construction may have appeared earlier in some temples in the Early Iron Age or Protogeometric period while the use of mudbrick walls persisted later in other places. Over time, temples were elaborated with interior colonnades to support roofs, front porches with columns to create a more impressive entrance, and sometimes an interior hearth with a statue standing nearby.

Although Geometric temples often survive in poor condition, terracotta "temple models" of the eighth century enable us to flesh out the picture. Four models were found at Perachora in the area that was part of the later sanctuary of Hera Akraia (Fig. 2.11) and may reflect (to some degree)

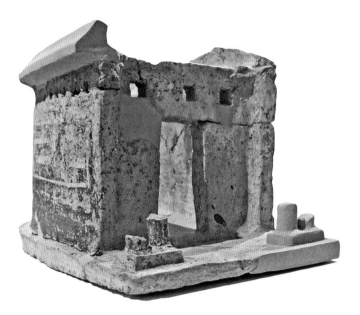

Fig 2.11 Athens, National Museum 16684 from sanctuary of Hera Akraia at Perachora, temple model, end of the ninth century BC, terracotta, H 20.5cm, L 35.6cm.

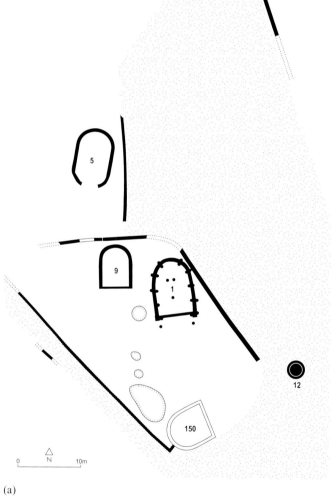

(a)

Fig 2.12a–b Eretria, (a) plan of Apollo Daphnephoros sanctuary, Phase 1, first half of the eighth century BC, and (b) perspective drawing of the buildings of the sanctuary of Apollo Daphnephoros (middle of the eighth century BC), seen from the east.

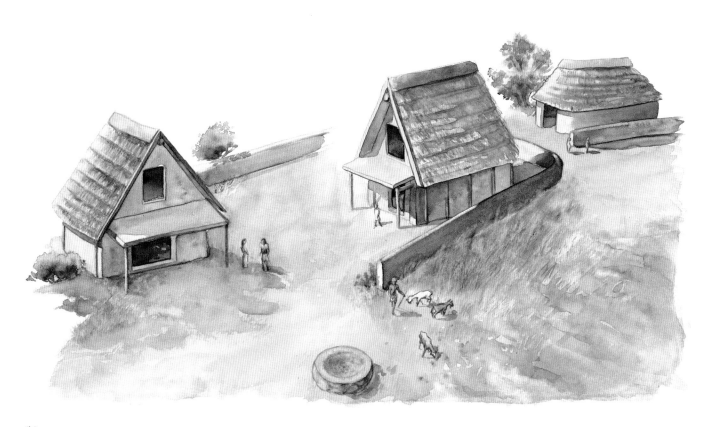

(b)

Fig 2.12 (*Continued*)

the temple constructed there *c.* 800 BC. Of the temple itself, only the stone foundations remain, and these indicate an apsidal structure oriented east–west, *c.* 8m long and 5.5m wide, with mudbrick walls. The models (*c.* 750–725 BC), also apsidal in shape, may add to this picture: each is preceded by a porch supported on double *prostyle* columns (columns placed immediately in front of the building), and the best surviving model indicates that windows at the top of the wall all the way around provided light and ventilation for the building, which was capped by a hipped roof.

Euboia, so important in colonization and trade, was also the site of early large buildings. The apsidal Building A ("bay hut") at Eretria (*c.* 9.75m × 6.50m) of *c.* 750 stood on stone foundations and had wooden columns on clay column bases (the bases are still extant); the disposition of the columns – lining the walls, both inside and out, and three within the structure – helped support the roof and reinforced the walls (Fig. 2.12a–b, see building 1 on plan). A porch with two prostyle columns preceded the building. It is unclear whether Building A was a temple or not, but an apsidal *Hekatompedon* ("hundred-footer," *c.* 35m × 7–8m), a mudbrick structure on stone foundations erected in the last quarter of the eighth century BC, certainly was: this

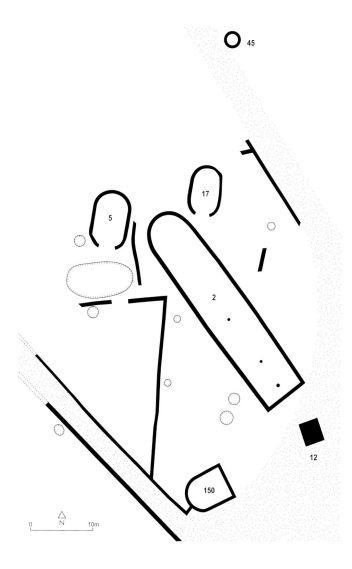

Fig 2.13 Eretria, plan of Apollo Daphnephoros sanctuary.

was located in the sanctuary of Apollo Daphnephoros and presumably was built for his worship (Fig. 2.13, see building 2). This Hekatompedon, the largest of all apsidal temples, had a different method of supporting its very long roof: an interior, central row of wooden columns on stone bases. Opposite the structure (though not directly aligned with it) was an altar with a sacrificial pit (Fig. 2.13, number 12).

By the mid-eighth century, rectangular structures had largely usurped the earlier apsidal temples. The temple of Hera (32.86m × 6.5m) at Samos of the first half of the eighth century BC – the first of many temples on this site – consisted of a long, narrow rectangular room of mudbrick walls on stone foundations with three columns in antis at the east end (Fig. 2.14a). A single row of wooden columns down the middle of the building supported the roof, probably of thatch, but also partially obscured the cult statue placed on a base at the far west end of the structure. A contemporary stone altar outside to the southeast was the focal point for offerings, but its orientation is different from that of the temple, which suggests that an altar here preceded the temple and that the later altar kept the previous orientation; in fact, archaeology demonstrates that there were several altars on the site, both earlier and later – c. 950, 850, c. 775, c. 750, c. 720 – of ever increasing size; they continued to be re-erected into the sixth century BC.

The temple was rebuilt c. 670 BC with dramatic changes: at the east, a *pronaos* (porch) with four columnar supports preceded the main room, which had only two columns in antis; instead, the interior space was entirely open, maximizing visibility for the cult statue that stood on a new base (Fig. 2.14b). A stone platform, perhaps a bench, lined the limestone walls. Stone slabs found outside the building have prompted some scholars to restore a *peristyle* (ring of columns) around this temple, but this reconstruction is disputed. However, it is certain that the sanctuary was further enhanced by a *stoa* in the late seventh century, the first such building attested for the Greek world; behind its wooden colonnade, it offered shelter from rain and sun to votive offerings and visitors.

0 5 10 15 20 25 30 m

(a)

Fig 2.14a Samos, Heraion, first half of eighth century BC, plan.

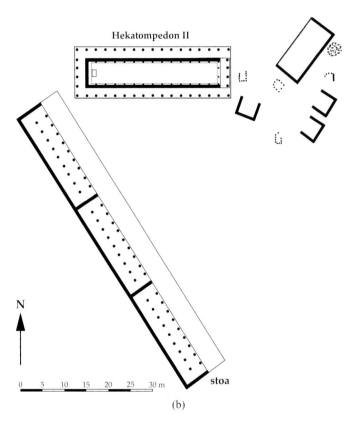

Hekatompedon II

N

0 5 10 15 20 25 30 m

stoa

(b)

Fig 2.14b Samos, Heraion, c. 670 BC, plan.

Stone walls largely replaced mudbrick by the late eighth century, and this permitted a change in roofing: no longer did the roof have to extend out so far to protect the vulnerable mudbrick walls, but could be truncated closer to the stone wall, if desired. An example is the rectangular temple of Apollo at Dreros, oriented north–south, with stone walls and foundations (Fig. 2.15a–b). A paved terrace preceded the structure, and the presence here of one column is attested; these clues suggest that there may have been a roofed porch, and if so, probably at least one more column. Within the one-roomed structure, wooden columns atop stone bases flanked a stone-lined central hearth. One can visualize the appearance of the Dreros temple – or its approximation – from a small terracotta model (Fig. 2.16), which is topped by a gabled roof ornamented with a Geometric pattern. But a gabled roof is unlikely at Dreros given the central hearth because the roof must have included some opening to permit smoke to escape.

The southwest corner of this large room was dedicated to cult: a stone offering table stood in front of a hollow rectangular cist and an adjacent bench (Fig. 2.15b). Three bronze figurines, two females and a larger male, contemporary with the temple were found in this area (Fig. 2.17). They were made in the *sphyrelaton* technique, a Near Eastern process, which involves riveting separate sheets of bronze together to create the statues; the seams are most clearly visible on the backs of the figures, especially that of the male. The male is nude save for a cap on his head, while the females wear long *peploi* (long, close-fitting garments made of heavy fabric) covered by a cape or mantle over the shoulders, and *poloi* (tall, cylindrical caps); all had inlaid eyes. Their original placement is unknown, but scholars have suggested that they stood atop the bench in the temple. The material, workmanship, and size of the figures, particularly the male, indicate the importance of the sphyrelata; are these meant to represent deities – Apollo and others – worshipped here? Within the temple were found bones, teeth, and goats' horns (also inside the cist mentioned above), animals closely associated with Apollo, as well as butchering knives and pottery suitable for storing and eating food and liquids. Together with the hearth, these objects suggest that sacrifice and dining may have occurred within the building.

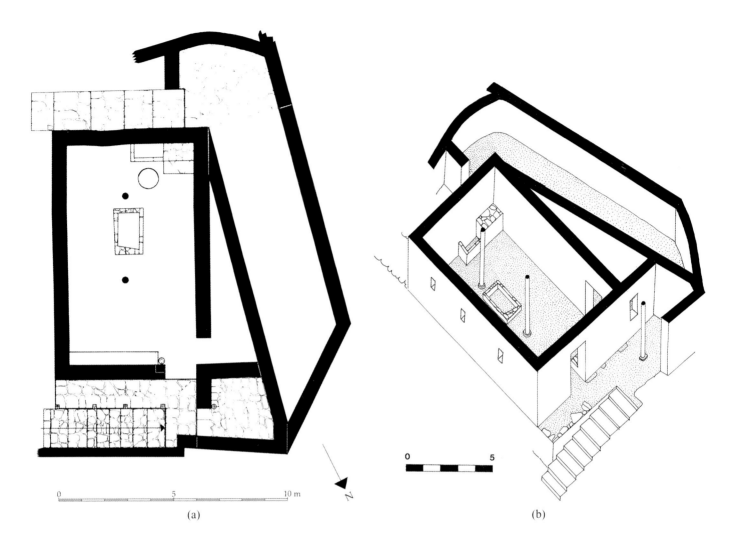

(a)

(b)

Fig 2.15a Dreros, temple of Apollo, end of eighth century BC, plan, 16m x 13.50m.

Fig 2.15b Dreros, temple of Apollo, end of eighth century BC, reconstruction.

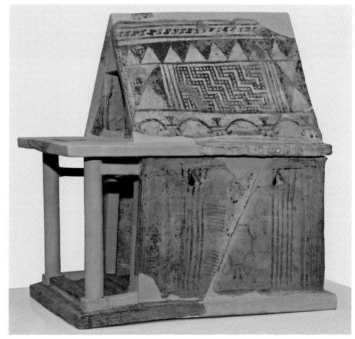

Fig 2.16 Athens, National Museum 15131 from the Heraion at Argos, temple model, first quarter of the seventh century BC, terracotta, L 27cm.

Box 2.1 The Doric and Ionic architectural orders

An architectural order is a collection of conventions or characteristics, which, over time, are used in a specific, formulaic way – the Doric order always has metopes and triglyphs in its frieze, for example – although some variations within the conventions are permissible. The characteristics of a given architectural order did not all appear at one moment, but in piecemeal fashion, then combined in variations until finally a pattern crystallized and was repeated again and again.

The Doric order developed on mainland Greece and by the sixth century, or perhaps even earlier, a number of its architectural conventions combined into a coherent, repeatedly used formula, which defined the order: fluted columns (sixteen or twenty flutes) standing directly on the stylobate and topped by capitals comprising an *echinus* and *abacus*. The columns support a plain architrave, above which runs a frieze composed of alternating triglyphs and metopes, and a cornice caps the structure.

As happened with the Doric order, the Ionic order gradually emerged, in the seventh century, as a set of architectural practices used for both buildings and votive columns and only achieved a fixed formula in the sixth century BC, trailing the development of Doric by a few

decades (Box 2.1 Fig. 1). The Ionic capital developed alongside the Aeolic capital (Box 2.1 Fig. 2) in the later seventh century BC. Aeolic capitals were already used in architecture by the end of the seventh century at Old Smyrna (see Fig. 2.52), while the Ionic capital seems initially to have been used not for architecture but for votive columns that supported statues and were dedicated in sanctuaries in the Cyclades. Ionic capitals for architectural use appeared in the Oikos of the Naxians on Delos in the first quarter of the sixth century BC. The Ionic capital quickly became the favored of these two possibilities – Ionic or Aeolic – and developed as a true order. The Ionic formula includes columns that rest upon bases (which were usually ornately decorated), a column capital comprising a volute and echinus, and in contrast to Doric columns, taller, thinner column shafts that have more flutes (usually twenty-four, and the flutes meet in a flat arris, while Doric flutes join in a sharp edge), lending them a more ethereal presence. The Ionic architrave is horizontally divided, usually into three registers, and rather than a Doric frieze of metopes and triglyphs, the Ionic frieze is a continuous, uninterrupted band, which is sometimes painted, sometimes sculpted in relief then painted. A dentil molding surmounts the frieze.

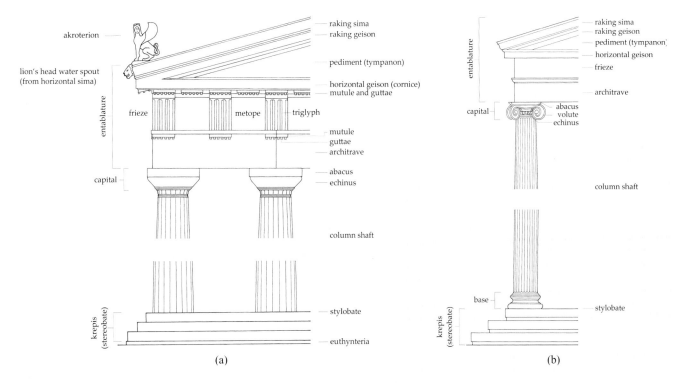

Box 2.1 Fig 1 Elevation of (a) Doric and (b) Ionic orders.

The Roman writer Vitruvius described the essential qualities of the Doric and Ionic orders, which had already existed for centuries by the time he wrote his ten books on architecture in the later first century BC. His text considers all aspects of ancient architecture and stresses the importance of proportions, symmetry, and so on. These orders formed a building canon, which could be varied within certain parameters to obtain different effects, but adhered strictly to certain "rules." Vitruvius describes the Doric order as masculine, the Ionic as feminine; it is certainly true that Ionic architecture has many more elements of decoration and molding, which were painted, and therefore, Ionic architecture appears more colorful and ornate, i.e., "feminine," to Vitruvius. The author also explains their various decorative components, such as metopes or dentil mouldings, as deriving from the wooden elements of early buildings (so, for example, triglyphs mask the ends of projecting beams). Scholars doubt the

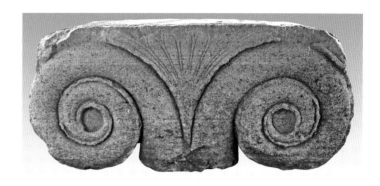

Box 2.1 Fig 2 Klopedi, temple of Apollo Maloeis, Aeolic capital, *c.* 520–500 BC, local trachyte.

truth of this claim (although early columns clearly were made of wood), and there is also some question as to whether the Ionic order originally arose in Asia Minor, as Vitruvius explains, or in the Cyclades islands, which is what current archaeology suggests. But Vitruvius seems accurate in stating that the Doric order originated on the mainland of Greece.

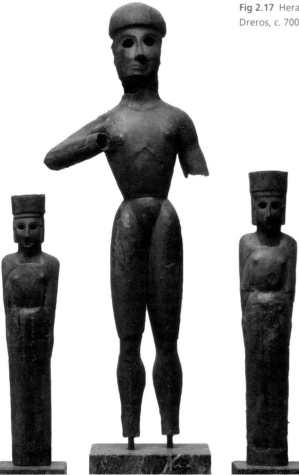

Fig 2.17 Herakleion Museum 2445, 2446, 2447, sphyrelata from temple at Dreros, *c.* 700 BC, hammered bronze, male: H 80cm, females: H 40m, 45cm.

The seventh-century temple (oriented north–south) at Iria on Naxos was already the third on the site, and presents an incipient feature that became standard for the Ionic order, which developed in the Cyclades: the column base with molding (Fig. 2.18a–b). Four wooden columns on bases created an impressive entrance to a tripartite cella constructed with stone walls. Wooden columns on bases divided the cella, and at least two of these interior column bases were marble and articulated with a torus profile. As at the temple of Apollo at Dreros, a stone-lined hearth or *eschara* stood in the interior; not surprisingly, this had been the case for the building's immediate predecessor, where an eschara stood atop an offering table belonging to the earliest temple.

Two temples at Kalapodi demonstrate that while stone construction was becoming common elsewhere, mudbrick walls continued to be used in temple construction around

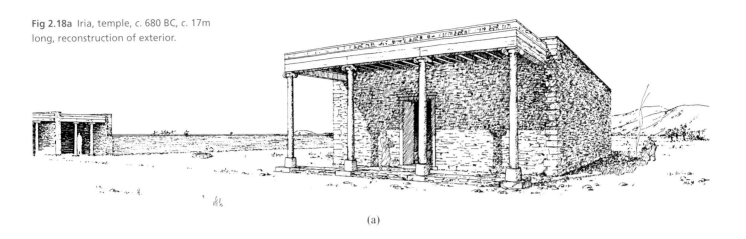

Fig 2.18a Iria, temple, *c.* 680 BC, *c.* 17m long, reconstruction of exterior.

(a)

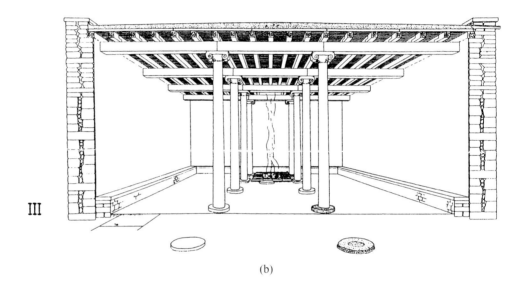

Fig 2.18b Iria, temple, *c.* 680 BC, *c.* 17m long, reconstruction of interior.

III

(b)

700 BC (Fig. 2.19), and these structures housed the basic features of Greek religious ritual: altar and cult statue. The nearly rectangular temples (north temple: 10m × 29m; south temple: *c.* 7.90m × 21m), probably dedicated to Artemis (who is clearly already present in the Mycenaean period) and Apollo, were erected atop previous constructions. Ash deposits and calcined animal bones lay on low altars within. Temple A had a circular stone to the south of the altar, perhaps for a cult statue, and the better-preserved Temple B (for Artemis) had wooden columns on stone bases running along the interior walls, an interior colonnade of wooden columns to support the roof, and a porch with four wooden columns; wall paintings once adorned this temple, as we know from extant fragments depicting battle scenes.

The seventh century also witnessed the emergence of a somewhat standard temple plan – rectangular building with pronaos, cella, peristasis or peristyle – to which variations and additions, such as the

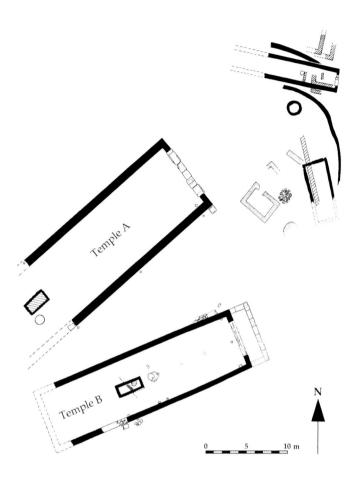

Fig 2.19 Kalapodi, Temples A and B, *c.* 700 BC, plan.

pronaos, could be made (see page 131, Box 3.1). The temple of Poseidon at Isthmia, dated by pottery beneath its floor to *c.* 690–650 BC, is exemplary (Fig. 2.20a–b). The peristyle with seven columns on its short ends, eighteen on the long sides (in archaeological parlance, 7 × 18, i.e., corner columns are counted in both directions), is long and narrow, which is typical for this period. The temple walls were of stone blocks of uniform dimensions: engaged columns abutted the exterior walls with plaster covering the exposed surfaces between them. The columns and superstructure were of wood, and the hipped roof was covered with terracotta roof tiles, a first to our knowledge. The innovation of terracotta roof tiles allowed more waterproof roofs, but also demanded a sloping surface and a support system beneath, that is, wooden trussed gable roofs. A continuous row of interior columns bisecting the entire length of the structure also assisted with roof support, and a doorway in each aisle provided communication between the pronaos and cella.

The temple of Apollo at Thermon exhibits other important architectural features, which became hallmarks of the Doric architectural order (Fig. 2.21). Its long, narrow cella was supplemented by an *opisthodomos*, a non-communicating porch behind the cella. Although the existence of a peristyle is uncertain, we know that the building's wooden superstructure included *metopes*: ten painted terracotta plaques with projecting tangs on the upper edge for insertion into a frame found here either were placed in the peristyle entablature or

Fig 2.20a Isthmia, temple of Poseidon, *c.* 690–650 BC, *c.* 39m × 14m, restored plan.

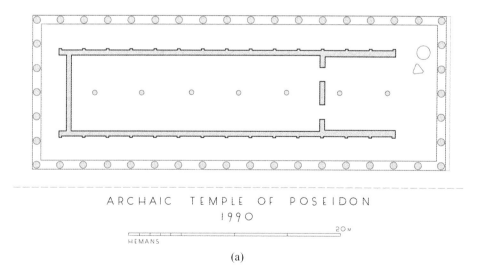

ARCHAIC TEMPLE OF POSEIDON
1990

20 M

HEMANS

(a)

Fig 2.20b Isthmia, temple of Poseidon, *c.* 690–650 BC, *c.* 39m × 14m, axonometric drawing.

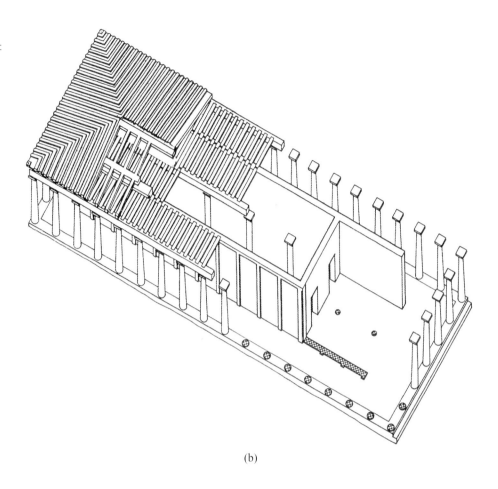

(b)

at the top of the *sekos* (the central core of the building with the cella) wall (Fig. 2.22). The metopes are made of Corinthian clay, painted in Corinthian style (see below), and depict mythological scenes; some of the figures' names are painted, while other scenes, such as Perseus holding the head of Medusa, are easily recognizable without the assistance of labels (Fig. 2.23a–b). When metopes were decorated (most were not), myth provided their subjects (see Chapter 3).

Gifts to the gods

The Geometric period or style takes its name from the simplified, schematic forms of small statues dedicated in the sanctuary of Olympia and elsewhere (Fig. 2.24). The bronze or terracotta images comprise human-formed figures (although they may represent deities, not humans), as well as horses, cows, bulls, birds, and other, mostly domesticated, animals,

Fig 2.21 Thermon, temple of Apollo, *c.* 640–630 BC, plan.

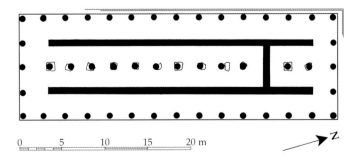

Fig 2.22 Thermon, temple of Apollo,
c. 640–630 BC, reconstruction of superstructure.

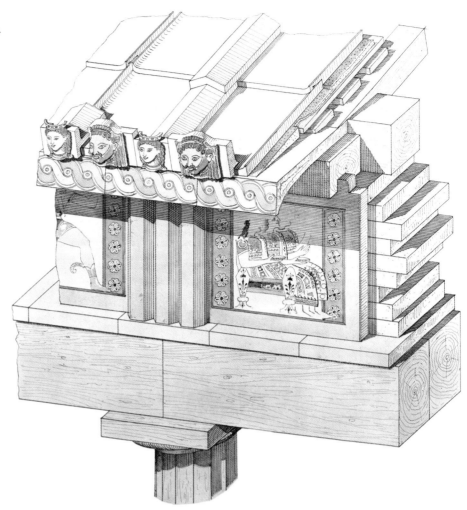

Fig 2.23a–b Athens, National Museum
(a) 13401 (Perseus), (b) 13410 (Aidon and
Chelidon), metopes from temple of Apollo at
Thermon, *c.* 640–630 BC, terracotta, H *c.* 87cm.

(a)

(b)

Fig 2.24 Olympia, museum, collection of Geometric bronze and terracotta votives.

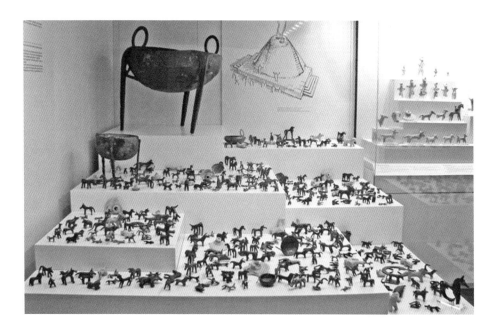

Fig 2.25 Athens, National Museum 6199 from Olympia, c. 750 BC, bronze, H 11.1cm.

varying in size from a few centimeters to about 36cm. They are found in the thousands at sanctuaries, and also turn up in other contexts, such as graves. Groups, such as adult female animals nursing their young (Fig. 2.25) or dancers, as well as figures belonging to the world of myth or fantasy, including the earliest centaur in Greek art, occasionally appear (Figs. 2.26–27). As mentioned above, hybrid beings, such as centaurs or sphinxes, are imports from the Near East, where such creatures had a long history before arriving in Greece. When embellished by some peculiar feature or an additional figure, the figurines have inspired scholars to propose mythological identifications: perhaps the wise Centaur Chiron for a six-figured Centaur carrying an object from Lefkandi (Fig. 2.26) and Nessos struggling with the hero Herakles for a pair of bronze figures (Fig. 2.27; see also Figs. 2.51a–b).

Another common bronze votive in sanctuaries during the Geometric period and the seventh century is the bronze tripod cauldron, which could be embellished with *protomes* (three-dimensional figures truncated and attached to another object; Fig. 2.28a); the protomes could be bulls, horses, or more exotic eastern creatures, such as griffins, sirens, lions. They are numerous at Olympia, where the Olympic games began *c.* 776 BC, according to legend (in fact, they are likely older); the bronze

Fig 2.26 Eretria, Museum 8620 from grave at Lefkandi, Centaur,
c. 950–900 BC, terracotta, H 36cm.

Fig 2.27 New York, Metropolitan Museum of Art 17.190.2072 from
Olympia, Centaur fighting man, *c*. 750 BC, bronze, H 11.3cm.

tripod cauldrons may have been victory prizes in the games
in their earliest manifestation before the athletic contests were
transformed in the sixth century BC into "crown games" (when
the sole prize was a vegetal crown – at Olympia, a crown made
of olive branches). According to this thinking, the tripods were
subsequently dedicated as thankofferings to Zeus by the victo-
rious athletes as indicated by inscriptions on them (Fig. 2.28b).
Some tripod legs are decorated with embossed or relief images
suggestive of mythological scenes, such as two warriors, perhaps
Herakles and Apollo, struggling for the latter's tripod, a narrative
recognizable from later labeled images of the tale (Fig. 2.29).

Not only were Greek objects that had been influenced
by eastern motifs dedicated in sanctuaries in the seventh

(a)

Fig 2.28a Olympia, Museum B 5240, tripod cauldron with protome, bronze, H 45.2cm, broadest D 72cm.

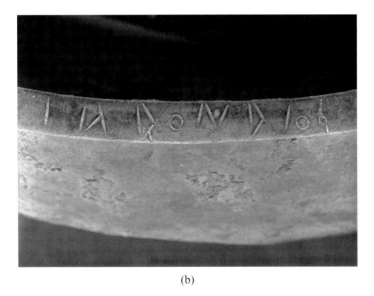

(b)

Fig 2.28b Olympia, Museum B 5240, tripod cauldron with protome, bronze, H 45.2cm, broadest D 72cm, detail of inscription.

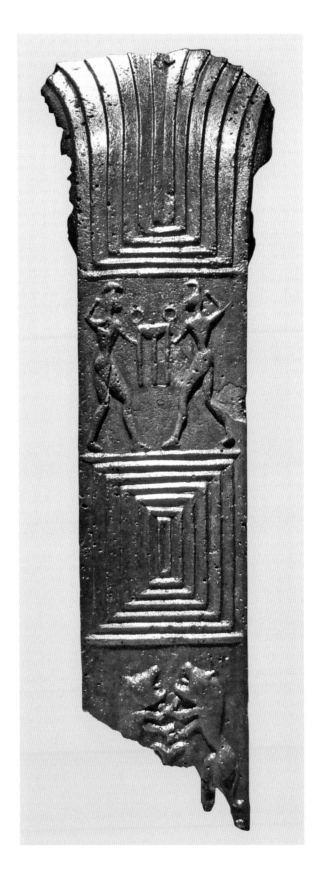

Fig 2.29 Olympia, Museum B 1730, tripod leg, bronze, H 46.5cm.

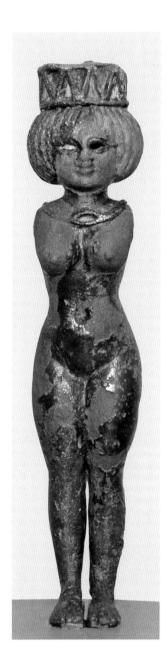

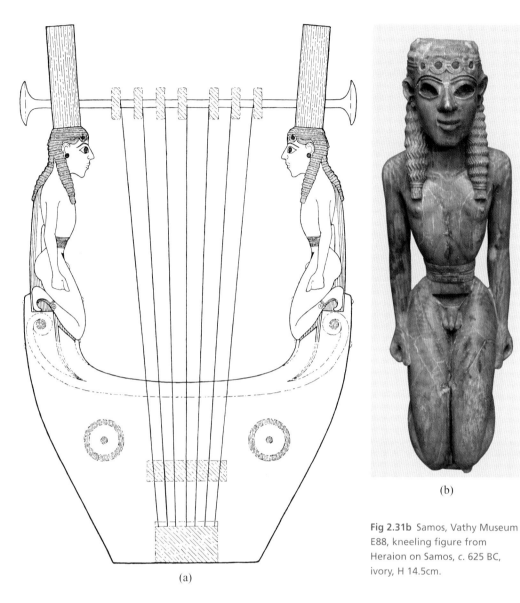

Fig 2.31a Reconstruction of lyre.

(a)

(b)

Fig 2.31b Samos, Vathy Museum E88, kneeling figure from Heraion on Samos, *c.* 625 BC, ivory, H 14.5cm.

Fig 2.30 Samos, Vathy Museum B1216 (Egyptian statuette) from Heraion at Samos, *c.* 730–656 BC (25th Dynasty), bronze, H 17.3cm.

century, but a flood of imported goods from the Near East – faience scarabs, bronze objects and sheets decorated in relief, ivory figurines, and the like – also were deposited at sanctuaries, such as Olympia, Perachora, and especially the Hera sanctuary on Samos. Votives at Samos include an Egyptian bronze figurine of a plump nude female with a box-shaped crown perched atop wig-like hair (Fig. 2.30). Her nudity is unusual for Greek sculpture, but is a commonplace in Near Eastern art and for small-scale figures in Egyptian art. The finely worked ivory figure of a kneeling or jumping male was one of a pair of figures that formed the frame supports for a wooden lyre (Fig. 2.31a–b). His eyes, eyebrows, and pubic hair were inlaid with

Box 2.2 Marble quarrying

Much can be learned about the quarrying and transport of ancient sculpture and architecture by studying the archaeological remains – toolmarks, debris in and around ancient quarries, roads, etc. – which are easily accessible today in many parts of Greece – Paros, Naxos, Thasos, Athens to name just a few places. Marble blocks were selected in the quarry with special attention to fissures and the texture of the marble's layers. Extraction of a block from the quarry is a multi-stage process: equally spaced square channels were carved into the block along the desired contour at precisely the same level, and iron wedges and levers were placed in these cavities. The masons swung heavy iron mallets and repeatedly struck the wedges simultaneously to free the block, while others worked the levers until the marble broke free (Box 2.2 Fig. 1). A layer of superfluous marble then was carefully removed in the same fashion first, and finally with picks and chisels, so as to reduce the mass and remove flaws but still protect the piece for transport; this excess marble was also usable for smaller sculpture and architectural details (every effort was made to keep any flaws from appearing on an exposed surface), so waste was kept to a minimum.

Transportation of the block out of the quarry was achieved with a wooden sledge and wooden beams laid down as a "track." If the quarry were high up a mountain slope, heavy, thick ropes attached to the block and wrapped around winches were used to haul the block out, the sledge sliding over logs laid on the track. The sledge was finally dragged to a stone road that led from the quarry to a loading platform, again using ropes and stakes driven into the ground to control speed. Here, the blocks were loaded on to wagons drawn by animals, then transported to a port, sanctuary, or city. Further finishing work on the block was carried out at its final destination.

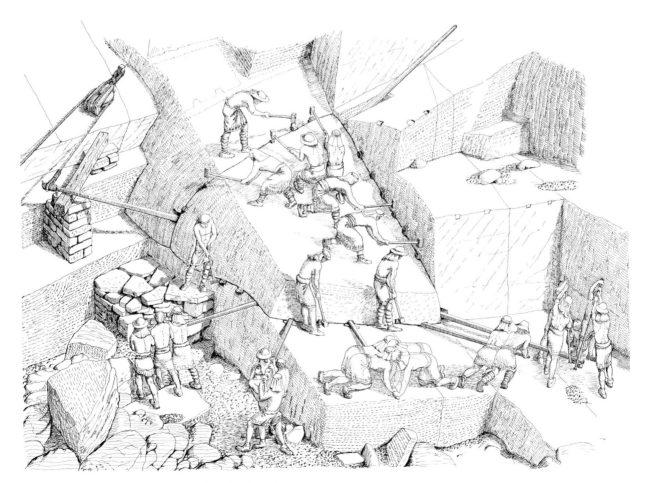

Box 2.2 Fig 1 Drawing of extracting a block of marble from the quarry.

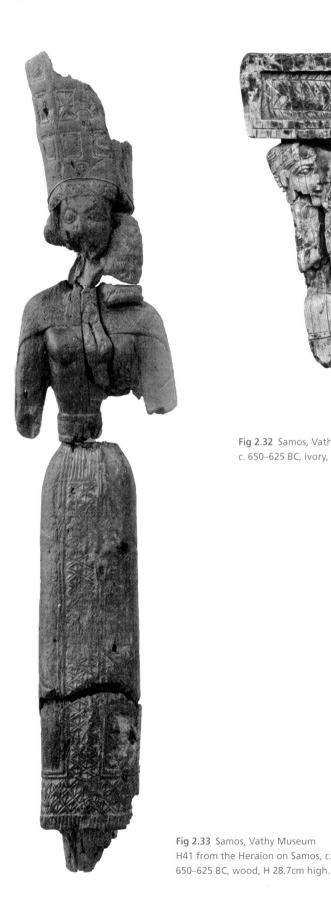

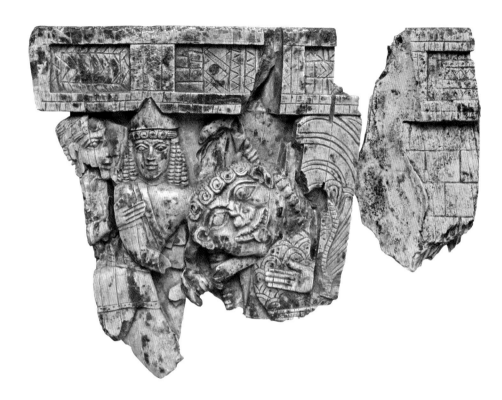

Fig 2.32 Samos, Vathy Museum E1 from Heraion on Samos, Perseus killing Medusa, *c.* 650–625 BC, ivory, H 10.6cm.

Fig 2.33 Samos, Vathy Museum H41 from the Heraion on Samos, *c.* 650–625 BC, wood, H 28.7cm high.

other materials, and the fine detailing of his hair, headband, and belt suggest influence from metalworking. An ivory relief depicts the beheading of Medusa by Perseus with Athena standing by to lend her support to the hero, who is in the midst of the grisly deed (Fig. 2.32). Medusa's mask-like visage is truly horrible, and it is noteworthy that Perseus' conical pointed cap is typically Near Eastern. The list of Near Eastern imports at the Samian Heraion goes on and on: ivory aryballoi; lion, ibis, and griffin figurines fashioned from bronze, ivory, and terracotta; beetle scarabs, and figurines of hippos, to name but a few. In addition, the site offers some extraordinary examples of eastern-influenced Greek objects, such as the diminutive wooden statue of a female, presumably Hera (Fig. 2.33). The figure, rendered in Daidalic style (see below), wears a tall polos on her head, usually an

attribute of Hera when it appears in the Greek world, a mantle tied at her neck and draped over her shoulders, and an ornately patterned peplos (a thick full-length garment) incised with decoration. Such wooden images may recall xoana.

Sculpting in stone

Located in the middle of the Aegean Sea, Crete was ideally situated to receive new technologies from the Near East, including the carving of large-scale stone sculpture. Crete produced some of the earliest Greek stone sculpture in the historical period (post-Bronze Age) in the seventh century BC, and although it is not over lifesize, it certainly marks a dramatic change from the Geometric small-scale terracottas and bronzes (Fig. 2.34a–b). The architectural sculpture at Prinias was attached to a small, roughly rectangular building, Temple A, perhaps dedicated to Artemis (Fig. 2.35a–b). The one-room structure has a hearth and two wooden posts, arranged in a similar fashion as in the earlier temple of Apollo at Dreros (Figs. 2.15a–b), but this time the walls (*antae*) of the building extend forward to create a pronaos preceding the cella. A limestone frieze of animals comprised a lintel for either the pronaos or cella: simple repeated figures fill the height of the frieze and process in profile with frontal heads; there is no background or any indication of a narrative. The free-standing females sitting atop the frieze, and the female figures in relief standing on the underside of the lintel, are rendered in Daidalic style, named for the mythological first artist, Daidalos of Crete (see Chapter 1). Typical of the Daidalic style are a U-shaped face, long, wig-like hair rendered in symmetrically placed braids or in stacked horizontal layers down the back and over the shoulders, a fringe of snail curls over the forehead, frontal pose with arms symmetrically placed and held close to the body, and legs and feet close together so that the figure resembles the block from which it was carved. In the case of female Daidalic figures, like those at Prinias, feet peep out from under a long belted garment, sometimes with a cape (*epiblema*) over the shoulders.

Considering the development of limestone sculpture on Crete, it is scarcely surprising that the first large-scale three-dimensional stone sculpture in Greece begins nearby in the Cyclades islands, where marble was, and is, abundant (see Chapter 1). The earliest

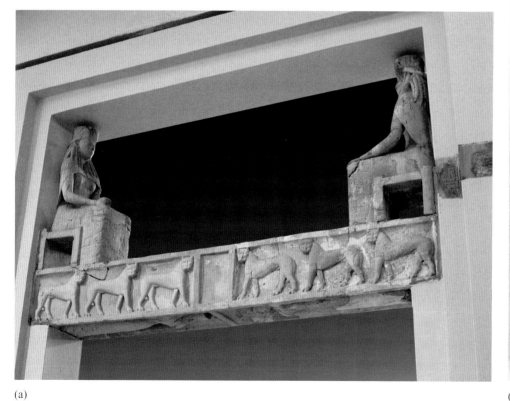

(a)

(b)

Fig 2.34a–b Herakleion, Museum 231, frieze and lintel from temple at
Prinias, c. 650–625 BC, limestone, H of seated woman 72cm, H of frieze
84cm.

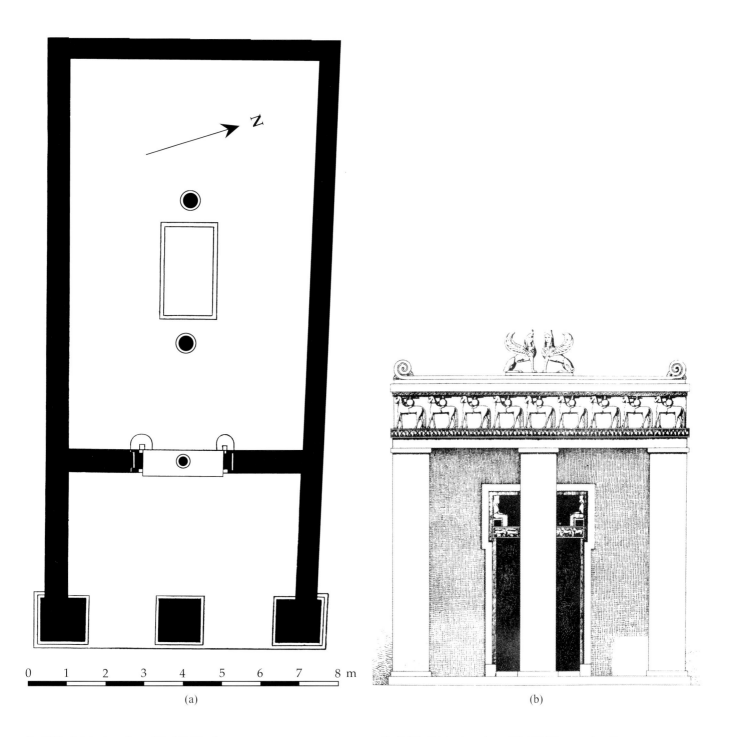

0 1 2 3 4 5 6 7 8 m

(a)

(b)

Fig 2.35a Prinias temple, c. 625–600 BC, plan.

Fig 2.35b Prinias temple, c. 625–600 BC, reconstruction.

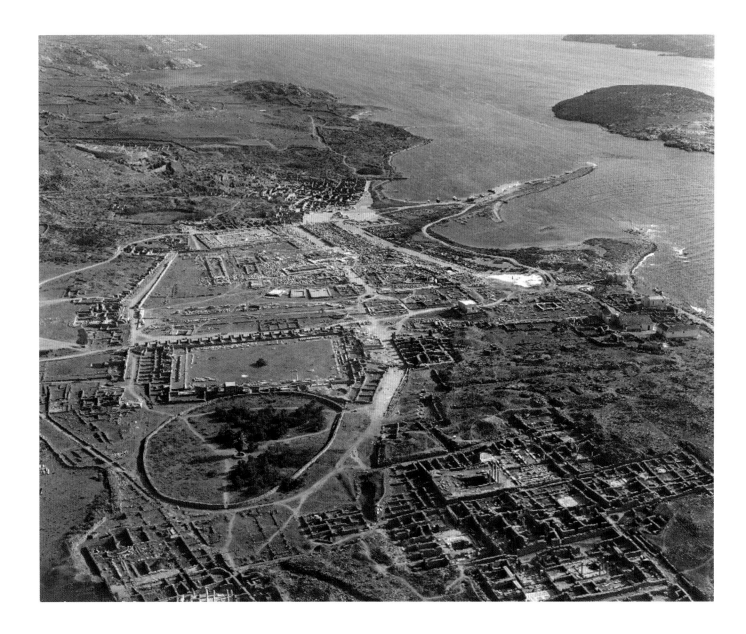

Fig 2.36 Delos, Apollo sanctuary, aerial view.

known monumental (H 2.3m) marble sculpture is a recent discovery: a female statue (*kore*) of *c.* 640 BC found on Thera in 2000. The figure is rendered in Daidalic style with her right hand held to her torso. The context in which she was found cannot be established so nothing definitive can be said about function.

The same is not true of a large kore made of Naxian marble, which was dedicated in the sanctuary of Apollo and Artemis on the island of Delos (Fig. 2.36), perhaps in

Box 2.3 Sculpting stone

Many unfinished and partially finished stone sculptures – some still in the quarry or along the transport road – as well as ancient metal tools inform us about ancient sculpting techniques (Box 2.2 Fig. 1). The debt owed to Egypt is clear from the application of the grid system to archaic sculpture (whereby a grid is applied to the front surface of the stone block to demarcate bodily proportions), and copper and bronze tools were useful for carving soft stone, such as limestone. Iron tools were better suited to work with marble, which Greece has in abundance. First white Naxian, then Parian marbles and less commonly, grey-white Hymettan marble from Athens dominated archaic works. White/yellow Pentelic marble from Athens was exploited from the later sixth century on. Brilliant white Thasian marble became common only in the Hellenistic period. Grey marble was also quarried on Samos and in Lakonia from the seventh century BC onward.

Once in the sculptor's workshop or at the building site, the first shaping of sculpture was done with points or punches, and the entire surface was worked simultaneously. After the age of the archaic grid, it is likely that some preliminary model, probably of fired clay or plaster, served as a guide, particularly likely with large-scale sculpture. Mallet and chisel were applied at an oblique angle to shape the stone further, then the claw chisel (borrowed from Egypt and first attested in Greece c. 575–550 BC) gave final shape to the stone surface, leaving telltale parallel scoring marks behind (Box 2.3 fig. 1). A rounded or bull-nosed chisel and tooth chisel provided finer modeling. A rotating drill, using a strap or bow attached to a twisted rope and a rounded chisel, drove holes directly into stone; it is attested very early for insertion of attachments, eye sockets as bedding for inserted eyes (of stone, glass, or ivory), nostrils, and ears, and was eventually used for creating drapery folds (a series of holes made in a row, then the webbing remaining between them removed). Toolmarks could be smoothed with rasps, and emery or pumice cleared the raspmarks.

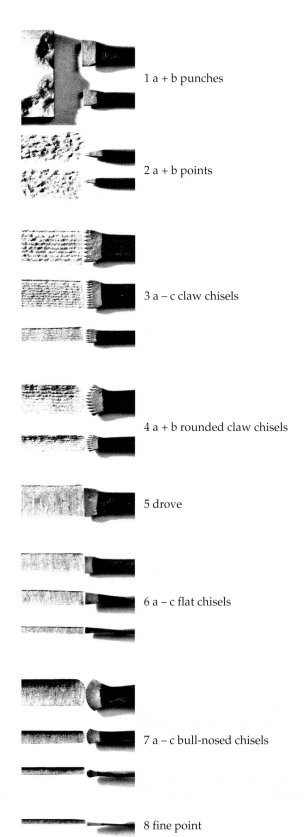

1 a + b punches

2 a + b points

3 a – c claw chisels

4 a + b rounded claw chisels

5 drove

6 a – c flat chisels

7 a – c bull-nosed chisels

8 fine point

Box 2.3 Fig 1 Sculpting tools and the marks produced by them.

Box 2.3 Fig 2 Piecing technique on Akropolis kore 682 of *c.* 525 BC.

Paint was applied to animate the sculpture and to articulate juxtapositions and details. After applying paint and sometimes gilding, the sculptor covered the surface of marble with *ganosis*, a mixture of wax and olive oil attested in ancient written sources and still detectable on many sculptures; after polishing, the ganosis-covered surface was intended to resemble the natural tone of skin. It is likely that ganosis also was applied directly to the marble to achieve this effect.

Piecing together stone sculpture, especially limbs, with bronze dowels was a common practice (Box 2.3 Fig. 2). Marble could be supplemented or extended in other materials, such as stucco, wood, or plaster, where marble was scarce (such as Ptolemaic Egypt) or for economical reasons, a practice that occurred in the Hellenistic period.

a temple to Artemis of the mid-seventh century BC (Artemision E). The tall sculpture is rendered in Daidalic style with a belted peplos and hands held down by her sides (Fig. 2.37a–b). An inscription carved on her skirt (Fig. 2.37c) states that the statue was dedicated by a woman, Nikandre from Naxos, to the "Far Shooter," which could be either Apollo or Artemis. Whom does this expensive dedication represent: Nikandre, Artemis, or simply an *agalma*, a beautiful gift? Her extraordinary thinness (nowhere is she thicker than 20cm) recalls ancient literary descriptions of wooden xoana (e.g., of the first statue of Hera on Samos). Drilled holes in the kore's closed hands once held metal attachments, perhaps a bow and arrow. Considering these characteristics, her location, and her size, it is likely that this figure is intended as an image of Artemis.

Archaic Delos possesses another contemporary Naxian marble sculpture, a statue clearly identifiable as the god Apollo (Fig. 2.38a–c). Although fragmentary, those fragments are impressive: a colossal triangular torso, and the rounded hips and upper legs of a monumental *kouros*, who wears a belt cinched around his waist. The scale clearly points to a deity. Found in the sanctuary of Apollo, this early statue, about 9m high when complete, depicts the god holding a bow and perhaps arrows, and was a dedication of the Naxians, as indicated by its inscribed base. Metal attachments were affixed to the marble to indicate locks of hair and his belt.

Naxos provided the marble for several other early large-scale sculptures, and three over-lifesize kouroi are still visible today in their ancient quarries where they were abandoned, probably because of damage (a crack or flaw; Fig. 2.39). But the largest kouros discovered thus far was found in the sanctuary to Hera on the island of Samos and was made of local Samian marble (see Fig. 3.21). Its 4.80m height would suggest that it represents a deity, but its inscription indicates that it is a votive offering, rather than an image of a god; in other words, size alone is not a criterion for distinguishing between deity and non-deity, and other facts, including context, must be considered.

(a) (b)

Fig 2.37a–c Athens, National Museum 1, "Nikandre" kore from Delos, c. 640 BC, Naxian marble, H (with plinth) 1.80m.

Funerary art and Geometric pottery

Burial practices in the Geometric period varied from region to region: both cremation and burial were used for adults, while burial generally was favored for children. Grave goods often accompanied male adult burials but were less common in female adult burials. Geometric pottery, which originated in Athens, served as grave gifts (perhaps in secondary use) or, more impressively, grave-markers (Fig. 2.40a). A closer look at one example of a Geometric burial demonstrates how informative the finds can be in reconstructing our knowledge of the past. The cremated remains of a pregnant woman were deposited in a belly-handled amphora, which was buried together with an assemblage of pottery and bronze, gold, and faience objects on the lower north slope of the Areopagos in Athens (Fig. 2.41a–b).

Geometric amphorae as cinerary containers were designated for women (kraters for men): this one is covered with bands of ornament and wide bands of black slip, with the greatest concentration of painted decoration on the area between the two handles. Among the grave goods was an object surmounted with five bulbous forms, which appears to represent a granary. This, together with imported gold earrings and a faience necklace, point to the woman's wealth: she belongs to a family with rich agricultural holdings. Before their deposition with the bodily remains, all these objects were visible to the mourners and functioned as status symbols, not only because of their intrinsic worth but also because some were imports. The same is true for a small ivory figurine found in another grave in the Dipylon cemetery

Fig 2.37 (*Continued*)

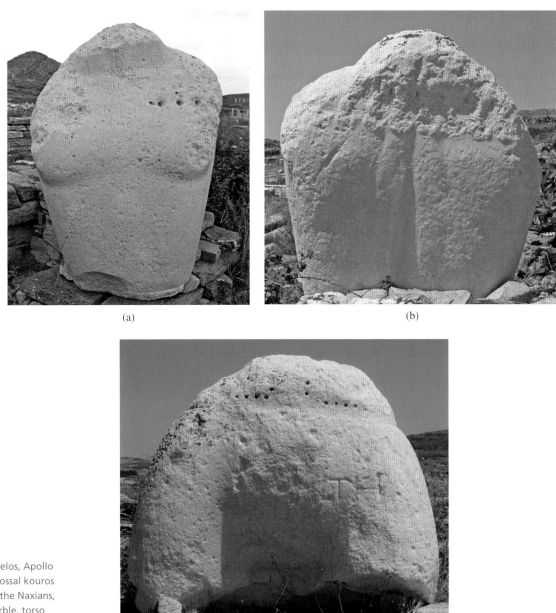

(a)

(b)

(c)

Fig 2.38a–c Delos, Apollo sanctuary, colossal kouros dedicated by the Naxians, *c.* 600 BC, marble, torso H 2.20m, hips H 1.20m, restored height *c.* 9m.

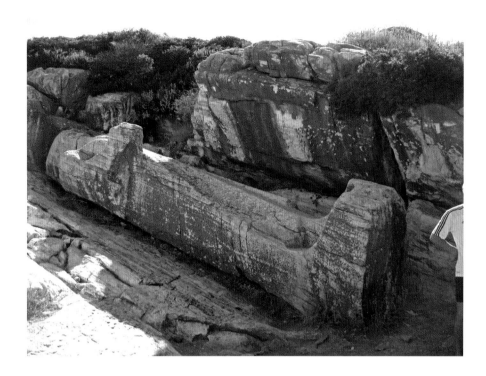

Fig 2.39 Naxos, Apollonas quarry, colossal kouros, c. 550–500 BC, Naxian marble, H 10.5m.

Map of ancient Athens, second century AD

(Fig. 2.42). The female figurine is nude save for the polos, which signifies her divine status; her nudity, imported material, size, and polos indicate reliance on Near Eastern images of female divinities, although the meander pattern on her polos is a typical contemporary Greek motif. In other words, the funeral and its accoutrements were not solely private matters but also could be used to signal social status in Geometric Greece.

Large, costly Geometric pottery gravemarkers offered another means of displaying wealth. While this practice extended back to the

(a)

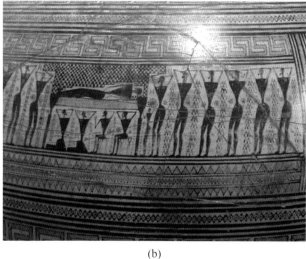

(b)

Fig 2.40a–b Athens, National Museum 804 ("Dipylon amphora")
from Athens, Kerameikos, Dipylon Gate, *c.* 750 BC, terracotta,
H 1.55m.

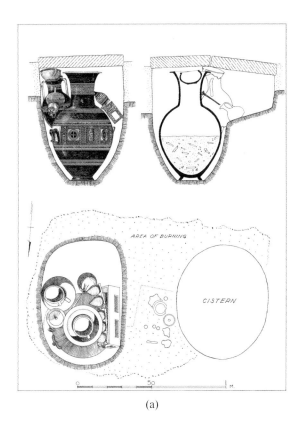

(a)

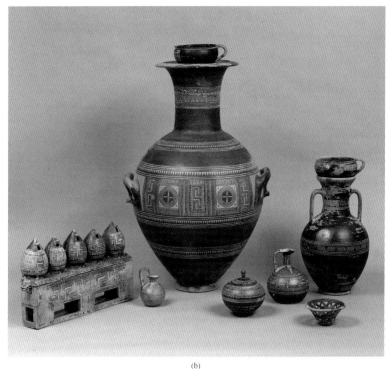

(b)

Fig 2.41a–b Athens, Agora Museum, "Rich lady's grave" from the lower north slope of the Areopagos in Athens, drawing of actual state and some of the grave contents (Agora 2004.02.0009), *c.* 850 BC.

tenth century BC in Athens, the period *c.* 770–750 BC saw a dramatic increase in such monuments, and the accompanying burials often contained valuable goods. The Dipylon amphora is covered with horizontally stacked bands of goats and repeating ornament, mostly lozenges, meanders, and other non-figural patterns, while a row of repeated deer encircles the neck (Fig. 2.40a); the cookie-cutter animals, their poses, and species recall eastern metalwork, while the overall dense patterning suggests influence from ancient textiles, such as the checkered shroud hovering over the corpse, which lies on a bier between the vase's handles (Fig. 2.40b). Mourners surround the corpse and tear at their hair in grief at the *prothesis*, the laying out and mourning of the dead. The black silhouette figures are rendered uniformly and schematically: inverted triangles to indicate the torso, wasp-waists, and simplified limbs or garments, with no individuation save the distinction between the sexes: females wear skirts, males do not. Zigzag ornament fills open space, and the raised shroud reveals the corpse, who is not painted in profile, but tilted toward the viewer. Information, rather than the imitation of nature, is the goal of the depiction, whose subject is an apt choice for a funerary marker. The molded legs of the bier and of the

stools provided for the mourners, the number of mourners, and the ornate shroud all suggest the wealth and/or status of the deceased.

While this is a narrative, no clues identify a particular individual or story. Such generic scenes decorate other funeral markers, but the specificity of some Geometric vase paintings suggests the possibility of myth. On a *louterion* (spouted krater) said to be from Thebes (Fig. 2.43a–b), a man grasps a woman by the wrist and steps forward to board a ship, manned by two banks of rowers. The man's gesture is known from later vase painting, where it signifies the woman's status as bride or sexual partner. If the later iconographical meaning can be extrapolated back in time, we would be viewing a couple boarding a ship; identities for the pair, such as Helen and Paris or Menelaos, and Ariadne and Theseus, have been proposed, but nothing secures the identification of this suggestive scene. This is true for a number of Geometric vase paintings. If these are depictions of myths, we still are unable to comprehend how this information was conveyed to the ancient viewer or how the ancient viewer recognized them.

The seventh century BC

Corinth

Corinth's geographical position – on the isthmus between the mainland and the southern peninsula or Peloponnese that divides the Saronic Gulf in the east from the Corinthian in the west – placed it at the center of trade between Greece and the Near East, where it played a pivotal role in the dispersal of oils and perfumes imported from the latter. The products arrived in Corinth in large containers and were decanted to small vessels for sale (Fig. 2.44); the painted pottery industry in Corinth grew in response to this stimulus, and these Protocorinthian ("first Corinthian") wares are small vessels shaped from the fine, buff-colored Corinthian clay. These wheel-made wares were hardened to a leather-like condition, then the design – often simple, irregularly spaced bands or rudimentary figural scenes – was sketched on to the surface as a guide for the brown or black slip. Details were incised into the slip with a metal instrument, then the pot was fired, and other details could be added in paint (most often white or purple) after firing. Various details recall eastern incised metal vessels, such as incision into black slip on the handles and necks, and rivet-like

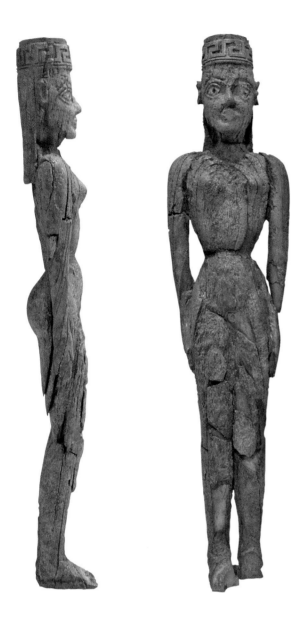

Fig 2.42 Athens, National Museum 776 from Kerameikos grave 13 in Athens, *c.* 730 BC, ivory, H 24cm.

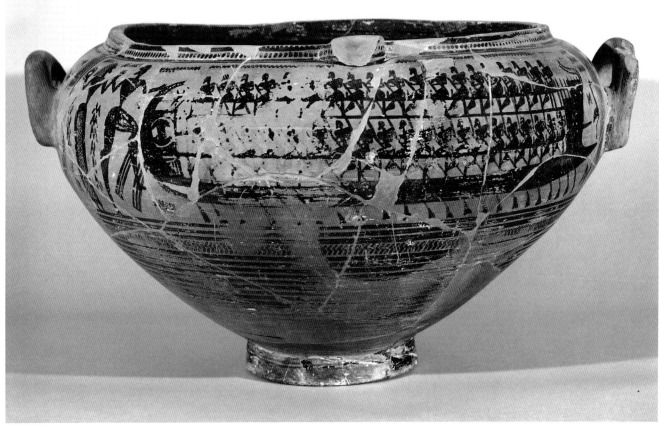

(a)

(b)

Fig 2.43a–b London, British Museum 1899.2–19.1, louterion from
Thebes, *c.* 730 BC, terracotta, H 30cm.

Fig 2.44 Bochum, Protocorinthian alabastron attributed to
the Typhon Painter, *c.* 640–630 BC, terracotta, H 9.6cm.

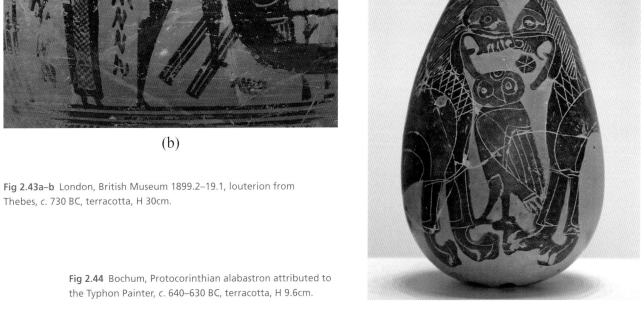

sculpted embellishments (Fig. 2.45a); it is likely that the technique of incising details was learned from imported metal and ivory objects, then applied to pottery in Corinth. This new technique, Protocorinthian black-figure, dominated the production of painted pots on the mainland during much of the seventh century BC, although pottery, especially simple pots for daily use (e.g., cooking and dining), was certainly produced and used everywhere in Greece.

Among the finest examples of Protocorinthian work is the diminutive Chigi olpe, which is a mere 26.2cm high (Fig. 2.45a–b). Typical of this fabric are the superimposed horizontal friezes filled with tiny figures and the liberal use of added paint in various colors, here rendered with extraordinary precision and detail. Opposed phalanxes of hoplites (heavily armed infantry) approach each other to the sound of a flute on the top frieze; long-haired youths hunt a lion in the middle frieze; and in the bottom zone, boys with the help of dogs capture a hare in a net. Three stages of male life, three types of activities of ever-increasing danger are portrayed: hare hunting, lion hunting, and that most dangerous type of hunting of all, warfare, where your quarry is armed and intent on killing you, as well. In addition, a mythological scene, the judgment of Paris, appears on the middle band, where it is divided from the lion hunt by a sphinx, a fabulous Near Eastern creature (Fig. 2.45b). The myth is identifiable through the painted names of the three goddesses, Athena, Hera, and Aphrodite, the last of whom ensures her victory by promising Helen to Paris (although Helen was married to someone else). This is among the first clearly identifiable mythological narratives in Greek imagery.

Early depictions of myth

Files of colorful animals became a favorite device on later Corinthian vases, though the sharp precision of the earlier small vessels yielded to a looser style on larger pots, and mythological subjects became more common. The brightly painted depiction of Herakles is clearly identifiable by inscriptions written in Corinthian script on a column krater (Fig. 2.46a). The hero wields a knife as he reclines at a symposion with King Eurytios and his sons, while Iole, the king's daughter, stands among them. Components of this image reveal tremendous attention to detail: each dog shown in a slightly different position, and one of them is in outline technique; the varied arm

(a)

Fig 2.45a Rome, Museo Nazionale Etrusco di Villa Giulia 22679 ("Chigi olpe") from Veii, Protocorinthian olpe, c. 650 BC, terracotta, H 26.2cm.

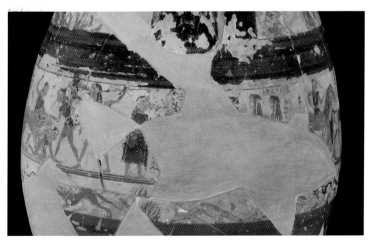

(b)

Fig 2.45b Rome, Museo Nazionale Etrusco di Villa Giulia 22679 ("Chigi olpe"), details, Judgment of Paris.

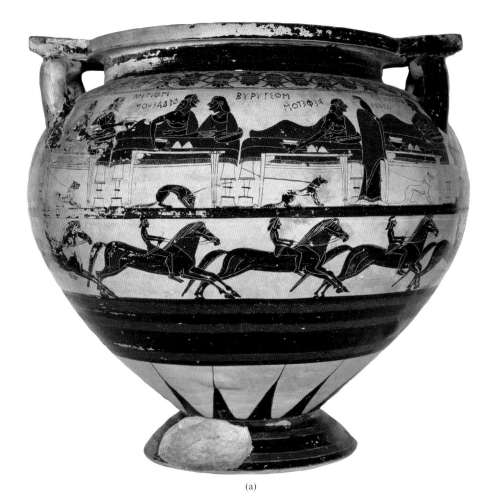

(a)

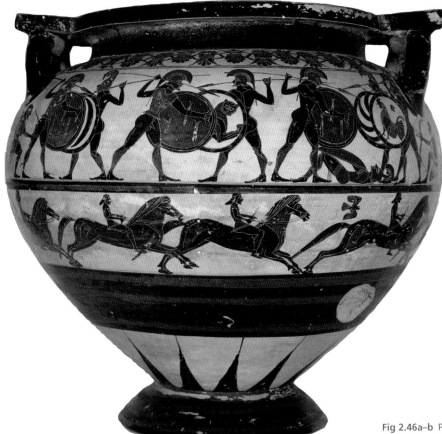

(b)

Fig 2.46a–b Paris, Musée du Louvre E635 ("Eurytios krater"),
Corinthian column krater from Etruria, Herakles banqueting with
Eurytios and his family, c. 600–590 BC, terracotta, H 48cm.

(a)

(b)

(c)

Fig 2.47a–e Eleusis, Archaeological Museum, Protoattic amphora from Eleusis by the Polyphemos Painter (name vase), *c.* 670–650 BC, terracotta, H 1.42m.

positions and gestures of the reclining banqueters; and the *lebes* (circular pot) from which the wine was decanted into drinking cups. This is the earliest scene in Greek vase painting of a symposion, a custom that appeared in Greece not long before. Another Trojan War theme (Fig. 2.46b; cf. Fig. 2.45b) decorates the reverse of the krater: fighting warriors, including Odysseus and Diomedes, and Ajax, who has impaled himself on his sword; again, all figures are named.

Athenian vase painters quickly learned the black-figure technique from their Corinthian counterparts and began to produce their own wares in the seventh century. Unlike the Corinthian vases,

(d)

(e)

Fig 2.47 *(Continued)*

however, these early Protoattic vases were very large (and therefore were used differently from the Corinthian examples), made liberal use of myth, and tended to cover the body of the vase with a single theme. An impressively large amphora, a striking contrast to contemporary small Protocorinthian vessels, was found at Eleusis, where it was used as a container for a child's burial (Figs. 2.47a–e). This was clearly an unforeseen use since the bottom of the vessel had been broken off in antiquity to insert the human remains, then reattached.

On the amphora's neck, Odysseus and two companions plunge a stake into the eye of the Cyclops Polyphcmos, an easily identifiable myth also recounted in *Odyssey* 9 (Fig. 2.47b). Odysseus and his men found themselves on the island of the Cyclopes while journeying home from Troy after the city's capture. The poem relates that the Cyclops was asleep when Odysseus attacked, but here he is awake, propped upright by the scene's "frame," holding a wine cup in one hand, and grasping the stake directed at his open eye with the other. This disparity between poem and image serves as a caveat against seeking a direct correlation between text and image in Greek art, looking for a dependence of the latter on the former: artists and poets were familiar with the same tales and their variants, probably transmitted orally, and while there may be many similarities between image and ancient text, it is unusual to find a one-to-one correspondence. *If* the painter of the Eleusis amphora followed the same version of the myth as that recounted in the *Odyssey*, he has compressed the narrative to show several moments at once (the Cyclops drinking, the men attacking), and one good reason for doing so may have been the physical limits of space. Odysseus is distinguished from his companions by his proximity to the Cyclops, and his sketchy rendering in outline technique suggests energy as he vaults upward to thrust the stake into the Cyclops' eye. His companions are depicted in black silhouette with white used for the skin of their faces.

A beast of prey attacks another quadruped on the shoulder of the amphora (Fig. 2.47a). The motif of animal combat, usually between a feline and bovine, as well as the numerous rosettes and other fill decoration on the vase, are common on Near Eastern objects. But this artist's rendering of the predator is puzzling: the body is that of a feline but the head with its long muzzle resembles a hound's. The osteological remains of lions are decidedly fewer in the Iron Age (e.g., at Delphi, a seventh-century sacrificial deposit at Kalapodi) than they were in the early Bronze Age (see Chapter 1), suggesting to some scholars that they

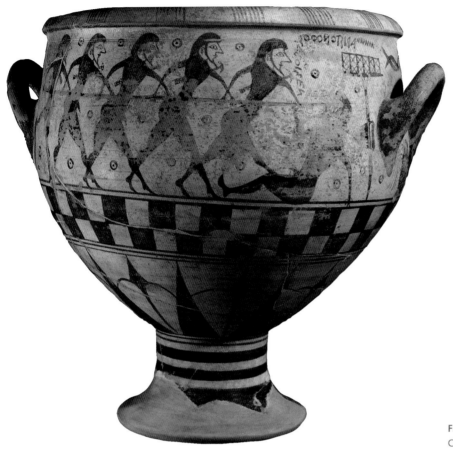

(a)

Fig 2.48a Rome, Palazzo dei Conservatori 172 from Cerveteri ("Aristonothos krater"), *c.* 670 BC, terracotta, H .36cm.

were no longer native but were imported, while others maintain that lions persisted in Europe until centuries later, perhaps as late as the first century AD. In any case, it is clear from his rendering that the painter of the Eleusis amphora had no first-hand knowledge of large felines.

The greater portion of the amphora's belly is occupied by a single panel narrative, the figures extending from top to bottom of the frame: two Gorgon sisters chase the hero Perseus, who runs to the viewer's right (Figs. 2.47a, c). He has already beheaded the Gorgon sister (Fig. 2.47d; cf. Fig. 2.32), Medusa, whose body with its rotund scaly torso and black and white skirt floats lifelessly against the background, blood emanating from her severed neck. Perseus is painted in silhouette – his black legs and winged boots are still visible – while Athena, who intervenes between the Gorgons and Perseus to protect the hero, wears a white garment and is outlined in black. The artist's delightful imagination produced Gorgons' heads with serpentine hair that resemble those common contemporary votive offerings, bronze tripod cauldrons with protome attachments (Fig. 2.47e; cf. Fig. 2.28a). The Gorgons' leering

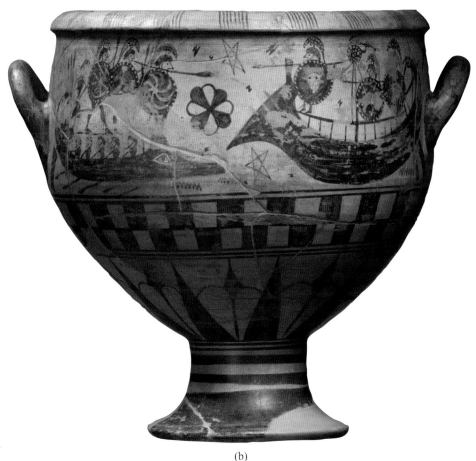

Fig 2.48b Rome, Palazzo dei Conservatori 172 from Cerveteri ("Aristonothos krater"), c. 670 BC, terracotta, H 36cm.

(b)

mouths and gnashing teeth run the full width of their heads, enhancing both their comic effect and fantastic appearance. They wear long dark skirts that completely reveal one leg and hasten along with their thin, spidery arms outstretched toward the fleeing Perseus.

In addition to the animal combat on the shoulder, Near Eastern influence is also evident in the choice of myths on the Eleusis amphora. Near Eastern monster-slayer myths, especially those concerning fantastic hybrid creatures, became enormously popular in Greek art, vase painting and other media across the Mediterranean in the seventh century BC, (admittedly, Odysseus only blinds the Cyclops, but he does enfeeble him.) During this time of colonization and trade, of far-off travels and wanderings, the stories of Odysseus' adventures on his homeward journey seem to have been especially appealing.

The myth of the blinding of Polyphemos recurs elsewhere in the Greek world, as we see on a krater from Caere in present-day Italy (Fig. 2.48a–b). Five virtually identical men wield a long stake as they rush toward the Cyclops (who is the same size as his attackers); the

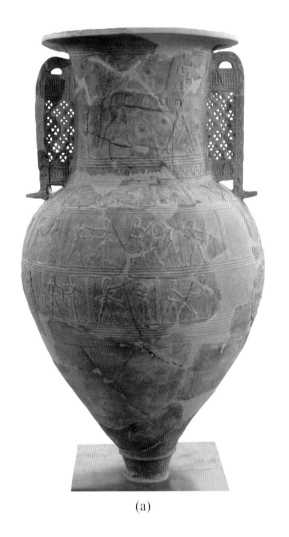

(a)

seated giant supports himself with his left arm while fending off the attack with his right. A wine vessel stands on the ground behind him. A Greek and a non-Greek (perhaps Etruscan or Italian) ship do battle on the reverse. The krater's tall foot and the large forms of the non-figural decoration are typical of west Greece and unlike those found on contemporary pottery from the Greek mainland. Aristonothos has signed the vessel just in front of, and above, the right handle, written in retrograde: *Aristonothos epoi(e)sen*, that is, "Aristonothos made (it or me)." This is one of the earliest craftsmen's signatures on a Greek vase, and it is written with the Euboian alphabet. But what does it mean to "make" this vessel? The verb ποιέω is used for potters' signatures on Attic vases in the sixth century BC and also appears in dedicatory inscriptions to indicate that someone made a dedication. Here, it may refer to the creation of the vessel, either the potter or painter, or perhaps both if one person performed both tasks, as is sometimes the case. The lettering and findspot suggest a Euboian artist working in one of the Greek colonies in the west; again we can observe the importance of Euboia in colonization and east–west contact.

Other aspects of the Trojan saga and its heroes also appealed to seventh-century craftsmen. A relief pithos from Mykonos is one of many such relief pithoi from the Cyclades, though few are decorated so elaborately (Fig. 2.49a–c). The reliefs, restricted to the front side of the vessel, depict the fall of Troy (*Ilioupersis*).

Fig 2.49a–c Mykonos, Archaeological Museum 2240, relief pithos from Mykonos (probably made on Tinos), early seventh century BC, terracotta, vH 1.35m.

(b)

(c)

Fig 2.50 Paris, Musée du Louvre E658 ("Lévy oinochoe"), c. 640–630 BC, terracotta, H39cm.

The Trojan horse, like a child's toy on wheels, fills the neck (Fig. 2.49b). Windows in the treacherous gift reveal Greeks hidden within, while Greeks clamber around it. Friezes on the body of the pithos are divided into metope-like squares and filled with identifiable scenes, such as the brutal death of the child Astyanax, in two- or three-figure compositions worked in disparate scales (Fig. 2.49c). Although the function of relief pithoi is not known, scholars suggest that they stood as gravemarkers or that human remains were deposited in them (see Fig. 2.47a).

Vase painting followed other paths in the eastern Aegean. Corinthian and Attic pottery were common imports to east Greece, but east Greek pottery was seldom exported in the seventh century BC. The Wild Goat Style, named for its most common figural motif, is well represented on the island of Rhodes, where the oinochoe (wine pitcher) was the most common shape (Fig. 2.50). Both silhouette and outline technique are used against a yellowish background with added red to enliven details. The neck and handle are painted black, and registers filled with animals, especially grazing goats, and blossoms cover the body. Fill ornaments, such as the ubiquitous rosette, are organized in regular patterns. Rivet-like attachments at the handle, the vertical depression running down it, and incised spirals on the neck imitate eastern metalware, while the painted decoration may take inspiration from textiles (cf. Figs. 2.40a–b).

Attic black-figure: painters and potters

Attic vase painters quickly mastered the black-figure technique invented in Corinth, and by the early part of the sixth century Attic wares dominated the market. These Attic craftsmen had the advantage of Attic clay, which fired to a brilliant orange color and contrasted with lustrous black figures produced by the slip derived from Attic clay.

Attic painters embraced myth whole-heartedly as we can observe from an upsurge in the variety and quantity of mythological images in vase painting. Among the earliest Attic black-figure wares is an amphora by the Nettos

(a)

(b)

2.51a Athens, National Museum 1002 ("Nettos amphora") from Athens, Protoattic/Attic black-figure amphora by the Nettos Painter (name vase), *c.* 625 BC, H 1.22m, terracotta.

Fig 2.51b Athens, National Museum 1002 ("Nettos amphora") from Athens, details of Protoattic/Attic black-figure amphora by the Nettos Painter (name vase), *c.* 625 BC, detail.

Painter on which the theme of the Gorgons recurs (Fig. 2.51a–b; cf., e.g., Figs. 2.32, 2.47). Like many other large amphorae previously discussed, this container was destined for funerary use: it stood as a gravemarker in the Dipylon cemetery in Athens. The Nettos Painter takes his name from the scene on the neck, where the Centaur Nettos (or Nessos) pleads for his life with Herakles; both names are painted near the protagonists (Fig. 2.51b). Nettos had offered to

help carry Herakles' bride, Deianeira, across a river, but en route, the brutal Centaur assaulted Deianeira, and Herakles rushed to her rescue. Herakles braces his left leg against the Centaur's back and pulls Nettos' head by his hair, preparing to attack him with a dagger. The Centaur supplicates his opponent by extending his hands toward the hero's chin, a common gesture that will be to no avail in this case. Two Gorgons traverse the belly of the amphora, their legs in a pinwheel pattern to signify running. Their lower bodies are in profile but their upper bodies face front, revealing their carefully rendered, mask-like, leering faces, tongues protruding from their mouths. To our left, a beheaded Medusa stumbles to the ground, blood pouring from her neck. Perseus and Athena are omitted; the narrative is reduced to its bare elements, the fate of Medusa clear, the role of Perseus simply implied. Dolphins leaping along the lower border allude to the seaside setting of the myth. As was the case with the Protoattic Eleusis amphora (Fig. 2.47), numerous fill elements on the vase, such as rosettes, as well as the mythological themes of hero killing hybrid monster, betray Near Eastern influence. But the use of Greek writing, the masterful incision to portray the wings and faces of the Gorgons, and the anatomy and hair of Herakles and Nettos signal a new style of painting that concentrates on action and heftier, volumetric figures. Although the use of a single narrative to fill the largest part of the vase is a legacy of Protoattic style, the Protoattic outline technique has vanished. Instead, the painter takes full advantage of the black silhouettes, added color, and repeated patterns created by the figures themselves (the Gorgons' whirling legs, the mix of animal and human limbs of Herakles and Nettos) to create an energetic narrative.

The early polis

Cooperative action among inhabitants of a region either as a concentrated city or living in loose settlements and houses (sometimes regularly planned as is often the case in Greek colonies in south Italy and Sicily), public spaces, shared

Fig 2.52 Old Smyrna, reconstruction of polis in the eighth century BC.

Fig 2.53 Zagora, late eighth century BC, reconstruction of courtyard house.

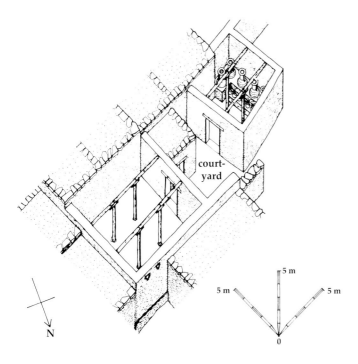

religious festivals and areas, a common set of customs or laws, such as the Dreros law code, a defense system, the construction of a central temple – these are the ingredients that constitute the Greek *polis* or city-state, which continued to have an agricultural base. Archaeology reveals the gradual crystallization of the polis in the late eighth century BC.

Although our evidence for houses in the Geometric period is relatively scarce owing to their perishable construction materials, enough remains to demonstrate that by the eighth century BC, stone multi-room houses of rectilinear form had replaced the oval and apsidal mudbrick dwellings of the Early Iron Age (Fig. 2.52), a parallel to developments in temple architecture. The courtyard was the focal point of some Geometric houses – this characteristic persisted in domestic spaces throughout the Greek and Roman periods (Fig. 2.53)– and stone benches lining walls are a common feature; the benches were for seating and storage as indicated by the occasional pithoi or holes placed in them. Central hearths for cooking and heating are attested in many houses.

Fortification walls from this time are relatively scarce, but a few well-built examples remain, including the remarkable walls at Smyrna, which have two phases (Fig. 2.52): the first of ashlar blocks laid in regular courses by *c.* 850 BC, and a second in *c.* 750 when the walls were repaired and widened. Such massive construction projects required planning, cohesion, and a large labor force, that is, a cooperative effort undertaken by an organized community. From the Late Geometric period onward, burials were usually relegated to areas well outside the city walls.

A central open public space for meetings or an agora for civic and commercial functions, sometimes oriented to the central temple, was an important feature. The Greek city of Megara Hyblaia in Sicily (founded in 729 BC) can claim to have the first agora known to us that was clearly planned from the start (as opposed to arising over time) as an open public space, which was later flanked by temples and stoas.

From *c.* 725 onward, components of hoplite weaponry and armor appear, and the hoplite phalanx, the practice of

infantry fighting in heavily armed ranks, also developed by at least the seventh century BC (see Fig. 2.45a). Armed warriors appear on Geometric vases, but doubt as to whether these are intended as reflections of reality or mythological figures makes it hard to describe them as hoplite warriors in the later sense of that term.

Vibrancy is the prime characteristic of the Geometric period and the seventh century in most of Greece. Stimuli came from the Near East in manifold ways, but whatever the Greeks adopted, they also adapted to their own uses.

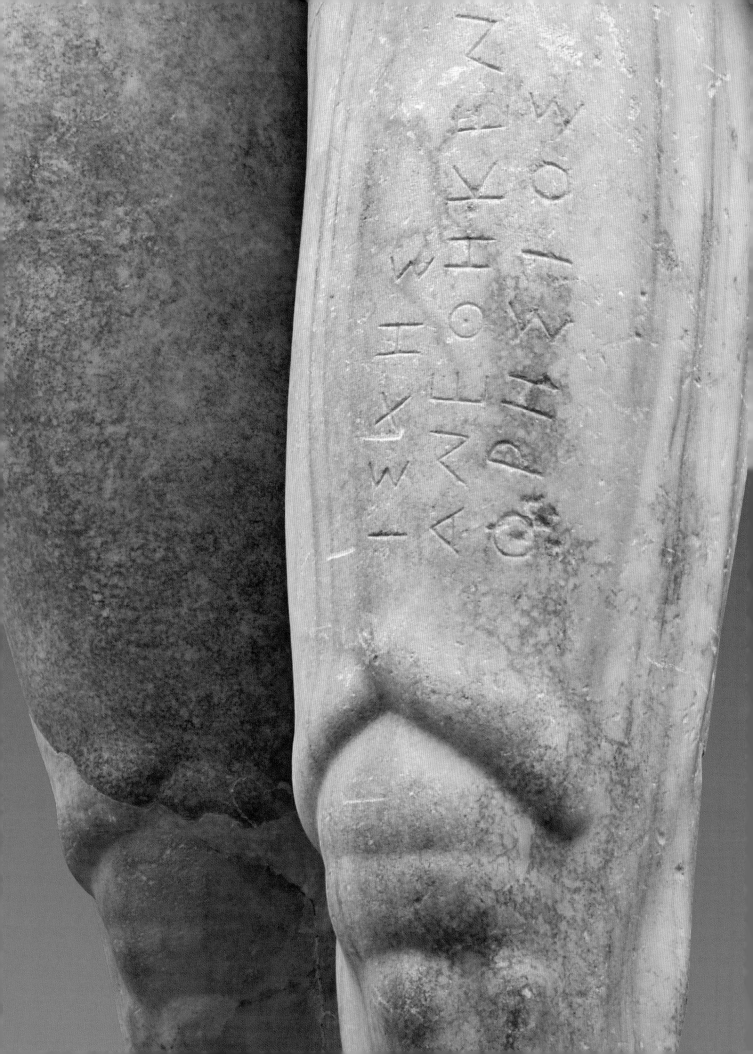

3 The Archaic Mediterranean

CONTENTS

TIMELINE – all dates in BC

c. 600–480	Archaic period
c. 600	Heraion at Olympia
early 6th century	First coinage developed in Lydia
c. 570–550	Ionic Artemision at Ephesos, Rhoikos temple on Samos
c. 550	"Basilica" at Paestum
c. 566/565	Panathenaic games reorganized
c. 546	The tyrant Peisistratos gains control of Athens, Krosis of Lydia defeated
c. 527	Hippias succeeds his father as tyrant of Athens
c. 525	Siphnian Treasury at Delphi, Attic red-figure begins
c. 520–505	Pioneer Painters
c. 514	Assassination of Hipparchos, brother of Hippias, by "Tyrannicides" Harmodios and Aristogeiton
c. 510	Expulsion of Hippias, Tyrannicides sculptural group by Antenor
508/507	Kleisthenic reforms lead to democracy in Athens
c. 499–494	Ionian revolt against Persian rule
c. 490–479	Persian Wars
c. 490	Battle of Marathon
c. 480	Persian sack of Eretria and Athens

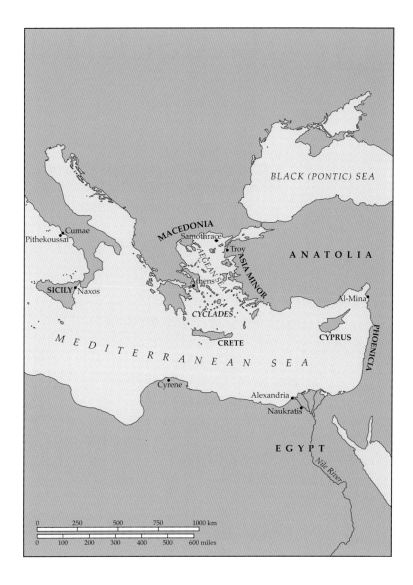

Map of the Mediterranean area

Temples, sanctuaries, and votives

The tremendous benefit from contact with the east is most evident in the Archaic period (*c.* 600–480 BC). The newly acquired knowledge that enabled Greeks to construct large-scale stone architecture and sculpture radically transformed the landscape in the sixth century: stone temples sprang up all over the Greek world, and large-scale stone statues were placed on elite private graves and populated sanctuaries, particularly Panhellenic ones, which flourished in the sixth century.

These developments were accompanied by a cultural richness in many realms: literature, philosophy, lyric, epic, drama (a relatively

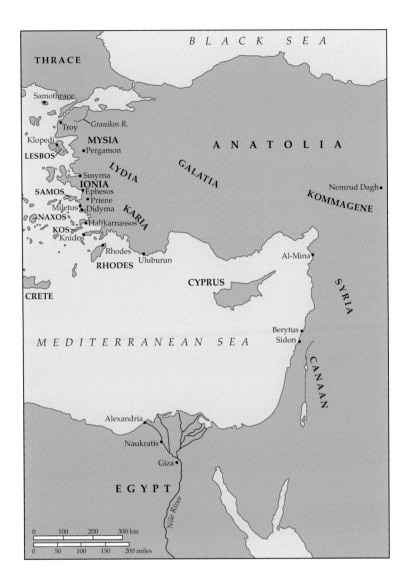

Map of the eastern Mediterranean

late phenomenon), and vase painting, as well as new forms of government and polis interaction. Aristocrats continued to hold the most power in governing Greek poleis, whatever the official form of rule, and this remained true even with the creation of a radically new type of government, democracy, in late sixth-century Athens. Aristocratic culture, which was defined by agonistic displays of wealth, physical prowess, courage, intelligence, and wit, dominated warfare, athletics, symposia, poetry, and philosophy, and aristocrats were the usual patrons of sculpture.

A new medium of economic exchange also emerged in the Archaic period: coins. Coins evolved from earlier weight standards in Lydia (in present-day Turkey) in the early sixth century BC, where they were

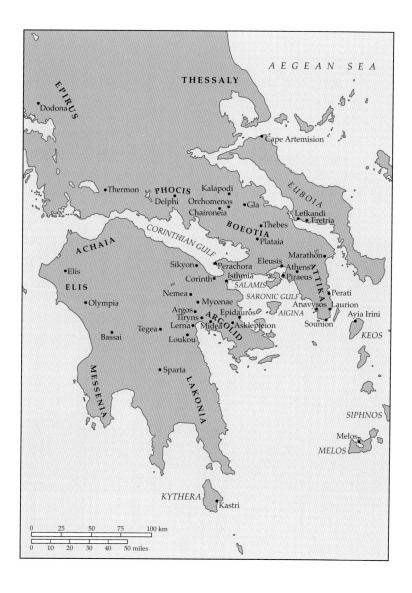

Map of southern Greece and the Peloponnese

made of electrum, an alloy of silver and gold. Greek cities soon began to mint coins in silver using their own weight standards and dies with standardized symbols, for example, owls for Athens, turtles for Aigina, the winged horse Pegasos for Corinth, and Medusa's frightening visage for Neapolis in Thrace (Fig. 3.1a–d).

Archaic temples: Doric

Like the temple of Poseidon at Isthmia of nearly a century earlier (see Fig. 2.20a–b), the "Heraion" at Olympia of *c.* 600 BC was originally constructed of mixed materials and is among the earliest Doric constructions in Greece (Figs. 3.2–3, see also 5.18). It was the first

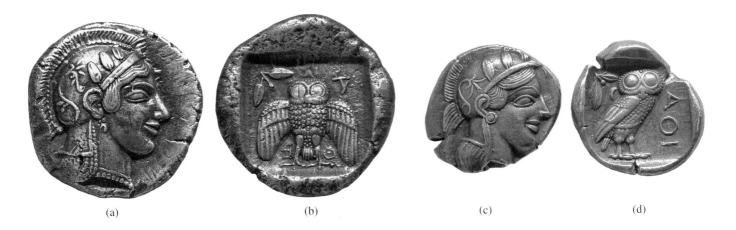

<div style="text-align:center">

(a) (b) (c) (d)

</div>

Fig 3.1a–b Berlin, Bodemuseum BM-101/02 (1875 Prokesch-Osten), Athenian dekadrachm obverse and reverse, after *c.* 467 BC, silver, weight 42.60g, D 35mm.

Fig 3.1c Berlin, Antikensammlung AM-002/02a (1875 Prokesch-Osten), Athenian tetradrachm, obverse, *c.* 450–400 BC, silver, weight 16.96g, D 24–28mm.

Fig 3.1d Berlin, Antikensammlung 1906/246 FM Beni Hassan from Egypt, Athenian tetradrachm, reverse, *c.* 450–400 BC, silver, weight 17.13g, D 23–26mm.

major construction at Olympia, and seems to have originated as a temple to Zeus, being then given over to Hera or to Hera and Zeus when a new temple was built to Zeus in the fifth century BC (see Chapter 4). Two steps capped the stone foundations (three steps became canonical *c.* 550 BC), and a peristyle of wooden columns framed the sekos. The walls were of limestone to about 1m in height, then continued upward in mudbrick. The original superstructure was probably of wood with a wooden roof (long since vanished), with terracotta roof tiles. A pronaos and slightly deeper opisthodomos, both with two columns in antis, framed the cella. Within it, two parallel rows of eight columns placed close to the walls, together with small spur walls attached to alternate columns, supported the roof. The cult statue once stood on the limestone base at the cella's west end. Already in the mid-sixth century BC, shortly after the temple was finished, the wooden columns began to be replaced by stone counterparts in the Doric order; this was a huge enterprise as the architecture above the columns had to be removed temporarily in order to do this. In *c.* AD 160, the travel writer Pausanias visited Olympia and reported that one wooden column still remained standing (Paus. 5.16.1).

The Olympia Heraion's 6 × 16 peristyle produced a long, narrow structure, which typifies sixth-century Doric temples (they eventually grew shorter in proportion to their width). No attempt was made at uniformity of the stone columns, which is not so surprising since their Doric capitals have varying echinus profiles, indicative of their production at different times. The columns varied in circumference and number of flutes (sixteen or twenty; sixteen was the earlier practice, twenty the later, although exceptions sometimes occurred); two

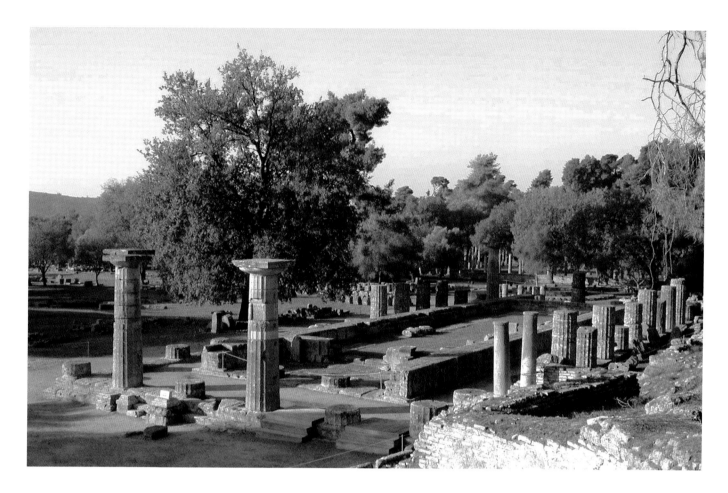

Fig 3.2 Olympia, "Heraion," c. 600 BC, 18.76 × 50.1m.

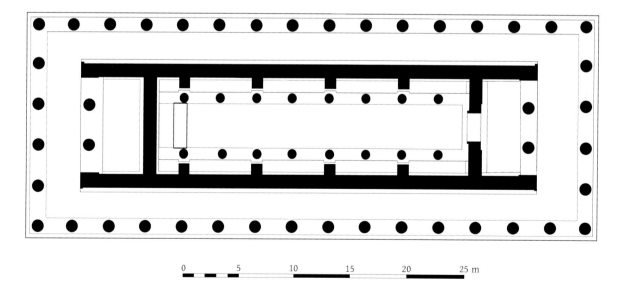

Fig 3.3 Olympia, "Heraion," c. 600 BC, plan.

Box 3.1 The Greek temple (see also p. 85, Box 2.1)

The sixth-century BC groundplan of a Greek temple consists of standard elements: a peristyle (a ring of columns) surrounds the core of the building, which consists of a pronaos (porch) with columns in antis (columns between the walls), which communicates with the main room, the naos or cella (Box 3.1 Fig. 1). Many temples, usually Doric temples, have an opisthodomos (back porch), also with two columns in antis. A walkway or pteron between the peristyle and cella allows circulation around the interior core of the structure. An *adyton*, an extra room behind the cella is an occasional addition with or without an opisthodomos (e.g., see Fig. 3.5).

Like verbal language, Greek architecture has a "grammar" that is malleable, as is poetry, but has fundamental rules. Within these simple parameters, Greek architects created hundreds of variations by manipulating the characteristics of Greek architecture. These include, for example, the placement of the peristyle with respect to the cella – how far distant they are from each other – which affects the depth of the pteron and the sense of spaciousness; the relationship of pronaos, opisthodomos, and cella columns with regard to the peristyle on both the short and long ends – when the columns are aligned, the building's

layout is almost entirely comprehensible from the exterior of the structure; the number of flutes on a column (usually twenty, but sometimes as few as sixteen) – fewer flutes means greater width of flutes and an illusion of less height; the ratio of the number of columns on the short and long ends of the temple, which affects the temple's proportions; the distance between columns of the peristyle, which also impacts the perception of spaciousness; the shape and profile of the echinus, which ranges from large and squat to tapered and small, thus contributing to the building's aesthetics – the profiles also can be used to date the structure when organized in a typological sequence; the treatment of metopes and triglyphs at the corners of the building, which was a special, ever-persistent problem in the Doric order; the proportions of one element to another and to those of the whole building; the number and placement of columns in the pronaos, cella, and opisthodomos; and the proportions of the inner core rooms with respect to each other. By experimenting with, and varying, these elements, architects explored the full range of possibilities in the Doric order. As well as addressing technical issues of stone construction, i.e., how to keep the stone structure together and standing, architects could create buildings that seemed spacious or closed, immediately clear or mystifying, long, tall, short, narrow, round, inviting or forbidding, integral to, or dominating, their landscape.

Ionic temple design also has numerous variations: the number of peristyles surrounding the central core, the number of columns in antis in the pronaos, the treatment of the opisthodomos with respect to the pronaos, the ratio of columns on the long and short sides, size and density of the columns, treatment of bases and capitals. Like the developed Doric temple, Ionic temples usually stood on a platform of three steps but this, too, could vary.

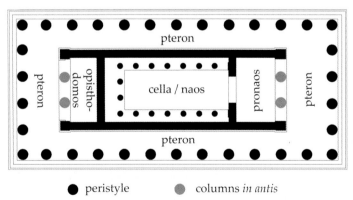

● peristyle ● columns *in antis*

pronaos + cella + opisthodomos = sekos

Box 3.1 Fig 1 Greek temple plan.

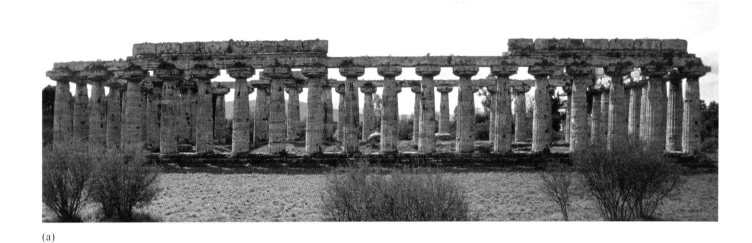

(a)

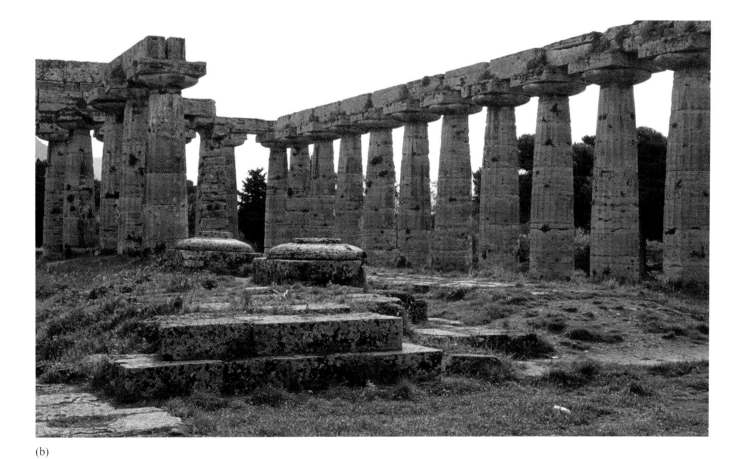

(b)

Fig 3.4a–b Paestum, Basilica, begun c. 550 BC, 24.5 × 54.3m.

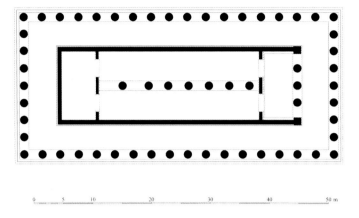

Fig 3.5 Paestum, Basilica, begun *c.* 550 BC, plan.

columns are monolithic stone shafts, others are composed of stacked drums. The columns are not regularly spaced but closer together on the long sides of the temple, presumably to give greater support to the structure, or conversely, more widely placed on the short ends to facilitate access to the cella. Corner contraction, a narrowing of the space between the three columns turning the corners, was deployed in order to terminate the ends of each Doric frieze with a triglyph (triglyphs should be centered over columns and regularly spaced, but at the corners they must be off-center so as to avoid ending the frieze with a half-metope) while not simultaneously lengthening the adjacent metopes. This knotty problem is the "Doric corner conflict," which afflicted all Doric quadrilateral structures; ancient architects struggled with it for centuries and eventually essentially abandoned the effort and built in the Ionic and Corinthian orders instead.

Greek temples of a short time later were entirely of stone from their inception; some of the best surviving examples are in southern Italy and Sicily (Magna Graecia), where Greeks established colonies in the eighth century. The so-called "Basilica" at Paestum was probably dedicated to Hera, who was worshipped at many temples in Magna Graecia (Figs. 3.4–5).

This well-preserved 9 × 18 *peripteros* (peristyle building) was constructed of local limestone (marble was not plentiful in Magna Graecia) with the exception of a horizontal band of sandstone dividing the architrave from the frieze. The columns stand atop three steps, a normal arrangement by this time, and offer good examples of *entasis* – the swelling of column shafts that then taper toward their capitals. The size of the columns was uniform, an unusual feature at this time (cf. Fig. 3.2). The architrave survives, but nearly everything above has been lost (if this area were of wood, this would vitiate the claim made above about all-stone construction). The echinus takes the form of a bulging disc protruding beyond the abacus, which itself projects beyond the architrave (Fig. 3.4b); this profile marks these capitals as early (the echinus narrows, tapers, and grows steeper over time). A vegetal pattern was incised and painted on the underside of some echinoi. The Basilica's pteron is much wider than that at the Olympia Heraion (Fig. 3.3) and provides a more capacious and

Map of Italy and western Greece

impressive framing device for the building's central core (Fig. 3.5). The pronaos' three columns in antis align with the peristyle columns and with the temple's central row of columns, which bisects the cella and supports the roof (cf. Fig. 2.14a). Two doorways permit communication between pronaos and cella. Rather than an opisthodomos opening to the rear of the building, the "Basilica" possesses a back room accessible only from the cella; this *adyton* became a common feature in western Doric temples. The adyton's function is not known, but it may have served as a treasury.

Archaic architectural sculpture

Sculpted or painted decoration was another common feature of Greek temples: architecture was usually partly painted in primary colors (cf. Fig. 2.23a–b). On Doric temples, sculpture could appear in

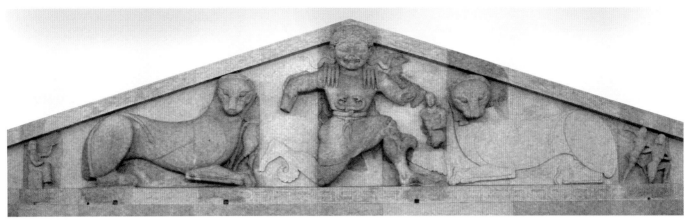

(a)

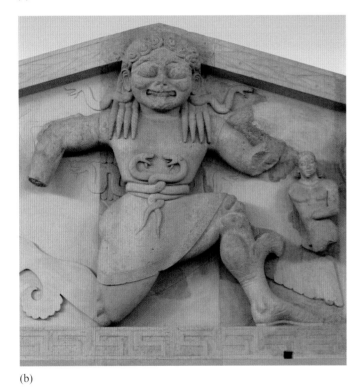

(b)

Fig 3.6a–b Corfu, museum, west pediment from temple of Artemis at Corfu, *c.* 580 BC, limestone, H 2.74m at center, L 22.16m.

the metopes, pediments or gables, and/or on the roof (these roof statues are called *akroteria*), and might be of stone, thin sheets of bronze on a wooden background, or terracotta. At the Heraion at Olympia, for example, the metopes may have been decorated with figural bronze sheets, which have been found at the site, while the two pediments may have had lime-stone relief sculpture. It is certain, however, that the Heraion's pediments were crowned by terracotta disks (more than 2.3m in diameter), painted in regular concentric patterns. It is important to note that architectural sculpture was not a requirement for a temple, and many, in fact, had none.

The Doric temple of Artemis on the island of Corcyra (modern Corfu or Kerkyra) is one of the earliest all-stone temples in Greece. Although its architecture survives in poor condition, the temple exhibits several important architectur-al features: the first stone capital; some of the earliest stone metopes, which were sculpted but are not well preserved; and one of the earliest extant sculpted pediments. Fifteen lime-stone slabs comprise the west pediment (Figs. 3.6–7), which

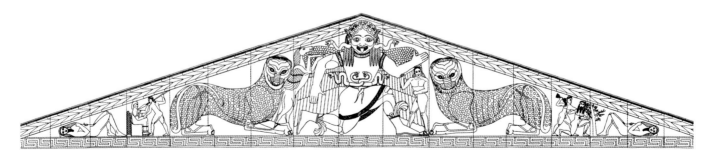

Fig 3.7 Corfu, museum, temple of Artemis at Corfu, west pediment reconstruction.

is dominated by a colossal running Medusa in the center. Medusa's visage could turn men to stone, and her leering, menacing head, sometimes attached to a body, was commonly affixed to temple roofs and pediments on archaic Greek temples; traditional interpretations maintain that she functioned as an apotropaic device to ward off evil, but a more recent view regards her as a symbol to inspire dread or fear in the visitor, as was suitable for ancient Greek religious experience. When the Greek hero Perseus beheaded Medusa (by using his shield as a mirror so that he could see his victim without looking at her directly), Pegasos and the young male Chrysaor were born from her severed neck (they were fathered by Poseidon). Although her head is still attached to her body in the pediment, Pegasos stands on his hind legs with his front legs on Medusa's shoulder, and Chrysaor or Perseus (the figure holds a sword) stands to her left. In other words, the artist apparently has compressed the narrative into a single moment to suit the space afforded him.

Typical of the archaic style is the emphasis on symmetry and creating abstract patterns of natural forms. Medusa's round mask-like face is framed by symmetrical corkscrew curls falling down her shoulders and snail curls over her forehead. The wings on her back and boots are precisely rendered, partitioned feathers. Entwined snakes form the belt that cinches her garment, and snakes emanate from her shoulders. Her kneeling position is artistic shorthand for running, and her knee muscles bulge in differentiated segments. Flanking this central image are mirror images of two panthers or leopards, whose bodies are in profile, their heads facing front, echoing Medusa's frontal gaze. A series of symmetrical lines define the loose skin across their foreheads and on their noses, and dotted disks adorn their bodies.

Myths – at least in later periods – usually were not haphazardly chosen to decorate temples but had a connection with the deity honored or the patron city. In the case of the temple of Artemis at Corcyra, it may be that the Medusa myth had a twofold reference: Corcyra was a colony of Corinth, where the winged Pegasos, Medusa's son, appeared on its coinage beginning by *c.* 650 BC; in addition, Artemis and Medusa were, in this early period, worshipped or portrayed as Potnia Theron, Mistress of Animals, and are often difficult to distinguish (see Fig. 3.30c).

Fig 3.8 Palermo, Museo Archeologico Regionale "A. Salinas" 3920B (Perseus beheading Medusa), east metope VII from Temple C at Selinus, *c.* 560 BC, limestone, H 1.45m, W 1.11m.

The Medusa myth recurs at Selinus on Sicily in one of the limestone metopes from the east side of Temple C (perhaps dedicated to Apollo), which were sculpted with mythological themes; most myths on the Doric frieze are confined to a single metope but others stretch across two metopes, so that the image skips the intervening triglyph (elsewhere, the narrative stretches across metopes but incorporates the triglyph in the depiction). The metope of Medusa is carved in deep relief and depicts Perseus beheading the Gorgon while the hero's patron goddess, Athena, stands behind him (Fig. 3.8). Paint survives well on Athena's peplos, and we should imagine all the sculpted metopes dramatically enlivened with color. All figures gaze directly at the viewer, and other than Perseus' violent deed, there is little interaction among the figures. Both Athena and Perseus have incongruent smiles – the typical "archaic smile," which seems to express not emotion so much as animation. Athena's and Perseus' heads and bulbous eyes are too large in proportion to the bodies and are nearly interchangeable. Although their faces are frontal, all legs are rendered in profile, a combination that is especially awkward in the case of Athena. The sculptural style is characteristically archaic (symmetry, patterning), but the focus on frontality (which occurs in many of the metopes on this temple), like that of Medusa on the Corfu temple discussed above (Fig. 3.6b), engages the onlooker and, in the case of visages of monsters and gods, was meant to conjure up awe in the viewer.

Archaic temples: Ionic

At the other end of the Aegean, on the islands and in Asia Minor, stone architecture and architectural sculpture developed in distinctively different ways. At their most highly decorated, Ionic temples have an extravagant appearance (and also were painted), and in sixth-century Asia Minor, they were of gargantuan stature – far larger than Doric counterparts in the west. Variations in general features

EPHESOS - ARTEMISION

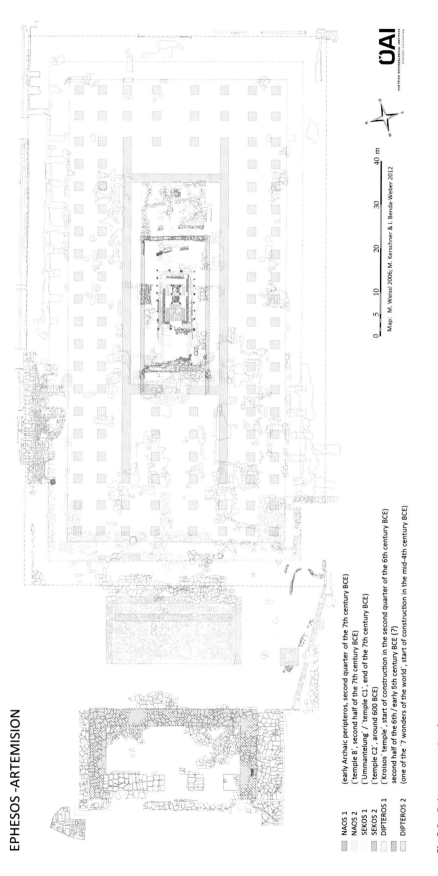

NAOS 1 (early Archaic peripteros, second quarter of the 7th century BCE)
NAOS 2 ('temple B', second half of the 7th century BCE)
SEKOS 1 ('Ummantelung' / 'temple C1', end of the 7th century BCE)
SEKOS 2 ('temple C2', around 600 BCE)
DIPTEROS 1 ('Kroisos' temple', start of construction in the second quarter of the 6th century BCE)
 second half of the 6th / early 5th century BCE (?)
DIPTEROS 2 (one of the '7 wonders of the world', start of construction in the mid-4th century BCE)

Map: M. Weissl 2006; M. Kerschner & I. Benda-Weber 2012

0 5 10 20 30 40 m

ÖAI
AUSTRIAN ARCHAEOLOGICAL INSTITUTE

Fig 3.9a Ephesos, temple of Artemis, c. 560–550 BC,
L 109.20m x W 55.10m, plan.

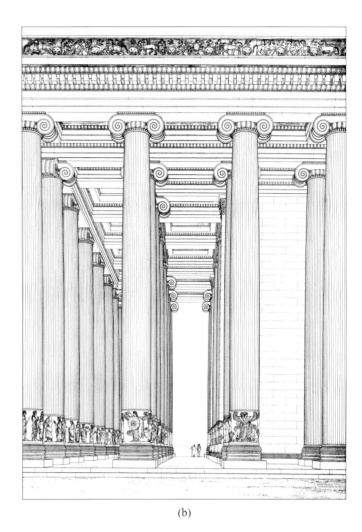

Fig 3.9b Ephesos, temple of Artemis, c. 560–550 BC, restored elevation.

(b)

Fig 3.10 Samos, Rhoikos Heraion (III), c. 570 BC, plan.

N

together with vast size often produced awe-inspiring, intimidating buildings inviting solemn reverence toward a mysterious deity.

The temple of Artemis at Ephesos (the Artemision) and the Rhoikos temple of Hera (III) on Samos were the first truly Ionic temples. Both had earlier predecessors (see Figs. 2.14a–b), but their sixth-century iterations were markedly more grandiose. The Artemision at Ephesos exhibits developed Ionic features, including volute capitals terminating in a spiral (Fig. 3.9a–b, Dipteros 1 on the plan), and was the largest temple ever constructed when it was built. Most of its columns were financed by King Kroisos of

Lydia in Asia Minor as known from the ancient historian Herodotos (1.92) and fragmentary dedicatory inscriptions. Kroisos was renowned in the ancient world for his astounding wealth and precious gifts of gold and silver to the sanctuary of Apollo at Delphi, where he sought advice from the oracle. His patronage at Ephesos testifies to the important regard in which the building was held in antiquity. The temple stood on two steps and possessed a double peristyle, perhaps 8 × 20, ringing the central core (thus the temple is described as *dipteral*): the number of lateral columns is uncertain, and there may have been an additional column on the back side of the structure. Its walls were of limestone sheathed with marble, all columns were completely marble, and, on some columns, a frieze of figural relief sculpture surrounded the shaft, at either the top or bottom (this is disputed, though the bottom seems more likely); thus, the visitor would pass through a tall forest of richly decorated columns of fine material, whose number of flutes varies between forty and forty-eight. The dense hall of columns was probably influenced by Egyptian temple architecture, where hypostyle halls commonly appeared on the interiors of walled structures; here the Greek architects inverted the Egyptian plan by placing the columns on the exterior, while the interior of the Artemision was left open to the sky (*hypaethral*). The interaxial spacing (the space between the centers of columns) of the peripteral columns and the column diameters diminished from the central members outwards on the temple's short ends; the effect was to create a greater space between the two central columns to emphasize the entry point and provide easy access to the cella.

Little remains of Rhoikos' Ionic Heraion on Samos (III) due to overbuilding by later temples, but its plan is clear – a dipteral structure with a deep pronaos leading to a cella (Fig. 3.10); note the absence of an opisthodomos or adyton, features that occur in Doric structures. Parallel colonnades run through the pronaos and cella and align with the façade peristyle columns, where adjustments were made to the spacing to emphasize the entry point to the structure, as was the case in the Artemision at Ephesos. The temple possessed stone column shafts and bases; no capitals survive but these, like the entablature, were probably of wood.

Box 3.2 Building in stone (see also Chapter 5, Box 5.2)

The elaborate construction technique of Greek stone architecture is well attested through archaeological remains: the buildings, the blocks and the marks upon them, clamps, dowels, and representations of architecture in other media.

Stone blocks destined for placement against other blocks (e.g., a row of blocks) had the joining ends specially treated so as to minimize the surface area in direct contact to create the tightest join (Box 3.2 Figs. 1–2). This special treatment, *anathyrosis*, involved trimming back the central area and smoothing the edges of the block. Dressed blocks were hoisted into place using ropes placed into grooves or holes carved into blocks or around projecting bosses, or by metal clamps attached to ropes (Box 3.2 Fig. 3). Blocks were wedged as close as possible to each other using metal bars, then secured by clamps (Box 3.2 Fig. 4).

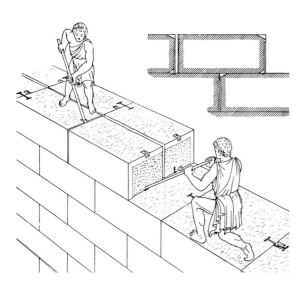

Box 3.2 Fig 2 Block placement.

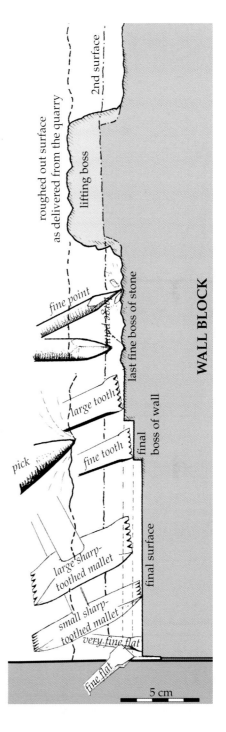

Box 3.2 Fig 1 Carving a wall block from stone, profile view.

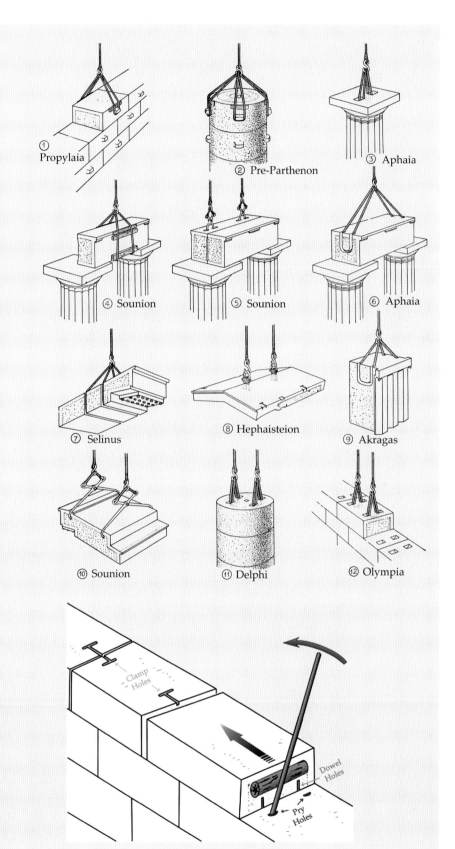

Box 3.2 Fig 3 Block lifting techniques.

Box 3.2 Fig 4 Block placement.

Sanctuaries and contests

Athletic, dramatic, and/or musical contests often constituted part of the worship of a deity or hero, and were an expression of the agonistic character detectable in almost every aspect of ancient Greek culture. Large sanctuaries, which attracted visitors, patronage, and building projects, flourished and grew in the sixth century BC with the establishment and expansion of Panhellenic athletic competitions.

The Olympic games in honor of Zeus were celebrated at Olympia every four years, and their cycle provided a means of dating in antiquity; that is, one would date by Olympiads (see Chapter 2). The Olympic competitions consisted of footraces, wrestling, boxing, chariot races, the pentathlon (footrace, wrestling, discus throw, long jump, and javelin throw), horseracing, and the pankration, an extreme type of wrestling in which only biting and gouging were prohibited (Philostratos, *Im.* 2.6).

By the later sixth century BC, three other Panhellenic games, in addition to Olympia, had been established: the Pythian games for Apollo at Delphi, the Isthmian games for Poseidon at Isthmia, and the Nemean games for Zeus at Nemea. Because the sole tangible prize in the four games was a vegetal crown bestowed on the first-place winner (no other status was recognized), they were referred to as "crown games." Each set of games occurred once every four years, with a staggered schedule so that crown games took place at one of these four locations annually. Heralds from the Panhellenic sites were sent out all over the Hellenic world to announce the competitions and call for participation. Unlike local games in which only residents usually could compete, the Panhellenic games were open to all Greeks, at least in theory: while we might expect such a call for participation to attract all those with athletic talent, regardless of social class, the reality was that most athletes were drawn from the elite class until the end of the fifth century BC or so. Who else would have had the leisure to train for such events? For an athlete to win in all four Panhellenic games in one four-year cycle (*peridionike*) was the "grand slam" of the crown games.

Box 3.3 Nudity and sport

Written and material evidence amply attest that homoerotism was a cultural norm for aristocrats (for whom we have the most evidence) in many parts of sixth-century Greece, including Athens and the Dorian cities, such as Sparta. Strong bonding between men, including physical intimacy, not only could satisfy personal desires but also could – and did – serve as a means of social networking, intellectual education, and creating a tightly bonded military. It is hardly surprising then to learn that male athletes exercised and competed in the nude. Vase painting often shows nude males engaged in all kinds of activities for which we know that nudity was not the norm in actual life, such as battle, where it would be suicidal, but these depict idealized images, in the sense that the nude male bodies represent youthful, athletic, beautiful males.

Female athletics were rare in ancient Greece; ancient authors describe with horror the spectacle of Spartan girls and women exercising in the nude in public (!). But in addition to the Olympic games for males of various age classes, there was a footrace at Olympia for girls, the Heraia, performed in honor of Hera, goddess of marriage. Women also could sponsor chariot races in the Olympic games and therefore achieve an Olympic win (since the owner, not the charioteer, has the victory), but they could not actually serve as charioteers.

Many visitors traveled to Panhellenic sanctuaries for the athletic games, but one should not overlook the religious importance of these activities, which were held in honor of the chief deity worshipped at each site. For example, the Pythian games were well-known but the centerpiece of the sanctuary at Delphi was the powerful and influential Pythian oracle, which attracted thousands of visitors from all over the Mediterranean, who consulted on political, military, religious, and personal matters. This potent force made Delphi the center of information in the Greek world and beyond, and produced a local group of experts on international affairs.

In addition to perishable sacrifices, worshippers, both individuals and poleis, could make more permanent gifts of thankofferings or propitiatory offerings to a full array of deities and heroes. These votives ranged from relatively modest items, such as metal pins, textiles, and terracotta figurines, to colossal marble or bronze statues, silver or gold objects, stone monuments, and buildings. Such images

Fig 3.14 Delphi, museum, Siphnian Treasury at Delphi, *c.* 525 BC, north frieze, marble, dimensions for entire frieze: L 8.63m on the long sides, L 6.25m on the short sides, H 64cm.

which are dated on the basis of stylistic comparison with the treasury's sculptures.

The Gigantomachy, the fight between gods and Giants, depicted on the well-preserved north frieze, demonstrates the complexities of archaic relief sculpture at its finest, but also exhibits features that presage the Classical style, which "officially" begins, according to modern scholars, after the Persian Wars, *c.* 480–479 BC (Fig. 3.14). The gods generally advance from the left, as is common for victors in archaic Greek sculpture, and are identifiable by attribute, by attendant figures, or by dipinti (painted labels), which are now faded, but still discernible with ultra-violet light. The Giants, who are armed as hoplites (heavily armed infantry), were also labeled. From left to right, Themis mounts a chariot drawn by two lions, while Dionysos, wearing a panther skin and identified by inscription, fights an advancing Giant behind Themis and her chariot. Two lions attack a frontally placed Giant – one of the only figures not shown in profile – while Apollo and Artemis, equipped as archers, move forward to meet oncoming Giants wielding shields. Inscribed on the

Fig 3.15 Delphi, museum, Siphnian Treasury at Delphi, south frieze.

edge of one shield is the signature of the sculptor, a rare occurrence on architectural sculpture. Figures overlap one another to suggest depth: this is especially effective with the Giants' three shields and the fourth shield behind them, seen from inside, and by means of the Giant lying beneath them and entwined among their legs. The patterned, flame-like locks of the lion's mane and face, along with the regular, precise drapery of Apollo and Artemis, and patterned musculature everywhere, typify the archaic style in relief sculpture.

But there are surprises here, such as the irregular drapery blown back to reveal the genitals of the giant Pharos, who runs toward three Giants at the far right. Such naturalism – drapery responding naturally and asymmetrically to movement – is highly unusual in archaic art, but is one of the hallmarks of the Classical style. The shield seen from within is also extraordinary; rather than resting atop the back surface of the relief, the shield illusionistically "penetrates" this plane to suggest depth that extends beyond. Likewise, on the south frieze, quadrigas move parallel to the relief plane, i.e., in profile (Fig. 3.15), but two quadrigas on the east do not (Fig. 3.16); instead, the horses'

Fig 3.16 Delphi, museum, Siphnian Treasury at Delphi, east frieze.

Fig 3.17 Athens, Akropolis Museum 681 ("Antenor kore") signed by Antenor and dedicated by Nearchos, from the Athenian Akropolis, *c.* 525–510 BC, marble, H (with plinth) 2.155m.

heads and foreparts splay out and turn toward the viewer to render the illusion of three-dimensional space. Again, the effort to create spatial illusion is more typical of the Classical, not the archaic, style. In short, the frieze may offer a stylistic fixed point for the Archaic period, but its sophisticated sculpture indicates that the characteristics of the Classical style are detectable well before 480–479 BC.

Monumental sculpture and aristocratic prestige: kouroi and korai

Anyone and any polis could make a dedication at a sanctuary – we have offerings from craftsmen, for example, even at large scale (Figs. 3.17–18), but most monumental dedications were made by aristocrats, who were responsible for erecting some of the first monumental stone sculpture in Greece (see Fig. 3.21): over-lifesize marble figures, male youths (*kouroi*) and females (*korai*), commonly used as votive dedications in sanctuaries (Fig. 3.19a). Egyptian sculpture was influential on the earliest monumental Greek stone sculpture: the wig-like hair, frontality, and block-like form recall Egyptian counterparts (Fig. 3.20), and note that Greek kouroi adopt the same striding pose, their hands at their sides. The Greeks borrowed the Egyptian practice of applying a grid on the block of stone to delineate bodily proportions: so many squares of the grid for the head, so many for the torso, the legs, and so on. But Greek sculptors altered the scale to enlarge the head and legs and shorten the torso to suit their own needs or taste. And unlike most Egyptian examples, which have an attached back pillar or are in relief, the Greek *kouros* or *kore* is carved completely in the round, giving it a more lifelike appearance. In addition, archaic kouroi have their weight evenly divided between their legs and not placed entirely on the back leg as Egyptian sculptures do. Kouroi and korai also could serve as cult images, usually erected by poleis or sanctuaries, rather than by individuals (poleis dedicated votives). As discussed in Chapter 2, Naxos and Paros were instrumental in the production of the earliest monumental marble

Fig 3.18 Athens, Akropolis Museum 1332 ("Potter's relief") from the Athenian Akropolis, *c.* 500 BC, H 1.22m.

sculpture, but it was on Samos that the largest kouros (thus far) was produced (except the colossos of Apollo on Delos, Fig. 2.38); it stood in the sanctuary of Hera on Samos and, according to the inscription (perhaps inscribed later) on its left thigh, was a dedication of Isches, son of Rhesis (Fig. 3.21). It towered on an enormous base at the eastern, entry end of the Sacred Way; a second kouros of the same material and scale stood on a base opposite it at the northeast corner of the later Rhoikos temple (Fig. 3.10) and may have been intended as a counterpart (for paired sculptures see, e.g., Fig. 3.24); both were of strongly veined Samian marble and painted.

The production of korai and kouroi began *c.* 640 BC (see Fig. 2.37) and continued in a variety of media and sizes until *c.* 470 BC. These works are characterized by strict frontality and a four-sidedness that betray the rectangular block from which they were carved. The korai stand with their legs close together, sometimes with one foot advanced, as do kouroi. The early treatment of anatomy is quite abstract with an emphasis on patterning and symmetry (Fig. 3.19), but greater and greater naturalism is apparent in later examples (Fig. 3.22a); here, details of anatomy are modeled by shaping the stone rather than by being incised on to the surface as can be seen in the rendering of the abdomen or the carving of eyes – early bulbous orbs resting on the surface of the face are later embedded in the orbital sockets. Hair tends to resist this trend toward naturalism, though one can observe increasing emphasis on the softness and malleability of hair (and later kouroi have rolled-up or short hair) as compared with the flat washboards of long hair attached to the back of the skull on earlier kouroi (Figs. 3.19b, 3.22b). In the absence of external evidence, the degree of naturalism is used to date these archaic sculptures, but regional and individual differences disrupt a purely linear development and present a much richer, more interesting picture.

Sex usually determines attire: most kouroi, except a small, distinct group of mantled kouroi, are nude save for an occasional fillet worn in the hair or a choker around the neck,

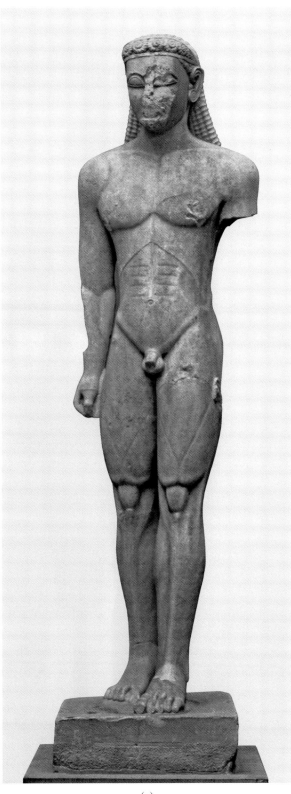

(a)

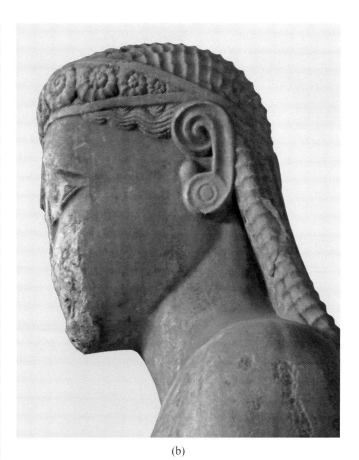

(b)

Fig 3.19a–b Athens, National Museum 2720 ("Sounion kouros") from Poseidon sanctuary at Sounion, *c.* 590 BC, Naxian marble, H 3.05m.

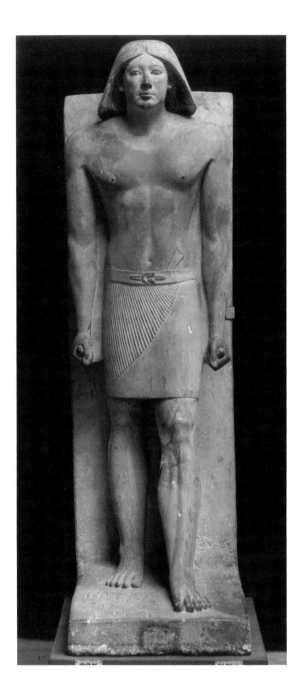

Fig 3.20 Cairo, Egyptian Museum C19, Renofer from Saqqara, Old Kingdom, 5th Dynasty V (2450–2345 BC), limestone, H 1.78m.

Fig 3.21 Samos, Vathy Museum (" Isches kouros"), early sixth century BC, Samian marble, H (reconstructed) 4.75m.

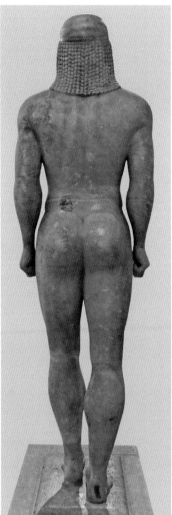

(a)

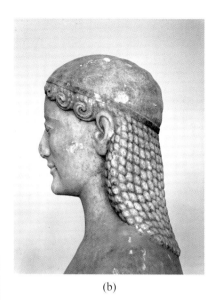

(b)

Fig 3.22a Athens, National Museum 3851 ("Anavysos kouros") from Anavysos, *c.* 530 BC, Parian marble, H 1.94m.

Fig 3.22b Athens, National Museum 3851 ("Anavysos kouros"), detail.

while females are fully clothed (Figs. 3.23–24). The artistic convention of (usually) nude males and clothed females reflects contemporary aesthetics and cultural standards, which celebrated the youthful, athletic, nude, male form, and required women to be modestly dressed. Regional distinctions are evident in the garments worn by korai (Figs. 3.23–24), and in bodily proportions, treatment of hair, muscularity, and faces for both korai and kouroi. For example, east Greek korai tend to have small, elongated eyes, thin-lipped, wide mouths, and delicately articulated eyebrows (Fig. 3.25). Attic korai, by contrast, have longer faces, less malleable features, smaller mouths with broader lips, more rounded bulbous eyes, more sharply defined brows (Fig. 3.23; see also Fig. 3.27). These are general traits, and within these categories there is much variation.

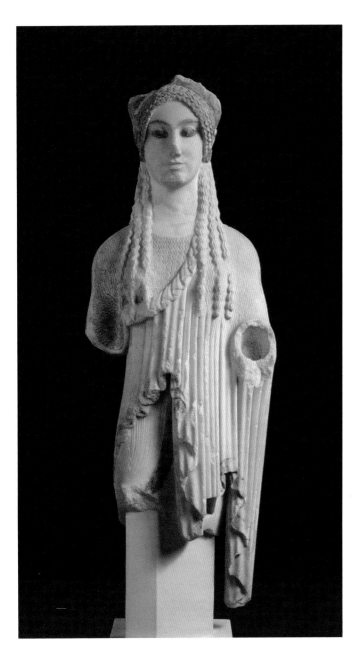

Fig 3.23 Athens, Akropolis Museum 674, kore from
Athenian Akropolis, *c.* 500 BC, marble, H 92cm.

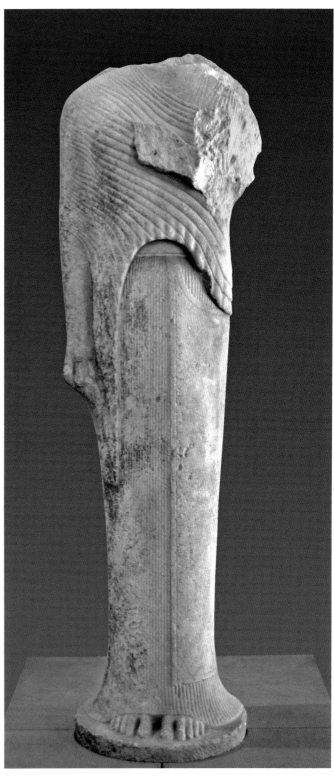

Fig 3.24 Paris, Musée du Louvre MA686 ("Cheramyes" kore) from
Heraion on Samos, *c.* 570–560 BC, marble, H 1.92m.

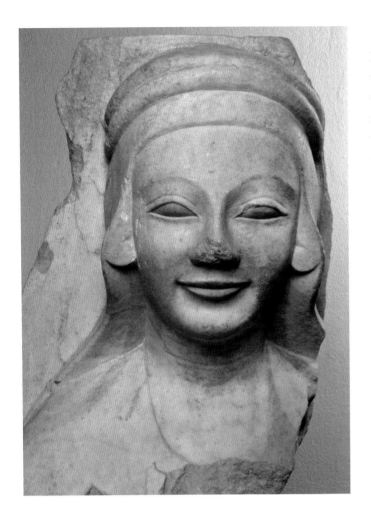

Fig 3.25 Berlin, Pergamonmuseum Sk 1721 from the temple of Artemis at Ephesos, *c.* 550–520 BC, marble, H 56cm.

Earlier Attic and Cycladic korai wear a heavy, woolen peplos, girt at the waist, which conceals the body (Fig. 3.27; cf. Fig. 2.34). Later Attic and Cycladic korai tend to be clad in a *chiton*, a light, cotton, pleated garment that adheres to, and reveals, the form beneath; a *himation*, a shawl-like garment, worn over one shoulder and falling diagonally across the torso, complements the chiton (Fig. 3.23). Attic korai usually grasp their garments with their left hands, thus creating a parabola of folds in thin chitons that consequently adhere tightly to the lower body (Fig. 3.17). With their right arms extended forward, they appear to make or receive an offering (they sometimes carry objects in their upraised hands, such as fruits, flowers, and small animals).

In the east Aegean – on Samos, for instance – the kore stands with her legs pressed together tightly, and her right arm is by her side. Her right hand grasps the epiblema worn over the back of her himation, under which she wears a chiton cinched at the waist (Fig. 3.24). The carefully differentiated garments cover most of her body although her toes peer out from her chiton, which flares in a circle, echoing the rounded base. The general impression is of a closed tapering cylinder, yet the rounded belly, the drapery modeling breasts beneath, and the soft imprint left by her thumb in the epiblema relieve her severe appearance. Like other korai, this one may have held a small animal – bird or rabbit – in her raised left hand, either an offering or an attribute. This dedication, one of a pair, from the Heraion on Samos bears a votive inscription carved on the edge of the himation, which records that she is an offering of Cheramyes, who dedicated a group of six marble sculptures at the sanctuary, including this one. Cheramyes' dedication demonstrates his piety and also his wealth: the large votive was placed near the entry to the sanctuary, immediately next to, and facing, the main pathway leading to the temple.

The largest group of votive korai yet recovered – more than seventy – comes from the Athenian Akropolis. Whom the korai represent has been the subject of great debate; most are dedicated by men so they are not portraits of their donors, but it is possible that the offering was made to Athena for some

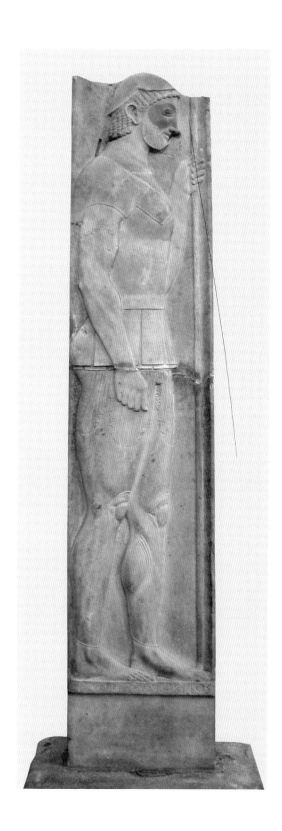

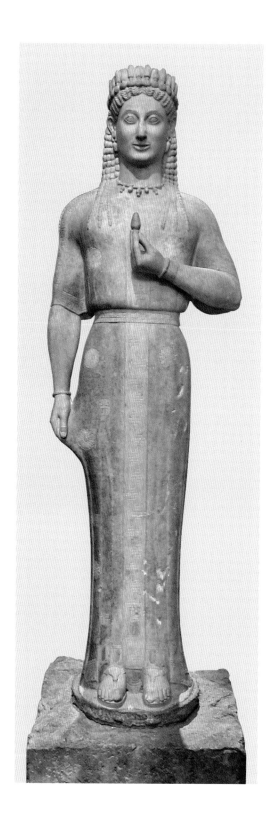

Fig 3.26 Athens, National Museum 29 ("Aristion stele")
from Attika, signed by Aristokles, *c.* 510 BC, Pentelic marble,
H 2.02m.

Fig 3.27 Athens, National Museum 4889 (Phrasikleia) from Merenda, *c.*
550–540 BC, Parian marble, H (without base and plinth) 1.79m.

service rendered or desired for a daughter or wife, who may be portrayed by the statue, or the korai may represent Athena herself.

In addition to their use as votive dedications, aristocrats also employed kouroi as funerary markers. The Anavysos kouros (Fig. 3.22a–b) commemorated a warrior, who died in battle: the inscription on the base believed to belong to the kouros names the fallen as Kroisos and exhorts the viewer to, "Stay and mourn at the tomb of dead Kroisos, whom raging Ares destroyed one day, fighting in the foremost ranks" (trans. A. F. Stewart). The Anavysos kouros is not a portrait or likeness of the individual Kroisos but a type meant to signify Kroisos (i.e., Kroisos' actual appearance is unknown). No armor appears (though his cap suggests the helmet he once wore above it), no physical wounds attest to Kroisos' battle injuries, no blood mars his physical beauty. When the ancient viewer read the inscription – and read it aloud, as the Greeks did – s/he mourned the image of eternal youthful athletic beauty. The size, the use of Parian marble, and the quality of carving indicate a wealthy Attic family grieving for one of their own. Less extravagant, though still costly, means were also available to commemorate warriors who died in battle (Fig. 3.26).

Korai statues also occasionally served as gravemarkers. Phrasikleia was honored in this manner, as stated in the inscription on the matching base (Fig. 3.27). She maintains the stiff frontal stance typical of korai but it is her right hand now that draws her belted peplos, richly decorated with incision and paint, to the side. Her left fingers clasp a blossom close to her breasts, and a floral crown, necklace, bracelets, and sandals contribute to her ornate appearance. Her hair – a series of wavy tresses drawn back behind her ears with a ribbon, then falling in pellet-like locks down her back and on her breasts – is a study in symmetry and abstraction, and her face with its bulbous eyes and doll-like archaic smile, is consistent with the archaic style.

Aside from her extraordinary state of preservation, one of the most interesting aspects of Phraskleia is the inscription on the accompanying base. It names the artist, Aristion of Paros, and goes on to declare that this is the marker of Phrasikleia, who will always be called "kore" because the gods gave her this name instead of marriage. While the term "kore" simply means girl, it is also one of the names for the goddess Persephone, the daughter of Demeter. Hades, god of the Underworld, abducted young Persephone from earth and took her to the Underworld to be his wife. Read metaphorically, this myth describes

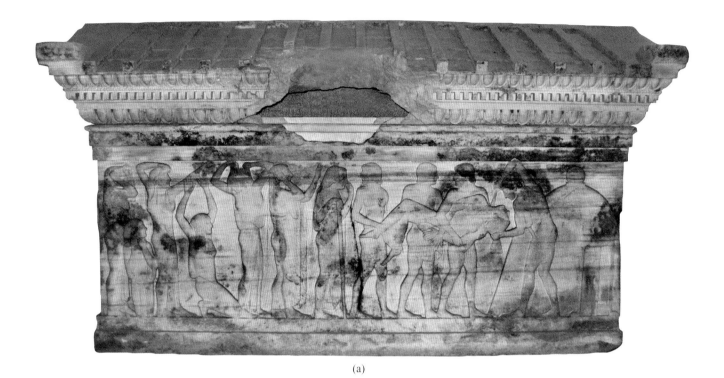

(a)

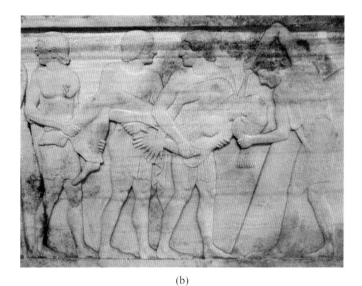

(b)

Fig 3.28a–b Çanakkale Museum, sarcophagus,
c. 520–500 BC, L 3.32m, marble, W 1.60 wide, H 1.78 m.

the death of a young maiden, who becomes queen of the Underworld. Thus, Phraskleia's epitaph implies that she, who was unwedded when she died, was also regarded as a bride of Hades, a trope well–known from ancient Greek literature. This also would explain her garment and jewelry, which are unusually elaborate: she is arrayed in her wedding finery.

A painted stone sarcophagus found at Gümüşçay near Troy in modern Turkey offers a mythological variant of this same idea (Fig. 3.28a–b). The sarcophagus, dated by stylistic comparison to contemporary mainland Greek works, such as the Siphnian Treasury at Delphi, was produced by a Greek artist(s) working for a patron in this Persian-controlled area, inhabited by Greeks. On one long side and one short are relief scenes of the sacrifice of Polyxena by Neoptolemos, son of Achilles, at the tomb of Achilles as men and women mourn nearby. The shade of Achilles had demanded that Polyxena be sacrificed to him to be his bride after death. On the reverse and the other short side, we see funeral rites, probably for the deceased. Although the bones of an adult

man were found in the sarcophagus, it is plausible that this was an unplanned use for this sarcophagus, which was probably a special commission to judge from its quality and decoration. It is likely that the commission was intended for a young, unmarried, female occupant, that is, an actual counterpart to Polyxena, but perhaps a delay in its completion or unexpected circumstances forced a change in plans. Like the statue of Phrasikleia, allusion is made to the idea of the bride-of-death but using a different myth to make the point.

Attic pottery

Patrons and pottery

As discussed above, athletes, sponsors of dramatic and musical contests, donors of large votives, and sometimes donors of sacrificial animals in the sixth century BC usually were aristocrats. This elite group also set the social standards: their choice activities – hunt, warfare, and the symposion – were emulated by non-elites and, together with Homeric mythology, constituted primary subjects for archaic vase painters. Many such vases were used at the symposion, an activity that scholars usually argue derives from the Near East, where monarchs and their royal courtiers reclined, dined, and ate together, enjoying the entertainment of music and dancers. Recently, however, this viewpoint has been challenged by a number of scholars, who argue instead for an eighth-century (or earlier) Aegean origin for the symposion and discount its reliance on eastern traditions. Wherever it derived, sixth-century Greek aristocrats took up this convivial practice, concentrating particularly on witty and intellectual conversation, poetry, wine, music, and the sexual allure of female courtesans (*hetairai*) and handsome boys, who sometimes acted as wine pourers.

Aristocrats imitated Homeric heroes and regarded them as their ancestors and models, which explains the popularity of such themes on symposion vases (Fig. 3.29, groups A, C, D, E). Among the earliest Attic black-figure vases to

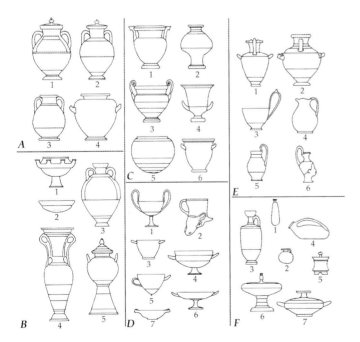

Fig 3.29 Vase shapes. **A:** 1 belly amphora, 2 neck amphora, 3 pelike, 4 stamnos **B:** 1 kernos, 2 omphalos, 3 Panathenaic amphora, 4 loutrophoros, 5 lebes gamikos **C:** 1 column krater, 2 psykter, 3 volute krater, 4 kalyx krater, 5 dinos or lebes, 6 bell krater **D:** 1 kantharos, 2 rhyton, 3 skyphos, 4 Siana cup, 5 mastos, 6 kylix, 7 kothon **E:** 1 oinochoe, 2 hydria, 3 kyathos, 4 oinochoe, 5 olpe, 6 head vase **F:** 1 alabastron, 2 aryballos, 3 lekythos, 4 askos, 5 pyxis, 6 plemochoe, 7 lekanis.

(a)

Fig 3.30a–c Florence, Museo Archeologico 4209 ("François Vase") from Chiusi, Attic black-figure volute krater signed by Kleitias and Ergotimos, c. 570 BC, terracotta, H 66cm, D (mouth) 57cm.

demonstrate this trend is the "François Vase," a volute krater (Fig. 3.30a–c) from an Etruscan grave in Chiusi. The krater also exhibits the technical possibilities of early Attic black-figure, and reveals the influence of Corinthian vase painting on it. Kleitias painted the vase and Ergotimos potted it, as we learn from their signatures, which appear twice on the krater. Indeed, with more than 200 mythological figures and over 100 identifying inscriptions, this large vessel serves as a virtual mythological encyclopedia of the Athenians. The vessel's decoration is divided into superimposed horizontal bands filled with miniature figures, both legacies of Corinthian vase painting, and depict various myths on each of its two sides. Side A themes

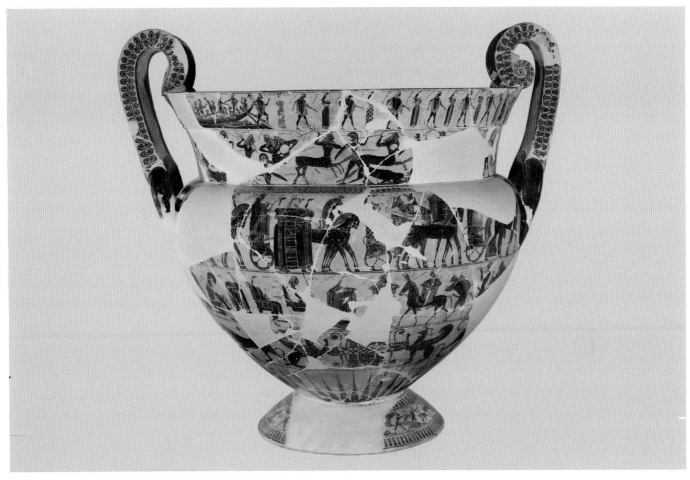

(b)

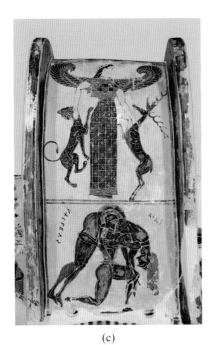

(c) **Fig 3.30b–c** (*Continued*)

Box 3.4 Etruria, Attic black-figure technique and the Etruscan market

Attic vase painters learned the black-figure technique in the seventh century BC, and by the early sixth century, Attic workshops were competing with their Corinthian counterparts and eventually overtook them. Attic clay is orange because of its high content of impurities, including micas, quartz, and feldspar. The slip derived from it produces a black gloss (alkaline, water, clay) when fired. Depending upon how much of the mineral illite is in the clay, the finished surface covered with slip can take on a glittering, silver cast or a lustrous velvet black sheen. In contrast to Protoattic vases (see Chapter 2), which tend to be large vessels with a single narrative or decoration that fills the vertical field of the body, early archaic Attic black-figure painting betrays its heavy reliance on Corinthian models: small figures, sometimes parades of animals, arranged in horizontal superimposed friezes with precise incision work borrowed from Near Eastern metalworking. In the Archaic period, we find an increasing number of painters' and potters' signatures although, relatively speaking, these

are still unusual in the great corpus of Greek vases. The practice of writing across vase surfaces, whether identifying labels or signatures, reinforces the impermeability of the picture surface. One must bear in mind that vase painting is the art of painting on a curving, three-dimensional object, which requires or invites adjustments to compositional elements.

It is important to note that most of the vases produced in Attika were not found there or even in Greece, but in Etruria in Italy, where they were imported and used as grave gifts, which often explains their high degree of preservation. The Etruscans were rivals of the Romans, who finally conquered the Etruscans. Their origin is unknown with certainty, but by c. 700, Etruscan culture was firmly established and the first texts written in the Etruscan language date to the eighth century BC (their alphabet was borrowed from Pithekoussai and Cumae, see Chapter 2). It is noteworthy that this language is non-Indo-European, although it is written in an adaptation of Greek script. We have only inscriptions from

the Etruscans (some of the oldest examples appear on imported Early Corinthian pottery), no literature, so what we know about them derives from archaeology and from Greek and Roman written sources. Although we know of some Etruscan sanctuaries, most Etruscan objects and monuments that survive are funerary in nature – hundreds of tombs adorned with wall paintings, gold, silver, pottery, including Near Eastern and Greek imports, particularly after c. 700. The Greek vases found in Etruria demonstrate familiarity with Greek myth and religion, which the Etruscans adopted and adapted to their needs.

Scholars debate whether the tens of thousands of Attic vases found in Etruscan graves were made for that foreign market – this is certainly the case for some special shapes found only in Etruria – or if they were exported to Etruria in a secondary market. In either case, it is certain that Attic vases were made using visual language and traditions familiar to Greeks, as we can judge from the same themes depicted by architectural sculpture in Greece.

focus on Achilles, the great Achaian warrior in the Trojan War (from top to bottom): the Kalydonian boar hunt includes his father, Peleus, in this illustrious event in which numerous heroes participated; the funeral games for Patroklos, organized by Achilles after the death of his companion at Troy; the wedding of Achilles' parents, Peleus and the goddess Thetis – this is the only theme to completely encircle the vase; and Achilles' ambush at the fountain house of the Trojan prince

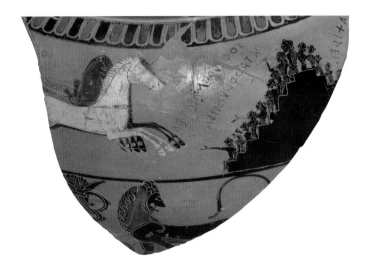

Fig 3.31 Athens, National Museum 15499 from Pharsalos, Attic black-figure dinos fragment signed by Sophilos, terracotta, H 5.2cm.

Troilos, whose death was a necessity in order for the Achaians to win the Trojan War (Fig. 3.30a). Side B includes Theseus and the Athenian survivors of the Minotaur as they arrive on Delos; the Centauromachy, fought by Theseus and the Lapith Greek men against the unruly Centaurs (Fig. 3.30b); and the return of Hephaistos, which does not concern heroes but the restoration of order among the Olympian gods. Both handles have the same theme painted on their exterior: the goddess Artemis in the top panel, and Ajax carrying the dead Achilles from the Trojan battlefield below (Fig. 3.30c). If the krater was designed to be used in the symposium – and this is a matter of debate because of its elaborate decoration and the painting's extraordinarily high quality – it would have provided symposiasts with much to stimulate conversation, poetic recitations, and philosophical reflections.

The same is true for the fragmentary dinos signed by the Attic painter Sophilos, which depicts the games for Patroklos as indicated by the painted caption, a rarity in the history of Greek vase painting (Fig. 3.31). The partial name of Achilles is easily legible above the crowd, and the end of a word can be seen at the far left edge, where we see two teams of yoked horses. The horses move toward a grandstand of spectators, who gesture toward the extraordinarily large animals; consistency of scale or space is not a concern for these early vase painters (cf. the ship and figures on the "François Vase," Fig. 3.30b). Behind the grandstand is another bank of filled seats, as if we see mirror images of spectators. A comparison of the Sophilos dinos with the François Vase is instructive in terms of quality and technique: Kleitias' work is much more controlled, precise, and detailed than that of Sophilos, who paints in a freer style.

Vase painters' interest in Homeric heroes continued throughout the sixth century, as exemplified by an amphora signed by Exekias as potter and painter (Fig. 3.32a). Unlike the horizontal stacked friezes with miniature figures of earlier Corinthian and Attic black-figure vases, the image now

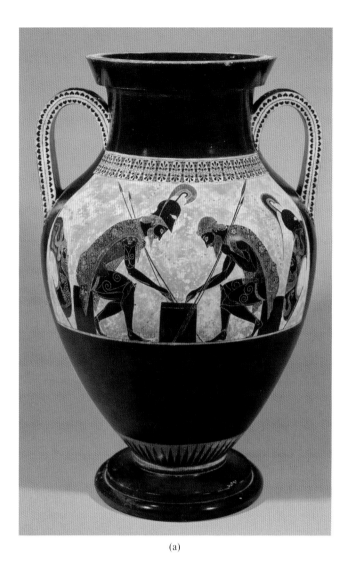

(a)

Fig 3.32a–b Vatican City, Musei dei Vaticani 344 from Vulci, Attic black-figure amphora signed by Exekias, c. 530 BC, terracotta, H 61cm.

occupies a single central panel: two warriors hunch forward over a small gaming table placed between them. Dipinti name them in the genitive (possessive) case: "of Achilles" and "of Ajax," presumably "image of." This self-consciousness of the art-making process is not unique (it occurs in contemporary relief sculpture, for example), but it is highly uncommon on vases at this time. It's worth considering whether contemporary developments in philosophy questioning the nature of reality might have had some influence on these artists.

To return to the Exekias amphora, all aspects of the composition – spears, arms, legs, even the banal words emanating from their mouths – "three," "four," their scores – direct the viewer's eye to this spot. One is tempted to say that their gazes also are directed here, but their eyes are rendered in frontal view, continuing a long-established practice in Greek vase painting that derives from Egyptian art. The quantity, variety, and sure-handed skill of incised details of clothing, anatomy, and armor are truly dazzling and impart a lace-like quality to the black silhouettes (Fig. 3.32b).

No extant literary source describes this encounter between the two Achaian soldiers, though, of course, there is ample attestation of their interaction in other ways: Ajax carried Achilles' corpse from the battlefield at Troy (cf. Fig. 3.30c), and after Achilles' death, Ajax vied with Odysseus for the hero's armor, but lost; Ajax's subsequent suicide is depicted by Exekias on another amphora. For the ancient viewer, the intertwined tales of the two heroes were well–known and would have been implicit in their reading of this quiet scene. A foreboding quality overshadows the image; the choice to show this particular moment between these characters invites the viewer to contemplate the game of chance or fate, and the role that fate will play in these two heroes' lives. Exekias' composition seems to have been influential on other vase painters, who reproduced the same scene repeatedly for the next several decades.

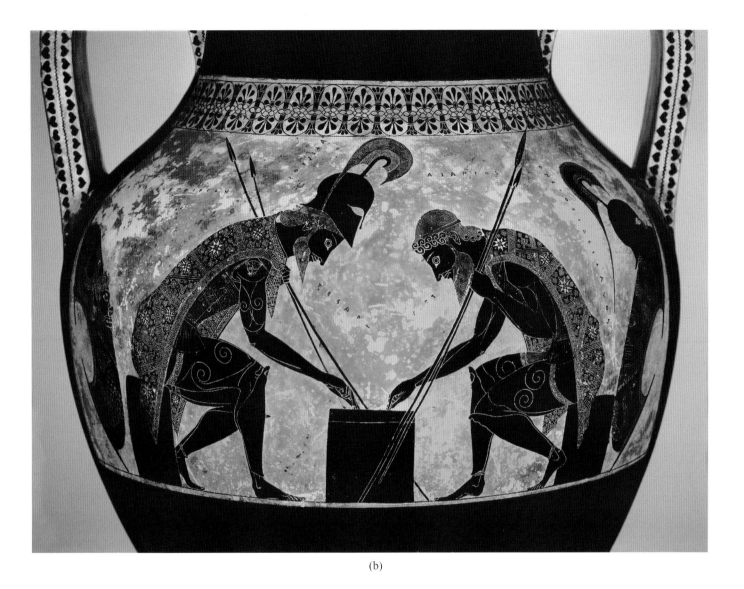

(b)

Fig 3.32 (*Continued*)

Vase painting scenes provide evidence of the use of specific vase shapes. For example, dinoi were used as athletic prizes (see the games for Patroklos in Fig. 3.30a), and volute kraters and dinoi (supported on metal or terracotta stands) served as mixing vessels for wine and water at the symposion – the Greeks did not drink their wine neat but used water to decrease its potency, and the mark of an outsider or barbarian was to drink undiluted wine. The drinking cup or kylix was another symposion shape. Exekias signed as both potter and painter on one that demonstrates this painter's ingenuity

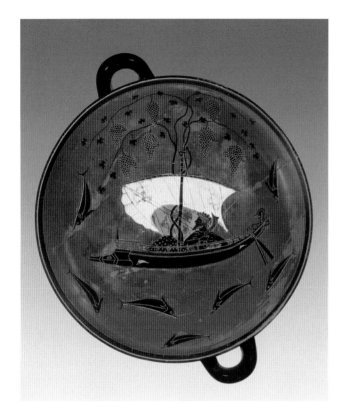

Fig 3.33 Munich, Antikensammlungen 2044 from Vulci, Attic black-figure kylix attributed to Exekias, *c.* 530 BC, terracotta, H 13.6cm, D 30.5cm.

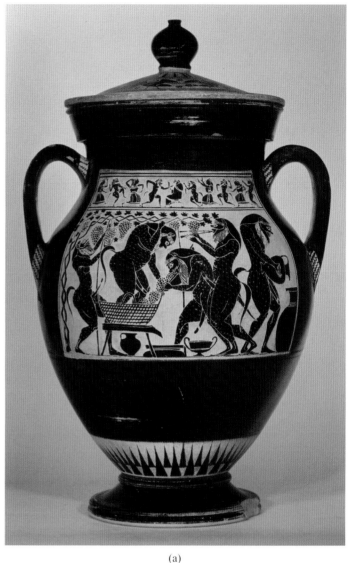

(a)

Fig 3.34a–b Würzburg, Martin von Wagner Museum L265, Attic black-figure amphora attributed to the Amasis Painter, *c.* 530 BC, terracotta, H 37.5cm.

(Fig. 3.33). The kylix *tondo* or center is given over entirely to an image of Dionysos, the god of wine (revelry and the theater, as well), reclining on a ship floating in the sea, which is red and imitates the wine that once filled the vessel, perhaps the "wine-dark sea" of Homeric poetry. The dolphins and grape vines allude to a myth in which the god was taken aboard by sailors, who tied him to the mast. As a demonstration of the god's invincibility, he freed himself, turned the mast to a grapevine, a symbol of his realm, and transformed the sailors into dolphins,

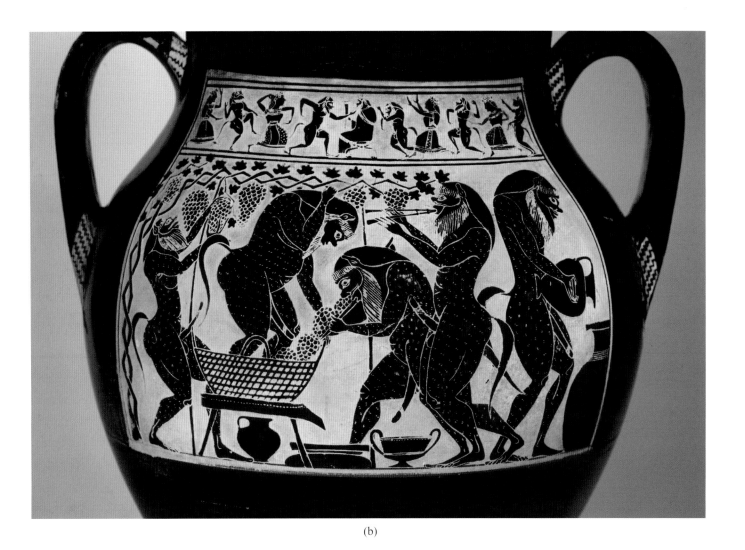

(b)

Fig 3.34 (*Continued*)

who leapt overboard into the sea. When the kylix was tilted toward the viewer's mouth, the ship and the god of wine would have appeared to be floating on the surface of the intoxicating substance – a clever combination of image and function.

Winemaking itself was sometimes the subject of vase painting. An amphora attributed to the Amasis Painter depicts a scene of satyrs, the half-animal/half-human followers of Dionysos, producing wine on the obverse, while satyrs cavort and pour wine for Dionysos on the reverse (Fig. 3.34a–b). The comical appearance of the ithyphallic satyrs – tufted fur, snub noses, pot bellies, and expressive faces – imparts humor to the painting. Above the main panels is subsidiary figural decoration: satyrs dance with maenads, the human-formed female followers

of Dionysos, with the seated god himself presiding among them. The Amasis Painter is named for the potter Amasis, who signs his name on several vessels; the name is of Egyptian origin (Amasis was Egyptian pharaoh *c.* 570–526 BC), suggesting that this potter may have been an immigrant. He would not have been alone among Athenian craftsmen; a number of potters' and painters' names indicate foreign origins.

Experimentation and competition

Ancient Greek society was nothing if not competitive. The invention around 530–525 BC of the Attic red-figure vase-painting technique may have resulted from this competitive spirit and, in any case, certainly inspired further rivalry. In the new technique, black slip was no longer used to paint the figures themselves, but to paint the area around them; the figures were left in the natural color of the fired clay – hence, red-figure, although orange is a more accurate description – then covered with a clear slip (Fig. 3.35b). Rather than black silhouettes, the figures and decoration were spotlighted against a black background. Incision no longer articulated details, and instead, details were applied with a brush and slip, both of which could vary in thickness. This new technique opened the way for experimentation and variation and quickly superseded Attic black-figure for all but a handful of vessels, such as Panathenaic amphorae (see Fig. 3.50a–b). By the 470s or so, red-figure was the dominant form of vase painting.

Box 3.5 Connoisseurship in Greek vase painting studies

Greek vases were signed by painters, by potters, or both using different verbs to distinguish their tasks. In some instances, the same person potted *and* painted a given vase and signed accordingly. But the most common scenario is that there are no signatures at all on the vase. John Beazley attributed many unsigned vases to the hands of known painters based on stylistic affinities between signed and unsigned vases (and for unknown individuals, he invented names, sometimes borrowed from the potter's signature, e.g., Amasis Painter; from a characteristic way of rendering something, e.g., Elbows Out Painter; or from the city in which the best example is housed, e.g., Berlin Painter), and was also able to distinguish artistic personalities among unsigned vases to whom he assigned other vessels. According to this thinking, it is in the mundane details – ear lobes, feet, ankle bones, clavicles, etc. – that an artist reveals his "signature" or identity. This scholarly practice of stylistic attribution is "connoisseurship" and, using the Renaissance workshop model, produces attributions to the master, workshop, followers, and so on. In fact, it is not known how Greek vase painters organized themselves, but attribution is one way to organize the many tens of thousands of extant Greek vases for further study.

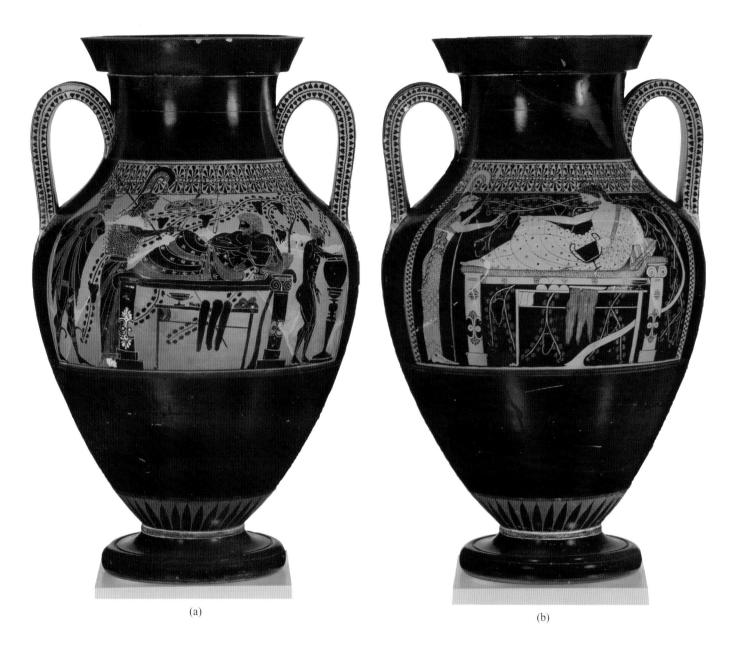

(a)

(b)

Fig 3.35a–b Munich, Antikensammlungen 2301 from Vulci, Attic bilingual amphora, Attic red-figure side attributed to the Andokides Painter, c. 525 BC, terracotta, H 53.5cm.

The Andokides Painter may have instigated the new technique since his works constitute the earliest extant Attic red-figure examples. His bilingual amphora (an amphora with black-figure technique on one side, red-figure on the other) demonstrates the possibilities afforded by red-figure (Figs. 3.35a–b). The composition of Herakles banqueting on a *kline* (couch) fills a single panel on both sides, but a comparison of the two sides reveals the different effects created by Attic black-figure and Attic red-figure. The incision work of the black-figure image is extraordinary, particularly in the depiction of Herakles' hair, Athena's

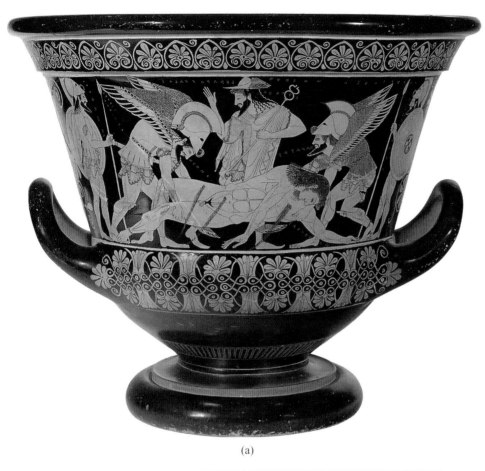

(a)

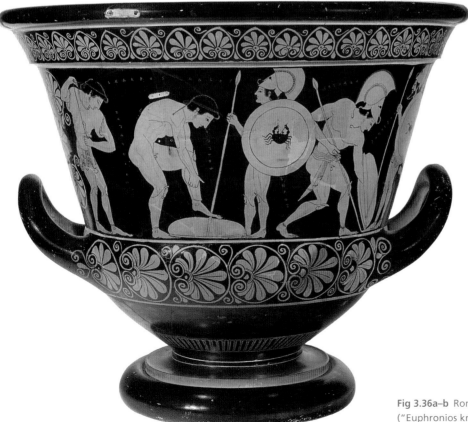

(b)

Fig 3.36a–b Rome, Museo Nazionale Etrusco di Villa Giulia
("Euphronios krater") from Etruria, Attic red-figure kalyx
krater signed by Euphronios, c. 510 BC, terracotta, H
45.7cm, D 55.15cm.

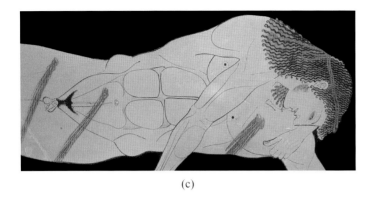

(c)

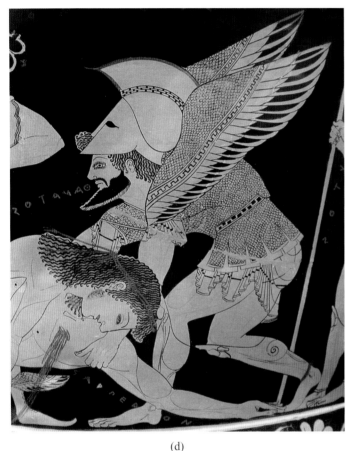

(d)

Fig 3.36c–d Rome, Museo Nazionale Etrusco di Villa Giulia ("Euphronios krater") from Etruria, Attic red-figure kalyx krater signed by Euphronios, *c.* 510 BC, terracotta, H 45.7cm, D 55.15cm.

aegis, and the anatomical details of the boy standing near the dinos, which are enhanced by the light lines against a dark background. Since the figures are painted with black slip, the painter can easily estimate how much space is needed, for example, between the wings of Hermes' boots and the adjacent grapevine. The red-figure technique, on the other hand, encouraged the painter to enlarge, and reduce the number of, his figures, and to paint broadly around them so as to allow ample space for figures, objects, and details. However, black-figure was retained for salient details on the red-figure side: two symposion vessels, a realistic touch because simple black-slip was the everyday symposia ware, and for the floral and zigzag panel borders – the use of black-figure for subsidiary decoration is common in Attic red-figure painting, particularly in its early years. Details of garments, anatomy, and ornament were added in black slip, which varies from thick slip for the dots and folds of Herakles' garment to the much more dilute slip for Herakles' clavicles. It is also noteworthy that Herakles' garment is – and *can* be – transparent because of the use of red-figure technique; had it been rendered in black-figure, transparency could not have been convincingly conveyed. The thick black lines are often so thick that they stand off the surface of the vessel (best viewed at an oblique angle) and are therefore called "relief lines." The light-on-dark composition makes the figures pop out from the dark background.

Vase painters quickly began exploring and exploiting the possibilities of Attic red-figure. Foremost among them were the Pioneer Painters of *c.* 520–505 BC, a group whose modern sobriquet was awarded for their intense interest in depicting details of human anatomy, exploring the effect of movement on the human figure, and rendering the human body in motion in two dimensions. The obverse of a kalyx krater signed by Euphronios depicts the death of the warrior Sarpedon in the Trojan War (Fig. 3.36a); men arm themselves, perhaps preparing for the same fate, on the reverse (Fig. 3.36b). The winged figures of Hypnos (Sleep)

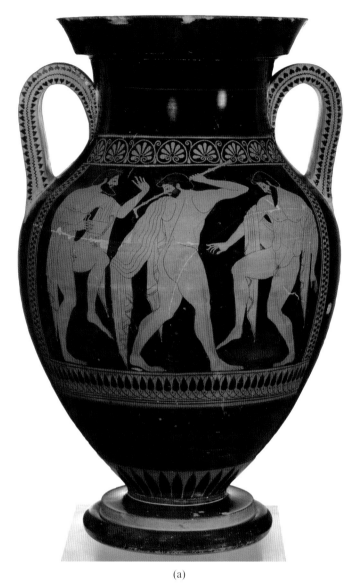

(a)

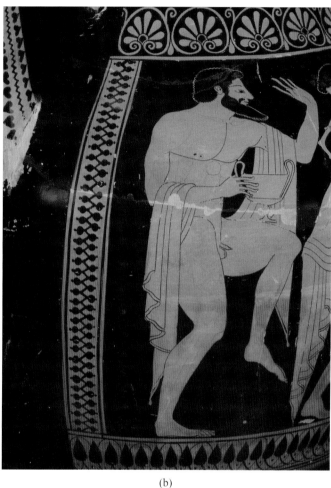

(b)

Fig 3.37a–b Munich, Antikensammlungen 2307 from Vulci, Attic red-figure amphora signed by Euthymides, *c.* 510 BC, terracotta, H 60.5cm.

and Thanatos (Death) carry the large, heavy corpse of Sarpedon off the battlefield. Hermes, in his role as leader of souls to the Underworld (*Psychopompos*), stands behind Sarpedon. With the exception of two soldiers, like sentinels, standing at the sides, all figures are named, and the symmetrical disposition of figures around Sarpedon typifies the archaic style. Euphronios lavished tremendous detail on Sarpedon's muscular, nude body (Fig. 3.36b); abdominal divisions, arm muscles, even the eyelashes, sideburns, nipples, genitals, and teeth, are painted in a variety of ways, from thick relief

lines to thin washes. Especially dazzling are the carefully patterned wings of Hypnos, Thanatos, and Hermes, and Thanatos' cuirass (Fig. 3.36d). Thanatos and Hypnos struggle to steady Sarpedon's body as it twists and falls forward toward the viewer – this is evident in the position of Sarpedon's right arm and foreshortened left calf. Unlike earlier painters or sculptors who used the simpler methods of overlapping figures or three-quarter views to suggest depth, Euphronios aims for the illusion of depth by foreshortening figures moving or twisting in space.

His contemporary, Euthymides, shared his interests in portraying figures in motion and in anatomical detail, and was intent on surpassing his rival Euphronios. Euthymides signed a red-figure amphora that depicts three revelers – one holding a kylix or drinking cup – in a variety of views: profile, three-quarter back, and three-quarter front (Fig. 3.37a). All figures are named – none is mythological – and another inscription runs down along the left border: "as never Euphronios," presumably "as never Euphronios did" or "as never Euphronios could" (Fig. 3.37b). Whether this refers to the dancing or painting is unclear, although this author favors the latter interpretation. Such a taunt is rare and revealing evidence for the society of vase painters and their competitive spirit: ancient authors do not discuss vase painters or the organization of their labor.

Contemporary sculptors shared the interests of the Pioneer Painters. A marble kouros base is carved in relief with nude athletes shown from a variety of perspectives – back view, frontal, profile, three-quarter – with foreshortened bodies where required, recalling the work of Euthymides (Fig. 3.38a–b). The sculptor's keen interest in complex modeling of anatomy, such as the upper back of the figure seen from behind, is evident. Presumably, the kouros that once stood on this base adhered to the traditional kouros format, which may have seemed oddly stiff compared with the acrobatic figures depicted on the base. In this respect, vase painters and relief sculptors led the way in rendering anatomy and movement more naturalistically, a change that did not occur in (extant) Greek free-standing sculpture for another generation.

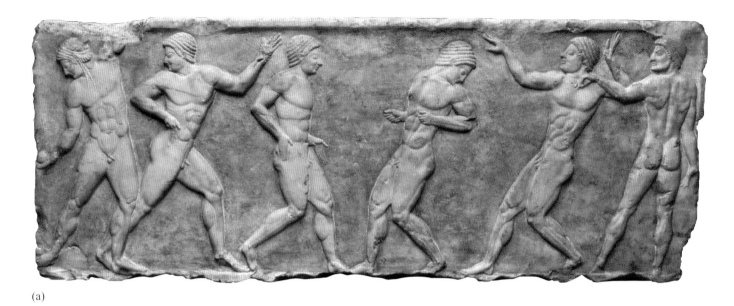

(a)

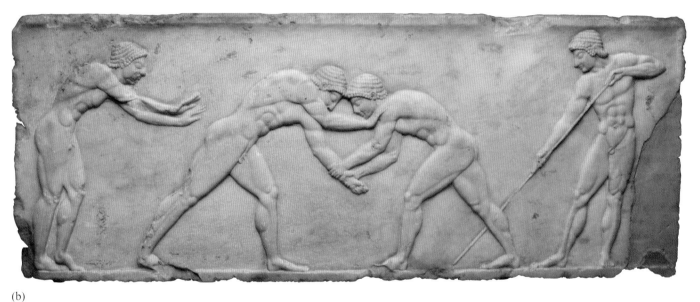

(b)

Fig 3.38a–b Athens, National Museum 3476 ("Ballplayers" base) from the Themistoklean wall in the Kerameikos in Athens, c. 510 BC, Pentelic marble, H 32cm, L 81cm.

Archaic Athens

Athens: tyranny to democracy

Aristocrats continued to govern everywhere in Greece throughout most of the sixth century, although tyrannies replaced aristocratic oligarchies in some poleis. The tyrants were of the aristocratic class and can be defined simply as those who had seized power unconstitutionally in contrast to our modern, entirely negative connotations attached to this term. Many tyrants were largely benevolent rulers,

and in some cases, great civic and artistic patrons (the tyrants of Greek cities in Sicily are especially notable in this regard). This was certainly true of Athens' tyrant, Peisistratos, who finally secured his power in Athens in 546 BC, after two previous, failed attempts starting in the 560s.

Peisistratos was succeeded after his death by his son Hippias. In *c.* 514 BC, two Athenian aristocrats, Harmodios and Aristogeiton, attempted to assassinate Hippias as the result of a personal vendetta. Although they were unsuccessful, they managed to kill Hipparchos, Hippias' brother; the assassins subsequently were captured and executed (see below). Not surprisingly, Hippias' rule grew much harsher, and in *c.* 510 BC, the Athenians, led by the wealthy Alkmaionid family, and aided by the Spartans, ousted Hippias from power and from the city.

The shape of the Athenian Akropolis and the area north of it changed markedly from the early decades of the sixth century BC to the expulsion of Hippias (Fig. 3.39). How much, if at all, this was due to the Peisistratids is impossible to determine because there is little evidence linking them to most of the changes. One must imagine numerous

Fig 3.39 Athens, Akropolis, *c.* 500 BC, plan: 1. Propylaia; 2. Pre-Pantheon; 3. shrine of Athena Polias; 4. Old Temple of Athena; 5. shrine of Athena Ergane; 6. Pandion; 7. fortification wall; 8. Pelargikon; 9. archaic fountain house.

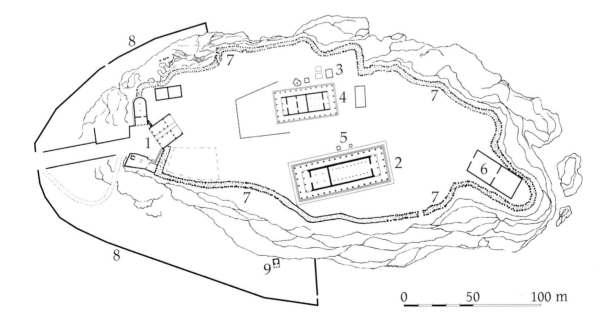

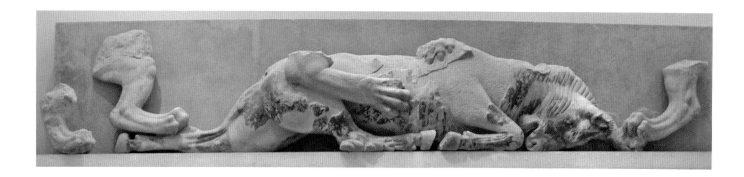

Fig 3.40 Athens, Akropolis Museum 3 from the Athenian Akropolis, *c.* 575–550 BC, limestone, H 0.97m, L 5.35m.

votive statues, including the many korai dedicated to Athena, on the archaic Akropolis, as well as two temples – the earliest (*c.* 580–570 BC) was the Doric Hekatompedon or "Hundred-Footer," which was named in an inscription (the "Hekatompedon inscription") and in a later inventory list pertaining to the Parthenon's cella (see Chapter 4). It may have stood on the site of the later fifth-century BC Parthenon, and if so, would be the first peripteros of three in total. But some scholars place this Hekatompedon on the Dörpfeld foundations to the north, and think only two temples, not three, ever existed on the site of the Parthenon. Extant architectural members of the Hekatompedon or "H-architecture" allow us to reconstruct the building as a *c.* 41m × 20m peripteros of limestone with some marble details. Painted limestone sculptures of lions mauling bulls (Fig. 3.40) once filled the pediments, possibly combined with a triple-bodied creature and Herakles wrestling Triton (Fig. 3.41). The extraordinary amount of paint remaining on the pediments is a salutary reminder of just how colorful and animated ancient sanctuaries were (and how little time these particular sculptures were exposed to the elements), and one should note the extremely careful and vivid rendering of details, such as the lions' talons, or the tortured face of the bull.

Fig 3.41 Athens, Akropolis Museum 35 (Bluebeard group), 36, 6508 (Herakles wrestling Triton) from the Athenian Akropolis, *c.* 575–550 BC, limestone, H 0.76.5–77.5m, L 3.25–3.53m.

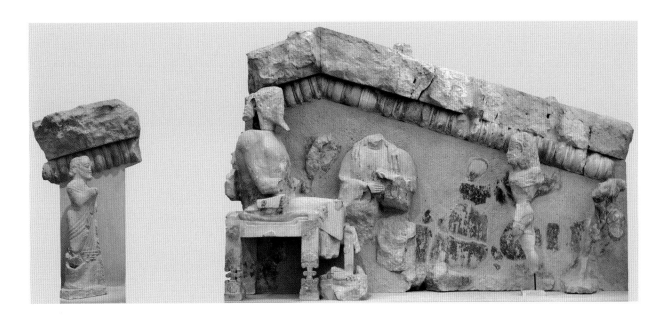

Fig 3.42 Athens, Akropolis Museum 9 ("Introduction pediment") from the Athenian Akropolis, *c.* 575–550 BC, limestone, H 0.94m, L 1.74m.

A group of small buildings also stood somewhere on the Akropolis (their exact place and function are disputed); we know of their existence from a series of architectural members reused as foundations of later, Classical buildings and from small poros pediments *c.* 560–550 BC, sculpted and painted with various mythological themes (Fig. 3.42). Several of the pedimental compositions are devoted to the adventures of Herakles, an especially common hero in sixth-century art (cf. Figs. 3.35, 3.41). Again, the high technical quality and brilliant color are noteworthy. The Hekatompedon inscription speaks of *oikemata*, small structures, on the Akropolis overseen by *tamiai* (treasurers), and it may be that the limestone pediments topped these buildings – wherever they were.

In addition, a new temple to Athena was erected on the Akropolis in *c.* 525–510 BC. The Doric temple stood on the limestone Dörpfeld foundations named after their excavator (Fig. 3.43). These blocks are now partially overlapped by the south porch of the later Erechtheion (late fifth century BC; see Chapter 4), but the building's plan is still easily traceable, and the temple's sculpted pediments survive in part. The dynamic, over-lifesize, free-standing sculptures depict Athena fighting Giants on one side (Fig. 3.44), and animal combats (again) on the other. Unlike the earlier sculpted pediments on the Akropolis, the Gigantomachy figures on the Athena temple are of marble, and as the largest and most costly architectural sculpture that existed on the Akropolis until this time, they surely would have been an impressive

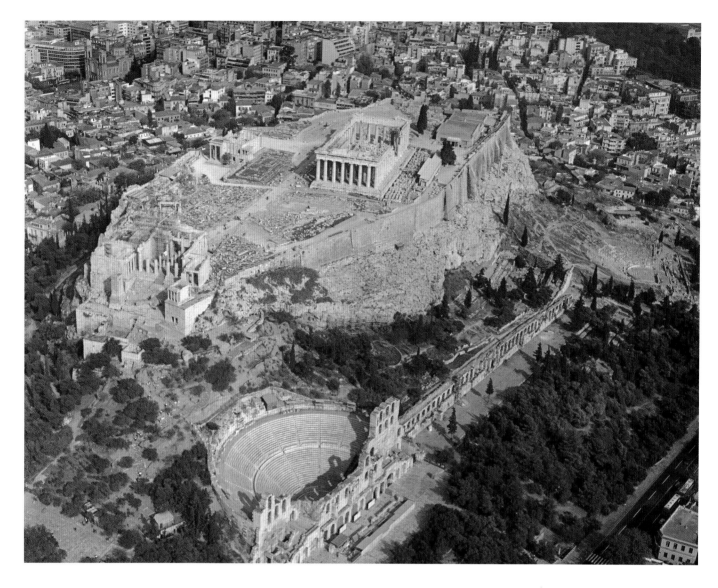

Fig 3.43 Athens, Akropolis, aerial view.

sight. By comparison with contemporary free-standing sculpture, such as frontal and static kouroi and korai, the temple figures seem remarkably animated and naturalistic, more akin to contemporary developments in relief sculpture.

The archaic Agora was located to the east of the Akropolis, as known from a reference in Pausanias combined with archaeological evidence, but the precise outlines of this space are unknown. A new Agora began to take shape at the end of the sixth century BC to the northwest of the Akropolis, an area that had served as a cemetery, for residential purposes (as attested by wells, not by structures), and for workshops. This new Agora eventually became the primary Agora of the Classical

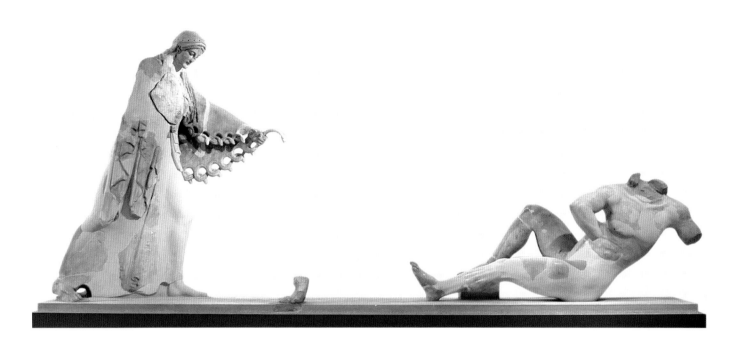

Fig 3.44 Athens, Akropolis Museum 631A from the Athenian Akropolis, Athena defeating a Giant, marble, H (Athena) 2.00m.

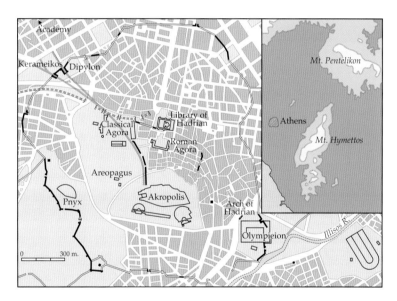

Map of ancient Athens, second century AD

period (Figs. 3.45–47). The Peisistratids left their mark in the new Agora by funding a public fountain house. In the ancient world, public fountains were the primary access to water in most places, especially in urban areas, and Peisistratos' patronage for this project was a work of public beneficence that surely contributed to the leader's popularity then and later. Another Peisistratan project in the Classical Agora, the Altar of the Twelve Gods of 522/521 BC, was surrounded by a nearly square wooden fence that served as a precinct enclosure. A statue base in front of the fence secures the structure's identification

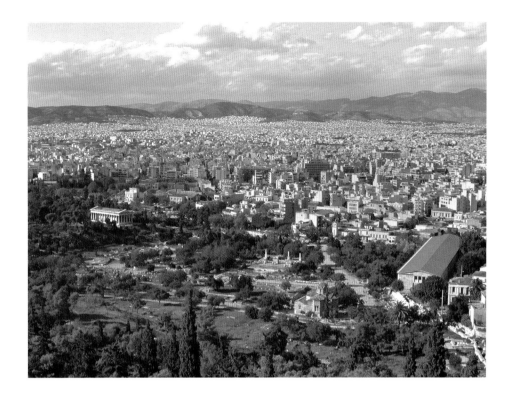

Fig 3.45 Athens, Agora.

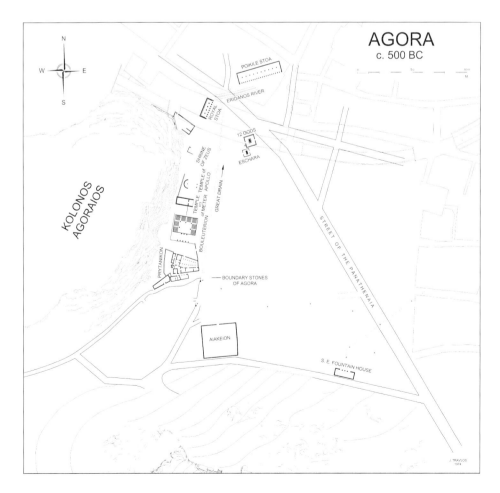

Fig 3.46 Athens, Agora, plan, c.500 BC.

Fig 3.47 Athens, Agora, reconstruction of the Altar of the Twelve Gods.

(Fig. 3.47): its inscription states that the accompanying statue was dedicated to the twelve gods. The altar was the official point from which all distances from Athens were measured, and it also served as a place of refuge. It was oriented to the Panathenaic Way, the ceremonial parade route for the Panathenaic procession that ran diagonally across the Agora, led to the west gate of the Akropolis and to the Altar of Athena within.

In addition, the Peisistratids resumed construction of a structure whose foundations had been laid earlier near the Ilissos River southeast of the Athenian Akropolis: the Peisistratids intended it as an Ionic limestone dipteral temple to Olympian Zeus (the Olympieion), the largest temple (107.7m × 42.9m) ever planned (Fig. 3.48). The Peisistratid period construction began toward the end of the sixth century BC, but was brought to a halt with the expulsion of Hippias in 510 BC (some of the remaining architectural members were reused in the later city fortification wall of *c.* 479/478 BC, the "Themistoklean" wall; see Chapter 4). Work resumed on this building in the late fourth century BC, as we shall see, but the new Pentelic marble building was not completed until the second century AD under the Roman emperor Hadrian.

While Peisistratos was still trying to gain a foothold in Athens, the Panathenaic festival was reorganized and embellished with a series of athletic and musical competitions. From 566 BC on in Athens, for example, the Panathenaic festival was celebrated annually in honor of Athena and her role in the Gigantomachy, but every four years, a more elaborate celebration occurred, which included athletic and musical contests, beauty contests, and contests linked to handling military weapons. The Panathenaic games took place every four years beginning in *c.* 566/565 BC and were open only to Athenians save for a few events. The athletic contests expanded over time and by the fourth century included the *stadion* (footrace), pentathlon, wrestling, boxing, *hoplitodromos* (armed race), and equestrian events; in addition, there were musical and tribal contests (restricted to Athenians), such as the *pyrrhic* dance (armed dance) competition. The prize awarded for athletic events was a large quantity of olive oil specially pressed from olives grown in the sacred grove of Athena, the city's patron

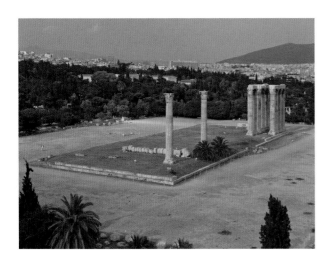

Fig 3.48 Athens, Olympieion.

(a)

(b)

Fig 3.49a–b Karlsruhe, Badisches Landesmuseum 65/45 from Vulci, Panathenaic amphora attributed to Exekias, *c.* 540 BC, H 59.6cm.

goddess. Based upon a description of preparations for the Panathenaia in a fourth-century BC text, scholars have assumed that the olive oil was presented in special amphorae made solely for this purpose: Panathenaic amphorae (Fig. 3.49a–b). These large, lidded vessels always feature an image of Athena, together with an inscription, "from the games of Athens," on the obverse and an image of the event for which the prize was awarded on the reverse. While the shape and size of these amphorae changed over centuries, as did the manner of depicting Athena, the basic format remained the same into the Roman period, and even more surprisingly, the vases were always rendered in black-figure even when this technique was no longer used for any other kind of pottery. The idea that the amphorae contained the prize oil, however, has recently been challenged: a study of Panathenaic amphorae from the Athenian Kerameikos

cemetery, where the amphorae were deposited as grave gifts, reveals that none of the amphorae ever contained oil. But the Kerameikos amphorae are a limited sample of all Panathenaics, and some scholars already have offered counter-arguments to the new challenge. The amphorae may have been connected with the games, but it is not clear that they were oil containers!

Athenian democracy and myth-making

What happened with the political situation in Athens immediately after the ouster of Hippias in *c.* 510 is unclear, although literary sources suggest a jockeying for power among aristocrats. In *c.* 508/507, an Athenian citizen, Kleisthenes, successfully introduced a series of reforms, which produced a democracy (literally, power of the *demos*; Attika was physically and governmentally divided into demes), the first democracy. He changed the number of tribes into which Attika was divided from the four established by Solon in 594 BC to ten, which were constructed in such a way as to represent a diversity of interests: people of the coast, the city, and those inland, according to a fourth-century BC written source (*Athenaion Politeia* 21.4). Each tribe was assigned an eponymous hero. All Athenian citizens were now eligible to meet, debate, and vote on legislation proposed by a group of five hundred citizens, the *Boule* or Council, composed of fifty members from each of the ten tribes. This was the first time that the entire citizen body in Athens or anywhere else had direct participation in their government. Compared with modern notions of democracy, this first democracy is wanting: its definition of "citizen" was limited to Attic freeborn males over the age of eighteen, i.e., no women, no slaves (like most ancient cultures, this was a slave society), no resident aliens (*metics*). But such a comparison is anachronistic; instead, one might think of all other contemporary and preceding governments, which were monarchies, tyrannies, aristocracies, and oligarchies. In this view, the new democracy in Athens was truly radical.

Although Harmodios and Aristogeiton did not kill Hippias and take down the tyranny, they soon were regarded by Athenians as instigating its demise and were honored, then heroized, for this achievement. Lauded as "Tyrannicides," their images were crafted by the Athenian sculptor Antenor and erected in the Athenian Agora – whether the archaic or Classical Agora, we do not know – in *c.* 510 BC and their descendants were fed in the

Fig 3.50 Naples, Museo Nazionale 6009, 6010, Tyrannicides (Aristogeiton – bearded – and Harmodios). Roman copy of Greek original by Kritios and Nesiotes of 477/476 BC, marble, H (without plinth) 1.85m.

Prytaneion at public expense for the duration of their lives. These were truly extraordinary privileges – the first time that contemporary (but deceased) citizens were honored by public statuary – and the public underwriting of lifetime meals was an award usually accorded to Olympic athletic victors or individuals of that exalted stature. The original Tyrannicides sculptural group was taken by the Persians when they sacked Athens in 480 BC (see below). In *c.* 477 BC, the Athenians replaced the original group with another by the sculptors Kritios and Nesiotes (Fig. 3.50; see Chapter 4) and erected it in the Classical Agora, where the fragmentary inscribed base has been found. Whether the original group looked anything like the replacement cannot be determined; based on most freestanding statuary of the late sixth century, one might expect two kouroi figures for the first group, but the replacement group, which we know from Roman copies and vase painting, comprised two dramatically positioned figures lunging forward to plunge their weapons into their quarry. These dynamic poses of the Tyrannicides are more akin to those of the sculpted Gigantomachies filling the west pediment of *c.* 510 BC at the temple of Apollo at Delphi, and – closer to Athens and closer in composition – the contemporary pedimental group from the temple of Athena on the Athenian Akropolis (see Fig. 3.44). In fact, the Athena from the Akropolis group lunges forward with her left arm outstretched similar to the pose of one of the Tyrannicides, although the latter exhibits more torsion, drama, and verve. Considering that free-standing sculpture with dramatic poses, that is, stances unlike those of kouroi, existed already at the time of the original Tyrannicides group, it may be that the original group possessed the dynamic poses of the later, replacement group familiar to us.

The adulation afforded the Tyrannicides is not the only instance of new democracy myth-making: Theseus, the legendary king of Athens, who was believed to have reigned in a far distant past, had been credited already in the Archaic period with *synoikismos* (unification) of the Attic demes. The democracy embellished this achievement by claiming that synoikismos was the first step in creating the Solonic tribes, which led to the Kleisthenic tribes. In other words, according to the new democracy, Theseus was the instigator of democracy.

The new democracy suspended construction on the Peisistratid Olympieion (Fig. 3.48), and instead began to focus its energies on construction in the new Agora north of the

Fig 3.51 Athens, Akropolis, Pre-Parthenon, after c. 490 BC, plan.

Fig 3.52 Athens, Akropolis, Pre-Parthenon, after c. 490 BC, unfinished column drum on the Athenian Akropolis, marble.

Akropolis and on the Akropolis. New accommodations were needed for the democracy's various constituencies, and these were erected along the west side of the new Agora (Fig. 3.46). The Boule or Council of 500 met in the Old Bouleuterion of the early fifth century BC (possibly the Old Metroon, which also served as an official archive). The Archon Basileus, the leading state official elected annually, had his office in the Royal Stoa (Stoa Basileios) of the same date, where the laws were publicly displayed. On the Akropolis, work began on a huge marble temple, the Pre-Parthenon, overlying the cella of the earlier Hekatompedon (if the Hekatompedon was, indeed, on this site and not on the Dörpfeld foundations; Figs. 3.39, 3.51). The Pre-Parthenon, like all other structures and statues on the Akropolis, was burnt and destroyed by the Persian invasion in 480 BC. From the Pre-Parthenon's remains, which still lie on the Akropolis – part of the poros limestone foundations, 78m long, and blocks of the marble superstructure (Fig. 3.52) – we deduce that the building had been completed as high as three column drums at the time of its destruction and was intended as a peripteral 6 × 16 temple. Some of the blocks of the superstructure were scorched and calcined from the Persian destruction, vivid reminders of this catastrophe. It is time to look at these events more closely.

The Persian Wars

In 499 BC, the Greek cities in Ionia revolted against the Persian king, whose vast empire then included this area. These Greek cities were required to pay taxes to the king, who restricted their trade and required the inhabitants to perform military service. The rebellious cities requested help from Greek cities elsewhere and were refused by all but two poleis, Athens and Eretria on Euboia, which sent aid in 494 BC. When the Persian king and his army crushed the Ionian revolt, Athens and Eretria had a new, very powerful enemy. In 490, the Persian king and army invaded Greece with the specific aims of punishing Athens and Eretria and subjugating all of Hellas to Persian rule. The Persians were repulsed at Marathon where a Greek force, led by and composed primarily of Athenians, routed the Persian army. When the battle ended, thousands of Persians lay dead, but the Athenians suffered

only 192 casualties, according to the fifth-century BC historian, Herodotos (*c.* 485–424 BC). This stunning victory filled the Greeks, particularly the Athenians, with pride and self-confidence, and inspired a series of monuments commemorating their achievement.

Among these was the Athenian Treasury at Delphi (Fig. 3.53), prominently located just around the bend of the Sacred Way from the

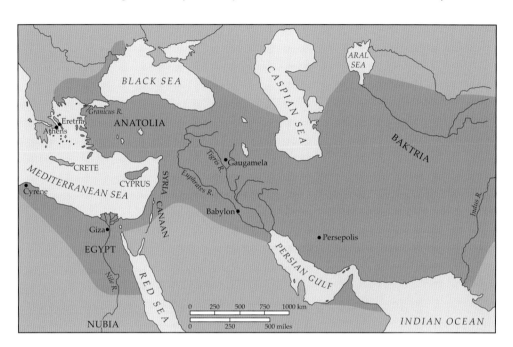

Map of the Persian empire c. 490 BC

Fig 3.53 Delphi, Athenian Treasury, after *c.* 490 BC.

Fig 3.54 Delphi, museum, metope from Athenian Treasury: Herakles v. Keryneian hind, marble, 67 × 63cm.

Fig 3.55 Delphi, museum, metope from Athenian Treasury: Theseus and Athena, marble, 67 × 63cm.

Siphnian Treasury discussed above (Figs. 3.12 no. 9, 3.13–16). The Parian marble building follows the same one-room plan as the Siphnian Treasury, but the Athenian Treasury is constructed in the Doric order and uses columnar supports rather than the ornate caryatids of the early Ionic building. The Athenian Treasury's sculpted metopes depict the labors of Herakles and the deeds of Theseus, the first (and not the last) juxtaposition of these two heroes on the same Athenian monument. With this iconography, the Athenians proclaimed their greatness through their local hero Theseus, while also asserting a claim to the Panhellenic hero, Herakles, whose adventures take him all over the Mediterranean and beyond. It was a subtle but unmistakable claim to leadership of the Greek world, which was clearly visible and intelligible to every Greek visitor to Delphi.

Compared with earlier architectural sculpture in Selinus or even the friezes of the Siphnian Treasury, the Athenian Treasury metopes are dramatically different in composition and style. Herakles energetically twists and vaults on to the haunch of the Keryneian hind, as he pulls back the animal's head to retrieve his golden antlers; the figures are carved in such high relief that parts of them, such as Herakles' head, are entirely in the round (Fig. 3.54). Although Herakles' right arm is largely missing, the remains indicate that he once reached upward with his arm breaking out of the metope frame altogether. The relief background's impermeability is reinforced by the cloak and quiver that hang on the "wall." Herakles retains the archaic smile and snail curls that are hallmarks of the archaic style, yet his body twists to reveal the front of his torso, where the sharply partitioned abdomen and highly articulated ribs suggest taut muscularity and patterning more familiar from the earlier Pioneer Painters (cf. Figs. 3.36–37) than from contemporary sculpture. Such athletic dynamism and three-dimensionality are unprecedented in Greek relief sculpture yet Herakles' anatomy seems old-fashioned. A second metope depicts Theseus in the presence of Athena (Fig. 3.55). Athena is patron goddess of many

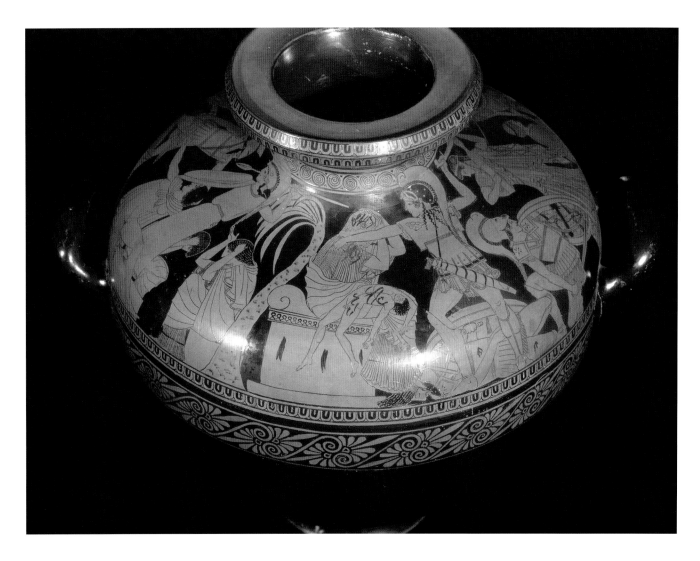

Fig 3.56 Naples, Museo Nazionale 2422 ("Vivenzio hydria") from Nola, Attic red-figure hydria attributed to the Kleophrades Painter, terracotta, H 42cm.

heroes, including Theseus, Herakles, and Perseus, so her presence is hardly surprising, but here the pairing is invested with special meaning: the patron goddess of Athens greets the hero and symbol of the Athenian democracy.

In spite of the overwhelming Greek victory in 490 BC, the Persians vowed vengeance and returned in 480 BC to exact it. This time, they advanced inland and sacked the Athenian Akropolis, among other places, smashing statuary, including the votive korai, and setting fire to the buildings, including the Pre-Parthenon (Figs. 3.51–3.52). A series of battles between Greeks and Persians in 480 and 479 ended with a resounding Persian defeat, first in the naval battle at Salamis and later on land at Plataia.

The emotional impact of the wars and the profound devastation of the Akropolis left a deep impression on the Athenians, which is visibly manifested in some vase paintings. Previous images of warfare, including depictions of the sack of Troy, represented heroic warriors, bravely fighting, dying, taking or defending the city. The sack of Troy as conceived by the Kleophrades Painter on a *hydria* (water-jar) of *c.* 480 BC differs sharply from these glorified images of warfare and instead depicts the Achaian warriors as brutal, menacing conquerors (Fig. 3.56). The scene unfolds in a continuous series of vignettes on the hydria's shoulder: Ajax grabs Kassandra, who clings to the statue of Athena for sanctuary as two women cower nearby, their hands held to their heads in distress. Kassandra's nakedness is remarkable for this period of vase painting, where the only nude females usually are hetairai (courtesans). Here, her nudity underscores her vulnerability and contrasts with her heavily armed attacker. The cult statue (*palladion*) of Athena is rendered as a peplos-clad figure, diminutive in scale, archaic in style with frontal pose and straight legs; that is, she is painted as an archaic kore. This use of "archaizing" style – a deliberate revival of an older motif or style – becomes canonical from this point onward to denote a statue amidst moving figures. The contrast of old and new is emphasized by the use of a frontal eye for the palladion of Athena while the remaining, living figures have eyes rendered in profile. On the other side of a palm tree, Neoptolemos, son of Achilles, pitilessly beats the aged King Priam seated on an altar (thus, the warrior commits another act of sacrilege since the altar is a sacred place of asylum), while the lifeless bloody body of Priam's grandson, Astyanax, lies across his lap. The old man tries to shelter his bleeding, bald head with his feeble arms. Beyond him, a Trojan woman wields a club against a fallen Achaian warrior. In spite of this spirited effort at self-defense, the prevailing mood is one of merciless aggression against the aged and helpless; other contemporary images of the same subject depict Neoptolemos using the corpse of Astyanax as a club with which to beat the old man. The horror of war, not its heroic value, is the message.

When does "Classical" begin?

Scholars traditionally cite the end of the Persian War, *c.* 480–479 BC, as the moment that marks the transition from the Archaic to the Classical period. Art – particularly sculpture – from the early Classical

Fig 3.57 Würzburg, Martin von Wagner Museum L479, Attic red-figure kylix attributed to the Brygos Painter, c. 490 BC, terracotta, H 14cm, D 32.3cm.

period is characterized by sobriety, solemnity, less abstract-ed and symmetrical renderings of the human figure and the world, in general, but also a new freedom of movement, including figures who stand in contrapposto that imbues them with a feeling of relaxation and naturalism. It is impor-tant to bear in mind that this dating is a convention of mod-ern scholarship and does not reflect the complexities of the period: some of the hallmarks of the new artistic style are already present before the conclusion of the Persian Wars, as we saw in the case of the Siphnian Treasury friezes (Figs. 3.14, 3.16; cf. Fig. 3.38a–b).

Vase painting also demonstrates Classical tendencies before the conventional starting date of *c.* 480–479 BC. Early fifth-century vase painters explored new compositional formats and more prosaic images, while continuing to engage with tra-ditional mythological subjects. A kylix tondo attributed to the Brygos Painter depicts the aftereffect of too much alcohol: a beardless young man vomits while a woman supports his head (Fig. 3.57). Both figures wear grapevine wreaths, which sug-gests that the woman is a hetaira, the young man a symposiast, who has imbibed too much (drinkers and revelers appear on the exterior of the cup). This simple two-figure composition exemplifies one contemporary vase painting trend toward reducing the number of figures and their action, offering still, quiet compositions.

The Berlin Painter is known for precisely this composi-tional format (though he also employed multi-figure compo-sitions) and even reduces or entirely eliminates the borders beneath and around figures to spotlight them more effective-ly against their black backgrounds. On one side of a lidded amphora, he paints Athena with an oinochoe (wine pitcher) in her extended right hand; she pours wine into a *kantharos* (long-handled drinking cup) held by Herakles on the other side so that the images on the two sides of the same vase work together to create a narrative (Fig. 3.58a–d). The figures stand on a thin border, which truncates just beyond the maximum width of each figure, as if they were standing on individual ground lines. The glossy black background, almost velvety in texture, makes the bright figures leap out, although mis-firing on the Herakles side has left a brownish patch on the

(a) (b)

(c) (d)

Fig 3.58a–d Basel, Museum of Ancient Art and Ludwig Collection BS456 (Kä 418), Attic red-figure amphora attributed to the Berlin Painter, Herakles, Athena, *c.* 490–480 BC, terracotta, H 79cm.

(a)

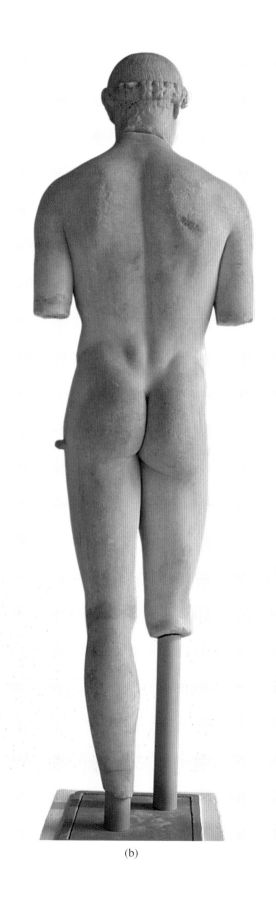

(b)

Fig 3.59a–b Athens, Akropolis Museum 698 ("Kritios" Boy)
from the Athenian Akropolis, *c.* 480 BC, marble, H 1.167m.

background. The crisp, precisely rendered relief lines and details, such as Athena's aegis and shield, her chiton, and the lionskin worn by Herakles, are typical of this painter's superlative skill. Athena's heavy chin departs from the more delicate visages of late archaic vase painting and, together with the gravity and monumentality of the figures, exhibits the somber expressions characteristic of the Severe Style (c. 480–450 BC) of the early Classical period.

Works of art created around the time of the Persian Wars are notoriously difficult to date without external evidence. The destruction level on the Athenian Akropolis should provide some help since the trash dumps containing the material destroyed by the Persians – the "Perserschutt" – should indicate what sculpture looked like before 480 BC. As an example, we can cite the "Kritios Boy," a Parian marble votive statue found on the Athenian Akropolis (Fig. 3.59a–b). Although he is youthful, male, and nude, like an archaic kouros, everything else about him sharply departs from what preceded him in three-dimensional sculpture. He stands in contrapposto, one leg bearing his weight, the other flexed, which produces a natural, relaxed pose. His slight shift in weight affects the entire body, and the sculptor has recorded it: his hips are not parallel to the ground but uneven (the hip of the weight-bearing leg is higher than the other). Anatomy is now fully modeled in a subtle and naturalistic way, rather than that of the beefier, somewhat inflated Anavysos kouros, whose abdominal area is a series of sharp divisions (see Fig. 3.22a). The Kritios Boy's slightly turned and lowered head breaks the central axis common to archaic kouroi, and the archaic smile is replaced by a somber expression with downturned lips and a heavy chin, both typical of the Severe Style. Instead of long, bead-like braids, narrow strands of hair radiate out from the crown of the head and wrap around a metal ring worn around the head; wispy tendrils of hair are visible on the back of his neck. His eyes were once inlaid with dark stones set in white paste.

What is the date of the Kritios Boy? This figure is among a group of sculptures that betoken the Classical style. The latest study of the Perserschutt indicates that the Kritios Boy post-dates the Persian sack. But in some respects, whether he dates before or after the sack is immaterial unless one wishes to posit that the Persian Wars somehow caused or inspired the new style. But we have seen that stylistic changes were already occurring in late archaic art considerably earlier than 490 BC. What came after the wars was new but not without a long evolution.

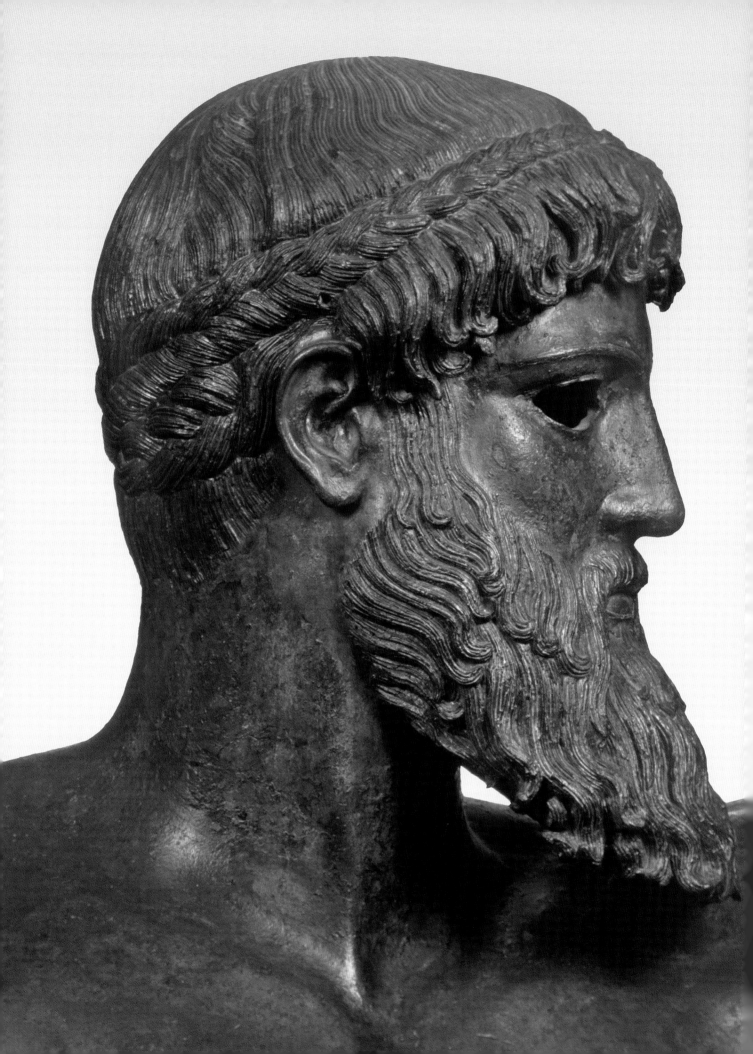

4 The Classical period: the fifth century BC

TIMELINE – all dates are BC

c. 480–323	Classical period
c. 480–450	Severe Style
c. 479	Battle of Plataia
c. 479/478	Themistoklean wall constructed in Athens
c. 477	New Tyrannicides group created by Kritios and Nesiotes erected in Classical Athenian Agora
c. 476?	Formation of Delian League
c. 470–460	Temple of Hera II at Paestum constructed
c. 470–456	Temple of Zeus at Olympia constructed
c. 470–420	White-ground lekythoi produced in Athens
c. 460–450	Niobid Painter
c. 454	Transfer of Delian League funds from Delos to Athens
c. 450	Polykleitos' Doryphoros
c. 447–432	Parthenon constructed
c. 431–404	Peloponnesian War: Sparta + allies v. Athens + allies
c. 420	Eretria Painter
c. 400–390	Temple of Apollo, Bassai – first use of the Corinthian order

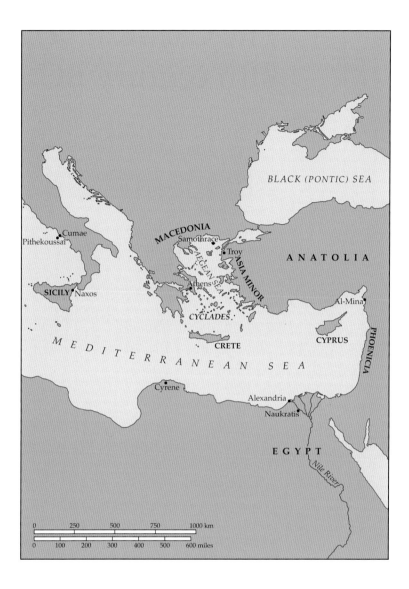

Map of the Mediterranean area

Scholars usually point to the end of the Persian Wars in 480/479 BC as the event that marks the start of the Classical period in the history of Greece because of profound political changes that occurred in Greece as a result of the conflict and Greek victory. The Greeks, of course, did not know that the Persians would not soon return, as they had for the past decade, and did not have the hindsight that we possess to declare that a new period had begun. Having already experienced the sack of several cities, including Athens in 480 BC, Greek poleis understandably remained nervous. The Athenian leadership displayed in several battles including the Greek victories at

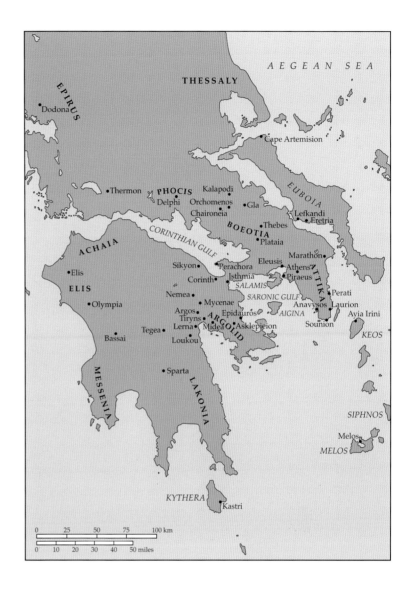

Map of southern Greece and the Peloponnese

Marathon in 490, Salamis in 480, and at Plataia in 479 shifted the balance of power in Athens' favor. Athens organized and led the Delian League, formed as a defensive alliance to which various Greek poleis and islands contributed ships and money against possible future Persian attacks. By the time that the league funds were removed from Delos to the Athenian Akropolis in 454, Athens' leadership in this maritime empire was indisputable though it was periodically challenged and questioned.

Athens provides the most plentiful information about social history, politics, religion, and art for the fifth century, but innovation and

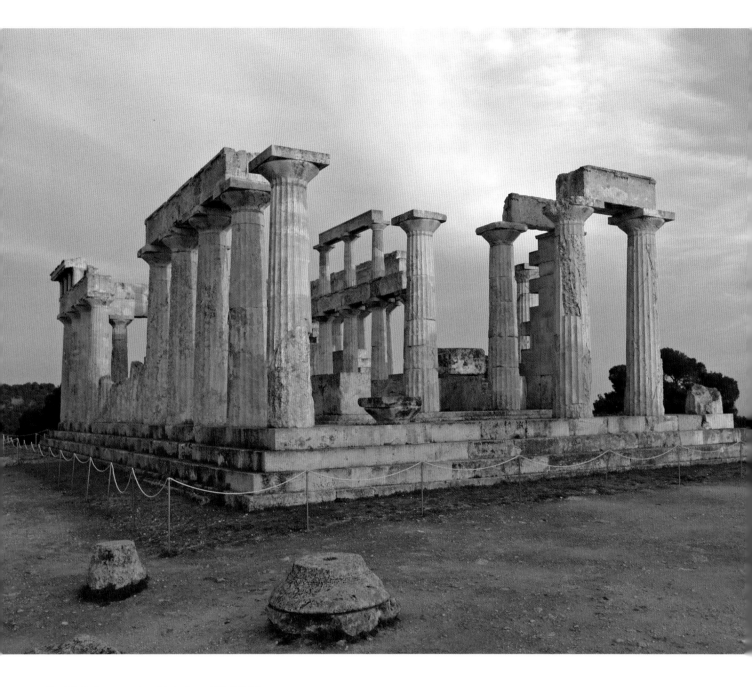

Fig 4.1 Aigina, temple of Aphaia, *c.* 490–480 BC, 28.815m × 13.77m.

new developments happened throughout the Greek world. This is especially true in the first half of the fifth century.

Defining Classical

The pedimental sculpture of the temple of Aphaia on the island of Aigina demonstrates some of the stylistic changes that took place in the first decades of the fifth century BC (Fig. 4.1). An

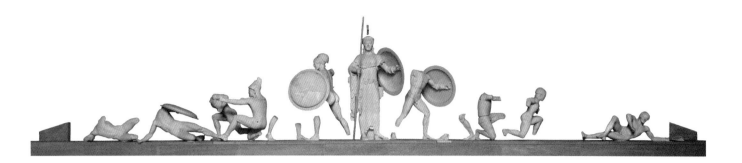

Fig 4.2 Munich, Glyptothek, west (second sack of Troy by the Achaians?) pediment of the Temple of Aphaia on Aigina, *c.* 470s BC, marble, H 1.72m, W 15m.

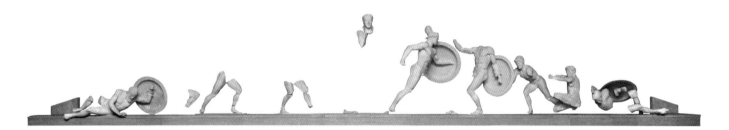

Fig 4.3 Munich, Glyptothek, east (first sack of Troy by Herakles?) pediment of the temple of Aphaia on Aigina, *c.* 470s BC, marble, H 1.72m, W 15m.

archaic temple to Aphaia, about whom we know little, had stood on the site, as we know from the architectural remains and an inscription; extant votives suggest that she was worshipped as *kourotrophos* (nurse) by both men and women. Recent study demonstrates that construction on the new temple took place after the Persian Wars, in the 470s BC, as indicated by the pottery found beneath it (this is in contrast to earlier scholars, who had placed the temple anywhere from *c.* 500 to 480 BC). The Doric limestone structure, 13.77m × 28.81m with 6 × 12 columns, was coated with plaster to imitate marble and partially painted. Its cella was divided by two rows of columns, and a limestone base was found near the door to the opisthodomos; the base once supported an old, wooden cult image of Aphaia. The two Parian marble pedimental compositions, bearing substantial traces of once brilliant paint, depict battles overseen by a centrally placed Athena (Figs. 4.2–3). Scholars disagree about which battles are depicted, but it is likely that we are witnessing two battles of the Trojan War in which mythological Aiginetan warriors and the hero Ajax were

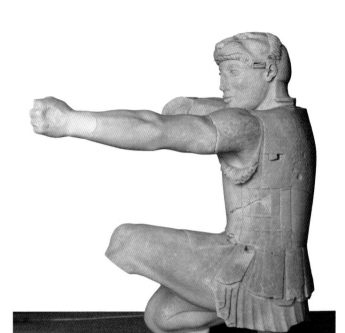

(a)

Fig 4.4a–b Munich, Glyptothek, Herakles from the east pediment of the temple of Aphaia on Aigina, *c.* 470s BC, marble. H 79cm.

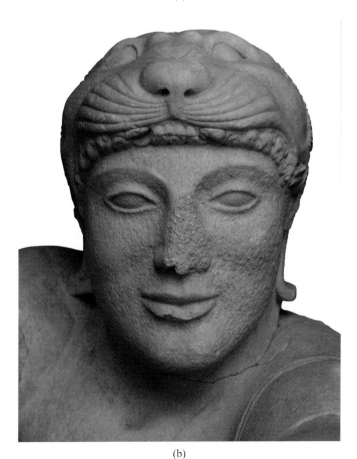

(b)

instrumental. These warriors included the sons of the Aiginetan king Aiakos, who himself was the offspring of Zeus and the nymph Aigina. The three-quarter-life-size figures are mostly nude save for occasional helmets, shields, and distinctive garb: a lion-skin cap for Herakles (Fig. 4.4a–b) in the east and a full bodysuit for an eastern or Skythian archer (Fig. 4.5a–b) in the west. They fight, tumble, and fall in a variety of positions; it is as if the metope sculptures from the Athenian Treasury at Delphi were freed from their backgrounds (see Figs. 3.54–55). Some body positions are more naturalistic than others, as can be seen by comparing the archer and Herakles. The alignment of Herakles' eye with his hand, his upright posture, and weight firmly resting on his back leg strike one as closer to the necessities for an actual archer than do the Skythian's lowered arm, forward position, and awkward balance. Scholars conventionally have dated the west pediment a decade earlier than the east based on style, but in fact, figures in both pediments exhibit features of archaic sculpture, such as the archaic smile, while others display the contrapposto, idealization, more natural movement (e.g., Herakles drawing his bow), somber expression, or body posture regarded as hallmarks of the early Classical Severe Style (*c.* 480–450 BC). Moreover, the backs of the sculptures betray no stylistic difference. Together, these observations indicate no clear division in terms of chronology (as opposed to individual workmanship) between east and west; instead, the sculptures display the experimentation that marks the period of stylistic change from archaic to Classical style.

The celebration of Aiginetan heroes on the temple of Aphaia on Aigina may have been a response to Aigina's perpetual and recent troubles with nearby Athens, as well as an effort to trumpet the island's own lengthy, stellar legendary past. Some scholars have suggested that the choice

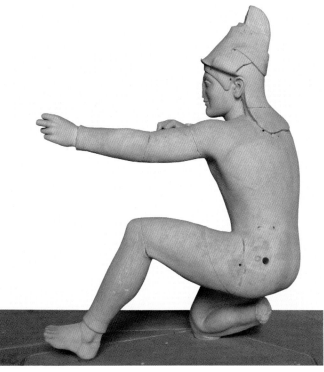

(a)

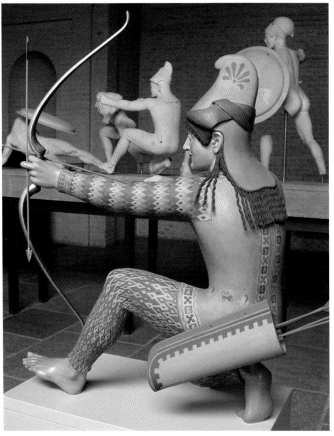

(b)

Fig 4.5a–b Munich, Glyptothek, eastern archer from the west pediment of the temple of Aphaia on Aigina, *c.* 470s BC, and reconstruction with paint, H 1.04m.

of themes also refers to the political differences between Aigina's aristocracy, who modeled themselves on the Homeric heroes, and Athens' democracy, which championed the hero Theseus, but we would be wrong to think that Athenian aristocrats were invisible in democratic Athens or that Athenian aristocrats did not emulate Homeric heroes. Conflict between the two poleis concluded when the Athenians seized Aigina in *c.* 431, evicted the inhabitants, settled Athenians on the island, and at some point installed a new image, perhaps of Athena, in the cella of the Aphaia temple.

Civic spaces and civic heroes in Athens

The development of the Classical Agora, particularly its west side, after the foundation of Athens' democracy in 508/507 was discussed in Chapter 3 (Fig. 3.45). While most civic buildings pertaining to governance were located here, the Athenian assembly of citizens met on the nearby Hill of the Muses in the Pnyx, a massive structure cut into the hillside, which was surrounded by large houses arranged haphazardly, as recognized from cuttings in the bedrock and plaster-lined wells (Figs. 4.6–7).

The number of buildings in the Agora continued to grow after the Persian Wars. Many scholars identify a stoa of *c.* 475–460 BC excavated at the north side of the Agora as the Stoa Poikile, although others prefer to view the structure as the Stoa of the Herms, also mentioned in ancient written accounts, because of the many herms recovered here (Fig. 3.46). The Painted Stoa takes it name from its interior paintings – either on the wall or on portable panels – of mythological events and the Battle of Marathon. Ancient written sources

Map of ancient Athens, second century AD

Fig 4.6 Athens, Pnyx, c. 330 BC, view from the Akropolis.

Fig 4.7 Model of Pnyx, *c.* 450 BC.

attest that the Stoa was used as a display place for military trophies, as a meeting place for philosophers and their pupils (hence the school of *Stoic* philosophy), as a public space for fishmongers, beggars, and performers, as a space for legal proceedings, and as the gathering place for those wishing to be initiated into the Eleusinian Mysteries, one of the most important religious rites in ancient Greece, which took place in nearby Eleusis.

The clustering of structures along the west side of the Agora, the Stoa Poikile and Altar of the Twelve Gods in the north, and the fountain house in the southeast left the rest of the Agora largely open except for a dromos, which bifurcated the open space nearly vertically, and the Panathenaic Way, which ran from the north diagonally to the southeast. Clues from written evidence suggest that the prominent "Tyrannicides" sculptural group was located along the dromos (see Fig. 3.51). When Alexander the Great conquered Persia in the 330s BC, he retrieved the original group and returned it to Athens. The second-century AD travel writer Pausanias (1.8.5) recorded seeing both groups when he visited the Agora.

The original Tyrannicides statues were the first to represent and commemorate verifiably historical figures in the Athenian Agora, and among the few such individuals to be portrayed in fifth-century Greek art. This public honor was accorded to an increasing number of living or recently deceased individuals in

Fig 4.8 Baiae, Museo Archeologico dei Campi Flegrei 174.479 from Baiae, Roman cast of one of the Tyrannicides (cf. Fig. 3.50), *c.* 30 BC–AD 130, plaster, H 21.6cm, W 10.6cm.

fourth-century Athens, but in the fifth century it was extraordinarily rare and indicates the Tyrannicides' importance to the city and its government housed in the same space. What remains of the group is a fragment of the inscribed replacement base made in *c.* 477, Roman marble copies of the group (the second-century AD Roman writer Lucian, *Philopseudes* 18, mentions the presence of the Tyrannicides by Kritios and Nesiotes), and images of the Tyrannicides in other media, such as plaster casts from Baiae in the Bay of Naples of the Roman period (Fig. 4.8) and late fifth-century Attic vase paintings.

The Kritios and Nesiotes group of *c.* 477 exhibits dramatically new poses for free-standing sculpture that express kinetic movement: the two free-standing figures, one bearded and therefore older, lunge forward, one wielding a sword in his outstretched arm, the other with a sword raised over his head, ready to strike. We do not know the precise disposition of the two original figures with respect to each other (were they parallel or at an angle?). Although perceived primarily through Roman copies, their heavy chins and over-emphatic musculature in their abdomens place them stylistically in the Severe Style period. The images of these heroic citizens provided inspiration for young men and citizens walking through the Agora and athletes competing on the dromos in the Panathenaic games, and also had a profound artistic influence in Athens and elsewhere on portrayals of active male figures, who were marked as heroes by their Tyrannicides' poses.

Heroic models at Olympia

Heroes also played an important role at Olympia, where their images provided models for mortal athletes striving for glory (Fig. 4.9). The temple of Zeus was constructed in

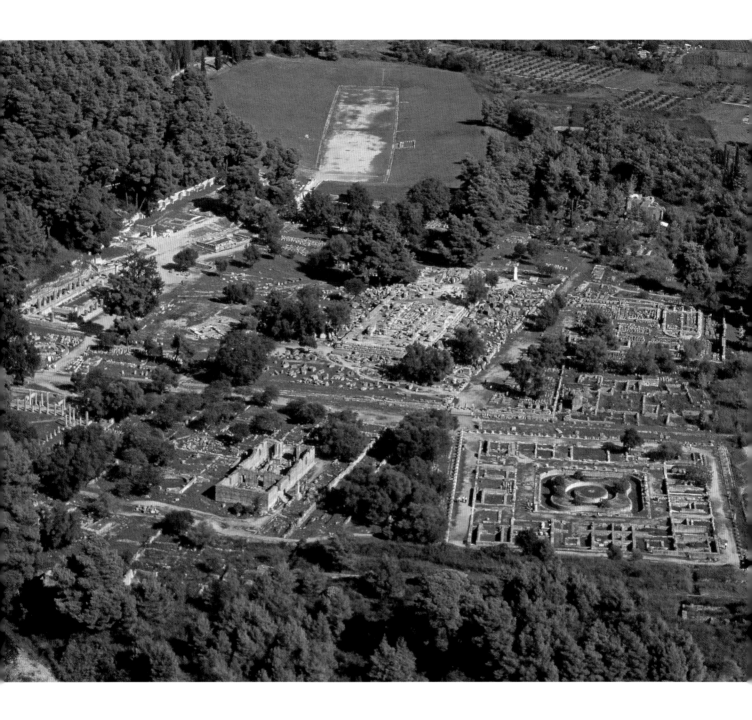

Fig 4.9 Olympia, aerial view.

Box 4.1 Copies of Greek sculpture

Greek sculpture was already being copied by Greeks in the sixth century BC (such as the korai from the Heraion on Samos, figures of the Geneleos group; see Fig. 3.24), but most of the free-standing Classical Greek sculptures seen in museums and elsewhere today are Roman copies; this is especially true for marble, but Roman copies were made in bronze, as well. The Roman copying industry, sometimes employing Greek sculptors, thrived beginning in the first century BC because of the demand for "Greek" sculpture by wealthy Romans eager to display their erudition.

Copies, both Greek and Roman, were made by measuring the original, whose precise measurements were then transferred on to the copy as work progressed. This procedure involved repeated measuring of numerous places on both original and copy from a fixed point or points in the form of a triangle; the evidence of these fixed points can still be seen in the form of small marble knobs or measuring points (with a hole in the center) on sculpture (Box 4.1 Fig. 1). While exact copies could be, and frequently were, taken, Roman sculptors often used the original or casts of the original as a starting point for an adaptation or new type (see, e.g., Fig. 4.8).

Box 4.1 Fig 1 Athens, Agora S2089, unfinished portrait of Alexander the Great, Roman copy of Greek original of the fourth century BC, marble, H 61cm.

the Altis, the sacred area at Olympia, under the patronage of the city of Elis, which controlled the sanctuary during much of the fifth century and had recently won a war against its neighbor, Pisa (Figs. 4.10, 5.18). Pausanias (5.10.3) recounts that the spoils of this encounter funded the temple and that the Eleans employed one of their own, Libon, as the architect. When it was built, the temple of Zeus was the largest structure at Olympia (it was much larger

THE CLASSICAL PERIOD: THE FIFTH CENTURY BC ❧ 207

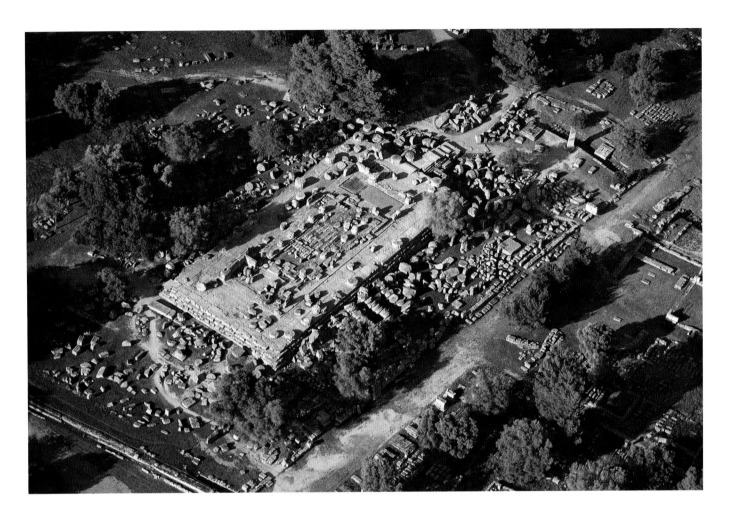

Fig 4.10 Olympia, temple of Zeus, c. 470–456 BC, aerial view, 64.12m × 27.66m.

Fig 4.11 Olympia, temple of Zeus, c. 470–456 BC, plan.

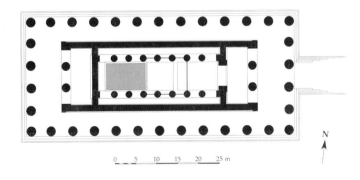

than the earlier "Heraion," see Figs. 3.2–3), indeed the largest temple completed on the Greek mainland at this time, and remained a commanding presence throughout Olympia's antique history. The Doric 6 × 13 peripteros was constructed of local shelly limestone, which was coated with white plaster to imitate more costly marble, then painted (Fig. 4.11). The temple's modest fabric was complemented by a Parian marble roof and painted Parian marble sculpture, a measure of the cost and importance of the project since the marble had to be imported to the Peloponnese, then hauled across land or up the Alpheios River to Olympia.

The temple's west pediment exhibited an arresting and energetic composition of over-lifesize figures engaged in

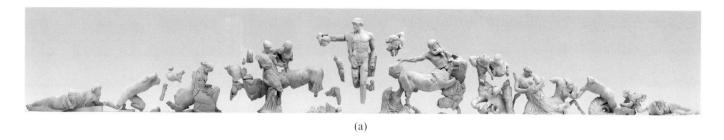

(a)

Fig 4.12a Olympia, museum, west pediment sculptures from the temple of Zeus at Olympia, marble, H (center) 3.30m, L 26.40m.

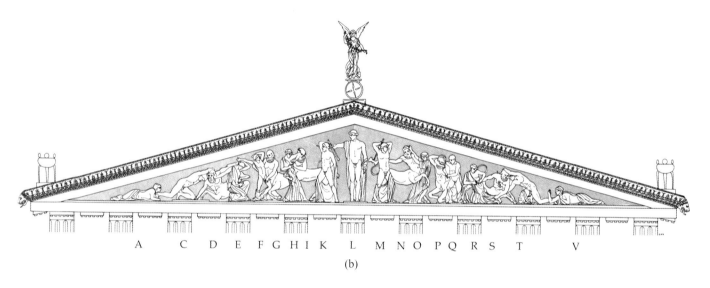

A C D E F G H I K L M N O P Q R S T V

(b)

Fig 4.12b Olympia, museum, reconstruction of the west pediment of the temple of Zeus at Olympia.

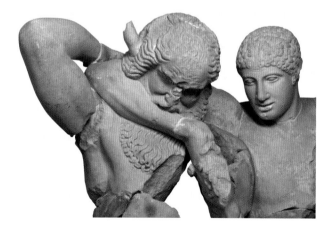

Fig 4.13 Olympia, museum, west pediment figures from the temple of Zeus at Olympia, marble.

the Centauromachy (Fig. 4.12a–b). According to this myth, the Centaurs were invited to the wedding of their neighbor, Perithoos, where they became drunk and began to sexually assault the Lapith women. A fight ensued in which Lapiths, including Perithoos' friend Theseus, routed the Centaurs. The pediment depicts Centaurs battling Lapith men and manhandling Lapith women in a swirl of movement and interlocking figures. The Centaurs' grimaces and snarls are met with their adversaries' impassive, almost pouting, faces (Fig. 4.13). Faces with heavy chins and thickly cut eyelids, together with dynamic movement, heavy doughy drapery (Fig. 4.14), and the use of the more voluminous peplos for female clothing in place of the diaphanous chiton of the Archaic period are hallmarks of the Severe Style. Overseeing the fray is the cool, calm, youthful nude figure of Apollo, who

Fig 4.14 Olympia, museum, west pediment figure from the temple of Zeus at Olympia, marble.

gestures encouragingly to the Lapith men. Although this myth had featured in vase painting prior to this time, it had never before appeared as architectural sculpture, much less as over-lifesize figures, and such a complex and sophisticated composition had never been crafted in three dimensions. The effect on the visitor to Olympia must have been overwhelming. Scholars have noted that several of the Lapiths are depicted in standard wrestling poses, which would have been familiar to athletes, trainers, and much of the audience attending the Olympic games, and one had a cauliflower ear, an injury typical for boxers. In sum, the composition was designed to appeal directly to the athletic competitors by offering models of heroism and courage to them in their physical *agon* (contest).

By contrast, the east pediment is all stillness (Fig. 4.15a–b). Were it not for Pausanias' identification of the subject (5.10.5–7) as the preparations for the chariot race between Pelops and Oinomaos, scholars might still be puzzled since the composition has no artistic parallel. King Oinomaos of Pisa invited suitors to compete in a chariot race for the hand of his daughter Hippodameia. Thirteen suitors had come and failed; Pelops was the fourteenth, and he succeeded thanks to infallible, winged horses provided to him by his former lover Poseidon (love affairs between gods and mortals are not uncommon in Greek myth). Oinomaos (the bearded, older man), Pelops (the unbearded, younger man), Zeus, Sterope (Oinomaos' wife), and Hippodameia occupy the center of the pediment (Fig. 4.16). With the exception of Zeus' central position demanded by his scale, the placement of the other four figures is highly controversial, resulting in more than seventy reconstructions to date. For the purposes of this study, the precise ordering of central figures is less important than the theme and the overall composition of the central group flanked by chariots, seated figures, including two seers (figures L and N), and reclining river personifications in the corners. Both protagonists wear armor; this seems strange equipment for a chariot race but is entirely appropriate for Olympia, where military thankofferings comprising armor, *tropaia*, were abundant;

(a)

Fig 4.15a Olympia, museum, east pediment sculptures from
the temple of Zeus at Olympia, marble, H (center) 3.30m,
L 26.40m.

(b)

Fig 4.15b Olympia, museum, reconstruction of the east
pediment of the temple of Zeus at Olympia.

Fig 4.16 Olympia, museum, temple of Zeus, east pediment
central figures from the temple of Zeus at Olympia, marble.

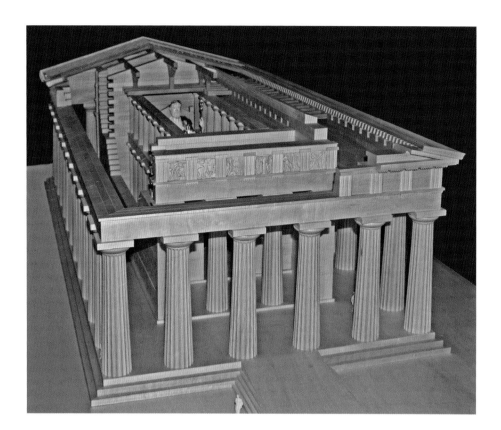

Fig 4.17 Olympia, temple of Zeus, model with view of the metope placement.

it is also noteworthy that contemporary and later writers indicate that the ancient Greeks regarded athletics as the ideal preparation for warfare. Pelops' success brought him not only Hippodameia but also the kingdom of Oinomaos, and we may posit a mythological analogy for the recent historical defeat of Pisa (Oinomaos) by Elis (Pelops, the local hero of Elis). Study of the sculptures' painted details in ultraviolet light has revealed that Zeus held a *tainia* (ribbon) stretched between his two hands, prepared to award this to the victor of this race, which was believed to be the founding event of the Olympic games. Thus, the choice of myth is well suited to the site, and it was in the fifth century that the hippic events became most popular at Olympia.

The temple's twelve metopes, distributed equally above the pronaos and opisthodomos, were carved with the labors of Herakles (Fig. 4.17). Over the course of his adventures, from his first task of killing the Nemean lion to his last, when he fetched the apples of the Hesperides, Herakles ages from a weary, beardless youth to a weathered, mature, bearded man (Fig. 4.18). The labors on the Olympia metopes represent

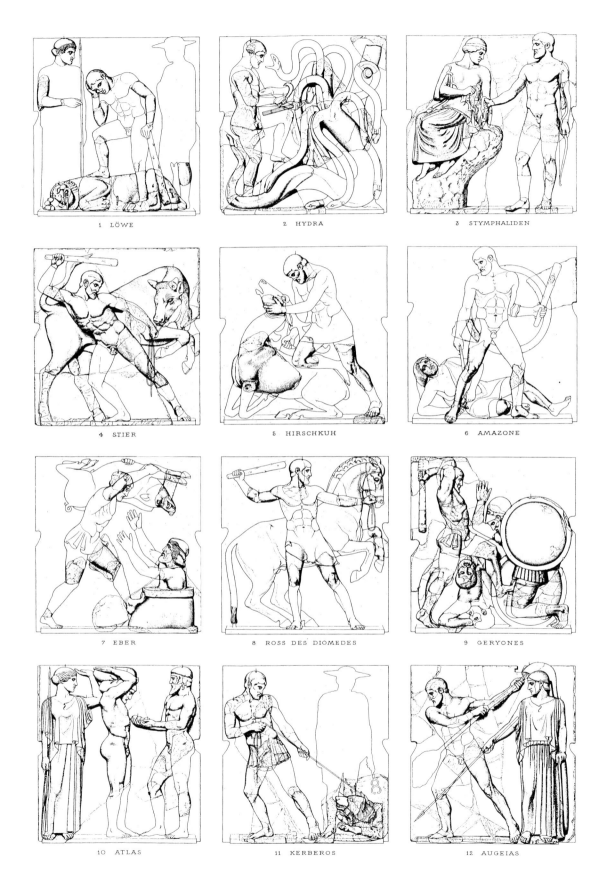

Fig 4.18 Olympia, temple of Zeus, reconstruction of metopes.

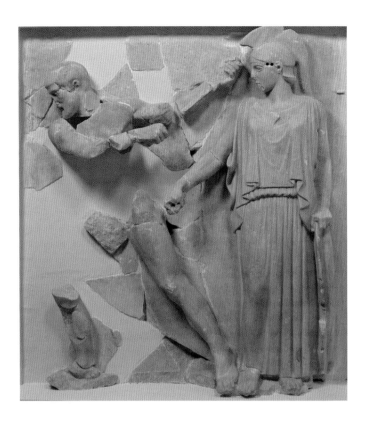

Fig 4.19 Olympia, temple of Zeus, Augean stables metope, marble, 1.60m square.

those accomplished in distant places, as well as those that took place in the Peloponnese. At least one of these labors, the cleaning of the Augean stables, which occurred near Olympia, is new to the repertoire of Herakles' adventures and seems to be a deliberate invention suited to the geographical situation, perhaps inspired by the actual diversion of the Kladeos River some centuries before (Fig. 4.19). Taken as a whole, the Olympia sculptures demonstrate a coherent thematic program suited to their site and designed to encourage athletes to aspire to the deeds and achievements of heroes, such as Herakles, Theseus, Perithoos, and Pelops.

Athletic victors at Olympia were permitted to erect (or have erected for them) statues within the Altis, which was an extraordinary honor: while victors' statues (or their extant bases) have been found at other Panhellenic sanctuaries, they are nowhere near as numerous as at Olympia, which had hundreds. Inscribed bases and written sources indicate the sculptors who created these athletic votives were sometimes prominent craftsmen – Myron, Polykleitos of Argos (see below), Lysippos of Sikyon (see Chapter 5), and Silanion of Athens, to name but a few – an indication of the importance of such statuary and the money invested in it. In addition to altars dedicated to heroes and gods and the temples, sculpted military and athletic victory monuments also dotted the sanctuary. A marble winged Nike gives some idea of the prominent and costly victory monuments that once adorned Olympia (Fig. 4.20). She touches down on a triangular marble base, which towered about 12m high when complete. The inscribed base indicates that the monument, which stood just next to the entrance of the temple of Zeus, was a thankoffering from the Messenians for a military victory probably in 425 BC, and that the sculpture was the work of Paionios of Mende. Other such monuments likened the victors to mythological heroes, especially Herakles in the case of athletes and Trojan heroes for military victories. Thus, the fifth-century Altis should be envisioned as a competitive ground for monuments – athletic, military, and, of course, religious. When an Olympic victor erected a statue at Olympia (or was honored by a statue erected by someone else), he

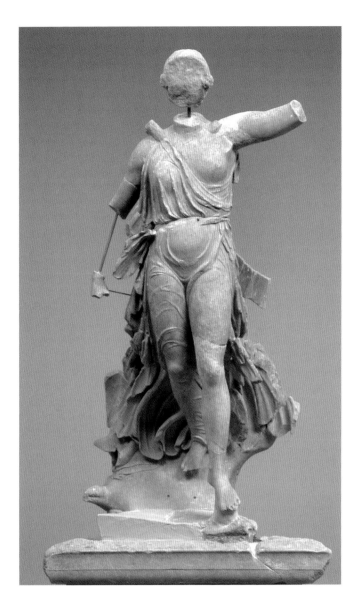

Fig 4.20 Olympia, museum 46–48, Nike of Paionios, *c.* 420 BC, Parian marble, H 1.95m.

joined an elite group of athletic and military victors, mythological heroes, and gods.

Only parts of a few of the many bronze athletic statues that once adorned Olympia have survived, but a well-preserved example at Delphi, which has produced far fewer athletic victory statues, gives some idea of the splendor of these images. The Charioteer of Delphi commemorates a chariot victory in Delphi's Pythian games (Fig. 4.21a–b). The over-lifesize bronze charioteer depicts not the patron, who financed the team and "possesses" the victory, but the charioteer, who was hired to participate in the actual event. The patron commemorated his triumph with a large bronze group of a charioteer in a quadriga drawn by horses. Only the charioteer survives as more than fragments and is one of the few monumental bronze sculptures extant from the Classical period. His inlaid eyes, separately attached bronze eyelashes, and copper-covered lips are still present, and his heavy chin and thick eyelids are characteristic of the Severe Style. He stands quietly, his face an image of poised concentration. With his arms outstretched to hold the reins and the turn of his head and upper torso slightly to his right, he appears alert and attentive. The superb quality of the detailed workmanship of the fillet worn round his head, and of his hair and drapery, as well as the quantity of bronze, point to a costly commission – and we must remember that he was only one figure of several! As discussed in Chapter 3, votives and monuments, such as the charioteer, were designed to impress the thousands of visitors at Delphi, who came for the Pythian games and also to consult the Delphic oracle.

Scholars usually assign the Delphi charioteer to the Sicilian tyrant Polyzalos of Gela (in Sicily), as a commemoration of his chariot race victory in either 478 or 474 BC Recently, however, this view has been challenged and the statue dissociated from the base inscribed with Polyzalos' name, so that the statue's date now can only be fixed *c.* 470–450 BC on the basis of style.

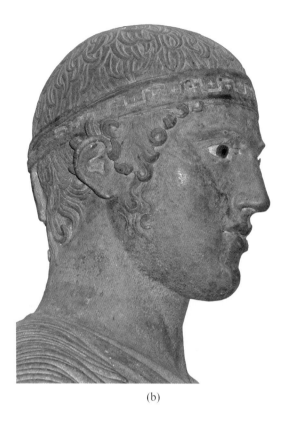

(b)

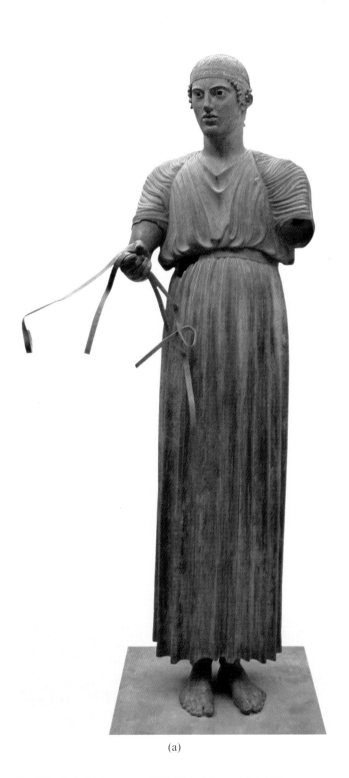

(a)

Fig 4.21a–b Delphi, museum 3484 ("Charioteer of Delphi"),
c. 470–450 BC, bronze, H 1.80m.

Developments in the west

Numerous objects, monuments, and ancient literary sources
attest to the wealth enjoyed by rulers and colonies in fifth-
century Magna Graecia. The generally good state of pres-
ervation of many of the temples here provides evidence for
developments in architecture and architectural sculpture in
the first half of the fifth century outside mainland Greece.
The peripteral Doric temple of Hera II, the largest of the
temples at Paestum, is constructed of stucco-coated lime-
stone (Figs. 4.22–23). The temple's sekos is raised on a step
with a small staircase leading from the pronaos to the slightly
higher cella. The building's longer proportions (6 × 14) and
shorter columns, which have entasis, more closely resemble
proportions of archaic, rather than Classical, temples. But
the latter archaism is offset by the use of a larger number of
vertical flutes in the columns than the norm (24 rather than
20), which gives an illusion of greater height to the struc-
ture. In spite of some old-fashioned traits here, architectural

Map of Italy and western Greece

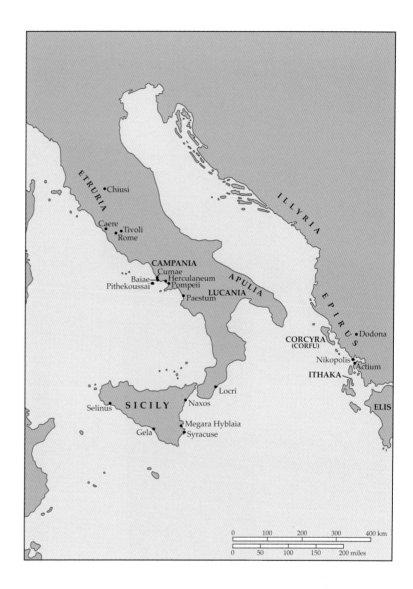

Fig 4.22 Paestum, temple of Hera II, c. 470–460 BC, 59.90m × 24.30m.

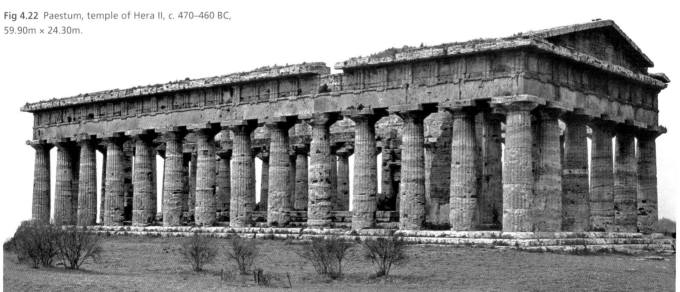

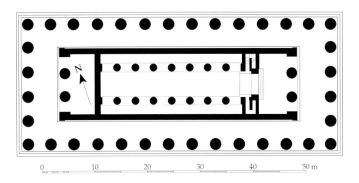

Fig 4.23 Paestum, temple of Hera II, *c.* 470–460 BC, plan.

Fig 4.24 Palermo, Museo Archeologico Regionale "A. Salinas" 3921B, metope from Temple E at Selinus, Artemis and Aktaion, *c.* 460–450 BC, limestone and marble, H 1.62m.

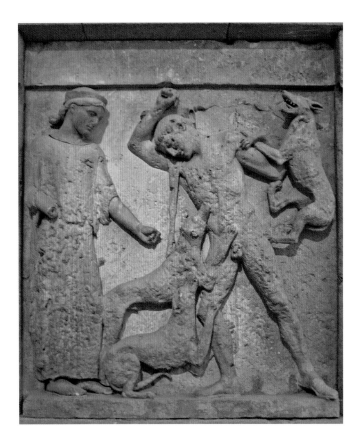

refinements – deviations from the norm – include stylobate and entablature curvature, corner contraction, and inclination of the corner columns. Such refinements (cf. p. 228), perhaps used to counteract optical illusions of sagging floors and ceilings and splayed columns, are widespread on the mainland but uncommon in Magna Graecia, suggesting that the architects at Paestum were taking note of developments further afield.

While there is no evidence of sculptural decoration on the temple of Hera II at Paestum, architectural sculpture is not unusual elsewhere in Magna Graecia. At 1.62m high, the metopes of Temple E, dedicated to Hera, at Selinus, Sicily offer extraordinarily large fields for relief sculpture (Fig. 4.24). These metopes were decorated in the akrolithic technique, which combines several materials: Artemis' flesh – her serene face, neck, arms, and feet – is rendered in marble, while the rest of the metope is of stuccoed limestone. She wears a Severe-Style peplos, and looks on as dogs attack the hunter Aktaion, who struggles to defend himself though his face is calm (he had offended the goddess; therefore, she maddened his dogs, who turned against him). Both figures exhibit contrapposto, and Aktaion's pose is borrowed from the Tyrannicides (Fig. 3.50) while his hairstyle recalls that of the "Kritios Boy" (Fig. 3.59a–b). The technical rendering may be less refined or sophisticated than that of the Olympian metopes (Figs. 4.18–19), but Aktaion's open stance, his focused attention on the dogs attacking his right side, and the threatening poses of the snarling dogs – one is suspended in Aktaion's hand and supports its hindquarters on the hunter's hip – lend energetic animation to the scene.

Terracotta offered another medium for sculpture – architectural and votive, relief and free-standing, ranging from tiny to well over lifesize. At Locri in southern Italy, hundreds of small terracotta plaques depicting various scenes, including wedding imagery, non-mythological abduction scenes, the abduction of Persephone by Hades, and Hades and Persephone enthroned, were deposited in a sanctuary

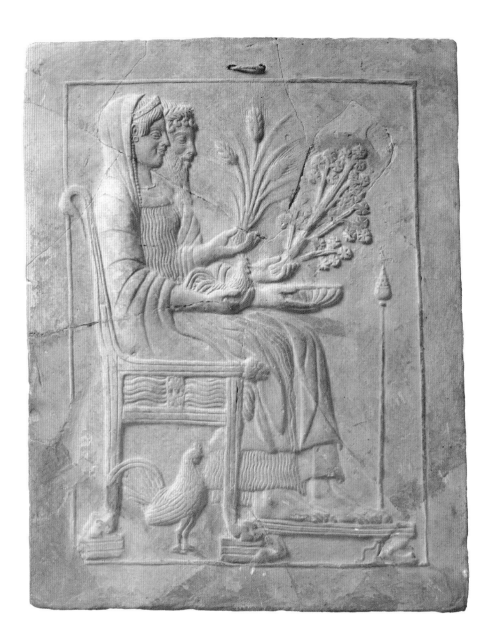

Fig 4.25 Reggio di Calabria, Museo Archeologico Nazionale 21016, pinax from Locri, c. 500–450 BC, Hades and Persephone, terracotta, H 28cm.

to Persephone (Fig. 4.25). The *pinakes* (or painted plaques) are modest products that follow iconographical types also seen on Attic vase painting, and are usually pierced with holes for hanging in the sanctuary. It has been suggested that these votive offerings were made by brides-to-be in the hope of obtaining a happy marriage. While Persephone is usually worshipped together with her mother, Demeter, on the mainland, she is worshipped at Locri with her husband, Hades, where this pair was regarded as the ideal couple, enjoying a marriage to which mortals might aspire. This is a sharp contrast

to the mainland perception of Persephone as a pitiable victim of Hades, trapped against her will in a deadly marriage (cf. discussion of Fig. 3.27), and where brides-to-be traditionally make offerings to Artemis, Aphrodite, and Hera.

Monumental painting and spatial illusion

Ancient written sources recount that the Stoa Poikile (Painted Stoa) in the Athenian Agora, as well as numerous other buildings in Greece, such as the Lesche of the Knidians at Delphi, were decorated with large-scale paintings on walls (or on portable panels affixed to walls), yet none of these fifth-century paintings survives. The written accounts name artists, such as Polygnotos, and subjects and sometimes enumerate characteristics of the paintings. Together with contemporary wall paintings surviving elsewhere and Attic vase painting, this written testimony enables us to obtain some idea of these lost works.

Painted symposion scenes decorated the walls of the Tomb of the Diver at Paestum in south Italy, while the eponymous scene of the tomb, a man diving into a body of water from a platform, was painted on the ceiling (Fig. 4.26). The symposion images are strikingly similar

Fig 4.26 Paestum, Museo Archeologico Nazionale 25103, painted cover slab from Tomb of the Diver at Paestum, c. 480–470 BC, limestone, 194 × 98cm.

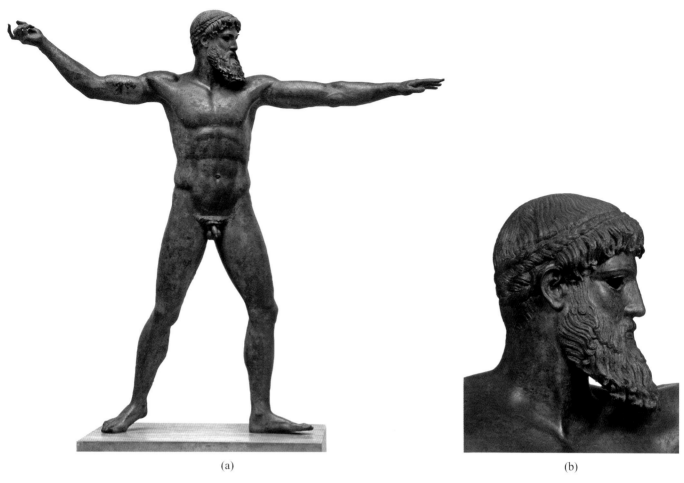

(a)

(b)

Fig 4.28a–b Athens, National Archaeological Museum B15161 ("Artemision god") from the sea near Cape Artemision, *c.* 460 BC, bronze, H 2.09m.

Box 4.2 Bronzeworking technique

Most ancient large-scale bronzes were melted down for other uses, such as coins and weapons, in late antiquity and the post-antique period. While small bronze figurines were usually mold-made, large bronzes in the Classical period were made in the *cire perdue* or lost wax method: the sculptor created a clay model to scale, coated this model with a layer of wax, which was further encased by a layer of clay on top. This then was fired so that the wax melted out through special channels pierced through the outer coating of clay, thus leaving a void between the two clay layers. Bronze was poured into this, and therefore took the form of the model (Box 4.2 Fig. 1). When the bronze cooled, the clay layer outside was removed, then the surface was finished and details added by "chasing" on to the cold metal. The interior clay largely remained and consequently provides useful material for modern scientific analysis.

Some of these steps are visually described on an Attic red-figure kylix of *c.* 480 BC, the name vase of the Foundry Painter (Box 4.2 Fig. 2).

Workers stoke the fire, while another assembles a male figure; on the reverse, two men put the final touches to a colossal bronze, armed male, and in both scenes, tools and models hang on the foundry walls. In the tondo is the master bronzeworker, Hephaistos, who presents divinely forged armor to Thetis, who, in turn, will give it to her son Achilles, waiting at Troy. By the juxtaposition of the tondo scene with the artisans on the exterior of the cup, the artist conveys the idea that bronzeworking is a kind of divine art.

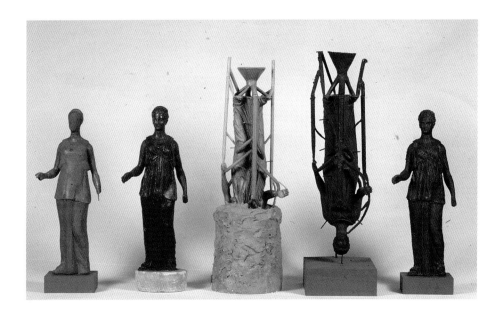

Box 4.2 Fig 1 Diagram of bronzecasting technique created by Christos Chatziliou and National Museum colleagues.

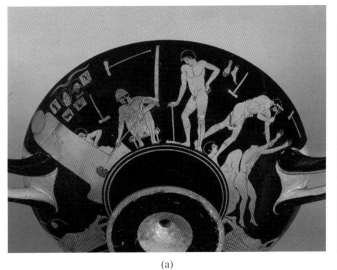

(a)

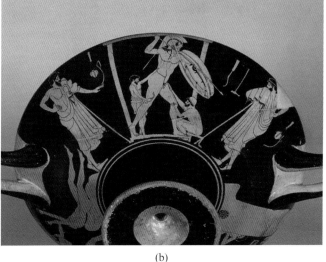

(b)

Box 4.2 Fig 2a–b Berlin, Antikensammlung F2294 from Vulci, Attic red-figure kylix attributed to the Foundry Painter (name vase), c. 490–480 BC, terracotta, D 30.5cm.

pivoting, at the moment of greatest tension. He stands poised on the ball of his right foot and the heel of his left as his torso turns to his left. His arms are outstretched to his sides – the right holds an object (now lost), which he is about to release, the left hand is downturned for balance – as he gazes intently along the line of his left arm. This pregnant moment is typical of early Classical sculpture, such as the east

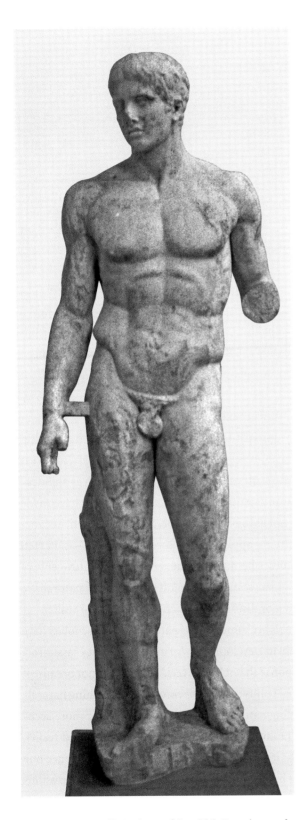

Fig 4.29 Minneapolis, Institute of Arts 86.6, Doryphoros of Polykleitos, Roman copy of Greek original of *c.* 450–440 BC, marble, H 1.98m.

pediment of the temple of Zeus at Olympia (Fig. 4.15a–b). The careful rendering of muscle, flesh, and bone structure animate the god's concentrated visage in spite of the absence of the original inlaid eyes. The god's long hair is braided and tied up, offering a venue for the sculptor to display his impressive skill in metal chasing (cf. Fig. 4.21a–b). The figure's size, nudity, and action point to it being a god – Poseidon throwing a trident or Zeus hurling a thunderbolt. The numerous archaic small-scale bronzes of Zeus hurling a thunderbolt show him in nearly the same position, which would seem to weigh in favor of him, as does the shape and size of the area formed by his partially closed hand. Where this statue originally stood just after it was made is also unknown, but display in a sanctuary would be in keeping with what is known of other statues of divinities at this scale.

Equally revolutionary though entirely different in impression is the Doryphoros (spear-carrier) by the sculptor Polykleitos from Argos. This free-standing figure is known today only from Roman copies in bronze and marble (Figs. 4.29–30); the original, perhaps of bronze, was created *c.* 450 BC. The nude male stands in contrapposto, his relaxed left leg drawn slightly behind him and poised on flexed toes, as if he had paused while walking or was about to step forward. His right arm hangs loosely at his side, his left is raised to support a spear (not extant) on his left shoulder. Rather than an essay in stop-action motion, like the Artemision god, the Doryphoros is a study of contrasts of tension and relaxation in an effort to depict the human form in less dramatic, but natural, movement. This is a key characteristic that signals the change from Severe to high Classical style.

Ancient authors record that Polykleitos wrote a treatise, the *Canon* (now lost), about his work, which described a sculpture of the same name that exemplified his principles of design. What little has been gleaned of Polykleitos' thought from the brief mentions in other ancient authors impels scholars to identify the Doryphoros with the Canon, which may have been used as a workshop or teaching model by this sculptor. We know that Polykleitos displayed an interest in design and proportion, and in the mathematical properties of the ideal form. The figure is rendered in a 7:1 head to body ratio, which becomes standard in Greek sculpture for the next century or so, and in a diagonal or chiastic (from the Greek letter *chi* or X) balance of tension and relaxation: the weight rests on the supporting right leg while the left arm

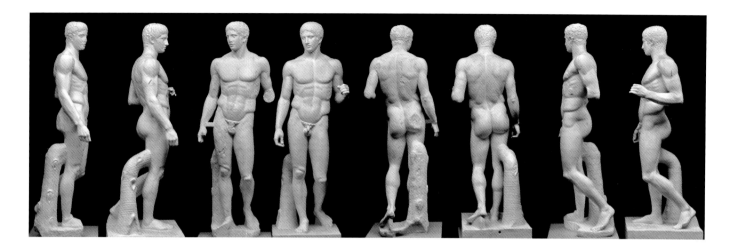

Fig 4.30 Berlin, Abguss-Sammlung der Freie Universität Berlin, plaster casts of the Doryphoros (see Fig. 4.29) in Naples, Museo Nazionale and that in Minneapolis, Institute of Arts.

also is tensed, and the relaxed left leg is matched by the right arm. The effects of tension and relaxation are carefully recorded in the uneven hips and shoulders and his arrested, asymmetrical movement; his frontality is disrupted by the slight turn and inclination of the head to the right, which creates an air of contemplation (the slightly parted lips add to this effect). Rather than a pregnant moment, we see movement, recorded with measurable precision.

This intellectual approach to art-making, the striving for an ideal form, is one of the hallmarks of mid-fifth-century BC art, and it is manifested not only in sculpture but in other media, such as architecture. The fourth-century sculptor Lysippos was reputed to have made men as they are and not as they appear to be, as was the practice of earlier sculptors. The latter – appearance, rather than reality – is, in fact, an excellent way to describe many of the tendencies of fifth-century art, which strove to create something that is convincingly naturalistic often by manipulating or distorting the actual substance or reality.

Classical sculpture is acclaimed for its naturalism, and scholars have endeavored to explain its development. An initial glance at Classical art often evokes the response that it looks "real." It does, but not because it reproduces any actual reality; rather, it reproduces something naturalistic, that is, resembling nature but not photographic – or more accurately, since photography is easily manipulated – documented reality. It is even more apt to refer to Classical sculpture as idealized since one rarely sees anything but youthful, fit bodies with somber expressions and nearly interchangeable facial features. By comparison with archaic free-standing sculpture, the Classical Charioteer of Delphi or Doryphoros looks remarkably life-like, animated, natural. But few human

bodies are chiseled with the muscular precision and symmetry of the Doryphoros, and were the Charioteer stripped of his garment, his legs would be found to be ostrich-like in comparison to his body. The reality is distorted to create an ideal form, yet the image appears plausible to the eye when measured against reality.

What caused this preference for naturalism can only be hypothesized. Scholars postulate that increasing medical knowledge together with contemporary philosophy are factors, but these cannot be the only explanations since we have already witnessed naturalism in sculpture *c.* 530 BC (the formerly touted equation of democracy with naturalism is a *non sequitur*). It was not a sudden change, as the temple of Aphaia sculptures make clear, nor did it first occur after the institution of democracy in Athens in 508/507 BC. And, of course, naturalism is already present much earlier in archaic sculpture, which increases in naturalism over time; this kind of naturalism may seem stiff by comparison with that of the Classical period (which is often much more than naturalism: idealism or heightened naturalism). Diodoros, writing in the first century BC, describes the innovations of the legendary Athenian artist Daidalos, who was imagined living far in the distant past in the time of the early kings of Athens or of Minos of Crete, in the Bronze Age or so. Diodoros (4.76.2–3) says that:

…later generations preserved a story to the effect that the statues (ἀγάλματα) which he created were exactly like living beings…they could see and walk, and preserved so completely the disposition of the entire body that the statue produced by art seemed to be a living being. Because he was the first to represent the eyes open and the legs separated as they are in walking, and also to render the arms and hands as if stretched out, he was marveled at…For the artists who preceded him used to make their statues with the eyes closed, and with the arms hanging straight down and attached to the ribs. (trans. J. J. Pollitt)

From this description, Diodoros could be writing about archaic korai and kouroi or Minoan objects or the Doryphoros. All are naturalistic when compared with what preceded them, and, in the case of the Minoan sculpture, what followed. Naturalism is a relative term, not a fixed value. Indisputably, Classical sculpture is more naturalistic more consistently than what precedes it, but naturalism is not a Classical invention.

Classical Athens: the Akropolis

Nowhere is high Classical intellectualism more apparent than in the architecture of the Parthenon on the Athenian Akropolis. With the

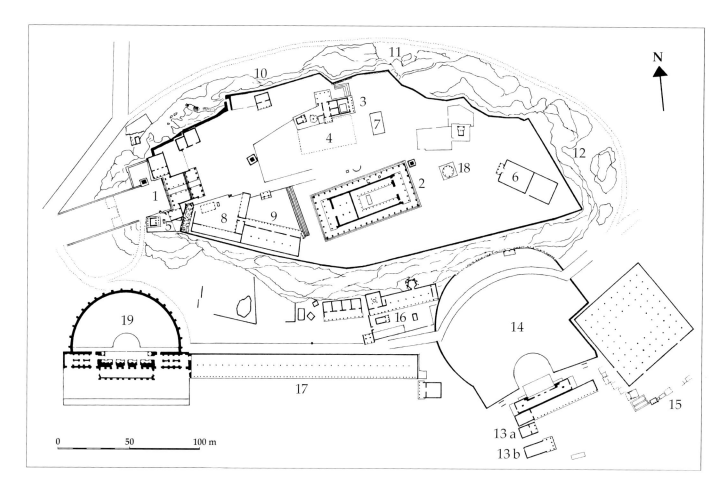

Fig 4.31 Athens, Akropolis, plan, c. 400 BC 1. Propylaia; 2. Parthenon; 3. Erechtheion; 4. Dörpfeld foundations; 5. Athena Nike temple and altar; 6. Pandion; 7. posited position of altar of Athena; 8. Artemis Brauronia sanctuary; 9. Chalkotheke; 10. Cave of Pan; 11. Aphrodite and Eros sanctuary; 12. Aglauros sanctuary; 13a. first temple of Dionysos; 13b. second temple of Dionysos; 14. theater of Dionysos; 15. Street of the Tripods; 16. Asklepios sanctuary; 17. stoa of Eumenes; 18. dedication (monopteros) to Roma and Augustus; 19. Odeion of Hendas Atticus.

Delian League funds firmly ensconced in Athens after 454 and income from the silver mines in southern Attika, Athens had a ready supply of money, which, instead of being applied solely to military defense, was tapped to finance new building projects on the Akropolis in the second half of the fifth century BC. (Fig. 4.31). The leading *strategos* (general) of Athens, Perikles, spearheaded the effort. These buildings, which replaced several destroyed by the Persians, demonstrate Athens' confidence and power as a military and social entity, as well as the city's civic and religious ideology, and served as a defiant rebuke to the Persians and the enemies of Athens.

Parthenon

The Parthenon's construction exhibits an intense interest in the intellectualization of architecture (Figs. 4.32–33). Building accounts indicate that work on this temple dedicated to Athena Parthenos began in *c.* 447 BC and finished in *c.* 432 BC. The architects Iktinos

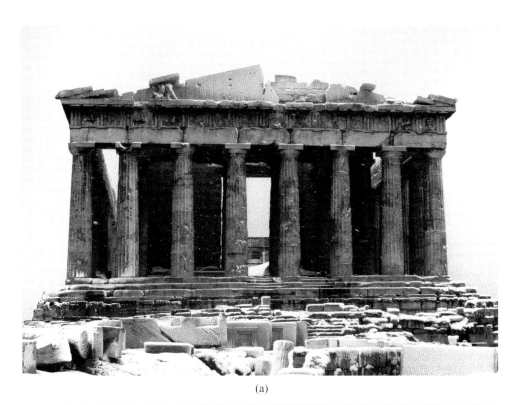

(a)

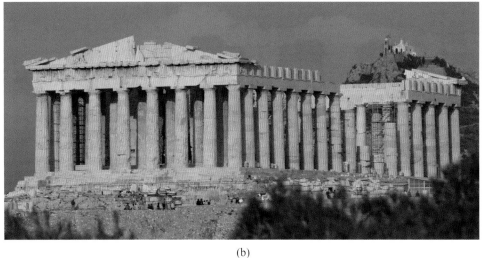

Fig 4.32a–b Athens, Akropolis, Parthenon, Pentelic marble, 26.19 × 69.61m.

(b)

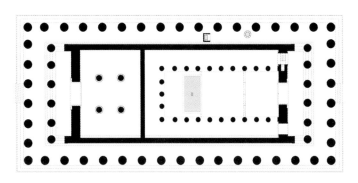

Fig 4.33 Athens, Akropolis, Parthenon, plan.

and Kallikrates designed a Doric, 8 × 17, structure of Pentelic marble; the temple's ratio of columns can be expressed as 2x +1, with x being the number of columns on the short sides. This change from the archaic standard of a long, narrow structure to a less elongated and wide design became canonical in the fifth century BC. Like most Greek temples, the Parthenon sits on the foundations of its immediate predecessor (slightly adjusted here: widened at the north and truncated at the east), the Pre-Parthenon (Figs. 3.51–52). Another indication of this reverence for the past, both religious and historical, is the careful design of the Parthenon's north side to incorporate an ancient shrine, probably of Athena Ergane, present since the earliest structure on this site, into the north colonnade. Furthermore, the Parthenon also includes some of the soot-stained, scorched blocks of the Pre-Parthenon, still visible today, while column drums of the Pre-Parthenon were built into the north fortification walls of the Akropolis, a clear reminder of what was destroyed by the foreign invader (Fig. 4.34; additional architectural members incorporated in the north wall derive from the temple that once sat on the Dörpfeld foundations).

The Parthenon combines both Doric and Ionic elements. The Doric peristyle encloses a pronaos and opisthodomos with Doric columns in antis, a cella with a Π-shaped Doric colonnade surrounding the cult statue, and an adyton with four Ionic columns behind the cella. The Parthenon's design includes more refinements than in any previous building (cf. p. 217), including stylobate and entablature curvature, column inclination (diagonally at the corners), and corner contraction, with the result that there is not a single straight line in the building; theoretically, such refinements require that every block in the building has only two possible places: its own and its mirror image on the structure. The work was done so carefully that the deviation in measurements between like members is never more than a few centimeters. The design and its execution constitute a mathematical, intellectual, and technical feat of the highest order.

The sculptor Pheidias supervised the building's sculptures, also of painted Pentelic marble. Although they were installed in their positions last, the pediment sculptures would have been the most eye-catching feature to a fifth-century BC visitor. Unfortunately, they survive in very poor condition, particularly on the east, as a result of centuries of damage and, in particular, an explosion in 1687 from a

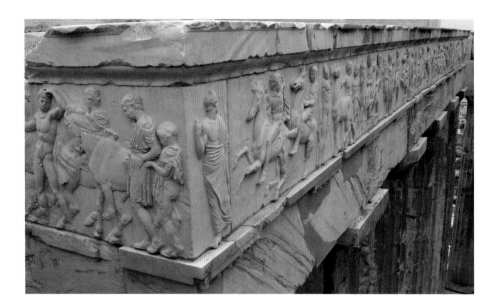

Fig 4.40 Athens, Akropolis, Parthenon, Ionic frieze *in situ* seen from northwest corner, Pentelic marble, H (frieze) 1.06m.

A continuous Ionic sculpted frieze circled the core of the building – its 160m length (129.5m survive) wrapped around the exterior of the sekos, passing over the pronaos and opisthodomos columns in antis and around the top of the cella wall (Figs. 4.33, 4.40). With a roof above it and visible only from an angle, the frieze was not so easy to see, but as was the case with the other sculptures on the temple, paint and attachments in bronze helped compensate for this. Details of the surviving architecture and the guttae lining the bottom of the Ionic frieze above the pronaos and opisthodomos suggest that the sculpted Ionic frieze was not part of the original plan, which called for a Doric frieze at this place (cf. the Doric frieze in this position at the temple of Zeus at Olympia, Fig. 4.17). According to this thinking, the change was made when the columns of the east pronaos were nearly complete and required them to be dismantled and adjusted westward several centimeters. This hypothesis, however, has been challenged: some scholars think the continuous Ionic frieze was planned from the very start. Whichever was the case, the Ionic frieze was considered important and worthy of enormous trouble and expense in spite of its awkward viewing angle.

The frieze is carved in low relief (5cm deep) with a figural procession that begins at the southwest corner of the sekos (Figs. 4.41–42): one file of participants moves along the west side of the temple, then down the north, while a second proceeds down the south side; the two portions converge on the east frieze. Approximately the first third of the procession is dominated by male riders and their cantering

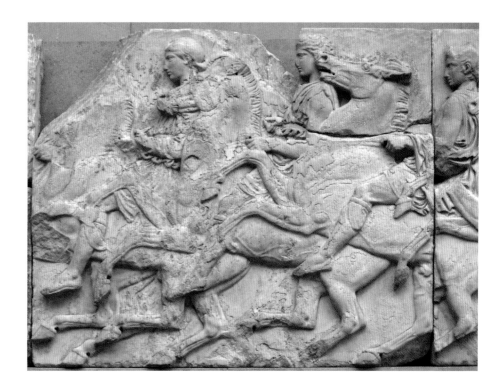

Fig 4.41 London, British Museum, Parthenon north frieze XL.109–XLI.112, Pentelic marble, H 1.06m.

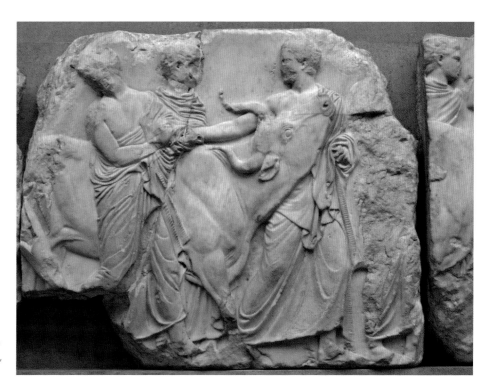

Fig 4.42 London, British Museum, Parthenon south frieze XLIV.133–XLV.137, c. 442–438 BC, Pentelic marble, H 1.06m.

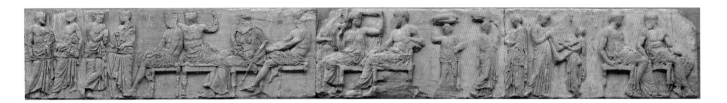

Fig 4.43 London, British Museum, Parthenon east frieze, IV.20–V.37, marble, H 1.06m.

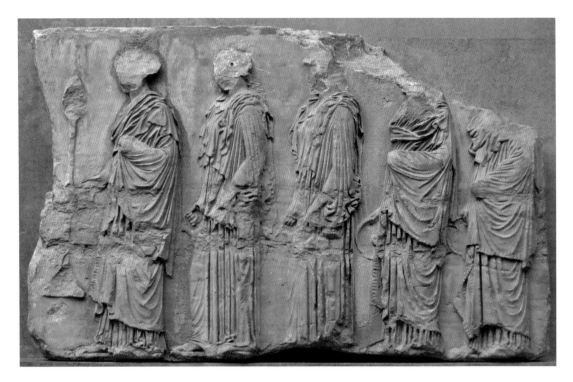

Fig 4.44 London, British Museum, Parthenon east frieze, VIII.57–61, marble, H 1.06m.

mounts, who yield to figures on foot bringing animal sacrifices and offerings as the file approaches the east side of the building. Here, standing officials and languorously seated Olympian deities, identifiable by their attributes or placement, frame a central scene that revolves around the folding or unfolding of a cloth, a peplos (note that the deities turn away from the central scene and toward the procession participants) (Figs. 4.43–44). This is a religious procession, but scholars have debated precisely which one for more than a century. The earliest interpretations viewed it as a depiction of the Panathenaia, the festival in honor of Athena, perhaps even a contemporary Panathenaia. Critics were quick to point out that particular elements known to be part of the procession, for example, a wooden ship with the peplos used as a sail, were nowhere to be found on the frieze (although the written sources for the festival date centuries after the frieze); that

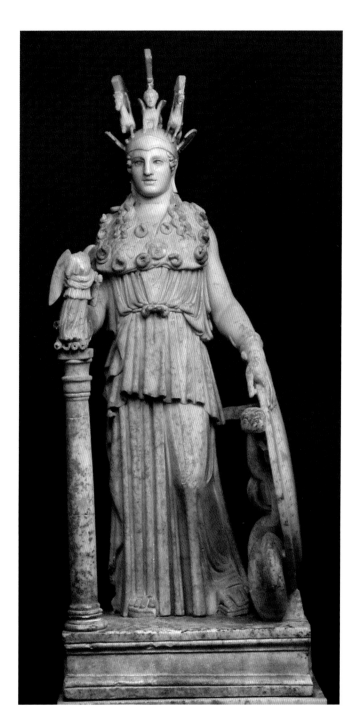

Fig 4.45 Athens, National Museum 129 (Varvakeion Athena) from Athens, c. AD 200–250, Pentelic marble, H 1.05m.

constituents who had no part in the procession, such as the cavalry, were included; and that the use of contemporary Athenians as components of the architectural sculpture of a temple is unprecedented (although numerous monuments and forms of cultural expression of this period are unprecedented). More recently, other suggestions for the frieze's theme have been made, the most convincing of which sees it as a compendium of several different Athenian religious festivals, including the Panathenaia, the City Dionysia, and the Arrhephoria in the center of the east frieze. This hypothesis accounts for all that is present on the frieze without requiring elements that are absent.

The figures' somber faces and restrained demeanor contrast with the excitable horses and sacrificial animals. Nearly all the human figures, with the exception of the eponymous heroes or administrators – the mature men standing on the east frieze – are youthful and idealized, with almost identical faces and bodily proportions. The horses are vastly too small for the men who ride them, but this discrepancy really only registers when it is pointed out; otherwise, the illusion of naturalism is completely convincing, perhaps because of the spectator's viewing angle from 12m below.

The colossal chryselephantine cult statue of Athena Parthenos, finished by Pheidias in c. 438 BC, no longer survives but is known from ancient written descriptions and small-scale replicas in other media (Fig. 4.45). It stood 12.2m high and had drapery made of gold sheets and flesh of ivory, all supported on a framework of timber (Fig. 4.46). Athena held an image of Nike (1.83m high) in her outstretched right hand, a snake curled beneath, and a shield leaned against her left side, as clearly indicated by the earliest replica on a clay token of the fourth century BC found in the Athenian Agora (Fig. 4.47). Three of the four Parthenon metope themes were reiterated on the cult statue: the Amazonomachy appeared in relief on the exterior of the shield, the Gigantomachy was painted on the shield's interior, and the Centauromachy was rendered in relief on the goddess's sandals. One would expect the sack of Troy somewhere as a match to the north metopes, but instead, the statue base was adorned with figures, either

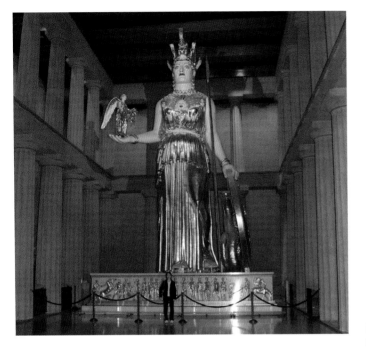

Fig 4.46 Nashville, Parthenon, interior with reconstructed Athena Parthenos.

Fig 4.47 Athens, Agora MC1353, clay token with Athena Parthenos from the Athenian Agora, fourth century BC.

Box 4.4 The first woman

As part of Prometheus' punishment for stealing fire from the gods and trying to deceive Zeus, Zeus ordered the creation of the first woman, Pandora. She was a mixture of earth and water fashioned by Hephaistos and adorned by Athena and other deities, including Aphrodite, who gave her beauty and desirability, and Hermes, who added a deceitful nature and a scheming character. Thus, Pandora is a καλὸν κακόν or beautiful evil. She was given a jar and warned not to open it, but in typical female fashion – so the Greeks imagined – she was unable to control her curiosity and consequently released all evil into the world; only hope remained within the jar. Zeus announced that her husband, Epimetheus (i.e., mankind), would be unable to live without her (i.e., woman), but living with her would bring nothing but misery. Yet, as the Athenians recognized, women are necessary for the production of children, i.e., future citizens, and they perform important religious functions. As a work of techne, handcrafted by Athena and Hephaistos, who are also the progenitors of all Athenians, Pandora was a suitable choice to stand beneath the feet of the virgin goddess in the Parthenon (see. Figs. 4.45–47).

in relief or separately attached, depicting the birth of Pandora, the first woman.

The building's sculptures offer a celebration of Athenian achievement, as well as a meditation on civic virtues, including religion, as expressed by Greeks – especially Athenians – fighting rebellious forces.

The history of Athens and its choice of patron deity, her birth and achievements, are central to the program, as well. Among these numerous themes, women play important roles in the sculptures: on the west metopes and the exterior of the Athena Parthenos shield, Amazons try and fail to invade the citadel of Athens, the heart of the patriarchal city, and threaten its male populace. Directly above the metopes, in the divine realm of the west pediment, the female deity Athena triumphs over her male antagonist, Poseidon. By contrast, the east metopes on the front side of the Parthenon reveal a divine order challenged by uncivilized Giants, who are soundly defeated by the Olympian gods, including Athena, who, like the Amazons, is androgynous but whose extraordinary status is justified by her divinity and paternity. The Lapith women on the south metopes virtuously struggle to maintain their chastity against the unwelcome, uncouth advances of the barbarian Centaurs at a wedding celebration. These women embody female vulnerability and modesty, and their plight permits the Lapith men to demonstrate heroic action and courage. The Ilioupersis on the north metopes presents the destruction and chaos wrought by the power of a beautiful and seductive woman, Helen, the putative cause of the Trojan War, who is worthy of both contempt and fear because her sexual potency can lure men to their deaths. And Athenian women participate in civic religious ritual as procession participants and in the peplos scene on the frieze.

Pandora is both the source and summary of these female characters. Women were necessary to the survival of the city – without them, there were no new citizens, soldiers, or workers, and they are critical to civic religious rites – yet to judge from literature, legal documents, speeches, and visual evidence, the contemporary perception of them was tinged with anxiety: women's seemingly irrational emotional nature, curiosity, and sexuality had to be kept in check (by their male superiors), or they could, and surely would, bring disaster to their families and community. In sum, the temple's sculptures are a skillfully orchestrated ensemble of myths, carefully juxtaposed to demonstrate civic ideology.

Propylaia

While the Parthenon was still under construction, the architect Mnesikles designed a new propylon or gateway to the Akropolis, and the Propylaia also housed several sanctuaries in their original positions

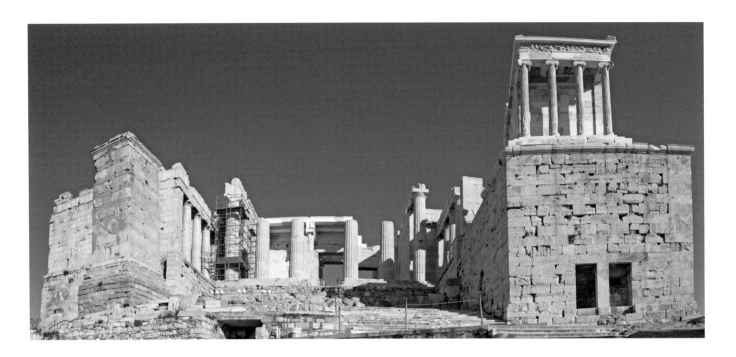

Fig 4.48 Athens, Akropolis, Propylaia, view from west, c. 438–432 BC.

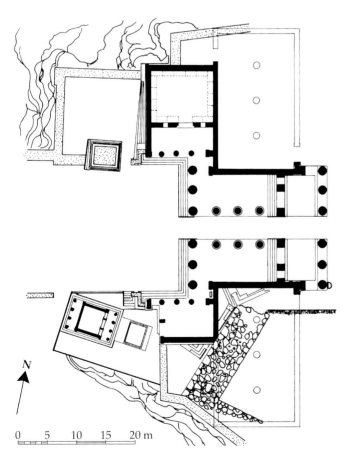

Fig 4.49 Athens, Akropolis, Propylaia, plan.

under its roof. This Classical structure changed the orientation of its late archaic predecessor (damaged by the Persians in 480) so as to direct the visitor toward the north side of the Parthenon and the pathway leading to the Altar of Athena (Figs. 4.31, 4.48; cf. Fig. 3.39). Although intended as a symmetrical building with a long monumental ramp leading up to a main structure flanked by two wings, what was actually built was quite different, perhaps a disappointing series of compromises for Mnesikles (Fig. 4.49). The ramp was truncated, the southern wing was sharply curtailed to yield to the shrine of Athena Nike, which had existed on this spot since at least the mid-sixth century BC, and the structure was never completed. The central portion bore the appearance of a Doric temple façade with a pediment and six columns on east and west; widely spaced central columns allowed for easier passage of traffic through the gate, so we see a canonical rule (evenly spaced central columns) of the Doric order broken. Because the gateway was built on sloping terrain, Mnesikles designed the central core

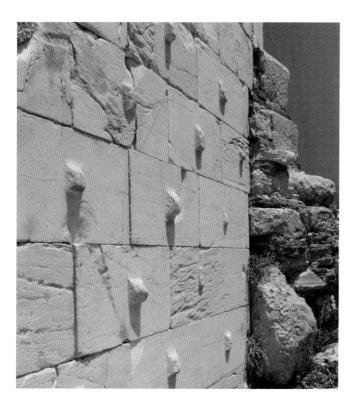

Fig 4.50 Athens, Akropolis, Propylaia, south side with lifting bosses, *c.* 438–432 BC.

on two levels with stairs joining them and covered it all with a stepped roof. He cleverly employed three Ionic columns, which were thinner and taller than the Doric columns on the west façade, on either side of the central interior passage to support the roof and allow for the maximum interior space. The north wing, fronted by three Doric columns with a room behind, appears to have been a dining area for important visitors and officials to judge by its offset doorway, which allowed the accommodation of couches around the walls. The south wing should have been its mirror image but was abruptly truncated to allow space for the altar of Athena Nike nearby. Lifting bosses used to raise heavy blocks with ropes remain on the south side of the building (Fig. 4.50); these were normally sheared off in the finishing process, and their presence here is one clue that the Propylaia is unfinished (though it has been suggested that they were left as a form of ornamentation, a practice that became common in the later fourth century and the Hellenistic period; if this *is* intended as decoration, it is a first in Greek architecture). The entire structure was built of Pentelic marble save for details, such as window sills in the north wing, *orthostates*, and door thresholds, which were added in blue Eleusinian limestone, a material also used elsewhere for highlights and decorative purposes.

Temple of Athena Nike

Concern for the past also figured in the construction of the fifth-century temple of Athena Nike (Figs. 4.31, 4.51a–b). The building was begun at the same time as the Propylaia, 438 BC, as indicated by the foundations for both structures, which were laid simultaneously. This small Ionic structure, also of Pentelic marble, sits atop a bastion jutting out from the Akropolis that marks the site of the ancient Mycenaean wall, the remains of which were incorporated into the bastion. The tetrastyle amphiprostyle (four columns on opposite sides fronting the core of the building) structure, facing east toward the temple's altar, had a single room behind the columns; in other words, the usual pronaos and entryway into a temple cella

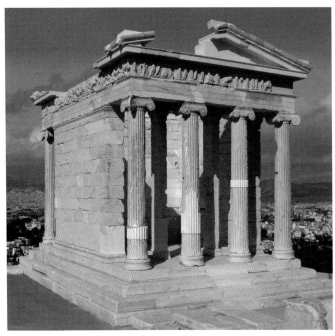

(a)

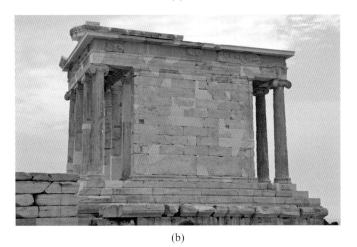

(b)

Fig 4.51a–b Athens, Akropolis, temple of Athena Nike, view from east, c. 438–424 BC, Pentelic marble, 5.40m × 8.17m.

was reduced or compressed to two pillars placed between the antae. The temple housed the archaic cult image of Athena, doffing her helmet with one hand while holding a pomegranate in the other, as we know from written sources (the statue itself, chiefly of wood, does not survive). The Ionic friezes on the four sides of the structure were adorned with relief sculpture depicting scenes of Greeks battling other Greeks on the north and west friezes; Greeks battling easterners (as indicated by their attire and armor), perhaps Persians, on the south frieze; and an assembly of gods on the east frieze (cf. Fig. 3.16; Fig. 4.43). If these are actually Persians on the south frieze, then the frieze may be the first "historical" theme (as opposed to mythological; the Greeks did not distinguish between "history" and what we refer to as their "mythology") to appear on a religious structure in the Greek world (Fig. 4.52). Even after the fifth century, historical images rarely occurred in Greek architectural sculpture, particularly on sacred buildings. When compared with earlier sculpted friezes, such as those on the Parthenon (Figs. 4.40–44) or Siphnian Treasury at Delphi

Fig 4.52 Athens, Akropolis Museum, temple of Athena Nike, block g of the south frieze, c. 427–424 BC, Pentelic marble, H 45cm.

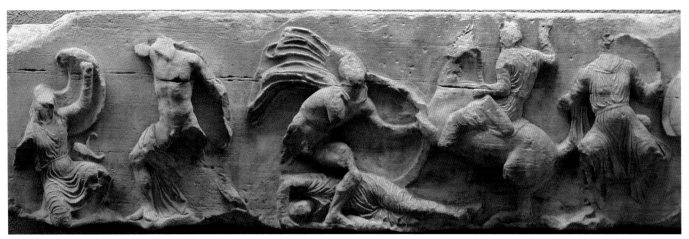

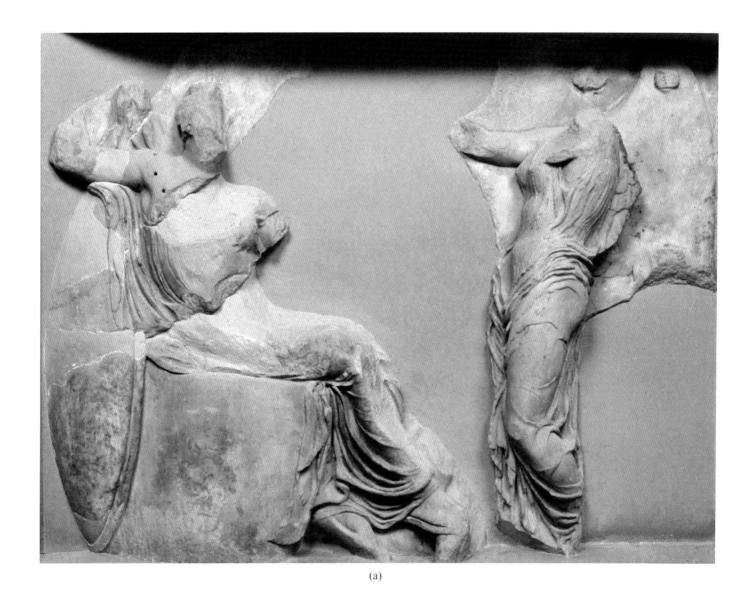

(a)

Fig 4.53a–b Athens, Akropolis Museum 973, a. Nike approaching seated Athena; b. "Sandalbinder" from the parapet around the temple of Athena Nike, *c.* 410 BC, Pentelic marble, H 1.06m.

(Figs. 3.14–16), the three battle friezes of the Nike temple have a considerable area of empty space around the figures, who are energetically engaged in combat. There are numerous bodies – injured or dead – on the ground level, the warriors' drapery flies out behind them in splayed folds, and diagonal lines formed by the figures' positions dominate the composition.

Sometime after *c.* 410 BC, a marble parapet, 1.50m high, with a metal grill surmounting it, was added around the Nike temple to prevent mishaps by those who wandered too

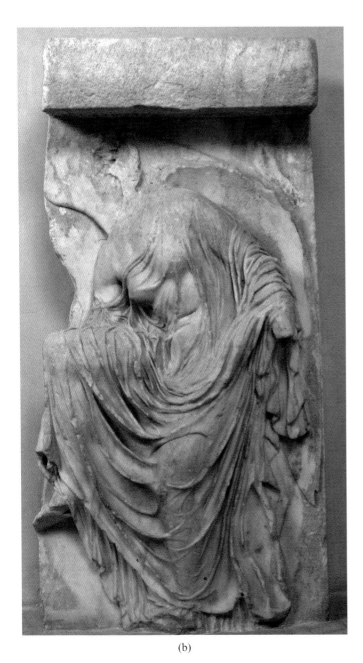

(b)

Fig 4.53b *(continued)*

close to the edge of the bastion. Relief sculpture ornamented the exterior of the parapet: Nikai leading bulls to sacrifice, adorning military trophies, and approaching Athena (seated) (Fig. 4.53a–b), appropriate imagery for a temple erected in honor of an Athenian military victory in the Peloponnesian War (though precisely which is unknown), a message reiterated in the temple's friezes. The "wet drapery" style is well illustrated by a Nike adjusting or removing her sandal, where clothing both conceals and reveals the body beneath (Fig. 4.53b).

Erechtheion

Religious conservatism may explain the peculiar, extraordinarily innovative, design of another of the fifth-century Akropolis buildings, the Erechtheion. The Ionic temple of Pentelic marble is one of the most extraordinary of antiquity and, like the Parthenon, reflects the fifth-century Athenian interest in the city's early history and in preserving its religious traditions (Fig. 4.54). Its asymmetrical plan and construction on two different levels were necessitated by the desire to preserve cult sites that stood within it and nearby (Fig. 4.55), and there are scholars who believe that Mnesikles, architect of the Propylaia (which also required accommodation of earlier existing cults), also designed this structure.

The east façade resembles a typical prostyle temple with six Ionic columns, but this is the only conventional façade of this structure. Housed within the eastern half of the building was the ancient olive-wood statue of Athena Polias, the image that received the peplos in the Panathenaia. The temple also included shrines for Erechtheus, Poseidon, Boutes (a hero who founded one of the priestly families serving Athena Polias), and Hephaistos. The projecting porch on the south side, with caryatids in place of columns, is particularly striking for its

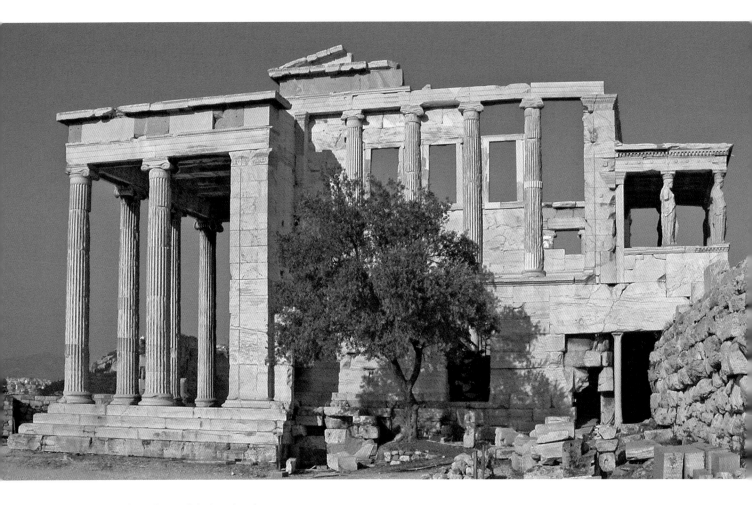

Fig 4.54 Athens, Akropolis, Erechtheion, view from west.

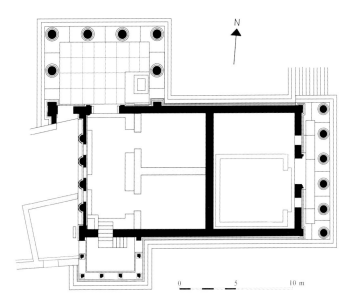

Fig 4.55 Athens, Akropolis, Erechtheion, plan.

offset placement (Fig. 4.56a–b), which also was dictated by concerns for cult: the caryatids served as attendants at the grave of Kekrops, an early king of Athens, who was thought to be buried below the southwest corner of the building. In addition, this portion of the building overlaps the Dörpfeld foundations belonging to the sixth-century BC temple of Athena Polias. A door in the south porch led to a staircase down to his temenos below. The west façade is also unusual for the placement of four Ionic columns set high on the wall (not on a stylobate as was customary), and a wall took the place of the usual intercolumniations. The projecting north porch had tall Ionic columns, and religious ritual seems to explain an exposed area in the floor: the aperture reveals an underground well that runs through an opening in the north wall and into the building. This northern interior

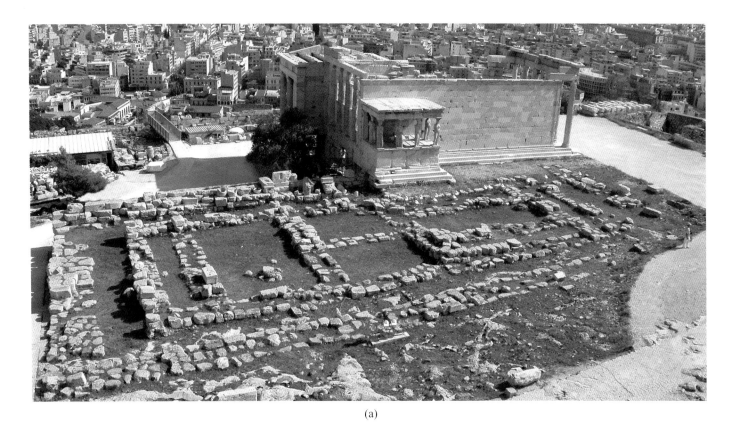

(a)

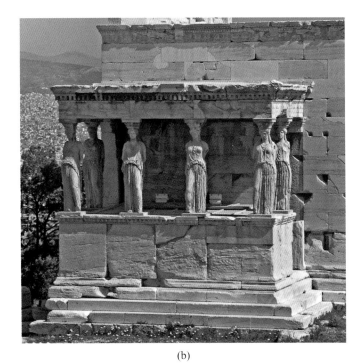

(b)

Fig 4.56a–b Athens, Akropolis, Erechtheion, south porch.

portion of the Erechtheion was divided into three chambers, each housing a cult area for a different deity; the walls were removed in late antiquity when a Christian basilica was installed in the Erechtheion.

Running around the entire building, and thus uniting it, is a blue limestone frieze to which painted marble figures were once attached. The subject of the figural frieze is disputed – the figures include seated women with children, an image of Apollo and his *omphalos* (literally, navel; the navel of the universe, represented by a stone, was thought to be at Delphi), and older, standing men – and may, like some of the Parthenon's sculptures, pertain to the city's legendary past. One of the complications concerning the frieze's interpretation is the fact that numerous frieze figures were replaced during the Roman period and may not have duplicated the originals.

Elaborate moldings and ornament everywhere on the Erechtheion, including around the north porch doorway,

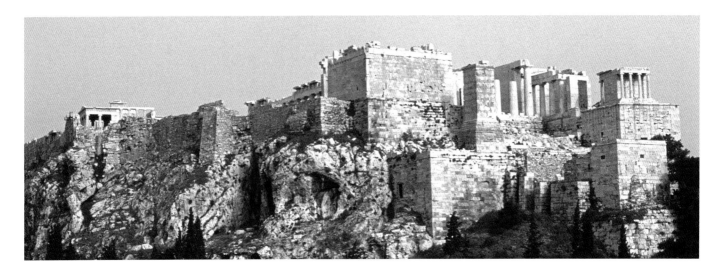

Fig 4.57 Athens, Akropolis, north slope with cave of Pan.

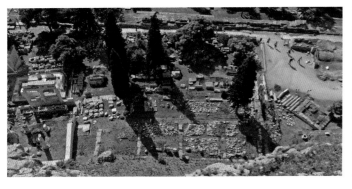

Fig 4.58 Athens, Akropolis, south slope,
Asklepieion seen from the Akropolis.

and the caryatids themselves provided models for many later buildings both in antiquity (e.g., the dedication to Roma and Augustus on the Athenian Akropolis, the Forum of Augustus in Rome) and in later western, especially Neo-classical, architecture.

Cult was not restricted to the surface of the Akropolis (several other sanctuaries existed on the surface, especially on the eastern portion), but extended to the slopes all around it. After the great victory at Marathon, which was partially credited to the god Pan, who inspired panic among the Persians, the Athenians established a cult in his honor in a cave on the north slope of the Akropolis (Fig. 4.57). At a location further to the east on the north slope, Aphrodite and Eros were worshipped as attested by inscriptions, niches for votive offerings, and sculpture found here. On the south slope, domestic dwellings were interspersed with public structures, including a shrine for the Nymphs, a sanctuary to Asklepios founded in 420/419 BC, an archaic fountain, and a temple to Dionysos located close to the fifth-century theater, a rectangular structure built into the slope (Figs. 4.57, 4.59; the theater changed shape in the fourth century BC). It was in the theater that the great plays of Aischylos, Sophokles, Euripides, and Aristophanes were performed in the dramatic contests – part of the City Dionysia festival – before an audience of *c.* 5000–6000 spectators seated on wooden benches.

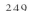

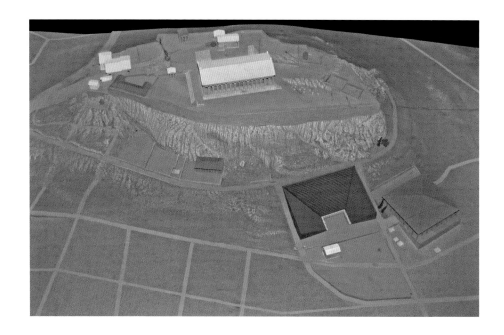

Fig 4.59 Athens, Akropolis, south slope, model, *c.* 400 BC.

Theseus, image of the democracy

When the Parthenon was begun *c.* 447, construction of a new temple, the Hephaisteion, was already under way on the west side of the nearby Classical Agora. The Doric peripteral, 6 × 13 Hephaisteion, begun *c.* 460–450, is the best-preserved ancient Greek temple, owing – at least in part – to its conversion to a church in *c.* AD 450 (Figs. 4.60–61). It stands amid

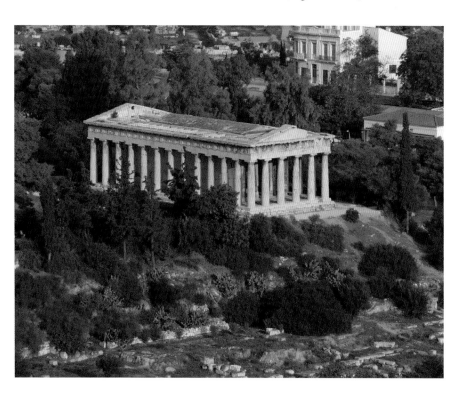

Fig 4.60 Athens, Agora, Hephaisteion, *c.* 460–420 BC, 31.776m × 13.708m, view from southeast.

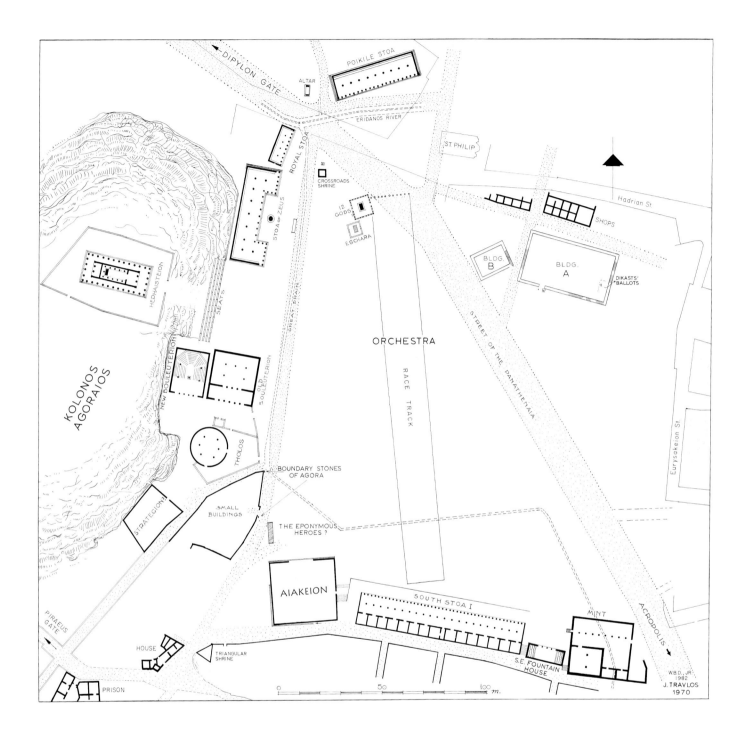

Fig 4.61 Athens, Agora, plan, c. 400 BC.

ancient bronze foundries and metalworkers' shops and is thus an appropriate location for the worship of Hephaistos, the god of metalworking.

The structure, nearly entirely of marble, was decorated with marble sculpture, whose disposition creates a special emphasis on the east entrance side of the temple, which faces the Agora. Cuttings in the pediments attest to sculpture, but no works have been attributed to the building with certainty, and no written evidence attests to their subjects. But the metopes' and friezes' sculptural themes were designed to instruct and inspire male citizens, who took part in the workings of the democracy in nearby buildings on the west side of the Agora (Fig. 4.61). The labors of Herakles fill the ten metopes (63cm high) on the east façade, while four adventures of Theseus appear on the south side (Fig. 4.62), and four on the north side at the eastern end of the temple, thus framing the Heraklean labors (Fig. 4.63). The west frieze (8m long), located above the opisthodomos, depicts the Centauromachy with Theseus in the middle (Fig. 4.64). The battle observed by Olympian deities on the longer east frieze (11.40m long), which stretches across the pronaos and abuts the peristyle, is not firmly identified, though the battle between Atlantis and Athens, one of the earliest and the greatest of Athens' legendary battles, may be intended (Fig. 4.65). The dramatically poised figures in the middle of both friezes – Theseus and an unknown warrior – adopt the poses of the Tyrannicides group standing nearby in the Agora (Fig. 3.50). The friezes may date as late as *c.* 420; note the wide spacing of the frieze figures, the numerous crumpled bodies, and the symmetrical composition of the

Fig 4.62 Athens, Agora, Hephaisteion, south side.

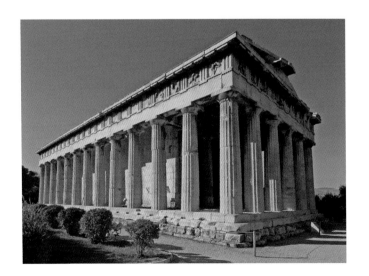

Fig 4.63 Athens, Agora, Hephaisteion, plan.

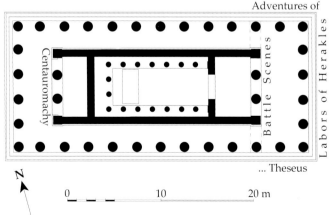

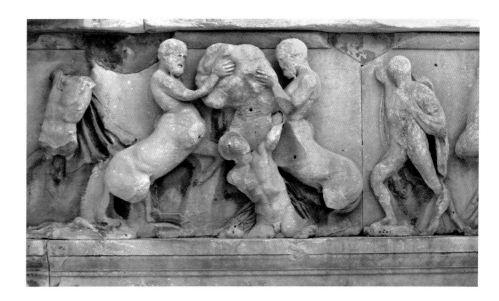

Fig 4.64 Athens, Agora, Hephaisteion, center of west frieze, marble, H 8.8cm.

east frieze. Like the Parthenon's frieze, that of the Hephaisteion was chiseled after the blocks were already *in situ* beneath the roof.

Inscribed building accounts of *c.* 421–416/415 provide information about the bronze statues of Athena and Hephaistos in the cella (ancient authors say that the student of Pheidias, Alkamenes, made them) and their installation, thus providing a later date for the completion of the entire sculptural adornment of the structure. Though they no longer survive, reflections in reliefs and free-standing Roman copies suggest that the two over-lifesize standing figures formed a closed composition and that Hephaistos wore workmen's clothing – a short, cinched tunic worn over only one shoulder (*exomis*) and a conical hat (*pilos*) – and held a hammer while an anvil stood before him (Fig. 4.66). The myth of the birth of Erichthonios, one of the early kings of Athens, either was depicted by marble figures attached to the statue base of dark Eleusinian limestone (cf. the Erechtheion frieze discussed above) or was alluded to by the presence of the baby Erichthonios in Athena's arms. The myth emphasizes the importance of the two deities of *techne* in the production of Athenians.

Read in conjunction with Hephaistos and Athena, who are responsible for the original Athenian (Erichthonios), the heroic deeds depicted in the

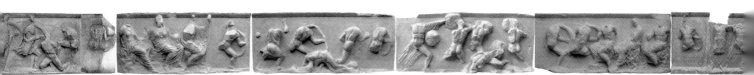

Fig 4.65 Athens, Agora, Hephaisteion, east frieze composite of casts.

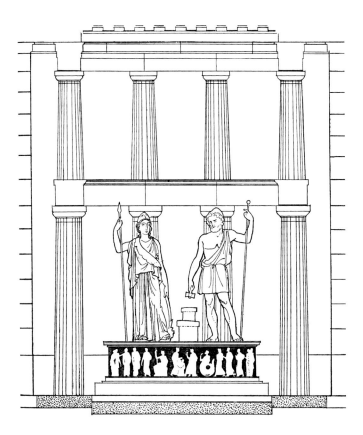

Fig 4.66 Athens, Agora, Hephaisteion, reconstruction of cult statues.

Hephaisteion's relief sculptures emphasize the city's legendary origins and proper inculcation of its *ephebes* (Athenian free-born males, approximately eighteen to twenty years old, who were enrolled at the age of twenty as Athenian citizens after having undergone military training), for whom Theseus was regarded as a model. Concentrated on the east side of the building facing the Agora, the temple's sculptures were intended to inspire Athenian citizens and ephebes, those who participated or would participate in the city's governance in the buildings nearby.

A new series of Attic vase paintings beginning in the first half of the fifth century also depict the deeds of Theseus, which, according to the second century AD writer Plutarch (*Theseus* 29), were created in emulation of the labors of Herakles. Theseus fights off a slew of brigands and monsters on the interior of a kylix attributed to the Codrus Painter (Fig. 4.67), who paints the entire cycle of Theseus' adventures, including his conquest of the Minotaur in the central tondo. No formal divisions are used to demarcate episodes; instead, Theseus is repeated in each vignette, and compositional elements, such as two different scenes with Theseus portrayed back-to-back, mark divisions for the viewer. This form of storytelling – showing more than one moment simultaneously – is

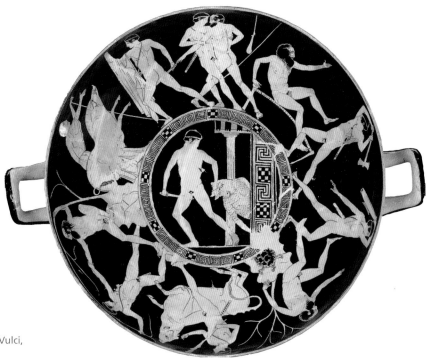

Fig 4.67 London, British Museum E84 from Vulci, Attic red-figure kylix attributed to the Codrus Painter, from Vulci, *c.* 440–430 BC, H 10.3cm, D 32.7cm.

referred to as continuous narrative and may have been influenced by monumental painting, whose large surfaces invited such sequential depictions (cf. pp. 210–12 above).

Funerary customs and social status in Athens

The inception of the Athenian democracy changed the physical appearance of the city and its surrounding region, and this change extended to memorializing the dead. Archaic funerary stelai had been commonplace throughout Greece and even monumental sculpture might be used to mark graves. But by the early fifth century BC, the production of such sculpture stopped, probably due to a sumptuary law (Cicero, *De legibus* 2.25–26) imposed by the new democracy in an effort to stem aristocratic display (though Athenians continued to emulate aristocratic habits in a number of other ways). By *c.* 470, a new, more modest form of commemoration had become common: the white-ground lekythos, usually decorated with funerary imagery,

Box 4.5 Erichthonios, Athena, and the Athenians

The myth of the birth of Erichthonios concerns the roles of Athena and Hephaistos as progenitors of the autochthonous Athenians. The myth occurs on the Akropolis, where Hephaistos, filled with lust for the virgin Athena, chased after her. Grabbing her at last, he was so excited that he ejaculated on to her leg. Taking a wad of wool (suitable for the goddess associated with weaving and techne), Athena wiped the sperm off her leg and threw it on to the earth. Nine months later, the earth goddess, Gaia (Ge), emerged from the earth to present the resulting child, Erichthonios, to Athena. Erichthonios was regarded as the ancestor of all Athenians, who are therefore autochthonous (born from the earth), not invaders from afar, thus giving them a legitimate (though historically inaccurate) claim to their land. This myth is portrayed repeatedly in Athenian art of the mid-fifth century BC, such as an Attic red-figure kylix of *c.* 440–430 BC, assigned to the Codrus Painter (Box 4.5 Fig.1).

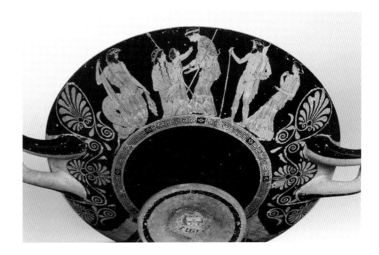

Box 4.5 Fig 1 Berlin, Antikensammlung F2537 from Tarquinia, Attic red-figure kylix attributed to the Codrus Painter, *c.* 440–430 BC, terracotta, H 12cm, D 31.2cm.

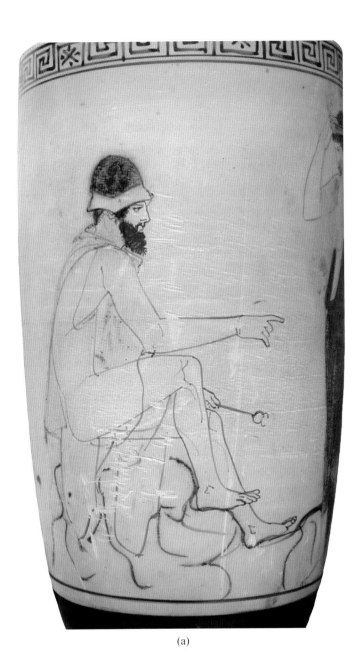

(a)

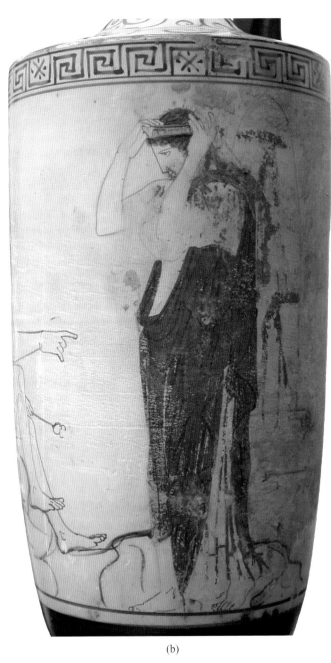

(b)

Fig 4.68a–b Munich, Antikensammlungen 6248 from Oropos, Attic white-ground lekythos attributed to the Phiale Painter, Hermes and woman, *c.* 435–430 BC, terracotta, H 35.9cm.

such as images of mourners at tombs or the dead being transported to the afterlife by Charon. The leykthoi served as containers for liquid offerings at the tomb or were deposited in the tomb as grave gifts or both. An Attic white-ground lekythos of *c.* 440–430 BC by the Phiale Painter depicts Hermes, recognizable by his traveler's hat, cloak, winged boots, and above all, his staff (*caduceus*), seated on a rock, awaiting a female, who adjusts the crown on her head (Fig. 4.68a–b); the woman is presumably the deceased, who will be transported to

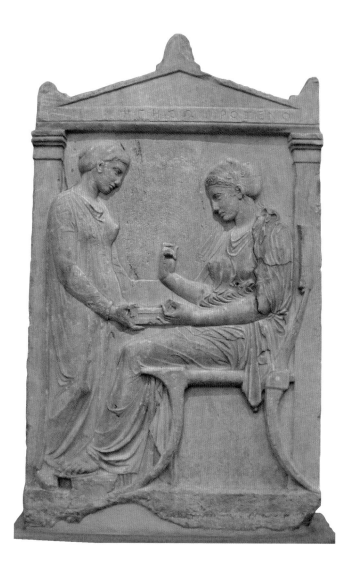

Fig 4.69 Athens, National Museum 3624 ("Stele of Hegeso") from the Kerameikos, Athens, *c.* 410 BC, Pentelic marble, H 1.56m, W 0.97m.

the Underworld by Hermes in his guise as Psychopompos (cf. Fig. 3.36a). She is richly adorned, and her crown suggests that she prepares to be the bride of Hades, the appellation for a woman who died unmarried (see Fig. 3.27).

White-ground lekythoi may have replaced funerary stelai in Attika since their numbers rise as the number of stelai trickle off, and conversely, the number of white-ground lekythoi dwindles *c.* 430–420 BC with the resumption of stone funerary stelai. The Classical stelai's intimate quiet imagery is similar to the many lekythoi paintings, but tends to avoid mythological imagery – except the occasional presence of Hermes – in favor of images that concentrate on familial relationships, "domestic" scenes, or, in the case of commemoration for men, more public roles, such as hunters or athletes, which often serve as inherent declarations of social status. The difference in iconography surely reflects the differing contexts in which the two types of objects – lekythoi and stelai – were viewed. The latter were prominent public markers, while the former were used at the funeral by the mourners and were "disposable" or were entombed with the dead.

The sculpture of the extensive public building projects described above had an immediate impact on this private art: the dignified but relaxed poses and demeanor of fifth-century architectural sculpture were eminently suited to the funerary format and are echoed on many tombstones. The Pentelic marble stele commemorating Hegeso (Fig. 4.69), whose name is inscribed on the architectural frame above the image, was found in the Kerameikos cemetery in Athens (Fig. 4.70). The well-dressed Hegeso sits on an ornate *klismos* (chair) with her feet resting on a sculpted footstool and gazes downward toward a necklace (originally painted), which once dangled from her right hand. A servant, much smaller in scale and with different attire, stands before her and holds a jewelry casket. The figures are still, quiet, contemplative, in the fashion of the tranquil figures on the Parthenon frieze, particularly the deities, whose relaxed poses seem at odds with a religious event (Fig. 4.43); this solemnity is typical of Classical funerary reliefs – rarely is emotion overtly expressed save for a handclasp between the living and dead. The simple composition of the Hegeso stele belies the relatively high quality of

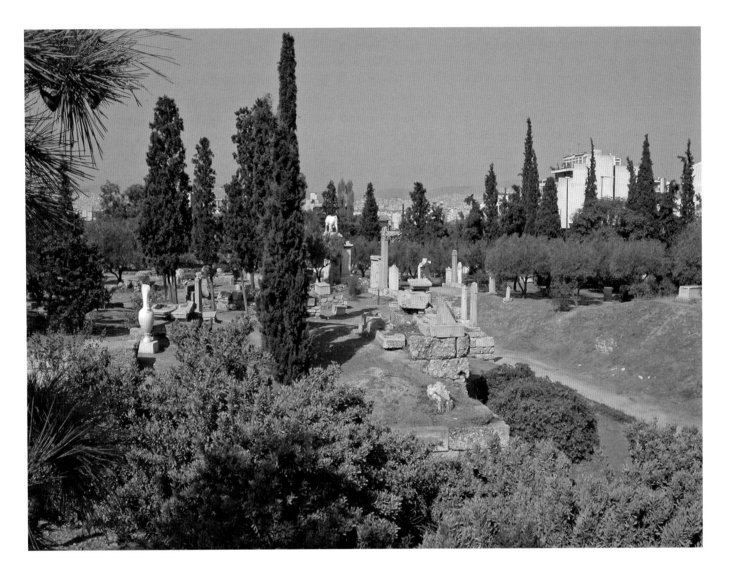

Fig 4.70 Athens, Kerameikos, view.

this relief compared with most funerary reliefs: Hegeso's garments – her semi-transparent drapery and elaborate veil, the fine-turned furniture, the size, and the material of the stele all point to an aristocratic patron. Although the relief may honor a private loss, its location in the Kerameikos was intended to draw public attention, especially that of the many passersby traveling the main roads leading to and from the city. The Hegeso stele exemplifies the power of the aristocracy, who continued to populate most leading governmental positions, and who dominated the social realm even if their political powers had been truncated under the democracy.

The reason for the resumption of stelai in Athens toward the end of the fifth century is unknown. Although the democracy was still in power, the enormous losses from the Athenian plague of 429 and those during

the Peloponnesian War may have altered perceptions of appropriate commemoration of the dead; one notes, for example, the extraordinary rise in the number of women and children (the future citizens) depicted on these reliefs as compared with earlier reliefs or even white-ground lekythoi. Such devastation of the population may have prompted an unrestrained outpouring of more elaborate monuments. What's more, there was an army of sculptors who had previously been engaged on various Akropolis projects, who were now available, i.e., unemployed, so not just sentiment but also highly unsentimental economics may have figured into the resumption of these stelai, whose compositions and style draw heavily on those of the Parthenon sculptures.

Impact of the Peloponnesian War

The twenty-seven-year Peloponnesian War between Sparta and its allies, and Athens and its allies left both sides exhausted. Effects of the war were manifested during and after the conflict, not only politically – Athens' loss of the war shifted the balance of power – but also in daily life, cultural attitudes, and religion, which increasingly stressed private, intimate, and erotic realms. For example, the cult of the healing god Asklepios was introduced into Athens in 420/419 BC, undoubtedly partly as a result of the losses of the war and the plague in 429 (see Chapter 5). New subjects emphasizing personal and private realms dominate Greek, particularly Athenian, art and signal a growing acknowledgment of the critical role played by mothers and wives in the survival of the polis. We have already noted the importance of women in the myths depicted by the Parthenon sculptures; this trend intensifies in the last decades of the century. One facet of this is the prominence of family scenes, particularly mothers and babies, on funerary stelai; another is manifested on late fifth-century BC Attic vase painting, which is replete with depictions of females, both non-mythological and mythological, in scenes concerning Aphrodite, at weddings, and in boudoirs. The women are clad in filmy, transparent, pleated drapery that reveals every contour of the nude body beneath; the multiplied parallel lines that describe the fabric and emphasize voluptuous bodies create an effect that is linear and highly ornate. An *epinetron* offers good examples of this new type of vase painting (Fig. 4.71a–b). The shape is closely associated with women, who wore these objects over the knee to card wool and also offered them

(a)

(b)

Fig 4.71a–b Athens, National Museum 1629 from Eretria,
Attic red-figure epinetron attributed to the Eretria Painter,
c. 420 BC, terracotta, L 29cm.

as votive gifts. This particular example is too small for practical use but emulates larger objects of the same shape; the scales atop the epinetron were meant to catch the strands of wool as they were wound around. The two flanking images depict women in a *gynaikeion* (women's quarters), preparing for the wedding of the mythological Alkestis, whose name, like those of most of the other figures, is painted on the epinetron. She leans on a bridal bed in an interior space, denoted by the Ionic column and doors. They are joined by the small male figures of Himeros (the personification of desire) and Eros. Numerous accoutrements associated with the gynaikeion appear, such as *lebetes gamikoi* (wedding vessels), the long-handled *loutrophoros* used to hold water for the bridal bath (and the funerary bath), jewelry boxes, perfume vessels, and a mirror. The women's drapery carefully describes the breasts and legs, and together with the women's relaxed poses, expresses languor, sensuality, and elegance. Circling the end of the epinetron is an image of Thetis' abduction by Peleus witnessed by Thetis' sisters, the Nereids, and her father, Nereus. This mythological event resulted in Thetis' marriage with Peleus, a wedding attended by all the gods (save Eris, the personification of strife; cf. Fig. 3.30a–b). This conglomeration of themes concerning women and marriage is well suited for the object, which served as a grave gift, perhaps for a woman.

Another consequence of the Peloponnesian War and Athens' defeat was the cessation of monumental building in Athens. Inevitably, artists – particularly sculptors and architects – left the city to seek commissions elsewhere. Pausanias credits Iktinos, one of the architects of the Parthenon, with the design of the temple of Apollo at Bassai (Figs. 4.72–73). Its traditional Doric exterior belies the fact that everything else about this small building (14.48m × 38.24m) is extraordinary and points to a shift in temple building, temple decoration, and religious practice. The limestone temple is located high in the mountains of the Peloponnese and partially sits on the site of an archaic predecessor. The peristyle at 6 × 15 is either provincially old-fashioned in recalling the long, narrow structures of the Archaic period, or intentionally retrospective: if Iktinos really was the architect, one is inclined to see it as deliberately retrospective since he was clearly an extraordinarily gifted designer and because the interior of the structure is revolutionary (Fig. 4.74). Like other temples before it, the temple of Apollo has a pronaos and opisthodomos flanking the cella and a conventional peripteral exterior,

Fig 4.72 Bassai, temple of Apollo, *c.* 400–390 BC, limestone, 38.244 × 14.478m.

Fig 4.74 Bassai, temple of Apollo, reconstruction of interior.

Fig 4.73 Bassai, temple of Apollo, plan.

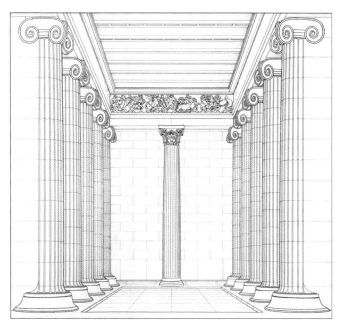

but unlike fifth-century temples, the temple at Bassai does not possess a free-standing colonnade in the cella flanking or surrounding the cult statue. Instead, it uses Ionic columns engaged to spur walls on the east and west flanks (the temple is oriented north–south), and at the south, one free-standing Corinthian column (the first ever; this order is first used in interior spaces, then moves to the outside, as well) stands between two Ionic columns, whose capitals are inserted at an angle. A door is cut into the east side of the cella beyond the columns, a feature that occurs elsewhere in temple architecture in the Peloponnese. In addition to sculpted metopes on the Doric peristyle frieze, a continuous sculpted Ionic frieze (63cm high, 31m long) devoted to two themes, the Amazonomachy and the Centauromachy, circled the *interior* of the cella, each myth occupying one long side and one short side. The deep carving and some features may have been designed to compensate for the low lighting of the interior. The frieze's workmanship is "provincial," focusing less on naturalism and more on conveying information and creating a sense of tumult; the elongated body proportions of Athenian sculpture are replaced here by shorter, squatter figures topped by square, oversized heads (Figs. 4.75–76). Instead of the sense of organized chaos common to scenes of combat in earlier fifth-century sculpture, the battle is overcrowded, with little free background space. One sees certain stylistic elements in common with fifth-century Athenian art, such as fluttering, unfurled drapery (cf. Fig. 4.52), compositional quotations from the Parthenon and elsewhere, and calm demeanors of combatants,

Fig 4.75 London, British Museum 534, Amazonomachy frieze from temple of Apollo at Bassai, marble, H 64cm.

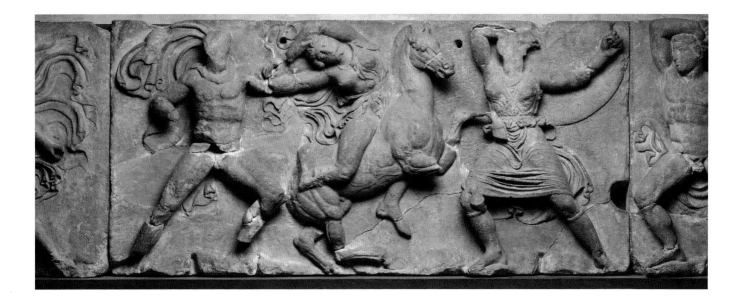

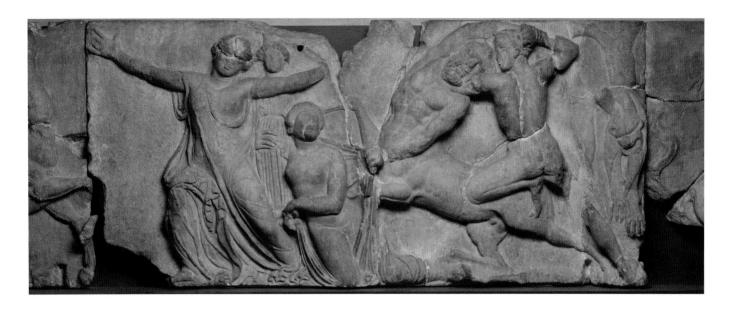

Fig 4.76 London, British Museum 524, Centauromachy frieze from temple of Apollo at Bassai, marble, H 64cm.

but strong diagonals created by lunging poses and outstretched arms cut across the composition, giving a sense of energy and heightened drama, and – together with exaggerated gestures and movements – melodrama.

Two wars bracket the period discussed in this chapter, the Persian Wars and the Peloponnesian War. The first resulted in a surge of Greek confidence and, ultimately, in Athens as an imperial leader of a maritime empire. Although Athens was not the only important city, it produced the most significant and elaborate building projects in the second half of the fifth century on both Attic soil and elsewhere (e.g., Delos). With Athens' loss of the Peloponnesian War to Sparta, the empire was over and with it, the wealth and confidence that fueled this kind of creative activity (Athens regained its footing some decades later but it was never the same).

What happens in between is a revolution in form and thought, and not only in Athens. The aims of classicism were the idealization of the human body in motion and at rest, and intellectualizing perception and recording one's observations in (idealized) visual form. The ideal was human self-mastery in the face of chaos and disorder, and to achieve this was to accomplish something heroic, even divine. But as the Peloponnesian War wore on for decades, this self-confidence began to be eroded, and answers were sought from other quarters. Ideals yielded to the unpleasant realities, traditional polis values were undermined, and other contenders quickly moved to fill the power vacuum left by Athens' defeat.

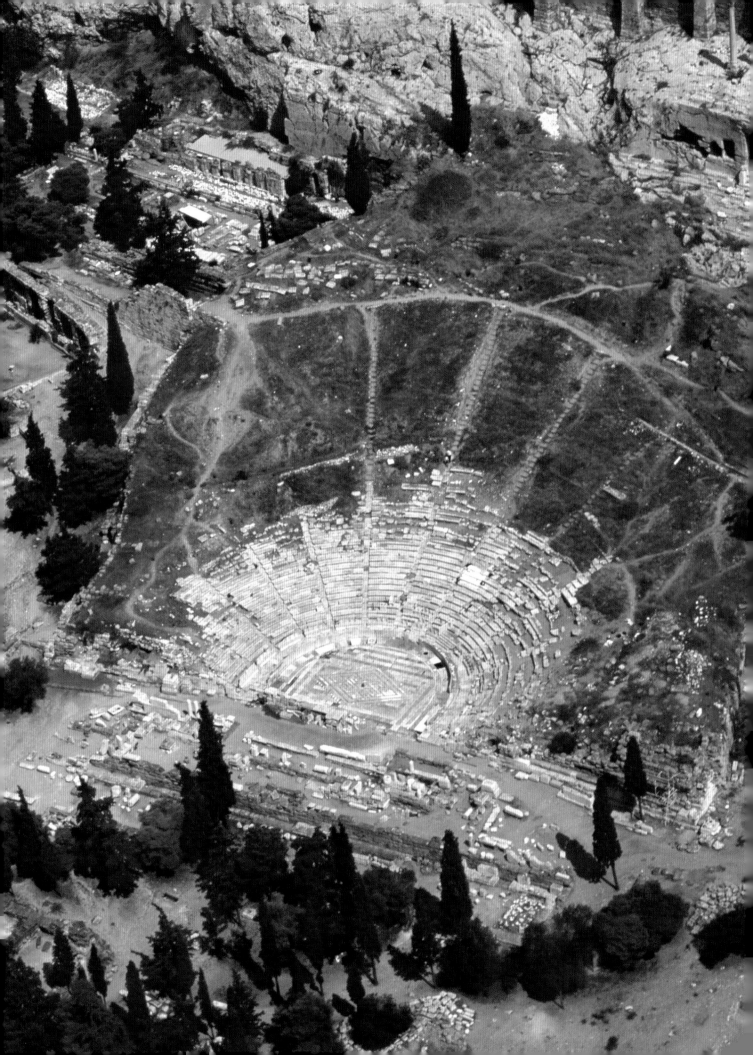

5 The late Classical period and Alexander, *c.* 400–323 BC

TIMELINE – all dates in BC

c. 480–323	Classical period
c. 394	Battle of Corinth, Dexileos Stele
c. 360s	Mausoleion at Halikarnassos begun
c. 350	Praxiteles
c. 348	Olynthos destroyed by Philip II of Macedonia
c. 340	Skopas
c. 330s	Theater of Dionysos in Athens changes shape and sets new model for theaters thereafter
c. 338	Battle of Chaironeia
c. 336	Philip II of Macedonia assassinated in Vergina and succeeded by his son, Alexander III (the Great)
c. 335/334	Lysikrates Monument
c. 334	Alexander III (the Great) and his army cross the Hellespont into Asia Minor
c. 330	Lysippos, temple of Apollo at Didyma begun
c. 325–311	"Alexander sarcophagus"
c. 323	Death of Alexander III (the Great) in Babylon

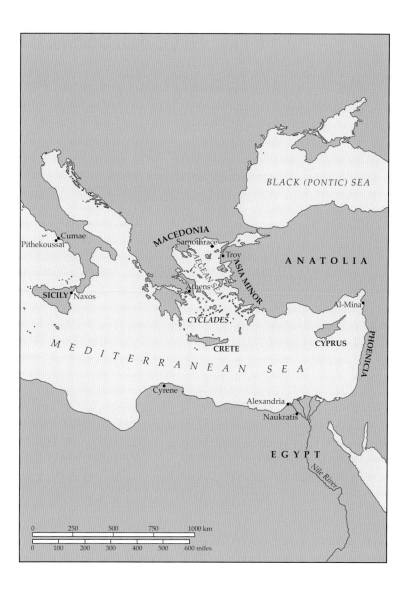

Map of the Mediterranean area

The fourth century BC marks a critical turning point in the ancient world as various poleis vied to fill the void left by Athens' defeat after the conclusion of the Peloponnesian War in 404 BC, while Athens itself struggled, sometimes successfully, to regain power. Sculptors and other craftsmen dispersed from Athens for work in other locations and for new patrons. Vase painting production rapidly diminished in Athens while there was a dramatic rise of the same industry in south Italy and Sicily. By mid-century, Macedonia, ruled by monarchs, emerged as a power to be reckoned with. Philip II of Macedonia began to engage aggressively with his Greek neighbors to the south in a play for territory and control. The second half of the fourth century is defined by the Macedonian presence in the rest of

Greece and Macedonia's imperialist ambitions. Philip II's aims were continued and expanded by his son and successor, Alexander the Great, who wrought profound changes in virtually every aspect of the Greek world.

The visual culture of Greece exhibits new trends and themes partially in response to these political upheavals. Sculptors now created works not only on commission but also on speculation from which a buyer could choose, and this influenced the "consumption" and function of art. A growing emotional intimacy in art and religious experience, a greater consciousness of the experience of the viewer in encountering a building or object, and new ideas and a new threat from outside shape fourth-century art and architecture. The fourth century also provides us with excellent examples of domestic architecture and its mosaic decoration, as well as urban planning, which enable us to formulate a picture of daily living.

Civic consciousness

A changed Athens

Sometime between *c.* 374, when Athens concluded a peace agreement with the Spartans, and 360 BC, the Athenians introduced the cult of Peace into their city (Plutarch, *Kimon* 13.6). To commemorate this, Athens commissioned the sculptor Kephisodotos the Elder to create a bronze sculpture of the personification of Eirene (Peace) carrying

Map of ancient Athens, second century AD

Fig 5.1 Munich, Glyptothek 219, Eirene and Ploutos by Kephisodotos, Roman copy of Greek original of *c.* 374–360 BC, marble, H 2.01m.

the baby Ploutos (Wealth) (Fig. 5.1). Pausanias (1.8.2; cf. 9.16.2) saw the monumental statue in the western part of the Agora (see Fig. 4.61); although the precise original placement is unknown, the choice of subject for a public commission and the sculpture itself reveal changing notions about civic life and the representation of those ideas in public art. The bronze original, no longer extant, is reflected in vase paintings, including Panathenaic amphorae of *c.* 360/359 BC (the amphorae yield the later date for the introduction of the cult and statue), and in numerous Roman copies of both the entire group and excerpts from it. A matronly, full-bodied, draped female stands in contrapposto, gazing down tenderly at the partially draped baby held in the crook of her left arm. The child looks and reaches up one hand to her, and a cornucopia once lay in his left arm. The locked gazes of the figures exclude the viewer and highlight the interconnection between the concepts signified by the personifications: Peace yields the robust child, Wealth. This veneration of Peace and its embodiment in maternal, nurturing form signifies a striking change in attitude from the more bellicose Athens of the past. As a pointed contrast, we might consider the Tyrannicides of *c.* 477 BC by Kritios and Nesiotes (Fig. 3.50), a civic commission also displayed in the Agora and copied on Panathenaic amphorae, which commemorated the downfall of the Athenian tyrants and the founding of the democracy in the sixth century BC in aggressive, dynamic form. The difference in attitude was a direct expression of the toll of continued warfare on Athens, and the emergence of an appreciation for peace when the empire had passed. Rather than the grandiose gesture, civic art – like private art – took on a new intimacy, a concern for human scale and human experience.

The cherubic Ploutos is a marked change from children in earlier Greek sculpture; depictions of children were rare, and one tends to see tightly swaddled nondescript bundles on late fifth-century funerary stelai or miniature adults on archaic stelai. Ploutos' small form and oversized head are more naturalistic treatments of a child's physique. Children – their form and character – constituted a growing subject in sculpture in the fourth century, especially on funerary reliefs where they

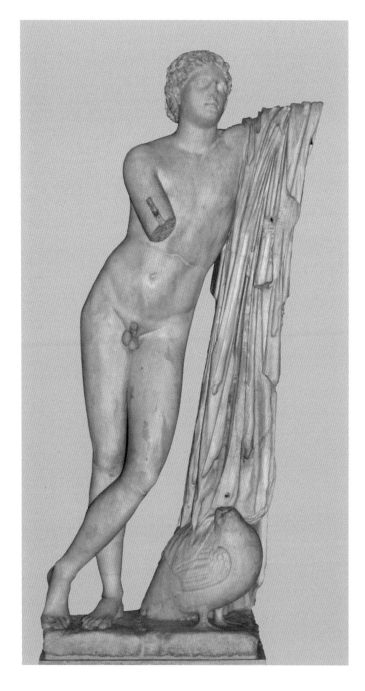

Fig 5.2 Rome, Palazzo dei Conservatori P2417, Pothos, Roman copy of Greek original by Skopas of c. 330 BC, marble, H 1.80m.

appear as toddlers and small children, and on reliefs and in three-dimensional sculpture dedicated in sanctuaries, such as those of Artemis and Asklepios; this trend accelerated in the subsequent period, when children – their behaviors and physical features – became a focus of sculptors' attention (see Chapter 6).

The Eirene and Ploutos group is also noteworthy for the use of personifications, which began to multiply in Greek literature, rhetoric, and art in the last portion of the fifth century BC (cf. Fig. 4.71a–b). These physical embodiments of abstractions could serve political ends, such as Eirene and Ploutos (Fig. 5.1), Demos, Demokrateia, and Themis. Personifications also proliferated in literature and vase painting devoted to amorous or erotic subjects; Himeros (desire), Pothos (yearning), Peitho (persuasion) first appeared toward the end of the fifth century BC and found their greatest popularity in the fourth century (Fig. 5.2).

Local heroes

Other public monuments in Athens, such as funerary monuments honoring the war dead, also reflect changes to civic attitudes in the fourth century. The Dexileos Stele, a marble cenotaph (a memorial to a dead person who was buried elsewhere) for a soldier fallen in battle, can be securely dated to 394 BC on the basis of its inscription, and constitutes one of the few fixed points in the later Classical period of Greek art (Fig. 5.3). It was common practice for the war dead to be buried in the state grave for veterans (the *demosion sema* between the Dipylon Gate and the Academy in Athens), so the family erected this memorial in their family grave plot in the Kerameikos in Athens (Fig. 4.70). The stele commemorates the heroic self-sacrifice of an Athenian citizen in the Battle of Corinth, offering an exemplar for the living, as well as honoring the memory of courage offered in service to the state. The prominent placement of the stele – atop a high curved base along the Street of Tombs with an unobstructed view – is one mark of the wealth of this

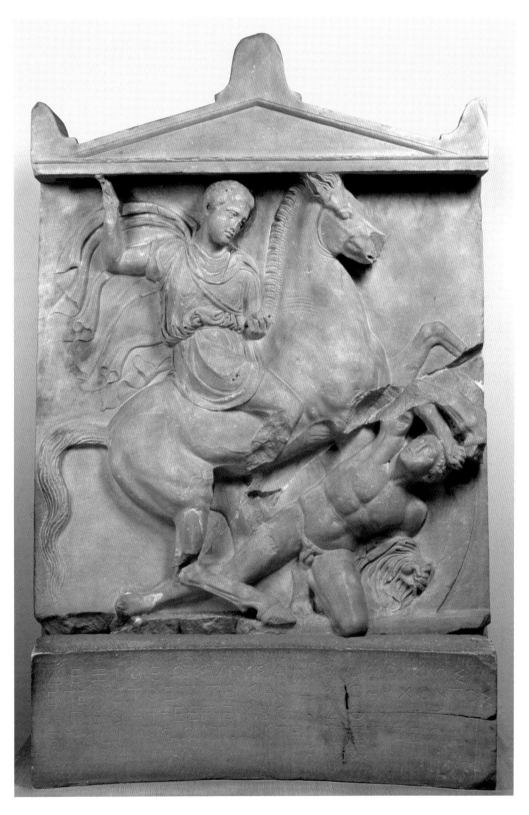

Fig 5.3 Athens, Kerameikos Museum P1130, Dexileos Stele, from the Kerameikos in Athens, *c.* 394 BC, marble, H 1.75m high.

family and the esteem in which Dexileos was held (cf. Fig. 4.69). The stele looks like a typical Athenian grave relief in format, but its subject – active combat – was relatively new in funerary art and appeared in somewhat earlier (*c.* 420 BC) and contemporary public funerary monuments, including others commemorating this same battle. Moreover, it departs from previous images of warfare, usually mythological depictions on public buildings, in its immediacy in this world (rather than the mythical realm) and its incorporation of a dramatic, energetic image of warfare into the private sphere. In contrast to the Eirene and Ploutos (Fig. 5.1), which works at a more human scale, Dexileos was publicly lauded in a manner previously reserved for heroes.

Stylistically, the stele is in keeping with mid- to late fifth-century Athenian art. Dexileos' steed is a direct descendent of the mounts on the Parthenon frieze (Fig. 4.41), his arced *chlamys* (cloak or cape) recalls those on the Nike temple friezes (Fig. 4.52), and his fallen opponent's anatomy, particularly the creases across his abdomen, echoes that seen on the Hephaisteion east frieze (Fig. 4.65).

Civic duty was also expressed and honored in other ways. The Athenian Lysikrates Monument, dated securely to 335/334 BC on the basis of an inscription, commemorates a victory in a *choregic* contest, an Athenian singing and dancing competition performed by groups of boys or men from one tribe against those of another (Fig. 5.4). The monument was erected by Lysikrates, a wealthy Athenian citizen, who sponsored the training of the victorious tribe in the *dithyramb* competition; the dithyramb was a special song in honor of Dionysos, the god of theater. Such choregic monuments were erected by the victorious patrons along the Street of the Tripods leading from the theater of Dionysos around the Akropolis (Fig. 5.5, see also Fig. 4.59) and trumpeted the achievements of generous benefactors, whose financial sponsorship was a civic and legal obligation, a *liturgy*, for wealthy citizens. Such monuments enabled individual citizens to stand out within the democratic system. There were numerous kinds of liturgies – military, theatrical, religious, and so on – and the competitive and public nature of the sponsorship of theatrical contests, rowing contests, and the like ensured substantial contributions, as well as a competitive spirit about the size, elaborateness, and quality of the choregic monuments erected after a win. While the monument

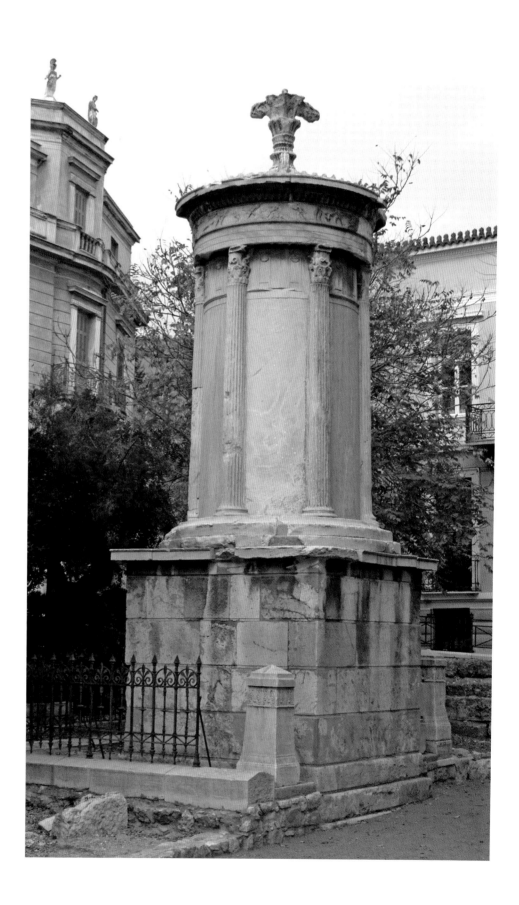

Fig 5.4 Athens, Lysikrates Monument, c. 335/334 BC, limestone and marble, H 10m.

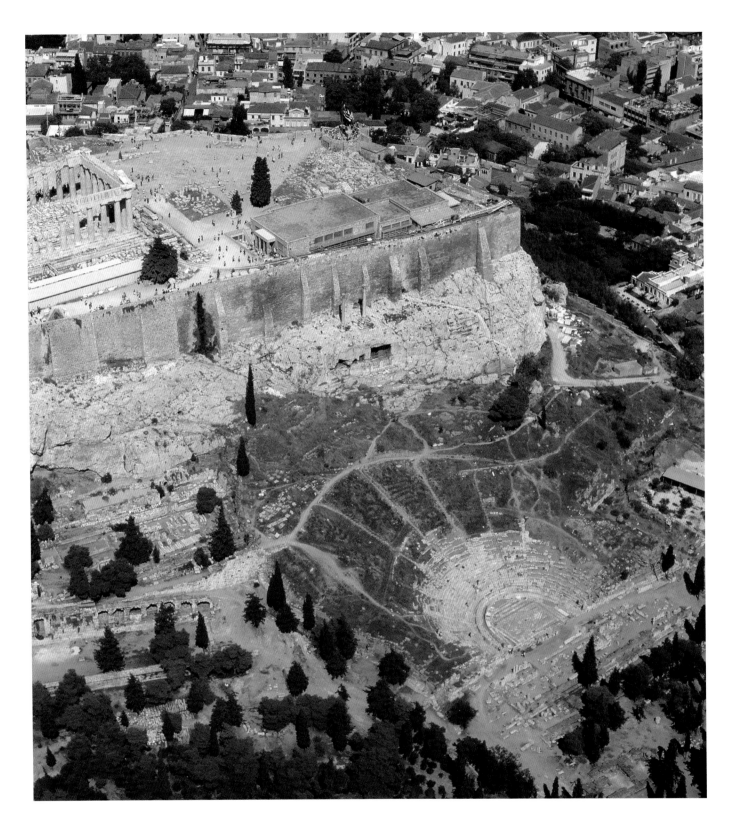

Fig 5.5 Athens, theater of Dionysos, aerial view.

celebrates the theatrical victory, it also makes a public declaration about Lysikrates' civic generosity (however compulsory) and his success.

A Pentelic marble cylinder sits on a square limestone base and was once crowned by a bronze tripod, now lost, atop an elaborate three-sided capital; the tripod was the prize awarded for the dithyramb victory. The cylinder walls are formed by blue Hymettan marble slabs adorned by engaged Corinthian columns, the first time the Corinthian order was used on the *exterior* of a structure (cf. Fig. 4.74), while the front, which faced the street, was left open so that the (hypothetical) statue within the tholos was visible from outside. A sculpted frieze, 25.5cm high, tucked just beneath the roof line depicts Dionysos and satyrs among the pirates, a theme already discussed in this text (Fig. 3.33), and an apt choice for a monument honoring a win in the dithyrambic competition. Unusually, however, the sailors turned to dolphins are shown here as hybrid beings – human foreparts and dolphin hindquarters. Two tripods, which once echoed the bronze tripod atop the monument, are carved in low relief in the spaces between the Corinthian capitals to emphasize the victory.

Urban landscapes

At the same time, the fourth century also saw developments in civic infrastructure, efforts to improve the polis with local works, rather than monuments expressive of imperial might and triumph. The construction and reconstruction of vast public theaters in many parts of Greece, such as the theater of Dionysos on the south slope of the Akropolis in Athens, testify to the ongoing commitment to public worship of Dionysos and civic spectacle in the form of dramatic performances and military displays (Fig. 5.5).

Moreover, the theater of Dionysos in Athens changed its shape in the 330s BC from a rectangular Π-shaped bank of seats around the performance space (Fig. 4.59) to two-thirds of a circle, which became the standard shape for theater design thereafter (Fig. 5.6). While the reason for the change in form is unknown, one can easily see how the new funnel shape facilitated amplification of sound and better viewing for much larger crowds. The rebuilding of the theater of Dionysos in Athens was part of a larger public works program, which included rebuilding the Pnyx (Figs. 4.6–7), improvements to the harbors of Piraeus, completion of the arsenal, and revival of

Box 5.1 The theater

While drama and the theater are later sixth-century BC developments, theater productions and construction grew ever more elaborate in the fifth and fourth centuries BC, and stone theaters were ubiquitous in the Hellenistic period. The archaeological evidence demonstrates that theaters were rectangular in shape until the construction of the theater of Dionysos on the south slope of the Athenian Akropolis in the 330s BC (Fig. 5.5). This new theater, which influenced all those after it (e.g., in Troy in 312 BC), had a rounded seating area (*koilon*), which slightly exceeded a half-circle in size, framing the orchestra; this approximately doubled its seating capacity and optimized acoustics. The early stage building or *skene*, a stone construction with wooden painted panels, served as a background for the action in the orchestra and a means of entrance and exit; as with the production itself, these painted panels or *pinakes* were often supplied by a choregos. In the new fourth-century theater, the dramatic action shifted to the top, horizontal surface of the skene. The space around the theater became the location of public monumental statues in honor of playwrights and patrons, and, as discussed in the text, choregic monuments clustered near theaters, especially the Dionysos theater in Athens (Fig. 5.4).

Dramatic productions inspired many vase paintings of the fourth century BC (particularly vases from south Italy and Sicily), where actors are clearly marked out by their costumes and/or masks and sometimes perform on a stage; small terracotta figurines depicting actors, particularly comic actors, are common from the fourth century BC on.

Fig 5.6 Epidauros, theater, aerial view, early third century BC.

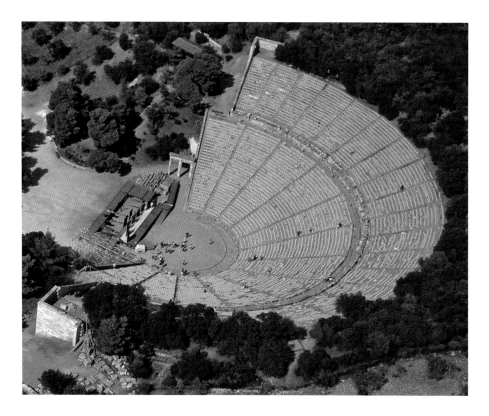

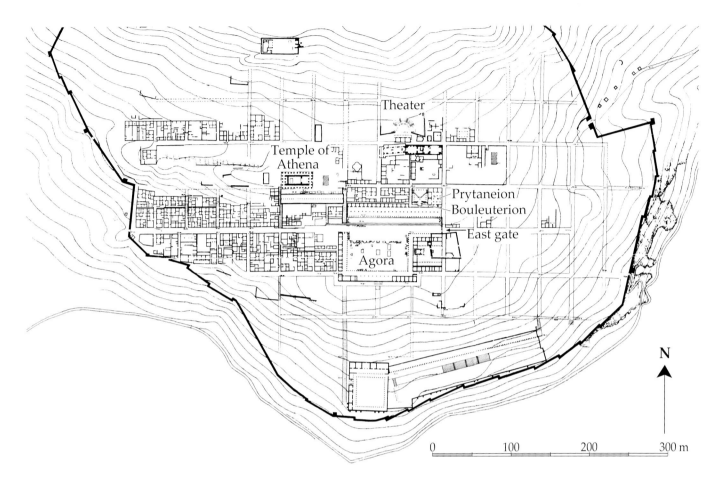

Fig 5.7 Priene, plan.

work on the Olympieion (Fig. 3.48), all initiated by the Athenian leader, Lykourgos.

The city of Priene in Asia Minor (the western coast of modern Turkey) also demonstrates an interest in civic investment. The polis may have moved from an earlier location, perhaps closer to the sea; its exact placement is unknown but its existence is attested by a coin and ancient texts, and we know that it was part of the Delian League. In any case, it was established on its present site on the south slope of Mt. Mykale in about the mid-fourth century BC. The new city was conceived as a whole, using grid planning (Fig. 5.7). This innovation, already known in Sicily and south Italy in the seventh century BC, places horizontal and vertical streets at right angles to each other so as to create an easily navigable space, a change from the haphazard growth of earlier urban spaces. The grid plan at Priene was adapted to the sloping site, oriented to the cardinal directions, and divided into standard-size blocks (*insulae*) encompassing about five hundred houses; fortification walls with

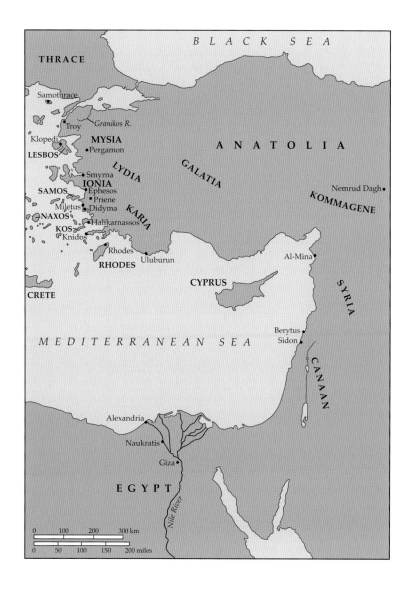

Map of the eastern Mediterranean

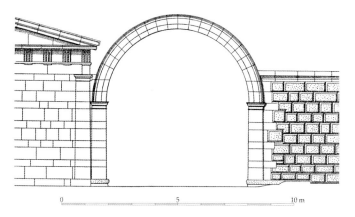

Fig 5.8 Priene, Agora, restored elevation of the east gate of the Agora.

sixteen towers, together with the steep natural terrain, provided protection.

Public buildings, such as the theater, agora flanked by stoas, bouleuterion, and prytaneion, were given generous spaces clustered toward the center of the grid, and house plans tended to focus on an interior colonnaded courtyard. The city was served by terracotta pipes running beneath the streets that delivered water from a spring above the city to fountains, troughs, and some private homes. It is noteworthy that arched gates are found at Priene; the first arches were invented in the Greek world in the fourth century BC (Fig. 5.8).

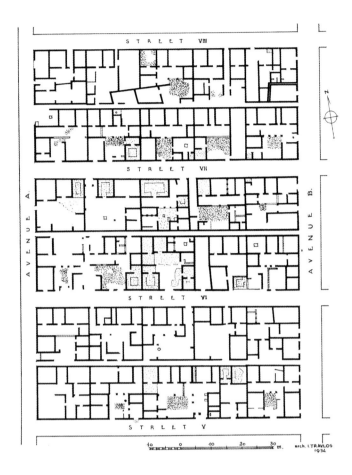

Fig 5.9 Olynthos, plan.

Likewise, at Olynthos in the Chalkidiki peninsula, the old town was replaced by a new one in 432 BC, laid out according to grid planning (Figs. 5.9–10). Multi-storey houses of mud-brick walls on stone foundations, constructed with wooden stairs and posts, stood back-to-back in close formation (Fig. 5.11), and the regular grid was broken only by a larger sanctuary and market. The town was destroyed in 348 BC and never rebuilt, so Olynthos offers a picture of urban dwellings on the Greek mainland in the fourth century BC without later overbuilding, such as exists at Priene, where habitation extended well into the Byzantine period. The Olynthos houses are nearly all uniform in size, roughly 17m square, and built around an interior courtyard, although occasionally, as at Priene, one sees two houses combined to form a single residence twice the normal size. Olynthos' two-storey houses included an *andron* (literally, the men's room) for symposia on the ground floor. Pebble mosaics, the earliest form of floor mosaic in Greece, adorned the floors of some houses, particularly in the andron; the scarcity of such decoration suggests that mosaics were a luxury.

Eretria also offers splendid examples of pebble mosaics in the House of the Mosaics built *c.* 370 BC and destroyed by fire about a century later (Fig. 5.12). The large house, arranged around two courtyards, has several rooms decorated with pebble mosaic floors: smooth black, white, red, and yellow pebbles were set into mortar on top of a foundation of larger stones, and three of these mosaics have figural designs. One notable mosaic lies on the floor of the entryway to one of several androxes, which varied in size to accommodate different numbers of guests (Fig. 5.13): a Nereid, perhaps Thetis, rides on a sea creature (*ketos*), carrying armor to Achilles, Thetis' son, at Troy. Adjacent to this Homeric subject is a mosaic on the floor of the andron itself that illustrates the mythological battle between griffins and the Arimasps, a mythical race of one-eyed men who were imagined to dwell in the north

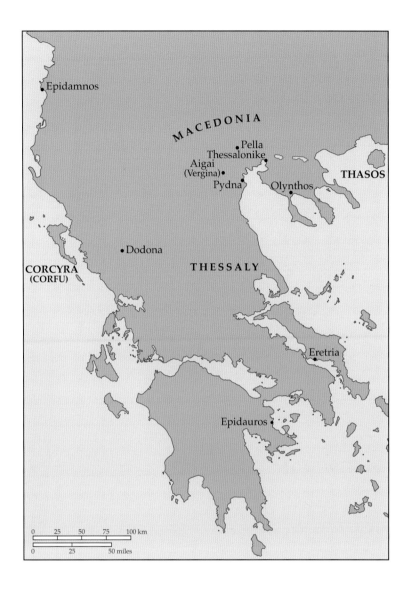

Map of Macedonia

connection. Asklepios is renowned as a healing figure – some-times a hero, sometimes a god – long before the fourth century (he is mentioned in the *Iliad*), but it is only toward the end of the fifth century and into the fourth that his popularity soars. Worshippers went to Asklepios' shrines, the most famous of which were at Epidauros and the island of Kos – although they existed all over Greece, including in Athens – to make offerings to the god, and purify themselves. The suppliant would spend the night in "incubation" in the shrine of Asklepios, who would heal illness by means of a dream sent to the slumbering worshipper, which either prescribed a regimen

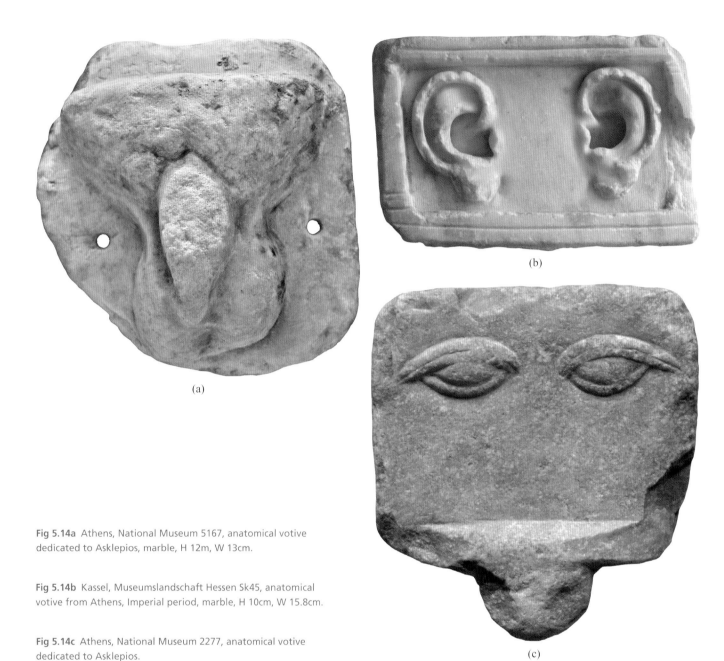

(a)

(b)

(c)

Fig 5.14a Athens, National Museum 5167, anatomical votive dedicated to Asklepios, marble, H 12m, W 13cm.

Fig 5.14b Kassel, Museumslandschaft Hessen Sk45, anatomical votive from Athens, Imperial period, marble, H 10cm, W 15.8cm.

Fig 5.14c Athens, National Museum 2277, anatomical votive dedicated to Asklepios.

Fig 5.15 Athens, National Museum 1407 from the Asklepieion in Piraeus, *c.* 400–350, marble, BC, H 21cm, W 30cm.

or directly healed the affliction. Cures are documented at sanctuaries to the god by inscribed pillars; votives of terracotta, bronze, or stone depicting whatever anatomical part was affected (hundreds are extant; Fig. 5.14a–c); or more elaborate votive reliefs, such as one that shows a worshipper, his wife, and children bringing an animal for sacrifice (Fig. 5.15). A substantially larger Asklepios leaning on a staff stands before an altar while an enormous snake, symbol of the god, coils behind him. This perceived intimacy between human and god, and the direct and immediate divine intervention were new to Greek ritual, at least in such a gentle manifestation. Asklepios was believed to be a son of Apollo, also a healer, and at Kos, Epidauros, and elsewhere, Asklepios took over a pre-existing shrine to Apollo. However, Asklepios' worship was different from that of Apollo, who healed in traditional ways: offerings were made, then the worshipper went away and hoped for the best.

Asklepios' best-known sanctuary was at Epidauros, where several buildings, including the temple and theater (Fig. 5.6), were constructed in the fourth century. Among these new structures was a circular structure (tholos), the "Thymele," as it was called in a contemporary inscription and by later writers, who name Polykleitos as the architect (Pausanias 2.27.5); inscribed building accounts indicate that the largely limestone structure was erected *c.* 365/360–320 BC (Fig. 5.16a–b).

Ringed with a Doric colonnade of twenty-six columns on the exterior, the roofed, single-room tholos was entered by a ramp at the east, where free-standing marble Corinthian columns, which supported the roof, stood on a patterned black-and-white marble floor and were surrounded by a wall of the same marbles. Elaborate marble moldings inside and around the doorway recall the Erechtheion's ornate decoration (Figs. 4.54–56). The Tholos' maze-like

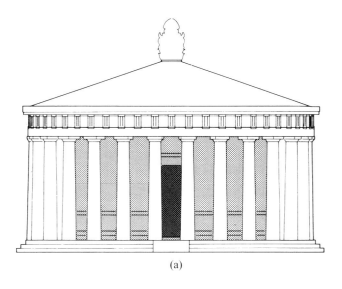

(a)

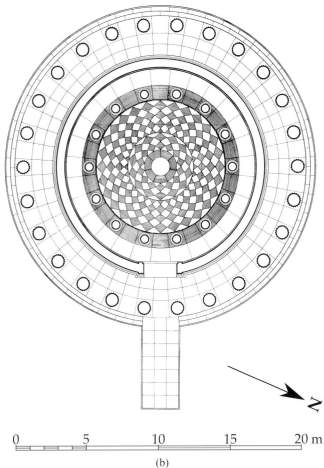

0 5 10 15 20 m

(b)

Fig 5.16 Epidauros, tholos, 9m high × 23m wide, (a) elevation reconstruction; (b) plan.

substructure consisted of three concentric walls separated from each other by communicating passageways centered around a *bothros* (pit); the pathway to the bothros is aligned with the building's exterior ramp. The substructure was accessible from the interior and has confounded scholars as to the building's function: some have ventured that snakes, symbols of the god, dwelt in the foundations or, more commonly, that this was the fictive burial place of the hero Asklepios. In any case, scholars generally agree that the labyrinth in the foundations was linked with Asklepios, who has a *chthonic* (earthen or underground) nature and whose snakes were believed by the Greeks to live in the earth.

Architecture, specifically the tholos form, could be deployed to suggest heroism or divinity for mere mortals (e.g., the monument for Theagenes in the Agora on the island of Thasos), though it is not the only building form to do so. The circular Philippeion at Olympia (Fig. 5.17) was begun by the Macedonian king Philip II to honor his victory in the Battle of Chaironeia in 338 BC and was finished by the ruler or by his son, Alexander the Great: it is planted squarely within the Altis of Olympia close to the "Heraion" and the Pelopion, a hero shrine to Pelops (Fig. 5.18; see also Fig. 4.9). Its Ionic exterior peristyle of eighteen columns is paired with nine engaged Corinthian columns on the interior (Fig. 5.19a–b), where they serve a purely decorative function (in contrast with the Tholos at Epidauros above); this pairing of different orders for interior and exterior is already seen in the Parthenon (Figs. 4.32–33), the Tholos at Epidauros (Fig. 5.16a–b), and the temple of Apollo at Bassai (Figs. 4.73–74). From the fourth century BC onward, this practice increases and with interior engaged columns often used ornamentally, not structurally. Within the Philippeion was a curved base that supported five statues of Philip and family members by the well-known sculptor Leochares, according to Pausanias (5.20.9): Philip and his son Alexander the Great, Amyntas (Philip's father),

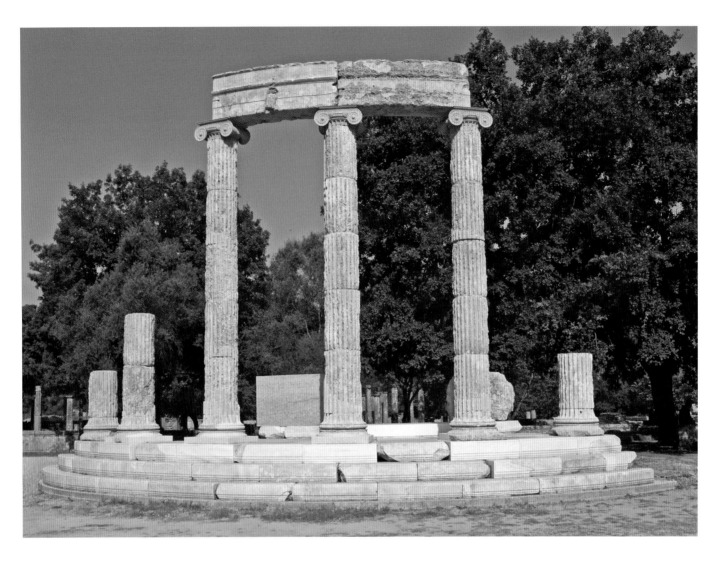

Fig 5.17 Olympia, Philippeion, c. 330–320 BC, D 15.24m.

Olympias (Philip's wife), and Eurydike (Philip's mother). The last two statues had already been moved to the Heraion (Figs. 3.2–3) when Pausanias arrived at the site in the mid-second century AD (5.17.4); by this time, the Heraion was used as something like a combination temple-museum. Pausanias claims that the statues were of chryselephantine, but the archaeological evidence suggests that they were at least partly of marble; they may have been gilt or, more likely, completed in chryselephantine, a material reserved for images of divinities, such as the colossal statue of Zeus in the nearby temple (see Figs. 4.10, 4.17). Material and placement suggest Philip's and perhaps Alexander's aspirations were to be viewed in the company of Pelops and Zeus.

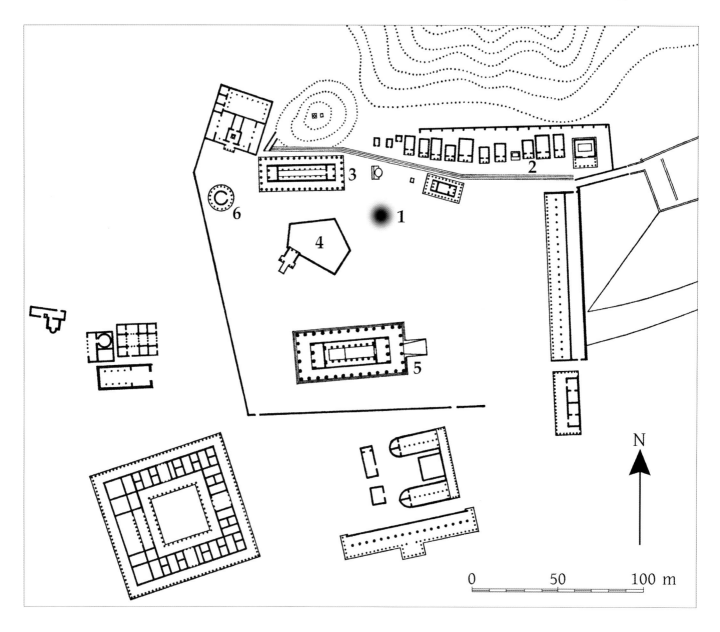

Fig 5.18 Olympia, *c.* 300 BC, plan. 1. area of ash altar;
2. treasury terrace; 3. Heraion; 4. Pelopion; 5. temple of
Zeus; 6. Philippeion.

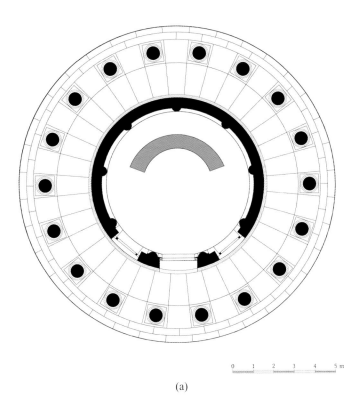

(a)

Fig 5.19a Olympia, Philippeion, *c*. 330–320 BC, D 15.24m, plan.

(b)

Fig 5.19b Olympia, Philippeion, *c*. 330–320 BC, D 15.24m, elevation reconstruction.

Intimacy and awe

The growing interest in exploring intimacy manifests itself in a variety of forms in sculpture. The sculpture found at Olympia of the adult Hermes holding the baby Dionysos (Fig. 5.20) in the crook of his left arm echoes the Eirene and Ploutos by Kephisodotos in Athens (Fig. 5.1). Pausanias (5.17) describes the Hermes and Dionysos group, which the periegete saw in the temple of Hera at Olympia (Figs. 3.2–3). Pausanias attributed the sculpture to the son of Kephisodotos, the sculptor Praxiteles of Athens, who was one of the most influential and important Greek sculptors in antiquity; Praxiteles is repeatedly cited by written sources in admiring tones as having produced one remarkable creation after another. Because ancient authors mention Praxiteles so frequently, we are in the unusual and fortunate position of knowing a great deal about his oeuvre, his exalted reputation, his commissions, and his wealthy family, among which there were several

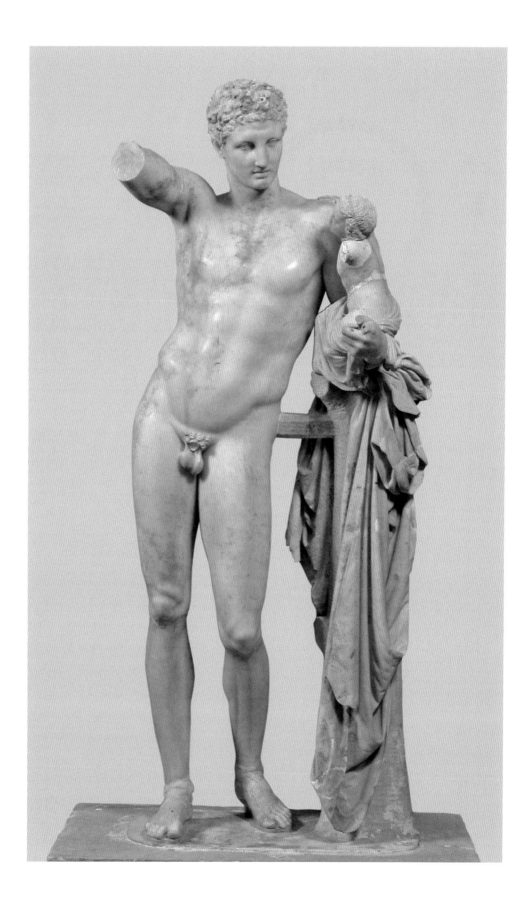

Fig 5.20 Olympia, Museum, Hermes and Dionysos by Praxiteles found in the Heraion at Olympia, marble, H 2.15m.

Box 5.3 Writing

Writing has been mentioned many times in this text: dipinti on terracotta and inscriptions on stone, clay, papyri, wood, and metal provide vital information about a wide range of issues, such as social, legal, and commercial organization; religious belief, practice, and regulation; building commissions, accounts, and inventories; and ownership and manufacture (not to mention literature), to name just a few. Inscriptions, such as the huge stone stelai recording the tribute given to Athens by its "allies," or treaties and laws, were publicly displayed as a form of "transparency of government."

Others, such as funerary inscriptions or votive statues, served personal needs while also being visible to a wider public and, therefore, were relevant to social standing. Yet others were entirely private. Forms of writing, particularly the civic documents issued by the state from the sixth century BC on, were rendered in various dialects and types of orthography (distinct "hands" of some lettercutters are discernible, and some inscriptions are aesthetically stunning; others were carefully placed on buildings for maximum effect). With so much writing everywhere – on statue bases, on vases (where we see genuine writing and also "nonsense"

writing, perhaps in imitation of the real thing), on public proclamations, contracts, leases, funerary monuments, temples and civic buildings, boundary stones, and so on – it is natural to question the extent of literacy and the ability to write. We tend to think of these skills as restricted to the elite classes – those with the leisure and means to learn – but this perception needs adjustment. Several rock-carved inscriptions, some in verse, of *c.* 550 BC from Attika were written by a man named Sotimides, who, in one instance, identifies himself as a lone shepherd near the border.

generations of sculptors (the names alternate generations). He worked in both marble and bronze, and is credited with dozens of works, including images of Aphrodite, Eros, Dionysos, satyrs, Apollo, Demeter and Persephone, Tyche (Fortune), victors' statues, and architectural sculpture. Several of his works, according to ancient writers, inspired erotic responses, most memorably the Aphrodite of Knidos (see below).

The group of Hermes and Dionysos, carved from Parian marble, was discovered in 1877. Pointing to the unfinished areas of the back of the statue, the plasticity of the drapery, elaborate sandals of the standing god, and softened, sfumato face of Hermes, traits best known in later periods, scholars debate whether it is an original Greek work by Praxiteles, an original work by a Praxitelean imitator of the early Hellenistic period, or a Roman copy; this author believes that the treatment of the drapery – its soft edges and fullness – and the hair indicate that it is a Greek original of the fourth century. This is the first large-scale sculpture to portray the theme, known from written accounts and in earlier vase painting, of Hermes' taking the newborn Dionysos from his father Zeus (from whose thigh Dionysos was born) to Nymphs, who raised the baby god to adulthood. The

sinuous S-curve formed by Hermes' outward jutting hip, produced from a markedly unnatural stance, was a hallmark of Praxiteles' style and lends a languid, sensuous aura to the youthful god. Hermes looks down with bemusement and tenderness at the baby, who eagerly reaches upward, perhaps for a cluster of grapes that originally dangled from Hermes' raised right hand (most of the upraised arm, the hand, and the posited grapes are now lost), displaying a remarkable precocity for this god of wine, perhaps suggesting that childhood is not an innocent state. The figures take no notice of the viewer, who observes a playful moment that was never intended for public spectacle. This is a contrast to earlier images of deities, which are more formal, hieratic, and serious in tone – designed for awe-inspiring worship, not charmed delight and amusement.

New trends in architecture

Religious awe in architecture was still a desideratum but evoked now in powerful new ways. Didyma was the location of an(other) oracle of Apollo housed in an extraordinary temple: it follows the old Ionian tradition of enormous Ionic temples – the columns here are the tallest of all temples – but the design is truly innovative (Figs. 5.21–23). Vitruvius (7 praef. 16) records the architects as two Ionians, Paionios of Ephesos and Daphnis of Miletos. The dipteral structure, 10 × 21, was placed high atop seven steps with a frontal staircase (twelve steps), an unusual feature for Greek temples. The pronaos had twelve columns in antis, which, together with the peristyle, created a forest of columns on elaborately decorated bases for the ancient visitor, a feature familiar from earlier Ionian temples (cf. Fig. 3.9b). Instead of entering the cella through a doorway (there *is* a central doorway but its threshold is placed some 5m above the stylobate, making it inaccessible without a ladder), access to the interior of the temple was gained by two downward-sloping tunnels ("labyrinths" in ancient written sources), which led from the shadowy pronaos into a courtyard open to the sky, to the light – the embodiment of the god Apollo. Within the courtyard was a small, traditionally planned tetraprostyle shrine, perhaps containing the cult statue. Ionic engaged pilasters were regularly placed on the upper portion of the enclosure wall. Opposite the shrine within the courtyard was a tall staircase (twenty-two steps) leading to an adyton reached by

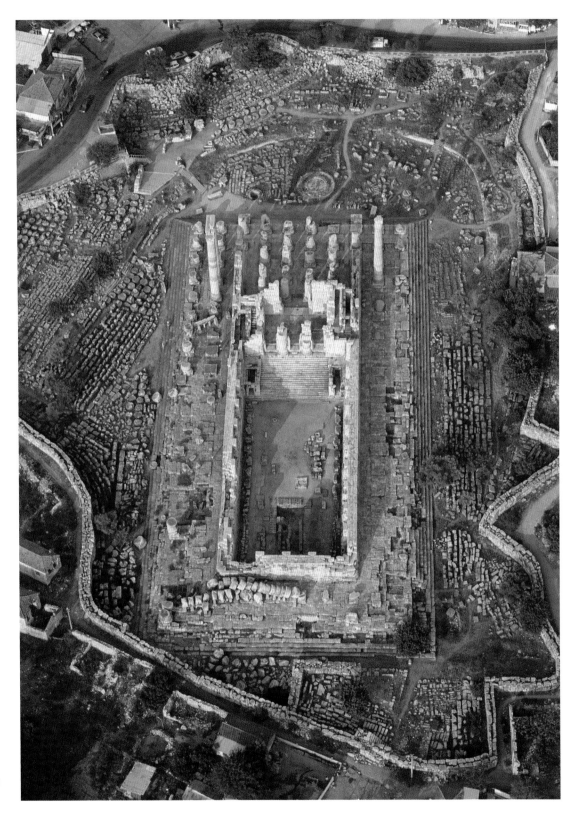

Fig 5.21 Didyma, temple of Apollo designed by Paionios of Ephesos and Daphnis of Miletos, 51.13m × 109.34m, aerial view looking to east.

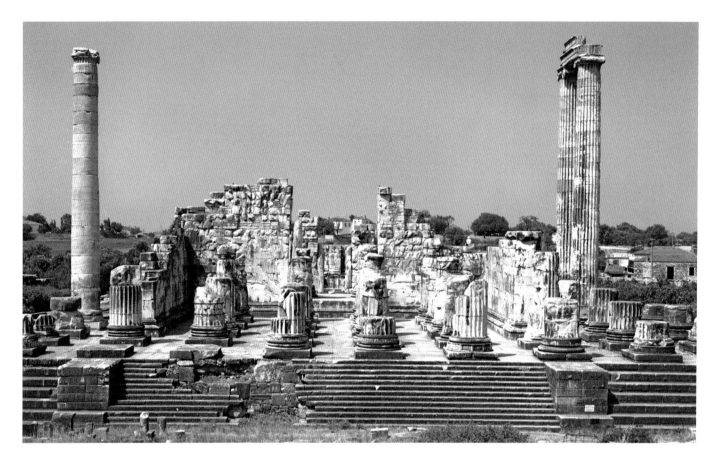

Fig 5.22 Didyma, temple of Apollo, east façade.

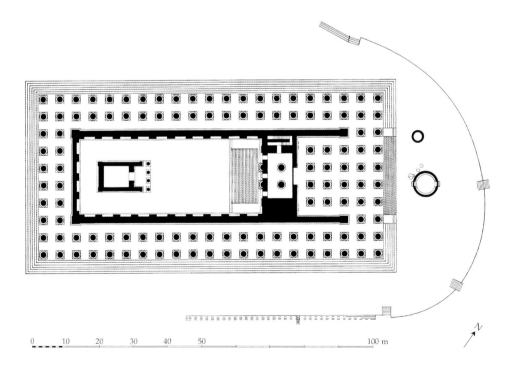

Fig 5.23 Didyma, temple of Apollo, plan.

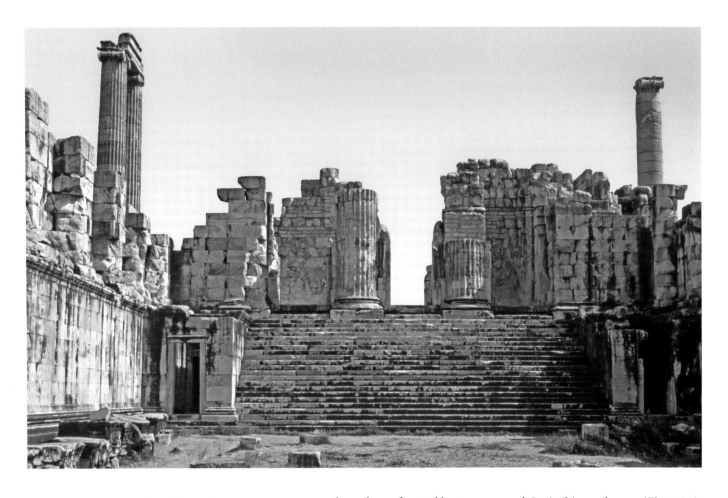

Fig 5.24 Didyma, temple of Apollo, interior.

three doors fronted by two engaged Corinthian columns (Fig. 5.24); two Corinthian columns within the adyton supported the roof. How all these architectural features functioned in the rites that took place here is not clear. In addition to the unusual architecture, the building holds yet one more surprise: architectural diagrams were etched into the lower, rough (thus, presumably unfinished) surfaces of the enclosure wall as the architects worked out measurements and details. The architecture is both overwhelming in its scale yet intimate at the same time. Like the temple of Apollo at Bassai (Figs. 4.73–74), the interior space is the focus of attention. It feels surprisingly small because of the high enclosure walls, yet unlike the building at Bassai, the light does not stream in from a single doorway; instead, the roof was removed to admit light, the god made manifest, from the open sky above.

Surprise also awaited the visitor to the temple of Athena Alea at Tegea in the Peloponnese, where another conventional exterior masks a remarkable interior. The Doric temple was, at 6 × 14, an

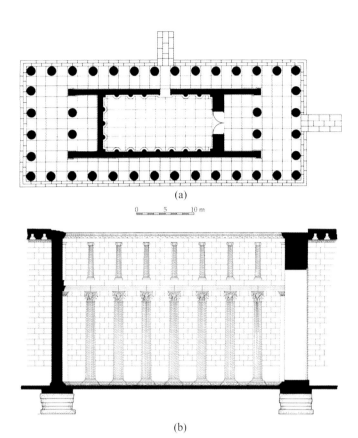

(a)

0 5 10 m

(b)

Fig 5.25a–b Tegea, temple of Athena Alea, *c.* 345–335 BC, 49.56m × 21.20m, plan and reconstruction of interior elevation.

unusually long marble structure – perhaps influenced by its archaic predecessor beneath – in a sanctuary with a history that dates back at least to the eighth century BC. Like other temples in the Peloponnese, this had an entry ramp on its east side (Fig. 5.25a–b; cf. Fig. 4.11), but in spite of its "normal" pronaos, cella, opisthodomos arrangement (with two columns in antis in both the pronaos and opisthodomos), the building also had an entry ramp on its north side that aligned with an ornate door leading into the cella; here, the room was organized into a two-tier arrangement with engaged Corinthian columns below and perhaps engaged Ionic columns above against three of the cella walls. In short, the orientation moved to the lateral side of the building (or at least shared prominence with the east), the cella interior was surprisingly open, and the interior columns were ornamental rather than structural. This was a natural development from the cella of the temple of Apollo at Bassai (Figs. 4.73–74), a structure with an even more conventional exterior and the use of multiple orders, and indicates a growing interest in the temple interior. Pausanias reports that the architect of the Tegea temple was the sculptor Skopas (see below), who may also have been responsible for the temple's exterior architectural sculpture; if this is true, it would go some way to explain the emphasis on enlivening the interior cella walls with architectural elements as if they were sculptural ornament.

The nude body: toil and care

Praxiteles' group of Hermes and Dionysos at Olympia was discussed above (Fig. 5.20). His most renowned creation in the ancient world, the Aphrodite of Knidos, offers a revolutionary and highly intimate encounter between goddess and viewer (Fig. 5.26). Ancient written sources cite this work again and again, indicating that it was admired for its beauty and produced a highly titillating effect, information confirmed by Roman sculptors, who repeatedly copied the statue in various media and scales. The original manner of the statue's display at Knidos on the coast of Asia Minor is not known; in

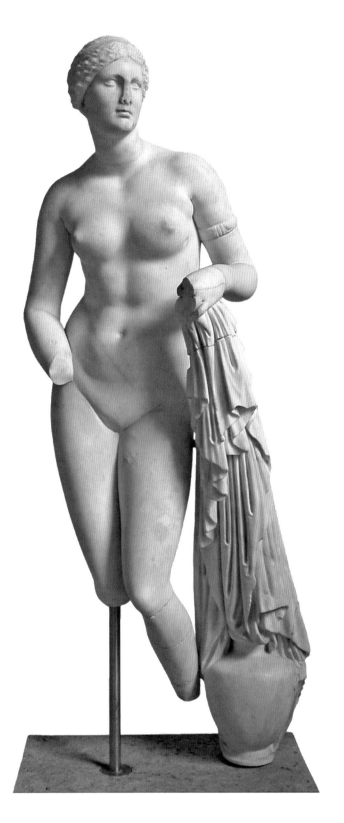

Fig 5.26 Munich, Glyptothek 258 ("Aphrodite Braschi"), Roman copy of the Aphrodite of Knidos by Praxiteles, marble, H 1.62m.

the Hellenistic period, she was placed in a circular shrine. The original over-lifesize statue of polychromed Parian marble (Lucian, *Amores* 13 mentions the marble type), now known only from the copies, was completely nude (save for a jeweled armlet) – the first monumental, three-dimensional fully nude female in western art. Aphrodite is shown at the conclusion of a bath, as indicated by the water jar. As if responding to an intruder who has spied her, she simultaneously reaches for her drapery and modestly covers her genitals with one hand. But the intruder in this instance is the viewer: the sculpted form responds to a viewer's gaze, another "first" in Greek art. Contemporaries regarded the figure's ample proportions as the model of female beauty. Pliny (*NH* 36.20), in fact, recounts the anecdote of a man who was so infatuated with the sculpted image that he hid in the shrine at night; he embraced the statue, which so inflamed him that he ejaculated on its thigh. Rather than the relaxed, reclining voluptuous clothed beauty on the east pediment of the Parthenon (Fig. 4.37), this image of Aphrodite captures the goddess in a moment of vulnerability – but only to the viewer's gaze for Aphrodite is, after all, a deity. Yet, this moment of intimacy, the direct encounter of mortal and deity, and the sense of drama created between object and viewer are evidence of a changing perception of humans, deities, divine images, and the idea of spectatorship, where viewers are encouraged to explore the manifold possibilities of a given object, rather than receiving a fixed vantage point or perception. In spite of her divine nature, however, we see the goddess in the midst of a mundane task.

The S-shaped line of the figure's right side emphasizes her curvaceous physique, while the head, turned to the figure's left, became the standard type for the depiction of this goddess hereafter: wavy hair parted in the middle and pulled back over the ears with a fillet, an oval face with languid, almond-shaped eyes, and a small, cupid's-bow mouth.

The Knidian Aphrodite quickly inspired a great many more female nudes in monumental Greek sculpture and indicates a changing attitude toward female nudity. Male nudity had been a norm of Greek art from early on, but female nudity had been restricted to small figurines,

(a) (b) (c)

Fig 5.27a–c Vatican City, Musei dei Vaticani, Museo Pio Clementino 1185, Apoxyomenos, Roman copy of original attributed to Lysippos, c. 330–320 BC, marble, H 2.05m.

usually inspired by Near Eastern models (cf. Figs. 2.30, 2.42), or to vase painting images of hetairai or victims of sexual assault, such as Kassandra (cf. Fig. 3.56). Praxiteles' creation is both consistent with his oeuvre, which tended to erotic, languid figures shown in seemingly private moments, as well as larger fourth-century trends, and also revolutionary in shifting aesthetic interest to the female nude.

The interest in everyday activities and exploring space becomes more and more common in Greek art. The Apoxyomenos (Scraper) of c. 330 BC by Lysippos takes up the theme of the nude male athlete, which had been depicted in Greek sculpture for centuries (Fig. 5.27a–c); statues of successful athletes were erected in Panhellenic sanctuaries to commemorate crown victories. The image of an athlete cleaning himself after exercising had occasionally merited treatment in large-scale sculpture before the fourth century BC (for example, Polykleitos engaged with this subject). One wonders about the purpose of Lysippos' original since written sources are silent on this point, but placement of the statue in a gymnasion or sanctuary would be

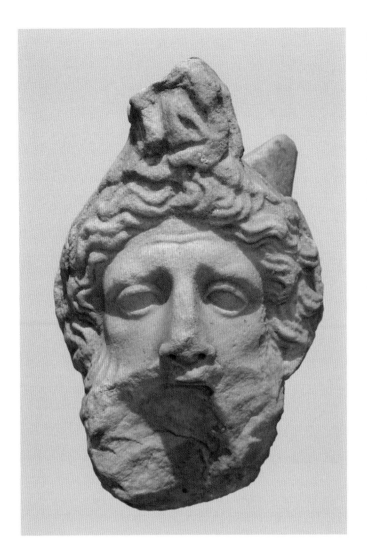

Fig 5.28 Athens, National Museum 144 (Priam), from the east pediment of the temple of Asklepios at Epidauros, c. 380 BC, Pentelic marble, H 15cm.

suitable. As the figure, known from Roman copies, pushes the strigil along the underside of his right arm toward the viewer, he extends this limb before him, penetrating the frontal plane of the statue, intruding into the viewer's space. Rather than balancing his weight between a forward and backward leg, as does the Doryphoros of the mid-fifth century (Figs. 4.29–30), the Apoxyomenos extends his legs laterally – weight borne on the left leg, the right leg, far to the side, and balanced on the ball of the foot, preparing to pivot. Like the Aphrodite of Knidos (Fig. 5.26), the Apoxyomenos twists at the waist and, in this case, produces a spiral effect that encourages the viewer to walk around the figure and examine him from a variety of viewpoints. This exploration of space – forward and laterally – is one of Lysippos' contributions, a trend that will continue and develop over the next few centuries. Another important Lysippan innovation is the use of a new canon of proportions, an 8:1 head-to-body ratio, replacing the 7:1 ratio used in earlier Classical sculptre, such as Polykleitos' Doryphoros (Fig. 4.29). The result is a longer, leaner body topped by a smaller head. Indeed, Lysippos' work was so dynamically new that one can refer to him as the last Classical and the first Hellenistic sculptor. He was also the court sculptor for Alexander the Great, a point discussed below.

Emotional expression

Increasing intimacy between sculpted figures and between gods and mortals has already been discussed in this chapter. A more general interest in emotional expression of many kinds – not just warmth and closeness but also fear and excitement – is also evident in fourth-century sculpture. The temple of Asklepios at Epidauros was ornamented with half-lifesize figures of the Amazonomachy in the west pediment and the sack of Troy in the east. The head of Priam, king of Troy, in the eastern composition is remarkable for its degree of expressiveness and pathos (Fig. 5.28). The remains of a hand, presumably that of Neoptolemos – Achilles' son and traditionally the warrior who kills Priam (cf. Fig. 3.56) – grab at his hair from above while the old man's brow wrinkles in distress, his eyebrows raised with surprise and pain over sorrowful

Fig 5.29 Athens, National Museum 179 (warrior) from the east pediment of the temple of Athena Alea at Tegea, *c.* 345 BC, marble, H 33cm.

Fig 5.30 Athens, National Museum 180 (Telephos) from the east pediment of the temple of Athena Alea at Tegea, *c.* 345 BC, H 31cm.

eyes. Unfortunately, the figure's mouth no longer survives though one can see from the shape and size that it was probably open. The violence of the gesture is paralleled only by vase paintings of this theme dating a century before and contemporary theatrical masks used in the performance of tragedies.

Likewise, the marble heads of male figures – Telephos and a warrior – from the sculpted west pediment of the Doric temple of Athena Alea at Tegea (Fig. 5.25a–b) reveal a similar dramatic intensity (Figs. 5.29–30). The west pediment depicted the battle of Greeks and Mysians in which Achilles wounds Telephos, the legendary founder of Pergamon and son of Herakles (see Chapter 6), while the east pediment was filled with the Kalydonian boar hunt (cf. Fig. 3.30a). Both heads are broad and square in shape with deep-set eyes under furrowed brows and turn and tilt dramatically. They express energy, tension, and dynamism,

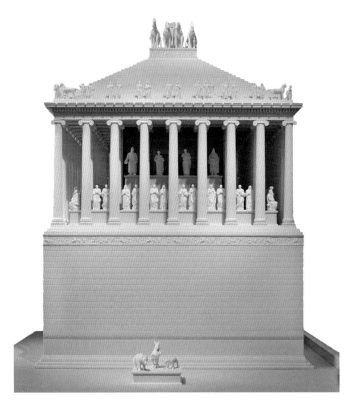

Fig 5.31 Halikarnassos, Mausoleion, *c.* 350 BC. Model made by J. Kościuk, K. Szydekko, and J. Kucharski, according to the reconstruction by W. Hoepfner.

purported hallmarks of Skopas' style, which is also recognizable on some of the slabs of the Mausoleion (Fig. 5.31–33). The temple's architecture is attributed to the famed sculptor Skopas, who was from Paros, the island known for its translucent crystalline marble so prized by sculptors and patrons, and who was ranked along with Praxiteles in skill (Fig. 5.2). How much of the sculpture is attributable to Skopas, however, is controversial. The innovative and superior quality of the surviving pieces of architectural sculpture, the similarities between the surviving architectural sculpture and architectural ornament (e.g., moldings), and Pausanias' (8.47.1) report that Skopas created statues of Asklepios and Hygieia flanking the cult statue together convinced earlier experts that Skopas also made the temple's sculpture. However, some recent scholarship challenges this view and dissociates Skopas from the architectural sculpture.

The wider world

Athletes had been the larger-than-life heroic figures of real life for centuries, and we have already seen the shift toward heroic imagery for other kinds of mortals in the grave stele for the warrior Dexileos (Fig. 5.3). A new kind of human

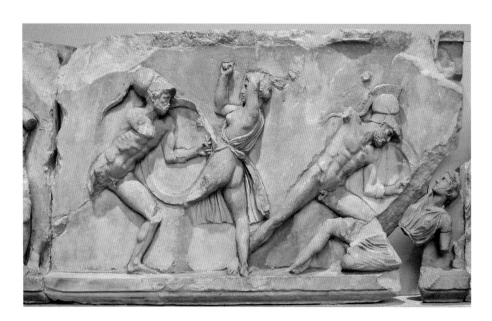

Fig 5.32 London, British Museum 1014, Mausoleion of Halikarnassos, detail of Amazonomachy frieze, *c.* 360–350 BC, marble, H 90 cm.

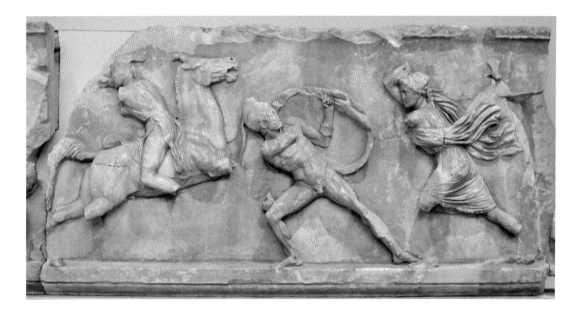

Fig 5.33 London, British Museum 1015, Mausoleion of Halikarnassos, detail of Amazonomachy frieze, marble, H 90cm.

hero, however, emerges on the Greek scene in the mid-fourth century. Rulers in the Near East had long been worshipped and venerated as heroes after their deaths and even during their lifetimes; Egyptian pharaohs, for example, were worshipped as divinities while alive. But this practice was rare in the Greek world. Grave monuments of the fourth century BC, such as the enormous, towering tomb at Halikarnassos built for the ruler Mausolos of Karia, attest to this growing practice in Asia Minor, an area settled by Greeks who lived side by side with the native eastern peoples. In the mid-fourth century, this region was part of the Persian empire and governed by regional satraps, such as Mausolos, who operated with a fair degree of independence. Begun by Mausolos in the 360s and continued by his wife Artemisia after his death, the Mausoleion (the modern English word "mausoleum" derives from the Latin word for this structure) was completed in the 340s after her own death. The tomb's original appearance is unknown, although its (rather disappointing) foundations and remaining architectural members, combined with the written accounts, indicate that it measured 140.8m in circumference and 44.8m high (Pliny, *NH* 36.30–31). Together with smaller copies in Greek and Roman architecture, this evidence suggests that the tomb was an elaborate manifestation of the Near Eastern tower tomb type (see Fig. 5.31, one of many reconstruction attempts). It was originally decorated with hundreds of polychromed marble sculptures on multiple levels, crowned by an image of Mausolos

and Artemisia standing in a chariot at the top. The sculpture was intended to glorify the deeds and continually invoke the memory of the ruler. Although Mausolos was a regional governor for the Persian kings, he clearly was familiar with Greek myth and art as indicated by his choice of themes for his tomb, which combine a common Greek subject, the Amazonomachy (Figs. 5.32–33), with traditional Near Eastern imagery, such as lions and hunt scenes. Further evidence of his erudite taste and substantial wealth is his employment of four prominent Greek sculptors to carve the Greek themes: Bryaxis, Timotheos (or Praxiteles), Leochares, and Skopas (Pliny, *NH* 36.30–31; Vitruvius 7. praef. 12–13). Skopas and Praxiteles have already been discussed here, and Leochares sculpted the images in the Philippeion (Figs. 5.17–19); Timotheos is credited with the pediment sculptures for the temple of Asklepios at Epidauros (Fig. 5.28). Also typical of eastern rulers and their tombs was the sacrificial offering that Mausolos received: remains of hundreds of animals, slaughtered at the time of the ruler's entombment, were found adjacent to the tomb door. More typically Greek were the funeral games organized by Artemisia in honor of the deceased ruler (Theopompos in *FGrH* 115 F 345) and the tragedy, *Mausolos*, commissioned from the contemporary playwright Theodektes (Aulus Gellius 10.18), whose play was performed at the dedication of the Mausoleion.

Not only is the Amazonomachy a traditional Greek theme, but also the execution of the relief is very much in Classical Greek style. The slabs comprise two- or three-figure groups of largely nude male warriors fighting against clothed – or partially clothed – Amazons. One Amazon, shown from a three-quarter back view, is almost completely nude: her drapery flies open to reveal much of her left side, her left breast, and her body from the waist down (Fig. 5.32). All traces of landscape are absent, and male figures are shown with conventionally athletic, fit physiques, although bodies are tauter and leaner than their fifth-century counterparts. Both male and female figures are seen from a variety of viewpoints – back, front, profile, three-quarter – on a single groundline and appear in many positions, though diagonal poses dominate the composition, creating a sense of movement and drama across the surface of the marble relief. The flying drapery of some figures is a direct borrowing from Athenian late fifth-century sculpture, such as the friezes of the Athena Nike temple (Fig. 4.52).

Alexander

This growing cosmopolitanism intensified in the second half of the fourth century, primarily due to the ambitions and achievements of one man, Alexander the Great. At mid-point in the fourth century, Alexander's father, Philip II, king of Macedon in northern Greece, conquered city after city in northern Greece, then Thessaly, and finally won control of Athens, Thebes, and Corinth at the Battle of Chaironeia in 338. He was succeeded at his death (by assassination) in *c.* 336 BC by his son, Alexander, who capitalized on the achievements of his father, then accomplished much more than Philip had ever dreamed possible. By the time of his own death in 323 BC at the age of thirty-three, Alexander and his army had conquered nearly all the known world from Greece as far eastward as Afghanistan and northern India, bringing Hellenism to far distant places. Likewise, he incorporated elements of the rich eastern cultures into the execution and extent of his power, including the royal image (his portrait), which was largely created by his court sculptor, Lysippos, mentioned above, and broadcast widely. According to ancient

Box 5.4 Alexander's conquests

Our chief ancient sources for the life and campaigns of Alexander the Great – Arrian, Diodorus Siculus, and Plutarch – date several centuries after his lifetime. He was born in 356 BC and succeeded his father, the Macedonian king Philip II, in 336 BC, when Philip was assassinated. Within a year, Alexander had secured his hold on Greece and turned his attention to conquering Persia in order to, as ancient authors recount, take vengeance on the Persians for their attack on Greece in the Persian Wars of *c.* 490–479 BC. In 334, Alexander and his army, composed of Macedonians, Thracians, Illyrians, and Greeks, crossed the Hellespont into Asia Minor. At the Granikos River, he defeated the forces amassed by the Persian satrapies and by 333, he had gained control of the Near East. On his visit to Egypt, which surrendered without a fight, in 332/331, he went to the Siwah oasis, site of a temple of Zeus-Ammon. As he approached, the priests of the temple came out to greet him, hailing him as the son of Zeus, and subsequently he began to accept honors usually accorded to an eastern potentate and Zeus. When he arrived at Persepolis, the capital of the Persian kingdom, in 331/330, Alexander and his army helped themselves to the treasury, and burned the palace. They pressed further eastward, conquering as they went, as far as modern Afghanistan and then just beyond the Punjab River in India. During his campaigns, Alexander founded many cities (many called Alexandria), instituted Greek cults, and introduced Greek theater, with the result that even remote places, such as Ai Khanoum in modern Afghanistan, were strongly marked by Greek culture. In spite of Alexander's ambition to continue, his army refused and insisted that they turn back. Alexander died in Babylon in 323, having conquered most of the known world.

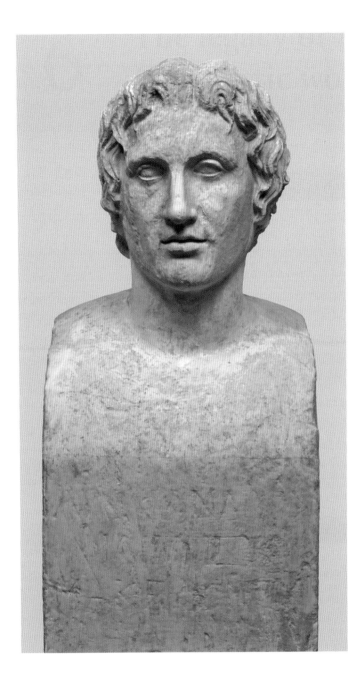

Fig 5.34 Paris, Musée du Louvre 436, Azara herm from Tivoli, Roman copy of a Greek original of *c.* 335–320 BC attributed to Lysippos, marble, H 68cm.

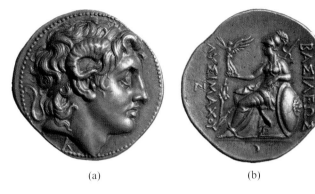

(a) (b)

Fig 5.35a–b London, British Museum 1919, 0820.1 from Lampsacus, tetradrachm minted by Lysimachos of Thrace *c.* 305–281 BC, Alexander as Zeus-Ammon on the obverse, Athena on the reverse, silver, weight 17.25.

authors, Lysippos was the only sculptor authorized to make Alexander's image (there were also a court painter and court gem-cutter, the latter of whom may also have designed coin dies). Though not a single original portrait by Lysippos is extant, some idea of his style is ascertainable from ancient writers and from one Roman copy, the Azara herm, which probably replicates a Lysippan portrait of Alexander (Fig. 5.34). Ancient authors provide descriptions of Alexander's appearance – slightly open mouth, prominent eyes, breathless expression, and slight turn of the head; these are difficult to discern in the Azara herm but we must keep in mind that it is a Roman copy.

Coin portraits of Alexander, however, transmit the visage described by ancient authors with greater fidelity. Posthumous coin images often show Alexander with the attributes of a deity, paired with Athena or another deity on the reverse (Fig. 5.35a–b). Using the coins and written descriptions as indices, scholars endeavor to recognize Alexander's portrait in other works. A small bronze figurine of a male (Fig. 5.36) originally held a lance planted on the ground in his upraised left arm, and thus provides the visible embodiment of "spear-won land," as Alexander declared of Asia Minor when he arrived there in 334 (Diodoros 17.17.2). As badly worn as they are, his facial features accord with written descriptions of Alexander and the portraits created of him by Lysippos. A vivid example of these portrait features appears in the

Fig 5.36 Paris, Musée du Louvre 370 ("Fouquet" Alexander) from Alexandria, Roman copy of an original of *c.* 335–320 BC, bronze, H 16.5cm.

Alexander mosaic found in the House of the Faun at Pompeii, which is believed to reflect a painting made during Alexander's lifetime or shortly after his death by Philoxenos of Eretria (Fig. 5.37a–b). Alexander is shown engaged in battle with the Persian king Darius, perhaps at the Battle of Gaugamela. His trademark *anastole* (cowlick) marks the central part of his dramatically leonine hair, and his wide bulbous eyes are framed by a furrowed brow as he turns his gaze filled with pathos toward his defeated enemy. The bronze figurine (Fig. 5.36) shares the same type of hair, arched eyebrows, and dramatic turn of the head (although in the opposite direction). We presume that the original that inspired this small figurine was lifesize or larger. Shown in heroic nudity, the bronze Alexander steps forward while simultaneously turning his head to the right. His taut, athletic body contrasts with his relaxed, open pose, which, like the Apoxyomenos (Fig. 5.27a–c), breaks with strict frontality to beckon the viewer to consider the figure from multiple vantage points. Unlike portraits of earlier rulers, Alexander's dispensed with the beard, and this became a fashion thereafter. The dashing figure of the charismatic ruler presents him heroically, and this portrait, together with others, was influential on subsequent ruler portraits (including those of Alexander made posthumously, Fig. 5.38), from Alexander's immediate successors throughout the Roman period and well beyond.

To judge from the ancient written and visual evidence, mythological models, particularly those of Herakles and Achilles, were prominent in Alexander's sense of self and the image he wished to convey to the world. Silver coins minted by him around *c.* 330 BC portray Herakles wearing a lion's skin on the obverse. A seated Zeus, based on the Pheidian cult statue from the temple of Zeus at Olympia (Fig. 4.17), with an eagle on his outstretched right hand, occupies the reverse, together with the legend, "ΑΛΕΞΑΝΔΡΟΥ" (Fig. 5.39a–b). One might perceive a comparison between the ruler and the hero here, although this is controversial; after Alexander's death, however, images made the comparison between the ruler and Herakles, or the ruler and a god, explicit.

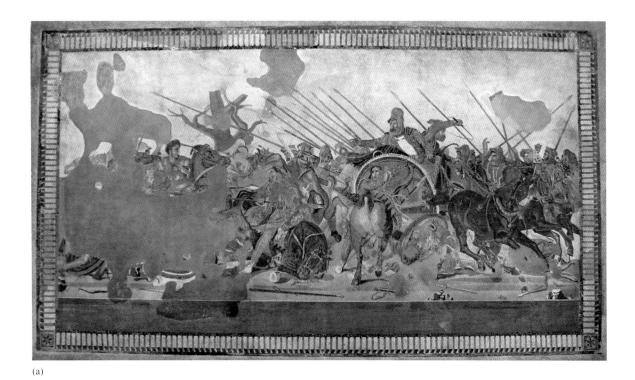

(a)

Fig 5.37a Naples, Museo Nazionale, Alexander Mosaic from the House of the Faun, Pompeii, 2.7m × 5.2m.

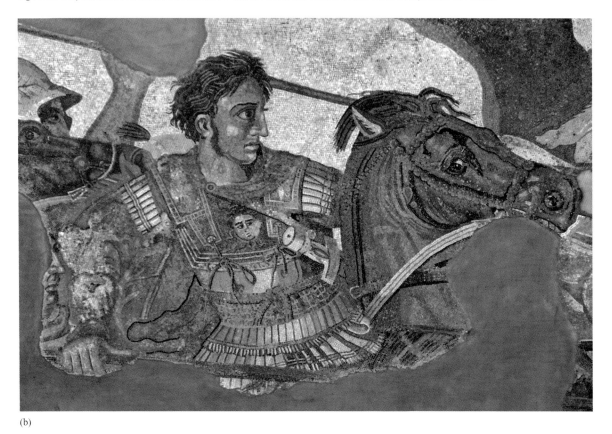

(b)

Fig 5.37b Naples, Museo Nazionale, Alexander Mosaic from the House of the Faun, Pompeii, detail of Alexander.

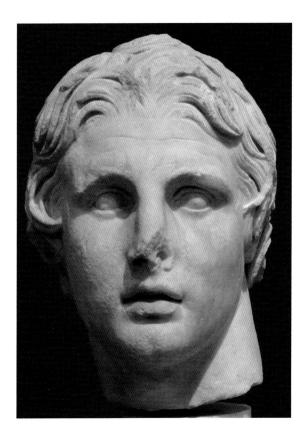

Fig 5.38 Istanbul, Archaeological Museum 1138 from
Pergamon, Alexander, marble, H 42cm.

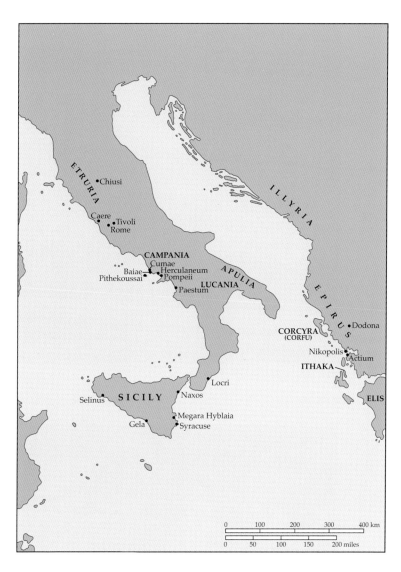

Map of Italy and western Greece

A changed world

Alexander's successors presided over geographically defined king-
doms – the Ptolemies in Egypt; the Seleukids in Syria and the Near
East; the Antigonids in Macedonia – and spent the next decades strug-
gling with outside powers and with each other, thereby forming several
more, smaller kingdoms (including the Attalids at Pergamon in Asia
Minor). The autonomous Greek poleis, governed by an oligarchy or,
more rarely, a democracy, were ostensibly ruled by monarchs overseeing
vast territories governed at the local level by officials in service to the king.
But the reality was far more complicated and erratic; Rhodes remained
independent, Athens and a few other cities experienced periods of

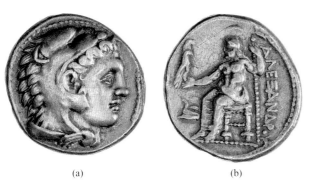

(a) (b)

Fig 5.39a–b New York, American Numismatic Society 1944.100.12983 from Amphipolis, tetradrachm minted by Alexander *c.* 330 BC, Herakles on the obverse, Zeus on the reverse, silver, weight 17.16g.

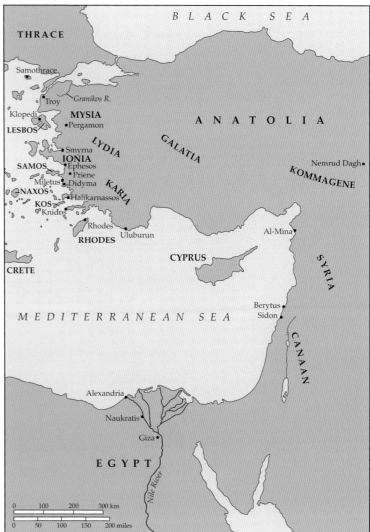

Map of the eastern Mediterranean

independence, and in these places and many others, the "polis" persist-ed in most respects – religious festivals and athletic contests, internal governance and finances, military training, and cultural institutions.

At another level, however, both local rulers and the *Diadochoi* (Alexander's immediate successors) endeavored to assert their dominance over their realms. Taking their lead from Alexander, they employed visual imagery and an association with Alexander to enhance and legitimate their status. The painted marble sarcophagus for the local ruler Abdalonymos of Sidon (in modern-day Lebanon), also known as the "Alexander Sarcophagus," depicts Abdalonymos together with Alexander and a group of companions battling against Greeks on one long side, while the other portrays the same protagonists hunting a

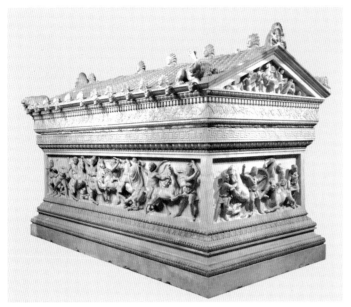

(a)

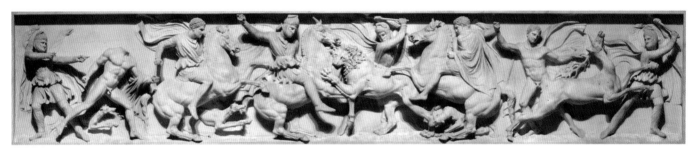

(b)

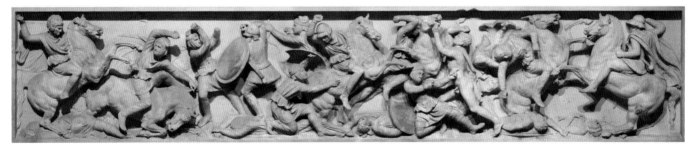

(c)

Fig 5.40a–d Istanbul, Archaeological Museum 370
("Alexander sarcophagus") from Sidon royal necropolis,
c. 325–311 BC, marble, L 3.2m, W 1.7m, H 2m, H of
friezes 69cm.

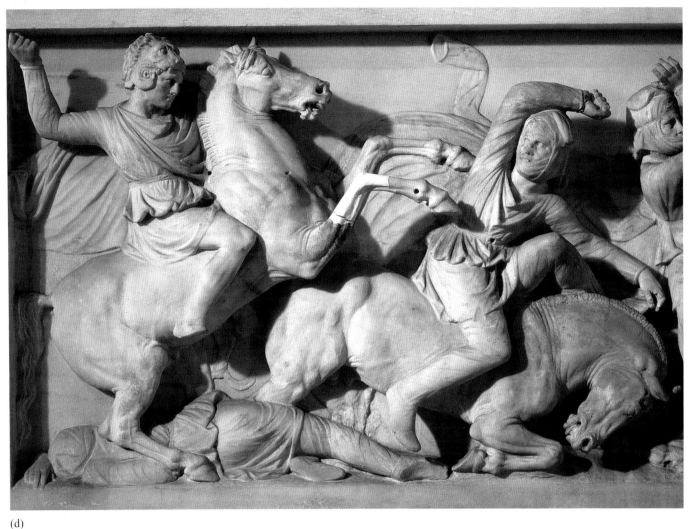

(d)

Fig 5.40 *(Continued)*

lion and stag (Fig. 5.40a–d). The hunt may represent one that actually happened in one of the many Persian *paradeisoi*, enclosed game parks for the purpose of hunting. Abdalonymos and Alexander are prominently placed in both scenes, immediately distinguishable from their cohorts. Together, they approach the hunted lion from the left, first Alexander on a rearing horse, then Abdalonymos in Persian attire, as they work together to bring down the fierce beast. Abdalonymos takes the central role in the battle scene, while Alexander, wearing a lionskin cap like Herakles, sweeps in from the left side. Note that Abdalonymos' pose in the lion hunt and Alexander's in the battle scene are remarkably similar as if to identify the former with the latter.

More so than any earlier reliefs examined here, those on the Alexander Sarcophagus are marked by crowding and overlapping

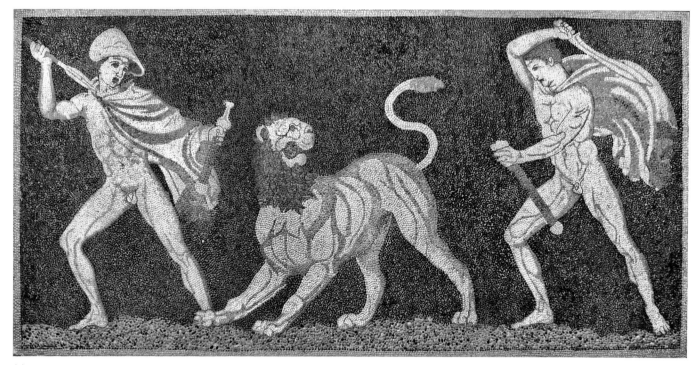

(a)

(b)

Fig 5.41a–b Pella, Museum, pebble mosaic of lion hunt from Pella, 4.90m x 3.20m.

Fig 5.42 Vergina, museum, tomb II façade.

figures – especially true of the battle scene – all of whom move on a shallow platform of relief. As was true for the Mausoleion friezes (Figs. 5.32–33), diagonal poses dominate the composition yet there is a more limited range of figural positions in spite of the greater depth of relief.

While used in the Mycenaean period, the lion hunt motif here derives from the official art of Near Eastern potentates, such as Assyrian kings, who portrayed themselves slaying lions, and paired such images with others of the king triumphant in battle. The same motifs occur on Abdalonymos' sarcophagus, which also incorporates Alexander into this program in order to establish Abdalonymos' close association with the king and his charisma. Alexander exerted influence and commanded respect even after his death as he attained the status of a legend. His imagery, which became synonymous with the iconography of power, provided the medium through which lesser mortals staked their claim to greatness.

The Near Eastern lion hunt image was recruited for reliefs, mosaics, and paintings connected with the Macedonian royal family and their close associates. Examples include the Krateros Monument at Delphi erected by one of Alexander's generals, Krateros (no longer extant, but known from ancient written sources and perhaps small-scale copies); a pebble mosaic of a lion hunt (Fig. 5.41a–b) found in the royal palace at the Macedonian capital of Pella (note that terracotta strips in the mosaic define outlines and modeling); and the painted frieze on the façade of a royal tomb at Vergina in Macedonia (Figs. 5.42–44). Vergina, or ancient Aigai, is the site of remarkable tombs used by the Macedonian royalty at the end of the fourth and beginning of the third century BC, which were discovered in the 1970s (and tombs continue to be discovered here). Not only were wall paintings, some of the only extant wall paintings from the ancient Greek world, found here but one tomb was found only partially looted; its contents of gold crowns (Fig. 5.45), gold and silver vessels, bronze gold-ornamented armor, and other precious objects (Fig. 5.46) give a glimpse of the fabulous wealth acquired by these monarchs and their sumptuous burial. The cremated bones of two people were enshrouded in fragmentary textiles placed in gold boxes in the tomb. Many more painted tombs have been found in Macedonia since this find at Vergina, though none with grave goods equal to those found here.

Typical for wealthy tombs in Macedonia, those at Vergina were given architectural façades in plaster, in this case, as if the building were a Doric structure, with a marble door. But above the Doric frieze is a continuous

Fig 5.43a Vergina, museum, tomb II façade, painting L c. 5m, H 1.16m.

Fig 5.43b–c Vergina, museum, tomb II façade, painting L c. 5m, H 1.16m.

(a)

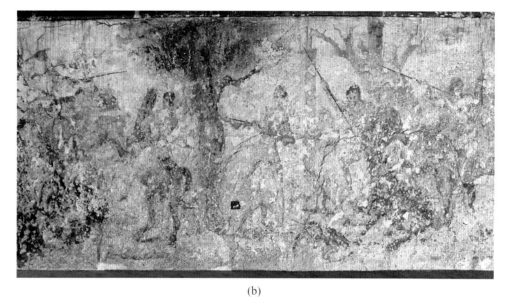

(b)

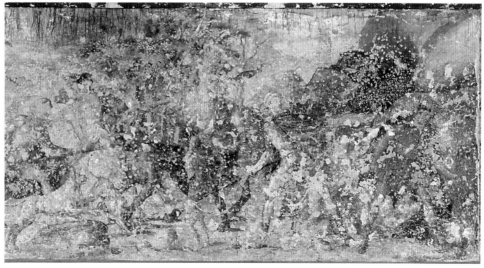

(c)

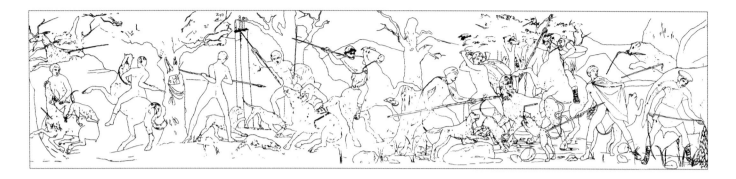

Fig 5.44 Vergina, tomb II façade, drawing of hunt painting.

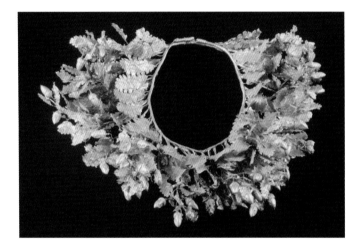

Fig 5.45 Vergina, museum, oak crown from tomb II at Vergina, gold.

Fig 5.46 Vergina, museum, portraits from couch in tomb II at Vergina, ivory.

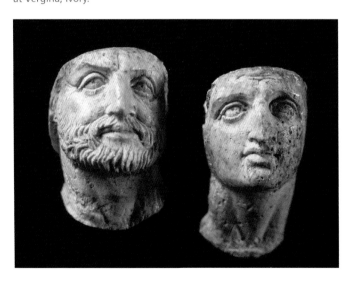

Ionic frieze, painted with a remarkable hunting scene (Figs. 5.43–44). Mounted hunters and others on foot bring down a stag, a lion, and two other animals, perhaps a boar and a bear emerging from a cave (the fragmentary condition of the painting makes it difficult to say). The findspot of the painting, together with the purple robes and Macedonian hats (*kausiai*) worn by some of the prominent hunters, leave no doubt that the hunt participants included Macedonian royalty. The painting is remarkable for its generous use of landscape – trees, rocks, cave, mountains – and depth. Some fifth-century vase paintings offer a rudimentary sense of depth (e.g., Fig. 4.27), which, we presume, is based on the copying of large-scale wall painting (to judge from written descriptions of the latter), and landscape elements occasionally occur in earlier vase painting and sculpture. Nothing, however, prepares the modern viewer for this extraordinary rendering of varied terrain and illusionistic space, enhanced by foreshortened renderings of rearing horses, dogs attacking their prey, and human hunters, on a single groundline. Colors are vivid, particularly blues and greens, and the purple used to pick out the chlamys or cloaks of several of the hunters. Some scholars have even ventured to see portraits of Alexander and Philip among the purple-clad hunters, though the very worn state of the painting should urge caution on this matter. What is clear is that the hunt takes place in a sacred landscape indicated by a sacred pillar and the beribboned tree.

Vergina has yielded not only the dramatic hunt painting but also another wall painting in much better condition, which was found within another tomb, this one looted almost entirely of its contents. Unlike the hunt fresco, which is limited to the long, narrow space above a Doric architectural façade, just above the

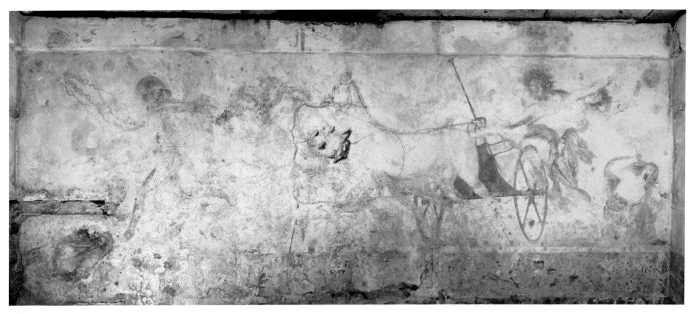

(a)

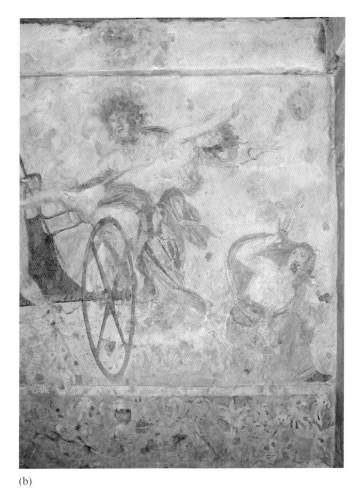

(b)

Fig 5.47a–b Vergina tomb painting, Persephone and Hades, room: 3.05m × 2.09m, H 3m, painting H 1m.

frieze line, the painting of Persephone's abduction by Hades to the Underworld and accompanying scenes stretched across three adjacent interior walls of the small tomb and employs over-lifesize figures against a plain background (Fig. 5.47a–b). Hades grasps Persephone about the waist as he clambers on to the chariot, while Persephone reaches out imploringly with both arms toward her female companion, who cowers nearby. Hermes runs in front of the chariot, grasping the reins to lead it to the Underworld. On the adjacent wall, Demeter, Persephone's mother, sits in a silent, mournful attitude. Three seated Fates are painted on the wall across from the abduction. The funereal theme is well suited to a tomb, whose occupant must have been well-to-do, perhaps royalty, to afford such large and skillful paintings. The monumental figures are rendered with a vivid use of foreshortening to create depth, such as the galloping horses and chariot wheels turning toward the viewer, with shading used to amplify three-dimensionality. Initial incisions for the outline of Hades' head are easily visible beneath the final composition. The energetic and free quality of rendering the faces, hair, and bodies of the principal figures causes us to revise our ideas of ancient Greek painting, which are largely based on vase painting.

Painting on vases continued in the fourth century BC, but the focus of activity shifted from Athens and Attika to south Italy, where both immigrant Attic vase painters and local painters began to dominate, then usurp, the market.

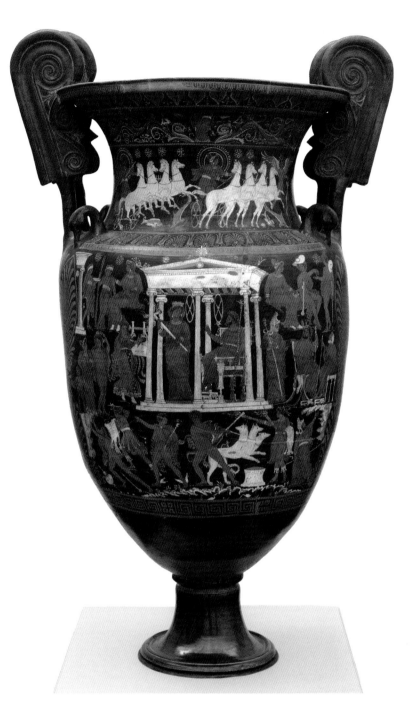

Fig 5.48 Munich, Antikensammlung 3297, Apulian red-figure volute krater by the Underworld Painter (name vase), c. 320 BC, terracotta, H 1.24m.

Their wares are richly ornate red-figure vases highlighted with plentiful added colors, especially white and yellow. Funereal, mythological, and "theatrical" scenes usually decorated such pottery, which is produced in larger and larger sizes and new shapes, in addition to those adapted from Attika. A heavily populated, richly decorated volute krater (Fig. 5.48), among the most common shapes for south Italian pottery, exemplifies many qualities of south Italian painting, although

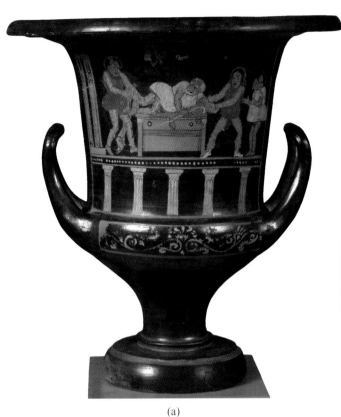

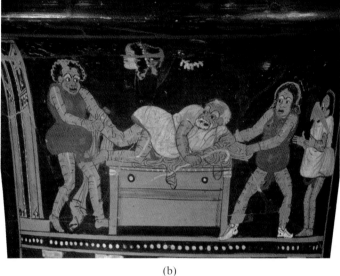

Fig 5.49a–b Berlin, Antikensammlung F3044, Paestan red-figure kalyx krater by Asteas, *c.* 350 BC, terracotta, H 37cm.

(a)

(b)

its quality is far above average. Persephone and Hades occupy the central architectural space, while scenes from the Underworld fill the remaining space, including Orpheus playing his lyre, Sisyphos perpetually pushing the boulder upward, and Herakles, exhorted by Hermes, wresting the triple-headed Kerberos from his realm.

Workshops in Apulia and Lucania were supplemented by workshops in Campania, at or near Paestum (Poseidonia), and in Sicily. Of the tens of thousands of south Italian vases surviving, only two painters can be identified by name, Python and Asteas, both working in Paestum. Asteas signed a kalyx krater, another common south Italian shape, which depicts a scene from Middle Comedy (Fig. 5.49a–b), apparently a specialty of Paestan vase painting. Actors such as these usually wore long tights and long-sleeved short chitons of apparently the same material, with a full, padded tunic that covers the body down to enormous genitals, presumably made of fabric or leather (Fig. 5.50). Comic masks cover their faces, and here on the vase, they move about on a clearly depicted elevated stage. On Asteas' vase, two figures try

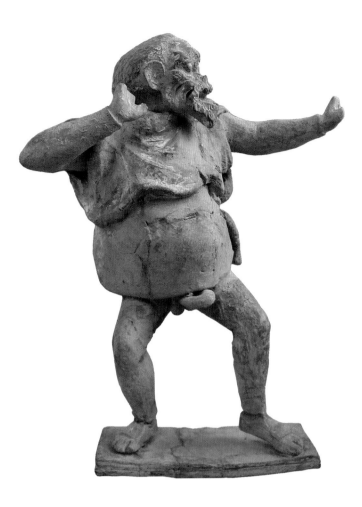

Fig 5.50 Berlin, Antikensammlung T.C. 6823 from Athens, figurine of comedy actor, terracotta, H 16.4cm.

to separate an old man (indicated by his white, thinning hair and white beard) from his money box. In spite of the garish costumes and playful tone, the painting is quite skillful with foreshortened figures and architecture and carefully applied curvilinear details, so beloved of late Classical painters, both in south Italy and elsewhere.

Several trends trace the new role of art in the lives of the citizens of the Greek poleis in the fourth century. Emotional interaction – between mortals, between gods, and between men and gods – became a focus of artistic and religious enterprise, expressed in the types of art and architecture produced, the mode of worship offered, and the perceived benefit to the worshipper. Likewise, the possibilities of space – exploration and manipulation – began to dissolve the boundaries between viewer and object or building, acknowledging and integrating the viewer in the experience of objects and places. Mortals started to take on roles formerly accorded only to heroes, and civic munificence was honored in ways that stress the individual's achievement in the life of the polis. As the independent poleis were subjugated to the Macedonian monarchy in the Hellenistic period, these artistic tastes intensified and mutated in response to the widening of the world under Greek control.

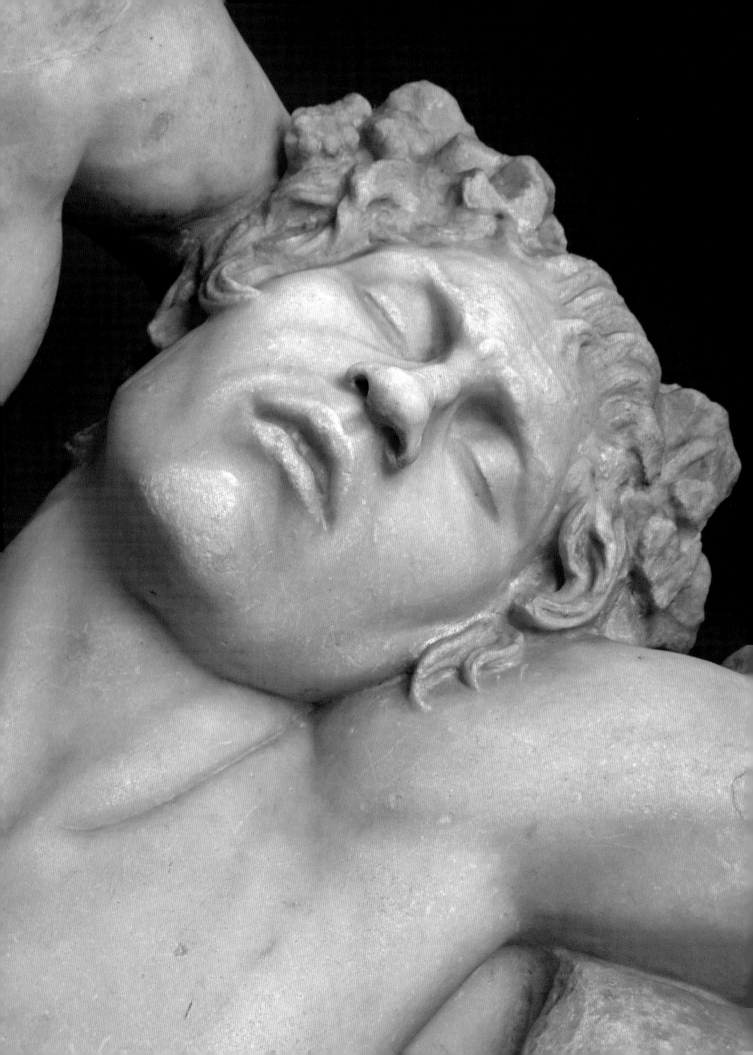

6 The legacy of Alexander: the Hellenistic world

CONTENTS

TIMELINE – all dates in BC

c. 323–31	Hellenistic period
c. 323	Death of Alexander III (the Great) in Babylon
c. 305–300	Ai Khanoum founded by Seleukos I
c. 282	Ptolemy II becomes ruler of Egypt
c. 280/279	Portrait of Demosthenes erected in Athenian Agora
c. 270s	Arsinoe II marries Ptolemy II, dynastic cult instituted, portrait of Hermarchos, Rotunda on Samothrace
c. 250	Moustafa Pasha tombs, Alexandria
c. 200	Portrait of Antiochos III
c. 170–155	Altar of Zeus, Pergamon, Nike of Samothrace
c. 168–167	Battle of Pydna
c. 166	Delos declared a free port
c. 134/133	Rome inherits Pergamon from Attalos III
c. 67	Delos sacked by pirates
c. 38–31	Construction of mausoleion at Nemrud Dagh for Antiochos I of Kommagene
c. 31	Battle of Actium

For modern scholars, Alexander's death in 323 BC marks the change from the Classical to the Hellenistic period of Greek history; at that time, virtually the entire known world from Greece eastward was under his command, a patchwork of disparate cultures, languages, religions, terrains, and climates. Alexander's immediate successors, the Diadochoi, struggled to consolidate their respective kingdoms with mixed success. In this vast, nominally Hellenic world, it is far less easy to follow developments and changes than to trace the stamp of Hellenism – its manifestations, uses, and adaptations to local cultures.

Simultaneously, the growing dominance of Roman power shaped events as Greek cities, struggling against each other or against their Macedonian rulers, sought outside aid. Invited to interfere, the Romans began chipping away little by little at Greek holdings, then finally made an aggressive push for control with lasting success. Scholars tend to punctuate the "end" of the Hellenistic period with the Battle of Actium in 31 BC when Octavian (who later received the title Augustus and became the first Roman emperor) defeated Mark Antony and Kleopatra VII, the last Macedonian monarch of Ptolemaic Egypt. But because the Romans were fascinated by Greek culture – traveled to Greece and studied there, imitated, emulated, and copied Greek objects and monuments – it makes it difficult, if not impossible, to pinpoint the end of the Hellenistic period, and this is especially true of the eastern Roman provinces, which constituted the Hellenistic world. The interaction of the Greek and Roman worlds is one of the most interesting phases of Greek history, producing changes in nearly every aspect of culture.

Self-fashioning

Royal images

The Diadochoi created images, as did Abdalonymos of Sidon (Fig. 5.40), and enacted policies to forge a link between themselves and the charismatic Alexander. Such efforts are most obvious in the realm of portraiture. Elements of Alexander's likeness – the positioning of the head, slightly parted lips, anastole, diadem, tousled hair, beardlessness, and prominent eyes – were applied to the images of Hellenistic rulers in an effort to conjure up the image of Alexander in the minds of viewers, to symbolically link themselves with the great leader. This is especially the

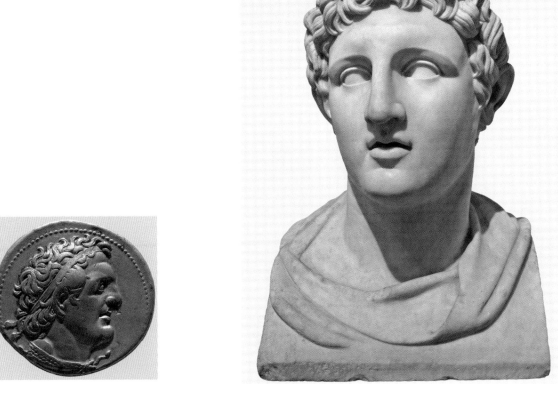

Fig 6.3 Naples, Museo Nazionale 6149 from the Villa of the Papyri at Herculaneum, herm portrait of Demetrios Poliorketes, Roman copy of Greek original of *c.* 306–283 BC, marble, H 43cm.

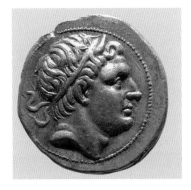

Fig 6.1 Berlin, Staatliche Museen zu Berlin 1891/460, oktodrachm of Ptolemy I (305–283 BC) from Alexandria, silver, D 36mm, weight 28.29g.

Fig 6.2 Berlin, Antikensammlung 1867/28780, tetradrachm minted by Demetrios Poliorketes, *c.* 291–290 BC, silver, 17.08g, D 31mm.

case with coinage, but the phenomenon is also recognizable in three-dimensional portraits of the Diadochoi, which are identified by comparison with inscribed coin images. In some cases, portraits of the Diadochoi adhere closely to Alexander's characteristics, but more often, individual images remain a strong presence beneath an Alexander "veneer" (Fig. 6.1). A silver tetradrachm minted by Demetrios Poliorketes of *c.* 306–283 BC is illustrative: the hair and diadem are quotations from Alexander's portraits, but the heavier face clearly belongs to the image of Demetrios Poliorketes (Fig. 6.2). A marble herm portrait of the same man, a Roman copy from Herculaneum (in Italy) of an original, exhibits the same combination of features, together with a slightly turned head, open mouth and diadem in emulation of Alexander (Fig. 6.3), but the ruler

Map of Italy and western Greece

also wears a chlamys, and the soft down of sideburns appears on his cheeks.

Demetrios may well have looked exactly like this, but it is impossible to know. His portraits had to be recognizable, but it is probably more accurate to refer to this visage as the *image* that Demetrios projected of himself. The same face appears on a full-body image of him: wearing a chlamys and sandals, the ruler props his left foot atop a rock and bends forward, while his right hand holds a trident planted on the ground (Fig. 6.4a–b). The general pose and trident are quotations from a statue of the god Poseidon sculpted by Lysippos and known

(a) (b)

Fig 6.4a–b Naples, Museo Nazionale 5026 from Herculaneum, Demetrios
Poliorketes, Roman copy of Greek original of c. 306–283 BC, bronze, H 30cm.

Fig 6.5 Eleusis, Museum 5087, Poseidon, Roman copy of original attributed to Lysippos, Pentelic marble, H 50cm.

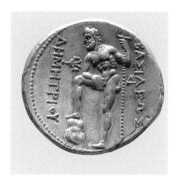

Fig 6.6 Berlin, Antikensammlung 1885/247 from Amphipolis, tetradrachm minted by Demetrios Poliorketes, *c.* 290–289 BC, silver, 17.31g, D 29mm.

from Roman copies (Fig. 6.5). This borrowing is significant, as is apparent from other images of Demetrios: coin and herm portraits portray him wearing bulls' horns (Figs. 6.2–3; just the tips are visible in his hair), an attribute of Poseidon (or Dionysos), and coins juxtapose his visage with an image of Poseidon (Fig. 6.6). The use of a divine attribute and sometimes even Poseidon's pose for images of the ruler are clear attempts to liken Demetrios to a god, to create an association between the two, as if the ruler himself were divine.

The next generation of ruler portraits tends to follow the same practice. A coin portrait of Seleukos I issued by his son Antiochos I in *c.* 277 BC renders the king with tousled hair and diadem, and bull's horns are added to the figure to liken him to a deity, probably Dionysos in this instance (Fig. 6.7). But this is not always the case, especially with rulers further east: a marble portrait of Antiochos I – an aging face with a strongly receding hairline – is clearly rendered differently, although the diadem still serves to mark his royal status (Fig. 6.8a–b). Many later rulers broke free entirely from the Alexander type, such as the kings of Baktria, a Hellenized outpost in eastern Afghanistan (see the discussion of

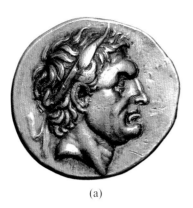 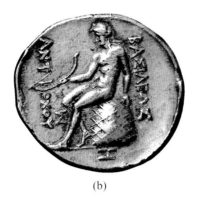

(a) (b)

Fig 6.7a–b New York, American Numismatic Society 1967.152.671 from Sardis, tetradrachm issued by Antiochos I showing Seleukos I on the obverse, Apollo on the reverse. 280–261 BC, silver, 17.03g, D 31mm.

Fig 6.8a–b Paris, Musée du Louvre MA1204, Antiochos III, Roman copy of Greek original of *c.* 200 BC, marble, H 35cm.

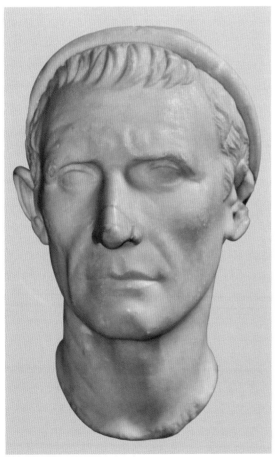

(a) (b)

(a)

(b)

Fig 6.9a–b Berlin, Bode Museum BM-018/40 from Baktria, tetradrachm of Eukratides I, *c.* 170–145 BC, silver, 16.90g, D 33mm.

Ai Khanoum below) (Fig. 6.9a–b). No trace of Alexander's features, pose, or attributes is discernible.

New faces

While statues of politicians, military leaders, poets, playwrights, and philosophers were uncommon or non-existent in the late sixth and fifth century, their numbers began to increase in the fourth century BC, then became abundant in the Hellenistic period (in addition to the ruler portraits discussed above). Honorific statues voted by the polis to honor an individual were placed in sanctuaries, in theaters, and in agorai (see Fig. 3.50). We are unusually well informed about the circumstances leading to the erection of a posthumous portrait of the orator Demosthenes (384–322 BC) in the Athenian Agora (Fig. 6.10). It was approved by the Athenians, perhaps at the request of Demosthenes' nephew during the archonship of Gorgias in 280/279 BC. Written sources tell us that the bronze statue by Polyeuktos was erected in the Athenian Agora near the Altar of the Twelve Gods (see Fig. 4.61). The image of Demosthenes, who stood with his arms held down before him, his hands clasped together (the copy illustrated here shows him grasping a scroll, an addition of the Roman copyist), was accompanied by an epigram that expressed the ruefulness felt by the Athenians, who did not heed his efforts to warn them against Macedonian aggression; in fact, they had condemned and sentenced him but he fled and eventually was driven to suicide: "If your strength had been equal to your will, Demosthenes, never would the Greeks have been ruled by a Macedonian Ares" (trans. A. Stewart). The image is known through some fifty Roman marble copies: Demosthenes wears a himation that leaves bare part of his sagging, thin torso, which, together with his wrinkled visage, furrowed brow, and receding hairline, convey his age. Naturalism, not idealism, is emphasized, but one wonders if the face captures Demosthenes' features: while all the copies share a similar visage with a short beard, which, by this time, is an old-fashioned feature, it has been observed that a typologically similar face is used for older men on contemporary funerary reliefs. In other words, this face may be but one "type" used for old men.

Old age combined with unkempt appearance and long beard (as if to emphasize the renunciation of the material world) become the

requisite visual markers of philosophers. Various portrait types can be recognized through inscribed Roman copies (Fig. 6.11), but most portraits remain anonymous to us because they are detached from the inscribed bases that once named them; recent studies have demonstrated that these portraits adhere to facial types that are more individualized for males than for females. The latter portraits, by contrast, are designed to convey ideals of feminine beauty and virtues through visage, hairstyle, gesture, and garments, rather than individual specificity (Fig. 6.12).

Fig 6.11 Florence, Museo Archeologico 70989 (92250), Hermarchos, Roman copy of Greek original of *c.* 270 BC, marble, H 1.07m.

Fig 6.10 Copenhagen, Glyptotek 2782 from Campania, Demosthenes, *c.* 280/279 BC, Roman copy of original by Polyeuktos, marble, H 1.92m.

Fig 6.12 Kos, museum 76 from the Odeion on Kos, female portrait, marble, H 1.97m.

Delight, curiosity, and awe

New subjects

Interest in individual likeness extends beyond the human visage to investigating various conditions, ages, behaviors, states of mind, and abnormality in the Hellenistic period. *Variety* itself becomes a field of exploration, particularly at an everyday level, but it also encompasses the mythological world. Sculptors of free-standing works transcended the traditional subjects of cosmic battles and heroic deeds to playful, sometimes aggressive, eroticism, pastoral imagery, and themes previously the targets of derision or comedy. In doing so, they pressed the boundaries of interaction between viewers and objects, viewer response, and conventions of taste (at least by previous standards). Because the function and original location of nearly all free-standing works discussed in this section are unknown (though there is much speculation), and most are known only from Roman copies (the Romans enthusiastically copied such works and adorned gardens, houses, and baths with them), one often can only make educated guesses about intended meaning or specific viewers. Even the dating of these works is controversial since it is almost entirely based on style; this is very tricky in the Hellenistic period because style was immensely varied in that vast geography and without the roughly uniform trends of earlier phases of Greek art. Instead, style *also* constitutes an area of experimentation, play, revival, and innovation. In an effort to sort the great number of these Roman copies and to try to offer some criteria for date and function, scholars often search ancient written descriptions of Hellenistic objects or their Roman copies with a focus on famous works of sometimes renowned sculptors, seeking to match textual descriptions with the extant copies. The results of this exercise are tenuous and limited, of course, only to those works and sculptors known from the surviving written corpus. A more promising route concentrates on Hellenistic poetry, which is mined for what it might reveal about cultural interests in various subjects; this can aid in positing functions or original locations for some objects.

Satyrs and nymphs making merry with music and dance or grappling with each other in sexual encounters are a common theme (Fig. 6.13), and a variant of the latter are satyrs pursuing hermaphrodites (Fig. 6.14). Mythological hermaphrodites are first attested

Fig 6.13 Rome, Musei Capitolini, Centrale Montemartini 1729 from Rome, satyr and nymph, Roman copy of original of c. 100 BC, marble, H 60cm, W 37cm.

Fig 6.14 Dresden, Skulptursammlung Hm 155, satyr and hermaphrodite, Roman copy of a Greek original of c. 150 BC, marble, H 91cm.

in the fourth century BC and, of course, the medical phenomenon of hermaphroditism was known to the ancient Greeks. In addition, there was *the* mythological Hermaphroditos, the offspring of Hermes and Aphrodite, known from the first century BC onward. Roman copyists produced many such works, which decorated the gardens of Roman homes, but the function of the original objects is unknown. It is possible that the sculptural groups of satyrs and nymphs or hermaphrodites were religious in nature, adorning sanctuaries of Dionysos: Alexandria (Egypt) is a possible location since the Ptolemies claimed Dionysos as their ancestor. We know, for example, that Ptolemy IV founded a festival to the god, and his splendidly decorated boat included a shrine to Dionysos, according to the writer Kallixenos (as cited in Athenaeus 5.205b–f). But if these sculpted figures once stood in sanctuaries, who dedicated them? Court officials? Wealthy citizens? The monarch or the royal family?

The satyrs struggling with their sexual prey offer complicated, sometimes awkward, compositions meant to be viewed from a variety of perspectives since their full meaning cannot be grasped from only one side. The sleeping hermaphrodite, known from several Roman copies, also invites contemplation from a variety of viewpoints but in a clearly choreographed sequence (Fig. 6.15a–b): the viewer was intended to approach the figure from behind, where one would see a shapely, young female figure, whose twisting torso reveals the outline of her breast. Circling round the figure, the viewer would be surprised to see male genitalia. This manipulation of viewers' expectations and guiding viewer experience is typical of Hellenistic art; again and again, in architecture, sculpture, and trompe l'œil wall painting, one witnesses this effort to guide so as to induce a sense of surprise and wonder.

Hellenistic sculpture encompasses not just rambunctious Dionysiac figures, but also slumbering ones, as well. The large image (H 2.15m) of a sleeping satyr, the "Barberini Faun," named for the collection in which it once was housed, is unusual in that it is a Greek original that has no known copies (Fig. 6.16a–b). The weighty figure, carved from Asian marble, sprawls on a rock covered with a feline skin, which extends over his left upper arm. His left arm partly hangs from the rock, his head resting on his left shoulder,

(a)

(b)

Fig 6.15a–b Paris, Musée du Louvre MA231 ("Borghese Hermaphrodite") from Italy, sleeping hermaphrodite, Roman copy of an original of *c.* 170 BC, marble, L 1.47m.

and his right arm bent back beside his head. His bent right leg is propped up on the rock, though the leg has been restored incorrectly and falls open too widely. He wears a grapevine wreath round his head, and his tail lies to his left side. The sensuous rendering of bulky muscles, veins, skin, and the sheer size of the figure are impressive. He appears lost in a dissolute drunken sleep as suggested by his ability to sleep in such an uncomfortable position and his slightly open mouth, but we know nothing of the figure's original location or sculptor.

Sleep and drunkenness are featured in other Hellenistic works, as well. The Roman copy of a thin "Drunken Old Woman," seated on the ground, grasping a vessel between her legs and throwing her head back in a gap-toothed expression, is a far cry from the idealized

Box 6.1 Nineteenth-century reception of ancient sculpture

Restoration of ancient sculpture was a commonplace in western Europe from the Renaissance period onward, especially in the nineteenth century. This practice was driven by the collecting of ancient sculpture by museums and wealthy individuals and by contemporary taste, which preferred whole images, however much invented in terms of restoration, to fragmentary originals. Some of these restorers were renowned sculptors in their own right. That is certainly true for the Danish Neoclassical sculptor Bertel Thorvaldsen (1770–1844), who lived the better part of his life in Rome, where he received numerous important commissions from patrons all over Europe and where he was able to study and work on ancient sculpture. Thorvaldsen made restorations to the Aigina sculptures (see Figs. 4.2–3), which were later removed.

Fig 6.16a–b Munich, Glyptothek 218 ("Barberini Faun"), c. 230–220 BC, marble from Asia Minor, H 2.15m.

(a)

(b)

Map of the eastern Mediterranean

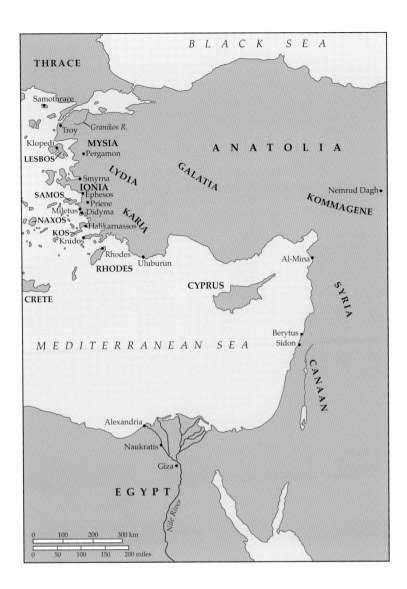

Fig 6.17 Munich, Glyptothek 437 ("Drunken old woman"), Roman copy of a Greek original of *c.* 225–200 BC, marble, H 92cm.

figures of the Classical period (Fig. 6.17). Her low-life appearance is countered by the elaborate garments that she wears, the rings on her fingers, the holes drilled in her earlobes that once held earrings, and the vine-covered jar she carries; this shape, a *lagynos*, was used, among other things, in festivals to Dionysos in Ptolemaic Alexandria, where many participants, including those at the lowest end of the social scale, sat on straw mats on the earth as they enjoyed the fruit of the god. Terracotta and bronze figurines from Alexandria show the same or a similar motif of an old woman, slave, or disabled person holding a lagynos. Religion may be the motivation for the creation of the drunken woman, but the questions of patron and original setting remain.

Architectural wonders

Like the sleeping hermaphrodite, the temple of Apollo at Did-yma, designed *c.* 330, endeavors to manipulate the visitor's experience (cf. Figs. 5.21–24). Its staircase and tunnels led the visitor up to the temple's dark pronaos, then light filtering up through the tunnels guided the visitor to the strongly lit interior courtyard. Surprise, delight, and awe were the aims of such creations.

Ptolemy II dedicated the Propylon in the sanctuary of the Great Gods on the island of Samothrace, as he proudly pro-claims in the building's dedicatory inscription (Fig. 6.18a–b). The building bridges a rushing stream in a ravine demarcat-ing the boundary of the sanctuary by means of a vault – essentially, a true arch (each block is carved at an angle to fit together like a puzzle with a keystone at the top) extended into space – which here actually redirects the river's flow. The visitor accessed the Propylon door through a hexastyle

Fig 6.18a Samothrace, Propylon, plan.

Fig 6.18b Samothrace, Propylon, restored east elevation.

(b)

prostyle porch (Ionic order on the exterior), exited from another (Corinthian order on the interior, sanctuary side), and stepped into the sanctuary, thus moving seamlessly from secular to sacred space. This combination of orders has already been seen elsewhere (e.g., Figs. 5.17–19). The dedicatory inscription appears in the epistyle on both sides of the structure, and the building's friezes were adorned with relief sculptures of religious symbols, *bucrania* (bulls' skulls) and rosettes.

Following in a tradition of circular buildings, such as the tholoi at Athens, Delphi, and Epidauros, the Lysikrates Monument in Athens, and the Philippeion at Olympia, the rotunda in the sanctuary of the Great Gods surpasses them in height (14m without the roof) and architectural complexity (Fig. 6.19a–b). The rotunda, which sits atop an earlier structure, consists of a two-tiered drum articulated with rich moldings, pierced at the bottom by a large door; the top portion has a gallery course (not a true walkway), and the interior mirrors the same dual-level design. Thasian (from the island of Thasos) marble sheathing concealed a sandstone core between the interior and exterior walls. Like the propylon in the sanctuary (Fig. 6.18), this structure also employs two architectural orders: Doric piers support a Doric entablature on the exterior, while an engaged Corinthian colonnade lines the gallery inside. A parapet with bucrania and rosettes (see Fig. 6.18) sculpted in relief links the exterior piers, while the same sculpted motifs adorn an interior parapet composed of altar-shaped blocks placed between the interior engaged columns. A dedicatory inscription centered on the exterior Doric architrave above the door states that the building was a votive from Arsinoe II, the Ptolemaic queen of Egypt (see below). The wooden roof covered with scale-like terracotta tiles was a first in architecture (*marble* tiles had been arranged in this manner on the Lysikrates Monument, see Fig. 5.4): it had a circumference of more than 47m and spanned *c.* 200m^2, the largest unsupported (i.e., no interior vertical supports) interior circular space until the Roman Pantheon in the second century AD. How the building functioned is unknown, but its sculpted imagery, together with its placement just beyond the end of the Sacred Way between two other sacred buildings, the Hall of the Sacred Dancers and the Anaktoron, suggests that it played a key role in the religious rites on Samothrace.

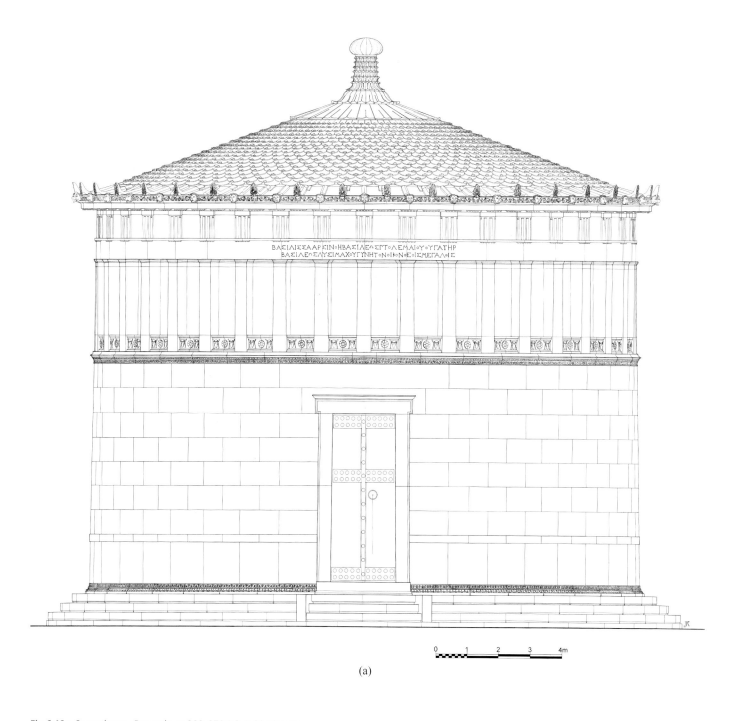

(a)

Fig 6.19a Samothrace, Rotunda, *c.* 280–270 BC, D 20.22m at
the euthynteria, restored exterior elevation.

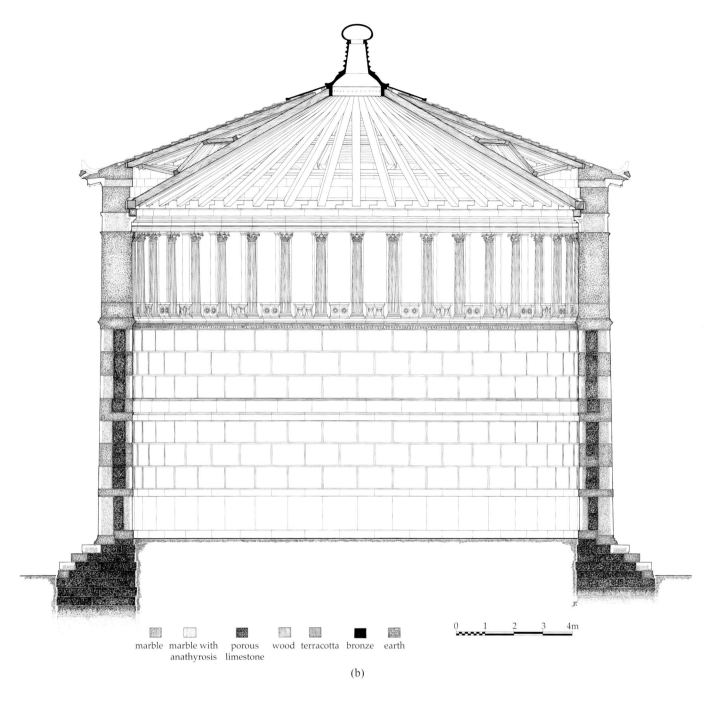

marble marble with porous wood terracotta bronze earth
anathyrosis limestone

0 1 2 3 4m

(b)

Fig 6.19b Samothrace, Rotunda, *c.* 280–270 BC, D 20.22m at
the euthynteria, section.

Hellenistic kingdoms

Ptolemaic Egypt

Ptolemaic Egypt was a powerful force in the Hellenistic world. This was largely due to its topography, which created a defensible territory, its enormous agricultural wealth and the taxes levied upon it, and superbly organized central administration with copious written documentation, of which an enormous number of papyri survive thanks to their use as mummy casings (cartonnage) and the arid climate. The dynasty ruled nearly continuously from the time of Alexander's death until Kleopatra VII's defeat by Octavian at the Battle of Actium in 31 BC, although Rome already was increasingly instrumental in Ptolemaic politics beginning in the second century BC.

The Ptolemies were great cultural patrons. For example, the well-known library and Mouseion (shrine to the Muses and museum) of Alexandria, both Ptolemaic projects, were cultural magnets for scholars, poets, and scientists throughout the Mediterranean, and Alexandria's two main harbors (and several smaller ones) made the city a hub of trade and shipbuilding, and promoted an international population. Alexandria was also endowed with the famous four-storey Pharos lighthouse of the third century BC, as well as Alexander the Great's tomb and the Sarapeion (a temple to Sarapis complete with a chryselephantine cult statue by an Athenian sculptor), among other attractions. Sadly, little is left of ancient Alexandria, although the city plan, a grid designed by Deinokrates, Alexander the Great's architect, is detectable, and some monuments survive in part. Underwater excavations in the harbor of modern Alexandria in recent decades have recovered many objects and considerably broadened our knowledge of the ancient city.

Of the extant architectural monuments, the best preserved are the private underground tombs dating from the third through second centuries BC. These multi-roomed structures were carved into the limestone and sometimes elaborately decorated with painting, sculpture, and architectural ornament; they served as resting places for the dead and as settings for funeral rituals, including banquets. Inscriptions indicate that they contained the remains of a remarkably cosmopolitan population from all over the Mediterranean and beyond. The tombs' rooms center around a peristyle courtyard (cf. Figs. 5.7, 5.9–12)

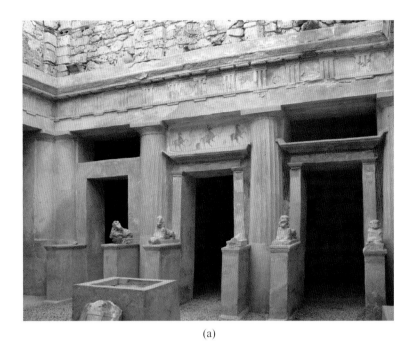

(a)

Fig 6.20a–b Alexandria, Moustafa Pasha Tomb 1, later third century BC, H (painting) 0.60cm.

(b)

and include a chamber with a rock-cut kline; some have *loculi* (long shelves) cut into the walls for further burials, which could be closed with a painted slab or ornamented with stucco architectural details. Water installations for funeral rituals are common. The design and décor of these tombs are marked by illusionism, and in some cases, the imprint of contemporary theater is clear. The Moustafa Pasha Tomb 1 of *c.* 250 BC is exemplary in its combination of stucco, stone, and painted architectural elements in its courtyard, complete with engaged Doric columns and frieze; ten rooms surround the peristyle courtyard (fig. 6.20a). An altar in the center is oriented toward the burial chambers in the south wall, where six sphinxes atop bases flank the three doors, and a panel blocks the transom opening above the central doorway. The panel is painted with three men on rearing horses – all skillfully foreshortened – separated by two women (Fig. 6.20b); the

Fig 6.21 London, British Museum 1995.10–3.1, Hadra hydria with inscription, "of Dorotheos," terracotta, H 35cm.

women turn toward the central male and an altar, while the riders pour libations from phialai (painting: 1.67m × 0.67m). Two riders wear the Macedonian kausiai like the hunters on the Vergina tomb frieze, where foreshortening is also applied to a rearing horse (see Fig. 5.43b), and the one at the far right sports a Macedonian helmet. The peristyle façades, especially the grand south wall, echo theater sets or stage buildings, which typically had three openings.

A series of terracotta vessels, Hadra vases, of *c.* 260s–190 BC served as cinerary urns and are named for the extramural Greek cemetery in east Alexandria where many (though not all) of them were found (Fig. 6.21). The vases take the form of typical Greek hydriae and are painted (in black or brown, sometimes with added white) with animals, vegetation, and sometimes Greek motifs (Panathenaic amphorae, hunting images). Greek dipinti, including the name of the deceased and the date of death, together with style, enable us to reconstruct the vases' chronology. The dipinti were added secondarily and not when the vase was fired, suggesting that the hydriae were not special commissions but purchased, then personalized. Curiously, clay analysis indicates that the vases' raw material was from Crete, which fell under Ptolemaic control in the second quarter of the third century BC; it is disputed whether the hydriae were made in Crete (where they also have been found), then exported, or made in Alexandria, but it is certain that Alexandria began producing its own, local version in white-ground technique around 240–120 BC. Scholars also disagree about the intended original use of the hydriae; some have been deemed prizes in athletic contests, which were subsequently used as ash urns. Many of the Hadra hydriae with identifying names were reserved for a special portion of the population: Ptolemaic military personnel or Greek visitors to Alexandria. These people were cremated, in contrast to the contemporary Egyptian practice of mummification.

Fig 6.22 London, British Museum GR 1873.8–20.389, Ptolemaic oinochoe for Arsinoe II, *c.* 280–270 BC, faience, H 32.4cm.

The Ptolemies also were great patrons of temples and other types of architecture (e.g., Figs. 6.18–19), and in the reign of Ptolemy II, the rulers, particularly Ptolemaic queens beginning with Arsinoe II, were themselves accorded worship; Arsinoe II was deified during her lifetime, and a festival, the Arsinoeia, was instituted after her death. Among the evidence for queens as cult recipients is a series of faience oinochoai that may have been used by worshippers in cult activities; they bear remnants of gilding and are adorned with images of Ptolemaic queens made in relief and attached separately (Fig. 6.22). Individual regents are identified by inscriptions that wish good fortune to the named queen, who usually holds a cornucopia and patera extended toward a beribboned pillar, while a *baitylos* (sacred pillar) appears nearby. Most of the oinochoai were recovered from graves, sometimes in southern Italy, indicating that the objects were considered worthy for use as grave gifts.

Alexandria seems to have been the source for a number of unusual subjects in Hellenistic sculpture, including old pastoral figures (shepherds, fishermen, marketwomen), beggars, peasants, dancers, actors, Africans, hunchbacks and figures with other physical abnormalities or diseases, often called "grotesques" in modern scholarly literature (Figs. 6.23–25). Many of these are small-scale terracottas, but some are of ivory or bronze or exist in larger format (such as Roman marble copies), as well. Many are remarkably naturalistic and detailed in recording aging skin, physical abnormality, and individuality – in other words, everything antithetical to the idealized generic figures of the Classical period. Again, the function of these works is unknown; they have been found in a variety of contexts: funerary, domestic, and religious. Scholars have suggested that they may have been religious votives, apotropaic, comic, scientific, decorative, or designed to evoke ridicule.

Alexandria, home to the greatest library in the ancient world, also produced some of the most erudite works of

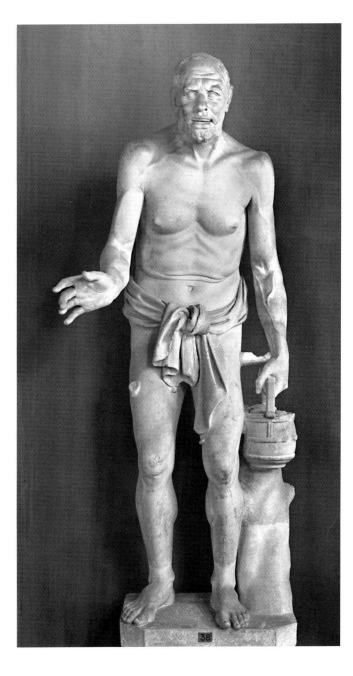

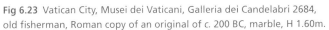

Fig 6.23 Vatican City, Musei dei Vaticani, Galleria dei Candelabri 2684, old fisherman, Roman copy of an original of *c.* 200 BC, marble, H 1.60m.

Fig 6.24 New York, Metropolitan Museum of Art, Rogers Fund 1909.39 ("Old Market Woman"), Roman copy of *c.* 14–68 AD of a Greek original of the late second century BC, marble, H 125.98cm.

Fig 6.25 Berlin, Antikensammlung Br. 30894, hunchback, bronze.

Hellenistic art. One of them is the Archelaos relief, which presents an elaborate celebration of the apotheosis of Homer and of poetry across several horizontal friezes (Fig. 6.26). This seems to have been a votive, perhaps a dedication by a poet victorious in a competition. Although it was found in Italy, several aspects of its imagery point to Alexandria as its place of production although it is of marble, a material that is not indigenous to Egypt (so the marble probably was imported for this special commission). All figures are named by inscription, and Archelaos of Priene, the sculptor, added his signature. Zeus reclines on a rock at the top of the relief, an irregular curved shape that suggests a craggy mountaintop. Mnemosyne (Memory) looks up at him while another Muse steps down to the next frieze, where four other Muses appear. Three more fill the frieze below next to an arched opening in which Apollo, the god of poetry, and the ninth Muse are placed. Outside this "cave," the poet celebrated by this relief stands on a base in front of a tripod, the symbol of Apollo. The mountainous landscape yields to a shrine in the lowest frieze, apparently the Mouseion in Alexandria: against a background formed by a curtain suspended from columns, Homer sits on a throne flanked by two young boys, personifications of his great poems, the *Iliad* and the *Odyssey*. Chronos (time) and Oikoumene (the inhabited world), identified by their portrait faces as Ptolemy IV and Arsinoe III (and note that Arsinoe wears an Egyptian headdress), crown him. A steer stands behind an altar flanked by personifications of Myth and History, and a crowd of figures (Nature, *Arete* or Excellence, Mindfulness, Trustworthiness, and *Sophia* or Wisdom) led by Lyric poetry, Tragedy, and Comedy hail him. The relief expresses the idea that Zeus, Memory, and the Muses inspire the victorious poet, who also honors the greatest poet of them all, Homer. These two Ptolemaic rulers were great artistic patrons and founded the Homereion, a shrine to the poet, in Alexandria. The esoteric nature of the relief eliminates the general public as the intended spectator, and unlike other

Fig 6.26 London, British Museum 2191 ("Archelaos relief") from
Bovillae, relief signed by Archelaos of Priene, marble, H 1.18m.

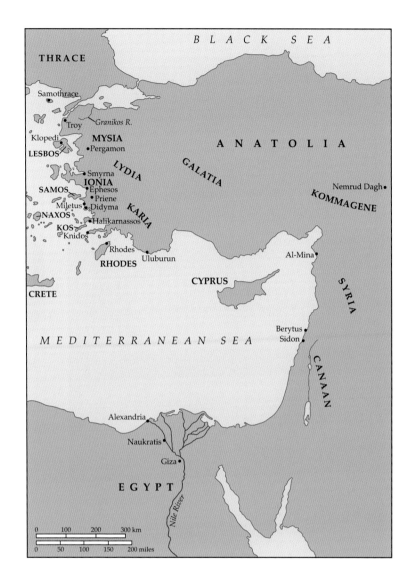

Map of the eastern Mediterranean

Hellenistic works that might appeal solely to the emotions or aesthetic preferences, the relief demands more from its intended viewer: a literate or well-educated person able to identify all the figures (or read their names) and to understand this erudite message.

The Ptolemaic monarchs of Egypt oversaw a vast territory and a large local population whose lives and beliefs were very distant from those of Macedonia or the Classical Greek world. Accordingly, their official portraits and

Fig 6.27 Paris, Musée du Louvre MA4891, Arsinoe II, third century BC, marble, H 44cm.

Fig 6.28 London, British Museum 1914.0216.1, Ptolemy I, basalt, H 64cm.

commissions shrewdly employed visual language targeted at both the native population and their fellow Greeks living in Egypt. Portraits carved in marble, an imported material, tended to follow Greek naturalistic traditions (Fig. 6.27, where we see Arsinoe II shown as the syncretistic goddess Isis-Selene), while portraits of granite and local stones usually depicted the rulers with Pharaonic headdresses and Egyptian-style abstracted features together with a back-pillar and hieroglyphic inscription typical of Egyptian portraits (Fig. 6.28). But there also are mixed statues that combine elements from both worlds and, curiously, such statues turn up not only in Egypt but in Greece, as well (Fig. 6.29).

Fig 6.29 Athens, National Museum ANE 108 said to be from Aigina, Ptolemy VI, granite, H 62.5cm.

The new Athens: Pergamon

Although Athens no longer enjoyed the international prominence it had in the Classical period, its glorious past as a great intellectual center and imperial power endowed it with cachet, and it continued to enjoy cultural achievements. Ruler after ruler traveled to Athens in the Hellenistic period and left their mark upon the city with monuments and benefactions, while in their home cities they erected monuments in emulation of those of Athens. A case in point is the revival of work on the Olympieion in Athens under the Seleukid king Antiochos IV Epiphanes in *c.* 170 BC. The king employed the Roman architect Cossutius, who probably was responsible for the temple's Corinthian peristyle, cella, and architrave, according to Vitruvius (7. praef. 15) (Fig. 3.48).

The Pergamene kings, the Attalids, regarded their city as a second Athens and endeavored to make it the new cultural center (Fig. 6.30). Eumenes II endowed it with a large library in *c.* 190 BC, in which a marble copy of the Athena Parthenos statue was housed; Athena Polias was their patron goddess, and a Panathenaia was celebrated at Pergamon in her honor. The Attalids won significant victories in a series of military campaigns against invading Gauls (from Galatia in modern Turkey), which they commemorated at Pergamon, in Athens, on Delos, and in Delphi in numerous sculptural monuments. Among them is the Dying Trumpeter, a Roman copy of an original Greek statue that, together with other sculptures, once surmounted an inscribed base (Fig. 6.31a–b); conventionally, scholars assign the original work to a Gallic victory monument in the sanctuary of Athena at Pergamon (Fig. 6.32), but another such monument at Delphi has recently been nominated as a possibility. A nude warrior, seated on his shield and encircled by his trumpet, twists his torso and supports his weight on his right hand, as he grimaces in pain from the wound to his right side. His shaggy hair (Diodorus Siculus 5.28.2 says that the Gauls washed their hair with

Box 6.2 The role of museums

Nearly every portable object illustrated in this book is now located in a museum. Why? What is the purpose of museums? Today, one would surely argue that museums are educational and entertaining and serve as stewards of the past (and the present in some cases), but the acquisition policies and role of museums have not always been as they are now. The world "museum" is from the ancient Greek term *mouseion*, a place (a school or shrine) connected to the Muses, mythological figures who personified various arts: music, poetry, dance, etc. One of the most famous Mouseia was in ancient Alexandria in the Ptolemaic period, where a group of scholars and poets worked in a setting akin to a modern thinktank (cf. p. 345). Modern museums housing collections of ancient art open to the public developed in the seventeenth and eighteenth centuries out of noble and royal collections. Acquisition practices in the nineteenth century were driven by competitive nationalism throughout Europe, a scramble to acquire ever better objects in a

competition among nations, and elsewhere, museums strove to create their own collections, either in emulation of the European example or under colonial patronage. Our modern perceptions of museums were formed in the post-World War II period, when the emphasis was on education and entertainment, and the focus was on collecting objects of beauty, "masterpieces," and singular examples. The lack of context for many ancient objects only became a central factor in acquisition policies in 1970 with the UNESCO convention on the Means of Prohibiting and Preventing the Illicit Import, Export and Transfer of Ownership of Cultural Property. This agreement was intended to stem illegal looting of archaeological sites – a problem everywhere in the world – and the export of the objects acquired in this manner out of their countries of origin. It imposed obligations on museums to be accountable for the provenance of the objects they acquired and to exert due diligence in the acquisition process, whether by gift or purchase.

Fig 6.30 Pergamon, Akropolis, aerial view.

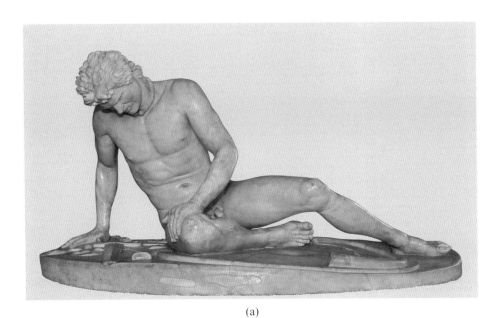

(a)

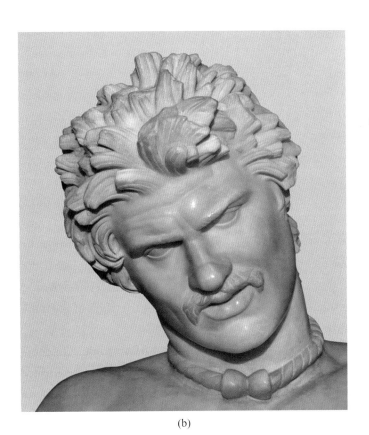

(b)

Fig 6.31a–b Rome, Musei Capitolini 747, Dying Trumpeter, Roman copy of original of c. 220 BC, Asiatic marble, H 93cm.

Fig 6.32 Pergamon, plan of Akropolis.

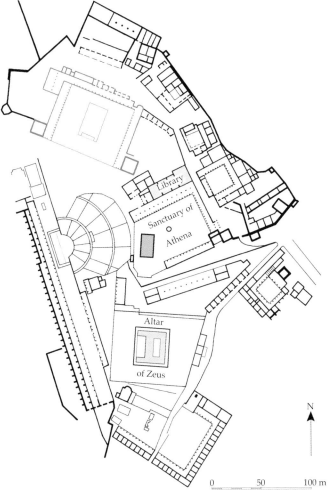

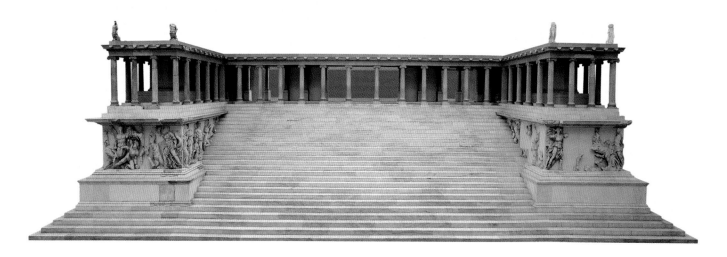

Fig 6.33 Berlin, Pergamonmuseum, altar of Zeus from Pergamon, c. 170–155 BC, marble, H 5.6m.

lime), moustache, and choker (torque) identify him as a foreigner, part of a growing interest in depicting non-Greeks, which arose from contact with these peoples during Alexander's eastward march. His bowed head, facial expression, and taut body are testimony of his pain and defeat, but also his dignity and humanity. The concentration on the inner psyche marks an intensification in the interest in depicting intimate moments and shrinking the distance between spectator and object, a topic discussed above. Although Pergamon styled itself a new Athens, this public commission marks a dramatic contrast with those from fifth- and fourth-century BC. Athens, e.g., the dynamic Tyrannicides group (Fig. 3.50), which commemorates a political change, or even more so, the Eirene and Ploutos (Fig. 5.1), which preaches the benefits of peace. Instead, the Dying Trumpeter manages to evoke the deeply personal and tragic aspect of warfare – the death of the individual human being.

At Pergamon itself, three other sculptural monuments commemorated the victory over the Gauls and together comprise the Greater Attalid Dedications. These were located in the sanctuary of Athena Nikephoros (bringer of victory), the oldest sanctuary at the site, which housed a temple to the goddess (Fig. 6.32). Aligned with the temple but on an adjacent, lower terrace was the Altar of Zeus, which exemplifies the Pergamene taste for the dramatic. Its size (36.44m × 34.20m) and extraordinary decoration create a breathtaking experience for the

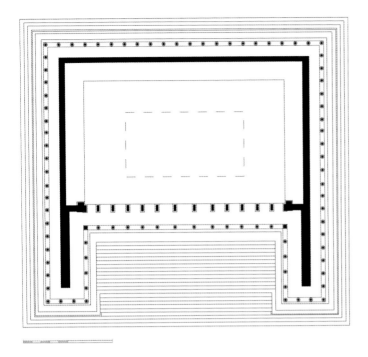

Fig 6.34 Berlin, Pergamonmuseum, altar of Zeus at Pergamon, plan.

Fig 6.35 Berlin, Pergamonmuseum, altar of Zeus from Pergamon, east frieze, Zeus and Athena, c. 170–155 BC, marble, H (frieze) 2.28m.

modern visitor to the Pergamon Museum in Berlin, where the monument was transported in the nineteenth century and re-erected (Figs. 6.33–34).

Viewers initially approached the east side of the altar (Fig. 6.35), the back, and encountered one side of a sculpted frieze, 2.3m high and about 120m long, which encircles the entire structure beneath the colonnade. The frieze depicts the Gigantomachy, the myth of the gods' defeat of the rebellious Giants, a familiar theme identifiable not just because of the attributes held by the gods but by the names of the gods and Giants, which were inscribed, then painted, on the moldings above and below the frieze and sometimes on the frieze itself. Circling around to the west or front, viewers would ascend the monumental staircase and pass through the colonnade to a room that housed an altar. On the exterior Gigantomachy frieze, the figures stride, writhe, twist, and collapse in a closely knit composition of interlocking figures (Fig. 6.36a). Carved in such high relief that figures on the west frieze actually emerge from the composition and climb the stairs with the spectator, the sculpture offers thrilling drama and theatricality highlighted by rippling muscles, animated drapery, emotive faces and gestures, and vividly grisly encounters.

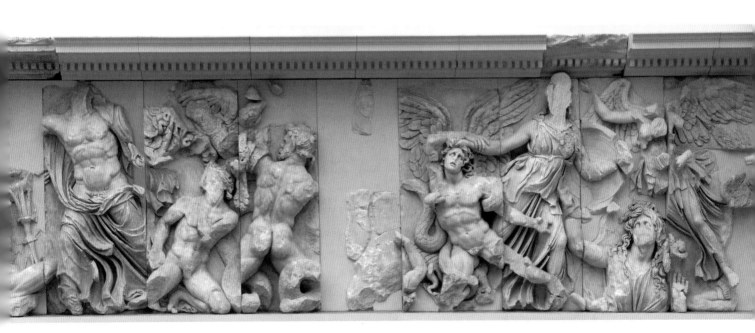

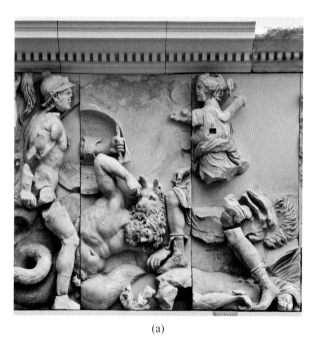

(a)

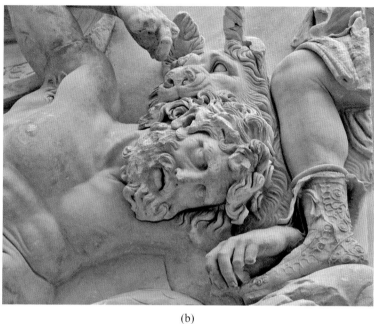

(b)

Fig 6.36a–b Berlin, Pergamonmuseum, altar of Zeus from Pergamon, east frieze details, c. 170–155 BC, marble, H (frieze) 2.28m.

Every detail has been carefully executed (note the armpit hair of the Giant, Fig. 6.36b), and the quality of sculpting is superb (see the treatment of the same Giant's left hand and fingers). This bravura style is known as "Hellenistic baroque," and, as we shall see, was used for works outside Pergamon, as well.

The initial impression of the frieze is one of chaos, yet there is disciplined order underlying this façade. Each of the structure's four sides is devoted to deities of different realms: Olympian deities on the east, gods of the night and Underworld on the north, gods of light and air on the south, and water deities and Dionysos and his retinue on the west. Diagonal poses dominate the composition and lead from one figure to another. All is movement in carefully choreographed interactions. Erika Simon has suggested that the order of figures was inspired by the *Theogony*, a poem composed by Hesiod in the eighth century BC. The poem gives an account of the birth of the gods, the Gigantomachy, and the ascendance of Zeus to the top of the pantheon. Pergamon's library, immediately to the north of the Athena sanctuary on the terrace above, was well-known in the ancient world so it is scarcely surprising that a literary source might lie behind this remarkable monument, but whether it was Hesiod's *Theogony* or not remains an open question.

This intellectualism is also apparent in the interior room, whose walls were lined with another, smaller sculpted frieze, 1.58m high × 80–90m long, depicting the life of Telephos, the mythical founder of

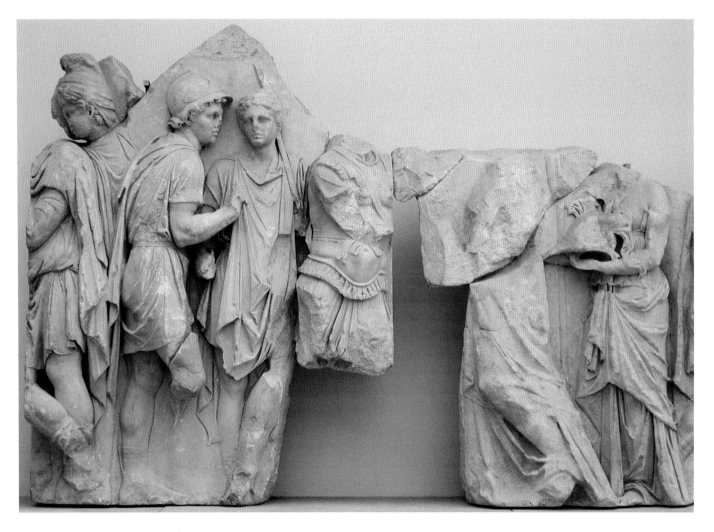

Fig 6.37 Berlin, Pergamonmuseum, altar of Zeus from Pergamon, Telephos frieze detail: Telephos (armed) receives armor from Auge, *c.* 170–155 BC, marble, H (frieze) 1.58m.

Pergamon (Telephos' mother, the mortal Auge, is credited with bringing the cult of Athena from Tegea in the Peloponnese to Pergamon). This frieze, which was never finished, is rendered in an entirely different style – in lower relief than the exterior frieze with far less bravura and drama – and is also differently conceived of as a narrative (Figs. 6.37): while the Gigantomachy appears to show a single moment within the battle – all figures are fighting without any distinction in time or place – the Telephos frieze unfolds over both time and place. This continuous narrative illustrates the life of Telephos from his birth (he is the son of Herakles, and therefore the Attalids are descended from Herakles and, by extension, from his father, Zeus) to death and repeats the figure of Telephos in different vignettes that are not clearly divided; instead, the episodes run together like a modern mural depicting the life of a famous figure or the history of an event with a beginning, middle, and end (Fig. 6.38). Remarkably, numerous landscape, textile, and architectural elements fill the field not occupied by figures (who include personifications), and there

Fig 6.38 Berlin, Pergamonmuseum, altar of Zeus, Pergamon, Telephos frieze, reconstruction.

10 11 12 7 8

16 17 18 20 21

28 30 31 1 34 35

44 45 46 49 50 47 48

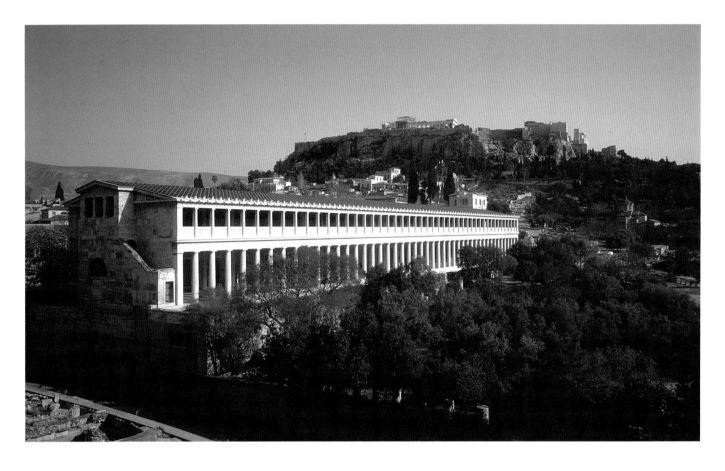

Fig 6.39 Athens, Agora, stoa of Attalos.

is a diminution of scale for higher features in the frieze to suggest depth of field (cf. Figs. 4.27, 5.43–44). As Huberta Heres points out, the version of the Telephos myth presented here seems to draw on varying, even contradictory, literary traditions, suggesting that the account on the altar was devised for this occasion. The altar's different narrative strategies and the juxtaposition of the founder's history with the cosmic event closely tied to Zeus and Athena on the same monument (whose V-shaped composition quotes the central motif of the Parthenon's west pediment, see Fig. 4.35) indicate thoughtful intellectual play on the part of patrons and designers.

This sensibility squares well with Pergamon's aspirations to become the new Athens, and as part of this, Pergamene kings dedicated monuments on the Athenian Akropolis, its slopes, and in the Agora (Fig. 6.39) to link themselves to a great intellectual, artistic tradition. Pausanias (1.25.2) reports having seen a dedication by the Attalids on the south side of the Akropolis, as he made his way around the Parthenon. Here, he saw four battle groups comprising figures one cubit

Fig 6.40 Naples, Museo Nazionale 6012, Amazon, Roman copy of a Greek original of *c.* 200–150 BC, marble, H 0.27m, L 1.16m (including base).

in size (about two-thirds lifesize) in the following order, which moves chronologically from most remote to most recent: the Gigantomachy, the Amazonomachy, the Battle of Marathon, and the fight between the Gauls and the Attalids (the Galatomachy). Using these themes, the scale, and the Pergamene Hellenistic baroque style as guides, scholars have identified a series of marble and alabaster sculptures as Roman copies of the original bronzes that once comprised this "Lesser Attalid Dedication" (Figs. 6.40–41). The Dead Amazon's clothing, hair, and wound are rendered with precision, while the awkward and realistic pose of the Falling Gaul is simply astonishing when compared with earlier works of sculpture. Parts of the original marble bases with cuttings for the statues were recently identified and permit a reconstruction of four long, rectangular bases with a total minimum length of 106m (perhaps as long as 124m), placed against or closely adjacent to the south wall of the Akropolis. The bases each carried at least thirty-three bronze figures, including both victors – on horseback and on foot – and the vanquished. This enormous ensemble would have been extremely impressive, not to say arresting, for the contemporary viewer.

The choice of the Gigantomachy and Amazonomachy mirrors the use of the same themes on the east and west metopes of the nearby Parthenon; given the Attalid kings' interest in presenting Pergamon as a successor to Athens, this surely is not accidental. The juxtaposition

Fig 6.41 Venice, Museo Archeologico 55, Gaul, Roman copy of a Greek original of c. 200–150 BC, marble, H 78cm.

of the Battle of Marathon to the Gigantomachy and Amazonomachy themes in the Lesser Attalid Monument and on the Parthenon metopes implicitly elevates this historical event to the great clashes of the past, and the addition of the Galatomachy (the Attalid army fighting Gauls) likens this contemporary event to those notable conflicts. In other words, the Attalids are put on a par with the victors, including those of the Battle of Marathon, who were mostly Athenians. In this visual juxtaposition, the Attalid kings drew a direct line between themselves and the fifth-century Athenians.

The Nike of Samothrace (*c.* 2m high), which was erected in the sanctuary of the Great Gods on the island of Samothrace, demonstrates the use of the Hellenistic baroque style in another victory monument for a naval battle (the precise occasion is a matter of controversy) (Fig. 6.42a–b). A winged Victory or Nike, her head and arms now lost, whooshes through the air and is shown at the moment of touchdown on the prow of a ship. She steadies herself against the wind, causing her torso to twist and her arms to shift. Her diaphanous yet voluminous drapery presses against her body, revealing her torso, even her navel, beneath, while deep folds push between her legs and billow out behind her. The pattern of feathers on her wings, the deeply carved drapery, and the energetic movement find parallels on the Pergamon Altar frieze, and for this reason, it is dated to the same period, *c.* 170–155 BC. Yet, from the

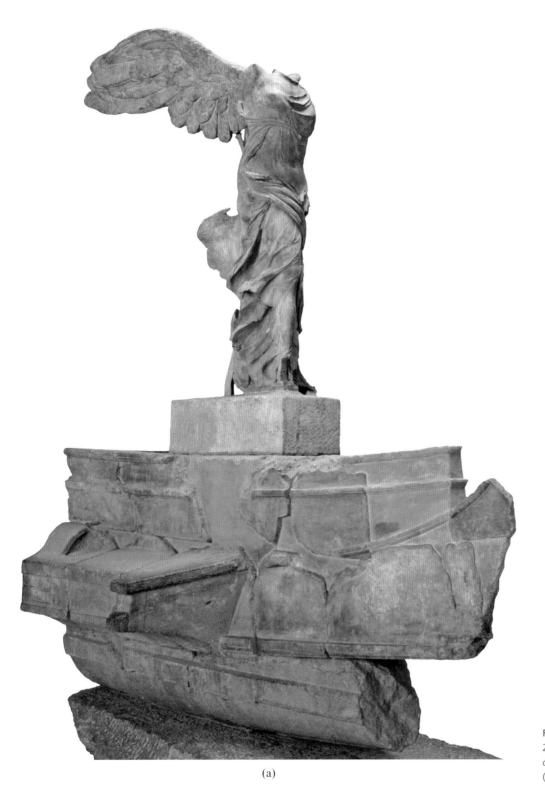

(a)

Fig 6.42a Paris, Musée du Louvre
2369, Nike of Samothrace
c. 170–155 BC, marble, H
(figure only) 2m.

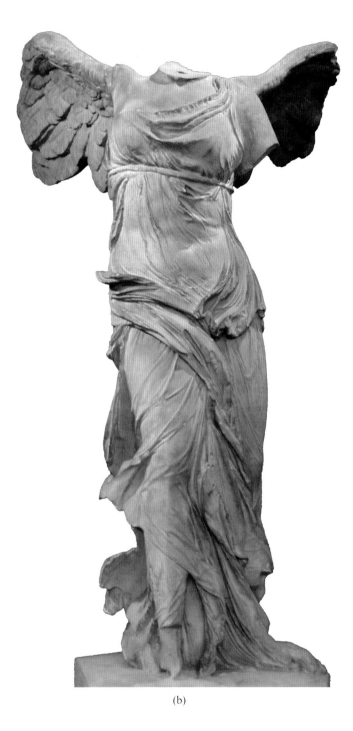

(b)

Fig 6.42b Basel, Skulpturhalle, plaster cast of 6.42a.

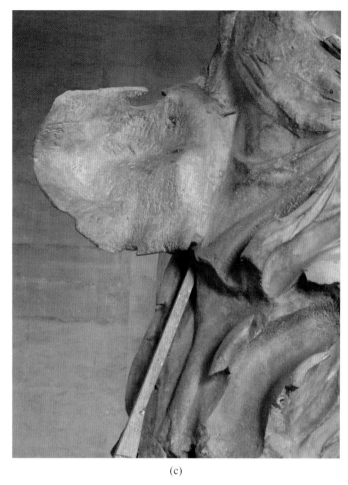

(c)

Fig 6.42c Paris, Musée du Louvre 2369, Nike of Samothrace *c.* 170–155 BC, marble.

back or side view, the Nike of Samothrace is disappointing (Fig. 6.42c): unlike the Parthenon pediment sculptures, for example, that are mostly worked completely in the round, the back drapery, as is the case with many Hellenistic sculptures, is not fully executed. The figure was meant to be seen from the front only, perhaps within a narrow architectural frame, and corners were cut, presumably to save time and expense.

Hellenistic baroque style was also used for portraiture, particularly (but not exclusively), in Pergamon, where a colossal marble portrait of Alexander the Great, contemporary with the Altar of Zeus, was found (Fig. 5.38). Although his portrait features, including the

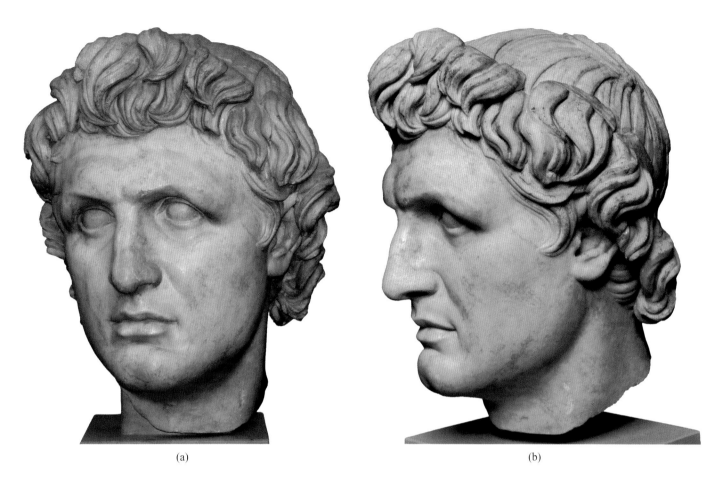

(a) (b)

Fig 6.43a–b Berlin, Pergamonmuseum P130 from Pergamon, Attalos I, *c.* 240–200 BC, marble, H 39cm.

anastole and breathless appearance, make him clearly recognizable, the angst-ridden face – furrowed brow, deep-set eyes – together with the rope-like rendering of hair strands belongs to the Hellenistic baroque style. Indeed, the style is so close to that of the altar that some scholars have suggested that the head derives from it, but this proposal has received little acceptance. More plausible is its use, together with a colossal portrait of Attalos I and a standing image of Herakles, for ruler cult in the building identified as a heroon at Pergamon. The head of Attalos I, approximately twice-life-size, is especially interesting since it was reworked (Fig. 6.43a–b): the plastically modeled hair and perhaps the diadem, composed of nine pieces of marble, were added to the already existing head, which was made *c.* 200 BC or shortly thereafter. The occasion for the additions has been much discussed; if the diadem were part of the additions – the dispute is over technical details of the carving – Attalos' exaltation to the kingship seems a likely impetus. But the style of the added locks of hair, associated with deities, as well as with Alexander the Great and his immediate followers, has

prompted other scholars to suggest the posthumous occasion of the installation of his cult (Attalos died in 197 BC).

Pergamon may have looked back to the glory days of Athens but it also looked ahead; the monuments celebrating contemporary Attalid victories over the Gauls, which commemorate victory not as mythological metaphor as in the Greek past but as literal documentation, anticipate Roman sensibilities and needs. Pergamon's last ruler ultimately colluded with the Romans, whose power over this great kingdom was finally secured in 134/133 BC when Attalos III willed the kingdom to Rome at his death.

Points east

As Alexander's army marched east, they left garrisons and settlers behind them. Alexander founded new cities, including many Alexandrias (for example, in Egypt, Mesopotamia, the Hindu Kush, the Indus plain and delta), typically with war veterans, volunteers drawn from the mercenaries, and natives, who were sometimes prisoners, sometimes recruits. These settlements were run by Macedonians, who benefited from the agricultural base of the local population. Although founded later, *c.* 305–300 BC under Seleukos I, Ai Khanoum in Baktria (in present-day Afghanistan) offers a good example of a Greek settlement in far eastern territory (Fig. 6.44).

Box 6.3 Archaeological sites in peril

Ai Khanoum in Afghanistan is but one example of an archaeological site that has been damaged – or more accurately, destroyed – in armed conflicts. It was excavated in the 1970s by a French team, but in the past few years the entire excavated area has been leveled and the site has been mined. However, this is not a recent phenomenon: warfare often results in theft or destruction of cultural properties – archaeological sites, museums and their collections (for example, the Baghdad Museum, the Tripoli Museum), and royal and private art collections, as well. While looting cultural treasures from a conquered enemy has been a human practice since there were any portable cultural treasures to take (it was normal practice for the ancient Romans when they sacked Greek cities, for example), the topic has received greater public attention in recent decades as legal cases involving restitution of property stolen during World War II or museum collecting practices have made the news. Other sites suffer from severe neglect, an overflow of visitors, thefts, and budget cutbacks. The remarkable site of Pompeii in southern Italy is, sadly, exemplary in this respect; several ancient buildings there have collapsed in recent years. The challenge of balancing priorities in cultural management has become increasingly urgent, and we can expect this to continue as more sites are excavated without sufficient resources to care for them after their exposure.

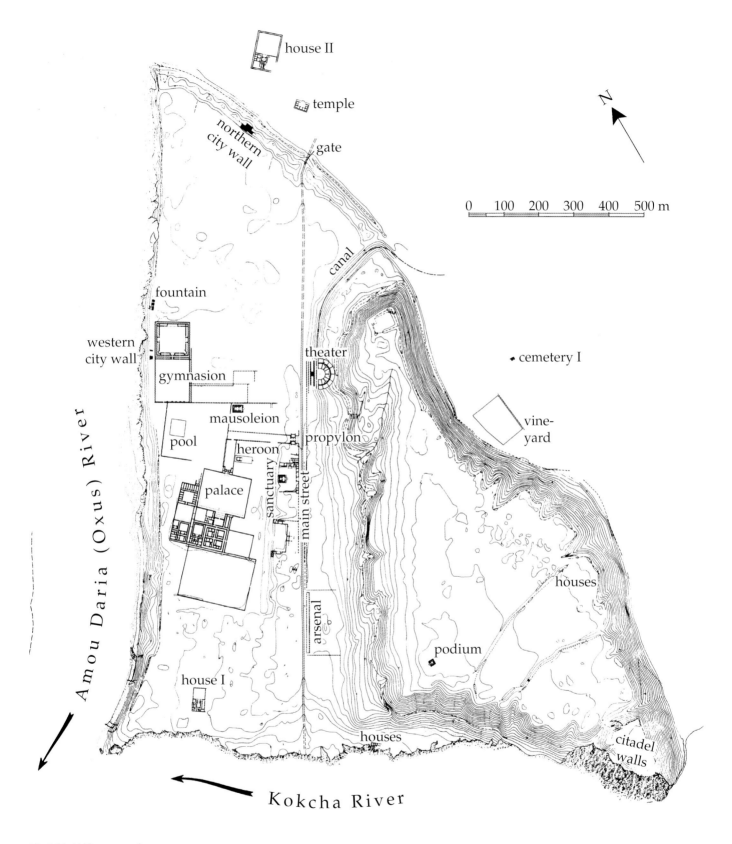

Fig 6.44 Ai Khanoum, plan.

Fig 6.45 Kabul, National Museum of Afghanistan 06.42.640, Corinthian capital from Ai Khanoum, before 145 BC, limestone, H .74cm.

Excavations revealed that Ai Khanoum, founded by Alexander at the confluence of two rivers, had trappings of a typical Greek city, such as a theater, fountain house, gymnasion, and votive and honorific statues inscribed in Greek. But most architecture in Ai Khanoum is made of mudbrick, according to local practice, and much of the city's architecture and sculpture reveals a mixture of influences. One example is a palace inspired by Neo-Babylonian or Achaemenid models combined with a peristyle arrangement common to Greek houses and stone columns in a variation of the Corinthian order (Fig. 6.45). Numerous sculptures either in purely Greek style (such as a herm) or a mix of Greek and local (Gandharan) styles have been recovered from Ai Khanoum and elsewhere in Baktria (Fig. 6.46). House plans at Ai Khanoum generally differ from those found in traditional Greek contexts, and the single extramural tomb that has been excavated follows eastern traditions of tall mudbrick mausolea (cf. Fig. 5.31). Two further tombs found within the walls close to the palace, however, have Greek temple façades with wooden columns in antis. In one of these stood an inscribed stone stele engraved in Greek, a copy of a famous text at Delphi that lists 150 maxims of the Seven Sages. A mausoleion at Ai Khanoum recalls Greek temple architecture: a rectangular, Ionic, peripteral structure on three steps. Its central structure, one large

Fig 6.46 Kabul, National Museum of Afghanistan 05.42.14, hermaic pillar from gymnasion at Ai Khanoum, first half of the second century BC, limestone, H 77cm.

room, divided into three portions by short side walls, has two columns in antis in the vestibule, typical for the pronaos of a Greek temple.

Likewise, a mixture of influences and traditions is discernible in the Kommagene kingdom, part of the Seleukid realm, in southeastern Turkey. Although this region rebelled and became independent in *c.* 162 BC, the lingering taste for Greek styles and persistent Greek influence can be seen in the spectacular mausoleion on the peak at Nemrud Dagh (2,150m above sea level) belonging to the Kommagene king Antiochos I (*c.* 64–38 BC), who claimed descent from Alexander the Great and from the Persian king, Darius I (Fig. 6.47). This site, consisting of a huge stone tumulus atop the ruler's tomb and a vast sanctuary, was constructed *c.* 38–31 BC. Colossal seated statues of Antiochos and four divinities, all carved from volcanic stone (*tufa*), stand sentry on the east and west terraces, and gaze imperiously from their limestone thrones over the dramatic landscape. The juxtaposition of the ruler with the gods, all at the same scale, was clearly intended to liken Antiochos to his divine companions (Fig. 6.48). Each group of sculptures was flanked by an eagle and a lion, together with sculpted stelai, and the order of reliefs and free-standing figures is identical on both terraces. The deities are a mix of Greek and Persian divinities: Apollo/Mithras/Helios/Hermes, Tyche of Kommagene, Zeus/Ahuramazda, and Herakles/Artagnes/Ares. Their faces are recognizably Greek in style though highly abstracted and simplified, while their headdresses are eastern. We know their identities from Greek texts inscribed on the reverse of the thrones (Fig. 6.49), and other inscriptions at the site (including on the reverse of the relief stelai) yield information about the deities worshipped and cult practices in honor of the king. The relief stelai depict a constellation, signified by a lion, stars, and an astrological text (Fig. 6.50); and Antiochos I shaking hands (dexiosis motif) with Herakles, Apollo, and other deities. The Greek hero carries his club, and has a lionskin draped over his left arm. He is otherwise nude, in contrast to the king, who wears eastern garments. In addition, reliefs depicting the royal ancestors of Antiochos, including Alexander the Great, also appear on both terraces for a total of ninety-six reliefs.

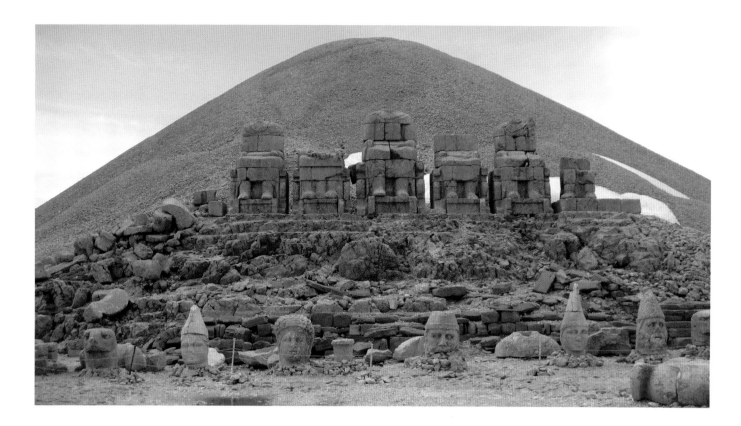

Fig 6.47 Nemrud Dagh, hierotheseion of Antiochos I,
east terrace, *c.* 50–35 BC, limestone, dimensions of tumulus
H 50m, D 150m, H (figures) *c.* 8m.

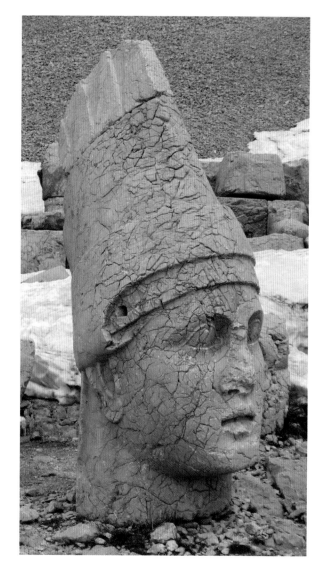

Fig 6.48 Nemrud Dagh, hierotheseion of Antiochos I, east terrace,
c. 50–35 BC, limestone, H (figures) *c.* 8m.

Fig 6.49 Nemrud Dagh, hierotheseion of Antiochos I, east
terrace inscription on enthroned figures, *c.* 50–35 BC,
limestone, H (figures) *c.* 8m.

Fig 6.50 Nemrud Dagh, hierotheseion of Antiochos I, relief,
c. 50–35 BC, limestone, H *c.* 2m.

The coming of Rome

Empire without end

By 300 BC, Rome had become a power to be reckoned with, and in the subsequent century would take an increasing interest, and lend an intervening hand, in events happening further east. The second century BC brought a flood of Greek art, taken as war booty, into Rome and aroused an appetite and curiosity for more such treasures. As the Roman military was intent on gaining control of the eastern Mediterranean, the art that the troops encountered in their campaigns became, at first, the loot of the conquerors, then attributes to demonstrate their ascendancy to power in the region and at home. Alexander's regal imagery appealed to Roman generals on campaign in the east, although aspects of the iconography were antithetical to Roman principles of leadership and government. Although the history of art often gives the impression that Romans had little interest in art early on, we should not think that Romans had no art before their encounter with the Greeks; on the contrary, literary sources speak of a venerable tradition of monumental painting and bronzecasting (much of which no longer survives), as well as of terracotta plaques and friezes adorning temples.

Clearly, the period of Rome's rise to power provided appealing and heady opportunities to men intent on ruling the world. Although the generals and their soldiers could not have known it, their acquisition of artistic treasures as plunder and their attraction to heroic Hellenic role models were only the first response to what is often perceived as a clash of cultures. To some members of the Roman political elite, Greek art offered an international style that provided Roman themes with greater visibility and panache. The borrowing of Hellenic styles signaled that Rome controlled the eastern Mediterranean and laid claim to the ancient traditions of the older culture. Some aspects of Greek art, its idealized figure style and mythological themes, for example, had already infiltrated Etruscan art and soon became fundamental to Roman visual habits. But to other members of the elite, Greek art (or perhaps all art in principle) seemed foreign and suspect, a diversion from the business of empire, and was cited in moralizing speeches about decadence and decline.

Fig 6.51 Delphi, Aemilius Paullus Monument, reconstruction.

Fig 6.52 Delphi, museum, Aemilius Paullus Monument, frieze, c. 168 BC, marble, H 45cm.

Monuments of victory

Aemilius Paullus was a Roman conqueror whose triumphal monument not only marked history but also made history. As the Roman general who defeated his Greek opponent, Perseus, at the Battle of Pydna in 168/167 BC, Paullus seems to have appropriated the monument of his enemy and turned it into his own in that year (Figs. 6.51–52). It was erected in the sanctuary of Apollo at Delphi, the oracular shrine where kings and conquerors had long come to have their chances of victory appraised by the Pythian priestess, directly in front of the temple of Apollo (Figs. 3.11, 3.13). Paullus placed a bronze (probably gilt, as well) equestrian statue of himself on a rearing horse atop a tall Pentelic marble pillar that was intended to honor Perseus had he won, as we learn from ancient authors (how much of this monument had been completed when Aemillius Paullus usurped it is debated). Adorning the top of the pillar, a figured frieze depicts the decisive battle in a series of scenes showing fighting soldiers differentiated as Macedonians or Romans by their weaponry. According to many scholars, one scene depicts the event that precipitated battle: a riderless horse, shown foreshortened, galloping into the distance. Accounts mention a stalemate between the Romans and Macedonians because a prophecy had warned that whoever made the first charge would lose the war (Plutarch, *Aemilius Paullus* 28). Both sides waited until a riderless

Box 6.4 Reworking and reusing earlier materials

The ancient Greeks and Romans were thrifty about recycling and reusing ancient material in new monuments, and this was an everyday practice. Stones hewn and dressed into blocks or slabs for building or funerary stelai, for example, provided ideal material for constructing walls. Such was the case for the fortification wall erected around Athens in 478 BC by decree of the assembly in response to a proposal from the leader Themistokles. Ancient writers remark on the rapid erection of this Themistoklean wall, accomplished in part by grabbing the material nearest to hand – archaic funeral stelai, archaic free-standing sculpture, and architectural blocks – and incorporating it into the fabric of the wall. Such material reused in a new context is called *spolia*, and one can see spolia built into monuments, especially Byzantine churches, all over Greece today.

The Romans used spolia, but also appropriated whole monuments (including earlier Roman monuments), made transformations, and reused them for their own purposes. The monument of Aemilius Paullus (Figs. 6.51–52) is one instance, but there are others, such as the Olympieion temple in Athens (see Fig. 3.48, Chapter 7).

horse broke through the Macedonian lines, provoking them to attack. That the horse had gotten away from its Roman rider may suggest to the cynical reader a clever tactic: by manipulating the prophecy to their own ends, the Romans undermined the morale and confidence of the enemy. In any case, Paullus' remaking of his enemy's monument into his own vehicle of glory served as a brilliant maneuver that asserted Roman dominance in the heart of Greece and altered the landscape of the venerable sacred site (and monument appropriation became a typically Roman practice in Roman lands and elsewhere). This point is emphasized by the use of a Latin inscription on the statue's plinth to proclaim the Roman general's achievement: "L. Aimilius L.f. imperator de rege Perse Macedonibus cepet" (Lucius Aemilius, son of Lucius, commander captured this from King Perseus and the Macedonians).

Aemilius Paullus' victory was celebrated in Rome with a grand triumphal procession, the highest achievement of a military career (Livy 45.40; Plutarch, *Aemilius Paullus* 38). This triumph, however, was extraordinary in its duration of three days and the lavishness of its displays: 250 wagons carried art objects, taken as war booty, on the first day; armor and weapons were brought out the next day in the hands of the three thousand men in the parade; on the last day Paullus made an appearance, along with his defeated opponent, Perseus, together with Perseus' children, and 210 oxen to be sacrificed to Jupiter. It was said that Paullus so enriched the public treasury with his war booty that the taxes of the inhabitants of Italy were not needed. The sight of the vanquished enemy and his treasures in the heart of Rome and under

Fig 6.53 Rome, Museo Nazionale Romano 1049 ("Terme Ruler") found at the foot of the Quirinal Hill in Rome, *c*. 170 BC, bronze, H 2.08m to top of head.

Roman authority demonstrated the rewards of conquest to the civilian population. The procession also upheld the notion that splendid art objects ought to serve the public good by being on display in full view. Triumph also had its personal advantages: Paullus brought the painter Metrodoros from Athens to create pictures representing his battles (some of these, no doubt, carried in the procession to be displayed to the crowds), and Perseus' library was hauled away to educate Paullus' sons, who were tutored by Greek intellectuals taken as war captives (the historian Polybius was among them), who thus served as slaves to Paullus. This brain drain from Greece to Rome formed another type of appropriation of Greece's deep cultural reservoir.

Paullus also celebrated his victory in Greece (in Thrace) to an audience consisting of representatives of all Greek cities. The Roman and Greek triumphal displays communicated different messages to eastern and western audiences. In the capital, the wealth and exotica on parade showed off the new resources commanded by Rome's empire. In Greece, the victory games demonstrated Roman mastery of public spectacle, which announced the defeat of the Macedonian kingdom and the beginning of a new era. Aemilius Paullus was known to have said that "a man who knows how to conquer in battle should also know how to give a banquet and to organize games" (Livy 45.32.11).

Roman identity

Roman "imperialists" required self-images appropriate to their newfound grandeur and status. The heroic nude statuary of the Greeks provided a suitable vehicle to convert their military and political power into a purely physical expression of superiority in terms of raw strength. The bronze statue of a Hellenistic "ruler," the so-called Terme Ruler, of the second century BC has confounded scholars, who debate whether it depicts a king from the eastern Greek world, a mythological figure, or a Roman general masquerading as one of these quasi-divine kings (Fig. 6.53). The portrait's sharply pointed nose resembles a Macedonian regal feature, suggesting an identification with eastern kings, perhaps

Fig 6.54 Rome, Museo Nazionale Romano 106 513 from the temple of Hercules at Tivoli, c. 100–80 BC, marble, H 1.88m.

Attalos II. Yet the small head (in proportion to the body) lacks the royal diadem, the attribute of kingship, and has a highly unusual face for a Hellenistic king, including a short, incised beard, and uses overwrought features in the compressed knitting of the brow, the full cheeks, and springing locks. Perhaps the Terme Ruler depicts an eastern prince (who would not yet have assumed the diadem) or relative rather than the king, but some recent studies associate the portrait with a Roman politician or general. In any case, we have evidence of the importation of such statues or their imitation; both modes of cultural transmission suggest the appeal of the model to audiences in the east or in Rome. The pose of the nude king resting on his spear derives from the well-known statue of Alexander with a lance (Fig. 5.36). The lance as a symbol of conquest and possession of foreign territory was an appropriate attribute for Roman expansion, and the figure expresses brute force with its bulging muscles and fleshy frame. The ruler gazes intensely outward, as if surveying his domain.

There are instances in which the heroic nude was modified for Roman audiences. The first-century BC statue known as the General from Tivoli, the town east of Rome where the statue was erected in a temple of Hercules, bears a modest demeanor (Fig. 6.54). The strapping nude torso is draped by a mantle that covers the lower portions of the male anatomy. The figure would have held a lance in his right hand, and, perhaps, a shield in the left. In distinct contrast to the head of the Hellenistic Ruler, that of the General from Tivoli represents an aged figure marked by crow's feet and wrinkles around the mouth. This physiognomy conveyed meaning to a Roman audience: advanced age signified trusted experience, wisdom, and *gravitas* (dignity or authority), and such faces repeatedly appear in Roman Republican portraiture, which are intended not as faithful likenesses but as carriers of messages about virtues possessed by the subject. Yet the vigorous musculature of the chest does not match the lined portrait head, and it is noteworthy that the sculpture was of Parian marble and presumably carved by Greek sculptors, who had long

experience of carving nude male torsos. The statue may appear awkward to us because of the clash between prosaic head and nude torso, but to a conservative Roman audience in a small town, the statue may have made sense. The hardened expression and traditional values reflected in the old face dignified the heroic nude and restrained its more flamboyant tendencies toward self-aggrandizement and showmanship, as seen in the Hellenistic Ruler (Fig. 6.53). The latter statue could easily have put off less cosmopolitan citizens for whom the bravura display of virility and power may have alluded to the quasi-divine character of eastern kings. The exalted nature of Hellenistic rulers posed an affront to Roman skepticism about men parading around as gods and the political dangers inherent in absolute power.

Delos: boomtown and cultural crossroads

Delos, already familiar from earlier chapters, was made a free port by the Romans in 166 BC, then was sacked by pirates in 67 BC. In the period of the late second and early first century BC, it was inhabited by Greek, Roman, and eastern merchants active in the slave trade, which enriched the island by transporting human cargo from the east to Italy. The city plan of Delos was dominated by its well-known sanctuary of Apollo (Fig. 6.55) and civic amenities, such as a theater (Fig. 6.56). Close to the hub of activity was the marketplace of the Roman traders, called the Agora of the Italians, which was adorned with marble portraits. Clubhouses for various merchants and businessmen embellished the city and within them were dining rooms, meeting rooms, and lodgings, as well as shrines, all lavishly decorated with sculpture, mosaics, and wall paintings. The clubhouse of the Poseidoniasts, who were shippers and traders, from Berytos (modern-day Beirut), included a shrine to Aphrodite-Astarte. Here was found the "Slipper-Slapper Group," a playful sculpture of the goddess halfheartedly fending off the attentions of Pan, while a flying Eros tweaks one of Pan's horns (the double entendre is hard to miss), dedicated by Dionysios of Berytos (Fig. 6.57).

The domestic quarter of Delos includes some grand establishments, such as the House of the Masks with its many floor mosaics depicting theatrical motifs, as well as the splendid image of Dionysos riding a

Fig 6.55 Delos, aerial view of sanctuary.

Box 6.5 Mosaics

Although mosaics had already been in use for several millennia in the Near East, the earliest Greek floor mosaics date to the Bronze Age, and the first figural mosaics to the end of the fifth century BC. Until the fourth century BC, Greek mosaics were composed of black and white pebbles, selected for their approximate uniformity of size and regularity of shape, set into an adhesive. Later examples of the fourth century BC added more colors and employed terracotta or lead strips to create contours and outlines (e.g., Figs. 5.13, 5.41). Black-and-white mosaics continue in use all through antiquity, and new, alternate techniques were introduced in the third century BC: polygonal marble chips or cubes of cut stones (or *tesserae*) of many colors were used for mosaics instead of round pebbles. The finest of these latter, tessellated mosaics were done in *opus vermiculatum* technique, which enabled as close an approximation to painting as mosaic permitted (e.g., Figs. 5.37, 6.58–59).

Fig 6.56 Delos, aerial view of theater quarter.

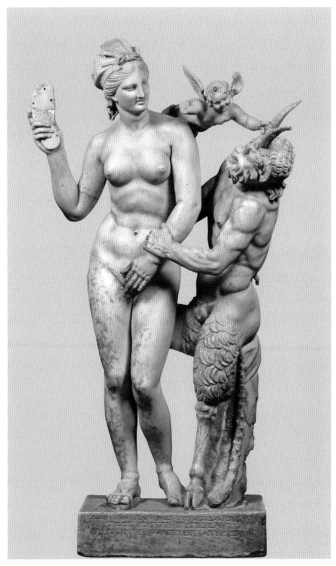

Fig 6.57 Athens, National Museum 3335 ("Slipper-Slapper Group") from Delos, House of the Poseidoniasts from Berytos, c. 100 BC, Parian marble, H (with base) 1.55m.

leopard (Fig. 6.58). By this time, *tesserae* (cubes) of glass, stone, or terracotta were used for mosaics, and allowed for much greater color range, which enhanced the ability to create the effect of shading, and sparkling effects (the Alexander Mosaic and others are not only tessellated but rendered in such fine sinuous lines of tiny tesserae that this technique was referred to by ancient writers as *opus vermiculatum* (worm-like

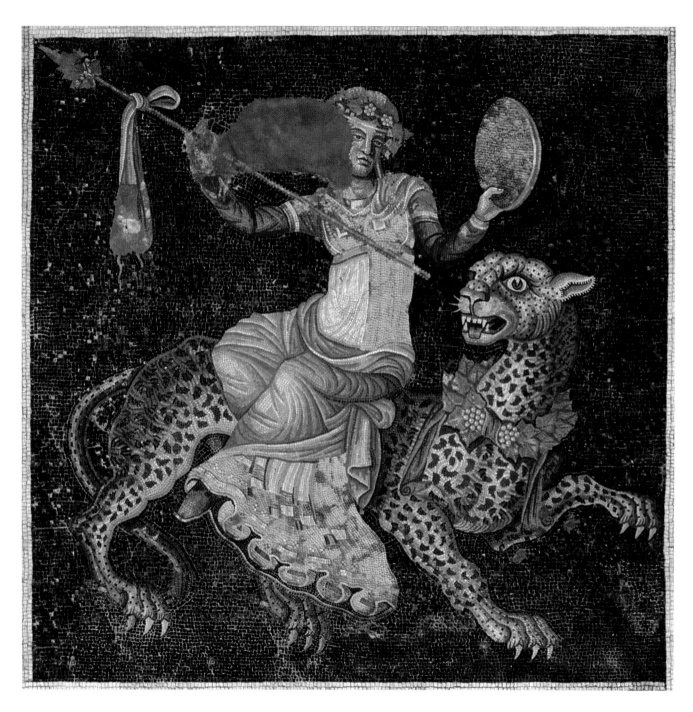

Fig 6.58 Delos, House of the Masks, mosaic of Dionysos riding a leopard, c. 160–100 BC, H 1.08m.

technique), Fig. 6.59; see also Fig. 5.37). Clearly, Delos was a posting that made the careers of some businessmen who then used their newly earned wealth to live in a stately fashion.

Another structure, the House of the Diadoumenos, was probably not a private home, but a public clubhouse akin to that of the Poseidoniasts or a private palaestra; marble architectural details convey its grand appearance. Numerous marble sculptures, including many

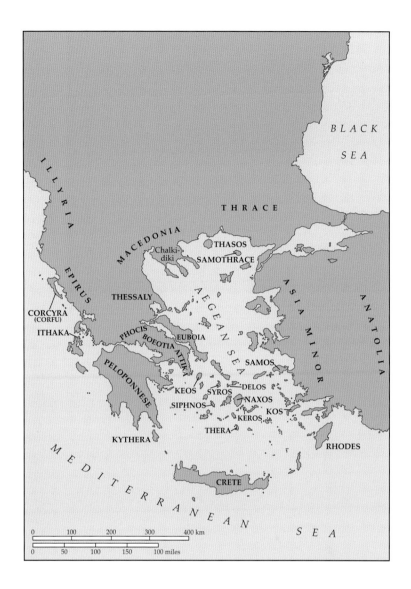

Map of regions of ancient Greece

unfinished statues, were found there, which has prompted the suggestion that an atelier of sculptors had worked in this house. Among the finished statues is the Pseudo-Athlete whose idealized nude body of Classical Greek art is topped by a non-ideal, bald, aging head, like the General from Tivoli (Fig. 6.60; cf. Fig. 6.54). The mantle swung from hip to shoulder in the rear does not cover the male anatomy as it does discreetly in the statue of the General from Tivoli.

A female portrait of the same date was also found in the House of the Diadoumenos (Fig. 6.61a–b). Differing from the bland, idealized heads of Hellenistic queens, the portrait shows a severe and striking face of a woman with a distinct character: a firm and forceful matron with a hooked nose (partly restored), high cheekbones, grimly set

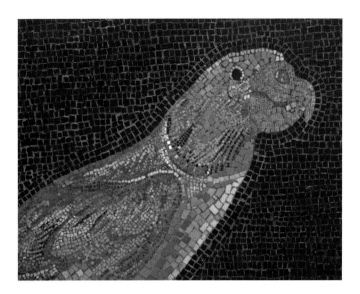

Fig 6.59 Berlin, Pergamonmuseum Mos 71 from Pergamon, Palace V, detail of parrot, *c.* 150 BC, H (of entire parrot) 49.5cm, width (of entire parrot) 57.5cm.

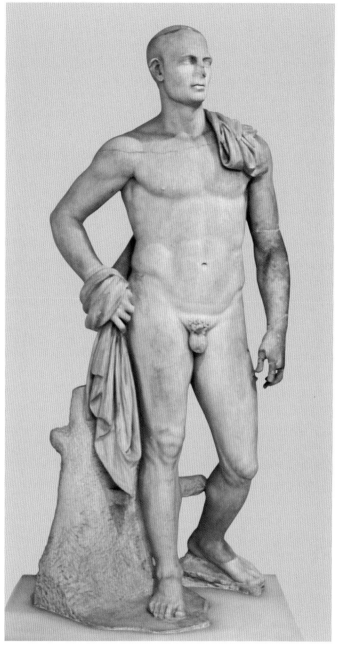

Fig 6.60 Athens, National Archaeological Museum 1828, pseudo-Athlete from House of the Diadoumenos, Delos, *c.* 100 BC, island marble, H 2.25m.

mouth, and long neck. She once wore earrings, and her hair is fixed in fine braids drawn back into a bun. Scholars have noted characteristics similar to those of coin portraits of Kleopatra VII. Although the Delos head clearly is *not* a portrait of the queen, the sculptor (or patron) may have intended a resemblance. As a portrait type, it shares the hard-edged looks of the male portrait of the Pseudo-Athlete,

(a)

(b)

Fig 6.61a–b Delos, Museum A4196, female portrait from House of the Diadoumenos, *c.* 100 BC, H 35cm, Parian marble.

and both exhibit a concern with character through their distinct physiognomies. The head is only a fragment of a complete work – the upper portion of the chest has been worked for insertion into a fully draped figure, a type appropriate for a demure matron. Female portraiture was more conservative in this period, as noted above, than that of its male counterparts, undoubtedly in part because of the masculine public roles that required more adventurous self-representation. It is not clear whether these works are meant to depict Greeks or Romans because objects found in the house – a copy of the Diadoumenos by the fifth-century sculptor Polykleitos (see Chapter 4) and an inscribed base mentioning the names and offices of two *paidotribes* (trainers in the gymnasion) – as well as the possible allusion to Kleopatra VII in the female portrait, suggest a Greek presence.

If Greek, the Pseudo-Athlete head is of a type little seen in the Hellenistic Greek world. If it represents a Roman, not only does the statue suggest that Romans abroad may have lost some of their inhibitions about self-representation – nude portraits were also used in the Agora of the Italians on Delos, while public nude portraits do not appear in the city of Rome until *c.* 30 BC – and perhaps wished to emulate the nude imagery of Hellenistic rulers, but it also reveals something about their patterns of art collecting: they looked upon Greek visual culture as a warehouse well stocked with appropriate types and styles to legitimize their status, to create their own sense of culture and their past. The Romans ransacked collections of Greek art, but their selections and appropriations of it show regard for its accomplishments.

In the late Classical and Hellenistic periods, two broad trajectories trace the new role of art in the lives of the citizens of the Greek poleis and in the emerging Roman empire. First, the grand motifs of heroic warfare and awesome divinity are diffused into quieter, modest responses to individual needs and tribulations on the Greek mainland and in the east. Gods and heroes are depicted on a human scale. Even the flamboyant showmanship of the frieze of the Great Altar of Pergamon or the Nike of Samothrace demonstrates how the rarefied world of myth comes into contact with the spectator on a visceral level, despite the bombastic flourishes of the style. Second, the Roman campaigns created a new market for art in the west, trafficked in artists as captives of war, and launched another role for art in service to its empire. Romans, in particular, were to define themselves against the older culture of the Greeks, and it is to this testy, mutually exploitive relationship between the two cultures to which we turn next.

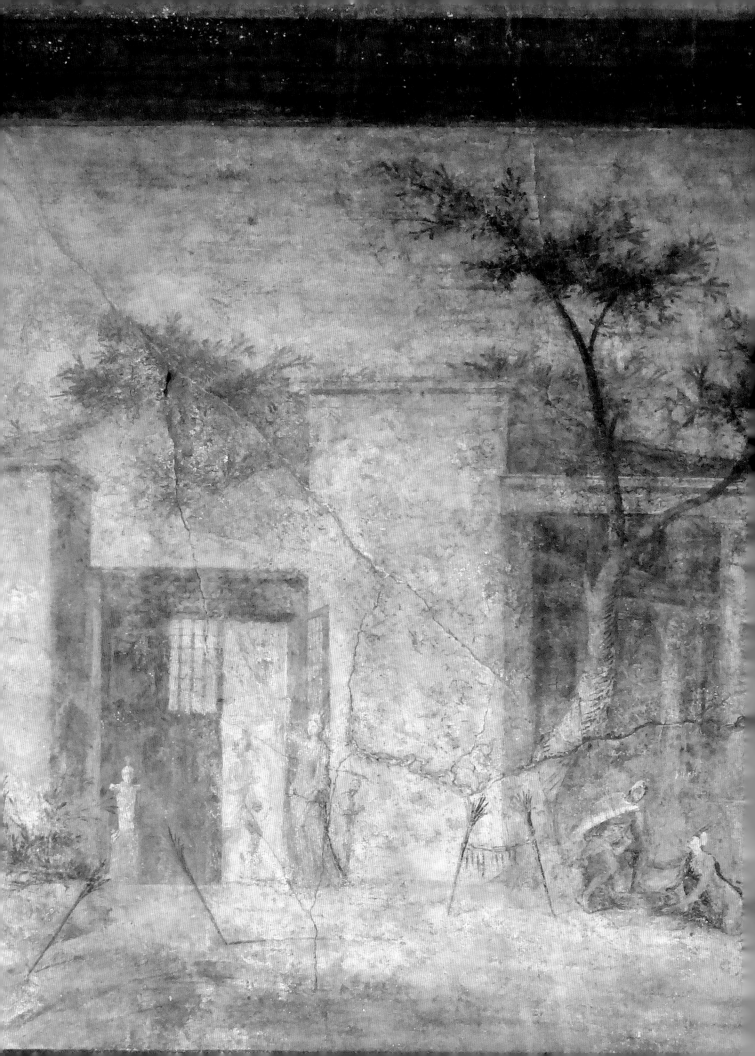

7 Roman conquest and the conquest of Rome

CONTENTS

TIMELINE

c. 508 BC	Traditional founding date of the Roman Republic after the overthrow of monarchy
c. 186 BC	Abolition of Bacchic mysteries
31 BC	Battle of Actium
c. 27 BC	Octavian proclaimed "Augustus," establishment of the Roman empire
c. 27 BC–AD 68	Julio-Claudian emperors (Augustus (d. AD 14), Tiberius, Caligula, Claudius, Nero (d. AD 68))
c. AD 69–96	Flavian emperors
AD 79	Eruption of Mt Vesuvius – destruction of Pompeii, Herculaneum, and other cities/towns in the region
c. AD 98–118	Rule of Trajan as Roman emperor
AD 118–138	Rule of Hadrian as Roman emperor
c. AD 312–337	Rule of Constantine as Roman emperor, the first Christian emperor
AD 324	Center of Roman empire moved from Rome to Byzantium

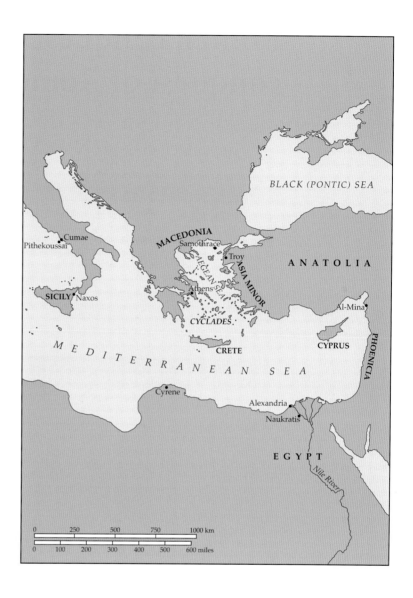

Map of the Mediterranean area

Roman conquest transformed Greece, which became the Roman provinces of Achaia (*c.* 27 BC), Macedonia (in part), Epirus, Crete, and Cyrene, but it had a profound effect on the Roman world, as well. With the infusion of tens of thousands of Greek objects taken as war booty into Rome, the Roman public quickly became familiar with, and enamored of, Greek art, and just as quickly, naysayers came forward to condemn the corrupting influence of such luxury and to denounce the intellectualism associated with it. But this was a minority opinion: not only were there Roman collectors of Greek art, but also we know of dealers and agents sent abroad to collect for Roman patrons, as well as forgers, eager to make some cash by satisfying an unquenchable thirst. And, of course,

Romans already had some familiarity with Greek culture from the Greeks living in south Italy and Sicily, as well as from their Etruscan neighbors (and earlier, their masters), who had close contacts with the Greek world and many aspects of its culture, including religion.

Roman politicians or intellectuals may have had qualms about Greek culture and its pernicious influence on the populace, but as the Roman poet Horace (*Epistles* 2.1.156) eloquently remarked, "Graecia capta ferum victorem cepit" (captive Greece captured its savage victor): Greek culture prevailed and thoroughly conquered and imbued Roman culture in many respects (the subject of Roman copying has been addressed several times in the preceding text). This final chapter will concentrate on the development of the imprint of Hellenism, i.e., "Classicism," on Roman art, which is profound (and we leave aside here the rich debt owed to Greek culture by Roman literature, rhetoric, and theater). To cite just a few examples, Roman imperial portraiture and middle-class art are heavily marked by the idealism of Classical Greek art at various periods (especially under the Julio-Claudian emperors and through much of the second century AD); Greek myth was a dominant theme in Roman wall painting and in funerary art, particularly sarcophagi; Greek paintings provided models for Roman counterparts; Greek architectural forms were combined with native Italic and Etruscan models in Roman architecture; and the use of rulers' likenesses on coinage to transmit messages was a Greek invention. However, the Romans were not slavish imitators but innovators, as well: many "copies" of Greek sculptural models are actually variations or inventions on a theme (musical variations on a sonata's or symphony's theme are analogous); the extraordinary variety of individual likenesses, both female and male, in elite Roman portraiture of all types – honorific statues, imperial statues, funerary reliefs, painting – is simply remarkable, as if the individual face were suddenly "discovered;" the invention of "concrete" (*opus caementicium*) and the exploitation of its flexibility produced some of the most impressive and creative architecture ever constructed; and the Roman interest in documentation of real events produced new ways to ornament public monuments and to transmit messages through them. This list is not exhaustive but meant to illustrate that the Romans, like the Greeks, adopted and adapted what they encountered.

What's more, having conquered the Greek world militarily and been conquered by Greek culture, Roman emperors, statesmen, and leading citizens erected monuments everywhere in the then Greek world, thus leaving their Roman stamp on these places while simultaneously staking a claim as the heirs of this rich heritage.

Greek and Roman, Greek v. Roman

It may be easiest to understand the concept of Classicism by looking at a work that combines both classicizing and non-classicizing Roman features, the "Altar of Domitius Ahenobarbus" (the original location of the base in Rome and its function are debated), an appellation that is misleading: it is unlikely to have been an altar and seems to have had nothing to do with the eponymous Domitius Ahenobarbus. Three reliefs, comprising one long side and the two short sides of a rectangular base, depict the wedding of Poseidon and Amphitrite, who are seated on a skillfully foreshortened chariot and rendered in a classicizing manner (Fig. 7.1a–b). Nereids riding sea creatures, Tritons (their serpent legs recall those of the giants on the Altar of Zeus at Pergamon, Figs. 6.35–36), and Erotes accompany them. Another relief, which constitutes the remaining long side, portrays a Roman census, a critical exercise for military service and taxation; this composition includes an animal sacrifice to the war god, Mars (Fig. 7.2a–b).

All the reliefs are of marble, but the census relief is of one type of marble, while the other three are of Asia Minor marble, and the style and composition of the two scenes are starkly different. The "busy" impression of the Poseidon/Amphitrite frieze is created by the general absence of empty space, figures who fill the height of the frieze (and note that the seated bridal pair would be much taller than the relief were they to stand up) and project beyond the vertical frontal plane, multiple levels of relief, figures' variety of positions with foreshortening where necessary, and a great deal of motion. The idealized figures have similar faces (except Poseidon. who is bearded), and the drapery responds to motion and both reveals and defines the bodies beneath. By contrast, the census relief is much more legible because of space left between most figures, who are nearly all rendered as a series of verticals with the exception of the horizontal line of animals – the bull, ram, and pig brought to sacrifice (*suovetaurilia*) – and a

(a)

(b)

Fig 7.1a–b Munich, Glyptothek 239 from Rome, frieze of the wedding of Poseidon and Amphitrite from the "Altar of Domitius Ahenobarbus," *c.* 130 BC, marble, H 1.52m. L 5.64m.

horse. Variations in the size of the figures – the god Mars is the tallest – relatively few planes of depth, restrained or absent movement, and simplified drapery, which suggests bodies beneath but does not adhere closely to them, also enhance intelligibility. The focus on clarity, non-idealism, documentation, and simplification is typically non-classicizing and common in Roman imagery, although we shall see that Classicism exists in elite Roman art in certain circumstances. It is clear that the Poseidon/Amphitrite reliefs originated elsewhere in the Greek world and were brought to Rome, where they were discovered, together with the census relief, in the Campus Martius.

(a)

(b)

Fig 7.2a–b Paris, Musée du Louvre LL399, census frieze from the "Altar of Domitius Ahenobarbus," *c.* 130 BC, marble, H 1.2m, L 5.6m.

Fixing the date of the composition of the monument in Rome is difficult; the weapons and garments of the census scene could suggest a date as early as the second century BC, while the date of the last census is 69 BC. The contrast between mythological imagery and a preference for documenting the real is among the chief distinctions between Greek and Roman art, and this census relief marks one of the first of a long line of "historical" reliefs in Roman art.

The allure of Greek myth

The myth of the Trojan War and the events leading up to it and following from it were central to Greek culture. The Romans

Map of Italy and western Greece

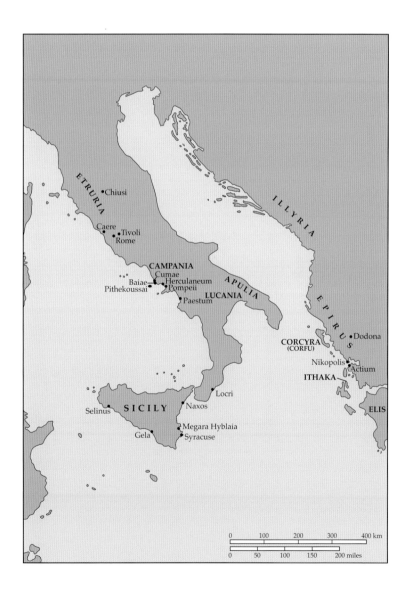

Fig 7.3 Rome, Ara Pacis, west façade, 13–9 BC, marble, 11m × 10m.

appropriated one strand of this myth, the survival of the Trojan warrior, Aeneas, who escaped from Troy with his father, Anchises, and his son Ascanius, and sailed to the Italic coast, where he established a new homeland at Alba Longa. This became the foundation legend of the Roman people, described by numerous ancient authors, including Virgil in his epic poem, the *Aeneid* (composed in the 20s BC) for Augustus (formerly Octavian), the first emperor of Rome. Augustan public monuments employed this myth repeatedly to stir a sense of Roman self-consciousness and to link the ruler back to the founder of the Roman people. Like Aeneas, Augustus led his people out of years of warfare to a peaceful period under a new form of government. The Ara Pacis (Altar of Peace) in Rome was voted by the Senate to commemorate Augustus' successful military campaigns in Spain and Gaul and his triumphant return (Figs. 7.3–4). The

Fig 7.4a Rome, Ara Pacis, detail of south procession frieze, 13–9 B.C., marble, H 1.55.

Fig 7.4b Rome, Ara Pacis, detail of panel of Aeneas, 13–9 BC, marble, H 1.6m.

richly decorated enclosure houses the actual altar within akin to the arrangement of the Altar of Zeus at Pergamon (Figs. 6.33–34). The enclosure's exterior north and south walls were carved in sculpted relief: a procession of priests, the imperial family, and those in their orbit stood on a single groundline above a lower register filled with a highly ornate and complex floral design (Fig. 7.4a). Flanking the entrances on the east and west were individual relief panels – again set atop the floral ornament – including one depicting Aeneas dressed in a toga and making a sacrifice (Fig. 7.4b; the hero was renowned for his piety). The style of Augustan public art revives fifth-century BC Classicism with its emphasis on idealized figures, emotional containment, drapery responding naturally to movement, and uniform proportions. But note that not all faces are the same – many individuals are, in fact, identifiable by means of other, known portraits – and that figures (including the children) are distinguished by attire and age. The Classicism – even precise copying of Classical sculpture and architecture – is typical of Augustan art and intentionally used to suggest a link between Augustus and the fifth century BC, the time of Athens' zenith. In other words, Classicism served as a political tool. In the case of the Ara Pacis, it celebrates peace under Augustus guaranteed by Roman imperial power. Characteristically Roman is the emphasis on documentation of real people and concentration on a real event, but in this case, an idealization of the real: some scholars believe that the procession represents the actual one that took place at the site of the Ara Pacis when the ground was consecrated, but that the individuals shown are an impossible mix of those present and those who were not. In any case, the altar includes myth but reserves its largest sculpted surfaces for Roman citizens, not gods or heroes.

Other aspects of the Trojan legends also appealed to artists and patrons as evidenced by the Odyssey landscapes, wall paintings that decorated a cryptoporticus on the Esquiline Hill

Fig 7.5 Vatican City, Musei Vaticani, Odyssey landscapes, panels 8–9: Odysseus in the Underworld, *c.* 50 BC, H 1.16m.

in Rome (Figs. 7.5–6). This cycle of paintings shows eleven episodes of Odysseus' wanderings in nearly square panels separated by painted engaged pilasters – complete with shadows – to suggest actual architecture. Far less accomplished in terms of technique and foreshortening than the hunt painting from the Vergina tomb façade (Fig. 5.43), the Odyssey landscapes are nonetheless impressive and extraordinary: hazy, atmospheric landscapes, dominated by sky, sea, and rocks, are the true subject as tiny human figures dart here and there in their vastness. The figures' names are painted in Greek, and continuous narrative (cf. Fig. 6.38) is used in the scene of Kirke and Odysseus, where the figures are repeated in two different moments from the same episode. In other words, both the subject and narrative technique of this panel are Greek. The extant paintings may have been part of a larger cycle but this remains unknown. In any case, this richly decorated interior suggests an interest and investment, at least among some erudite Romans, in Greek culture and mythology combined with a novel interest in painted landscape.

Roman wall painting embraced Greek myth wholeheartedly, as we see from many examples at Pompeii and elsewhere, where the inclusion of mythological paintings in large, elaborate homes of

Fig 7.6 Vatican City, Musei Vaticani, Odyssey landscapes, panel 6: Odysseus and Kirke, c. 50 BC, H 1.16m.

freedmen and the elite suggests their significance as markers of education and status (Fig. 7.7). One room of the "Villa of the Mysteries" at Pompeii is adorned with wall paintings concerning rituals in honor of Dionysos (or the Roman Bacchus) (Figs. 7.8–9). The paintings are a mixture of mythology and what seems to be the real world: in an indoor location, a real(?) woman prepares herself for an initiatory ordeal, involving the reading of a text and flagellation by a remarkable winged female. Interpolated into the midst of this indoor scene is a rural locale: two young satyrs sit on a rock in front of which stands a goat. Around the corner, an aged Silenos

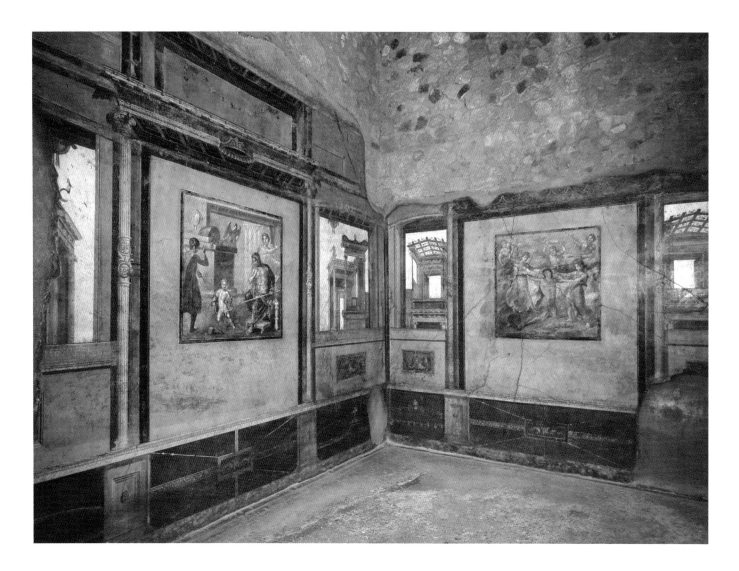

Fig 7.7 Pompeii, House of the Vettii (VI 15, 1), AD 62–79, triclinium *n*.

(a mythological follower of the wine god) also sits on a rock and holds up a silver vessel to allow a young satyr to inspect its reflection of a mask held by another satyr behind him. Next to this group are Dionysos reclining in the lap of his consort, Ariadne. All figures stand on a single groundline, painted as a shallow, illusionistic projecting shelf or stage. No comparable images exist from the Roman world, and scholars speculate that the paintings may reflect rituals that occurred in the room. The Bacchic mysteries had a fervent following in the Roman world until their abolition by Senatorial decree in 186 BC (Livy 39.18; *ILS* 18; *ILLRP* 511).

Roman sarcophagi sculpted with Greek myths were produced in Italy, in Attika, and in Asia Minor, most abundantly from the second quarter of the second century AD to the early fourth century AD

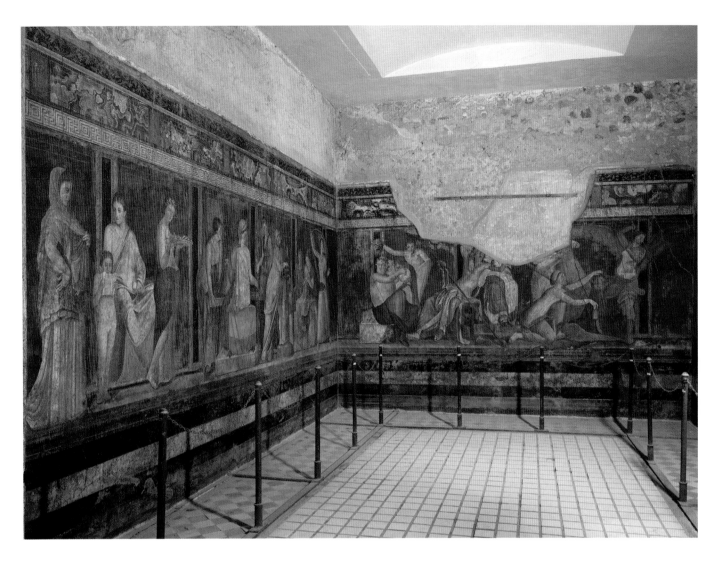

Fig 7.8 Pompeii, Villa of the Mysteries, Room 5, overall view, mid-first century BC.

(though production stops in Attika by *c.* AD 260–270; Fig. 7.10). They were used locally but also exported widely east and west. Most myths, such as Hippolytos and Phaedra, a tragic story of a stepmother's adulterous love for her stepson and his rejection of her (and naturally, both their deaths), cannot be directly connected to the deceased but may have more general thematic meaning, e.g., the death of a young male. But some themes are more common in some times and places, e.g., Athens, where myths concerning Achilles are particularly frequent and seem closely linked to ideas of ephebes and their training.

The examples discussed in this section are all private art. It is noteworthy that Greek myth only occasionally appears, either as sculpture or painting, on Roman public buildings, religious or otherwise. The Aeneas myth is the exception, and this, of course, is really about Rome, not Greece.

Fig 7.9 Pompeii, Villa of the Mysteries, Room 5, satyrs, goat, Silenos, Dionysos, and Ariadne, H 1.62m.

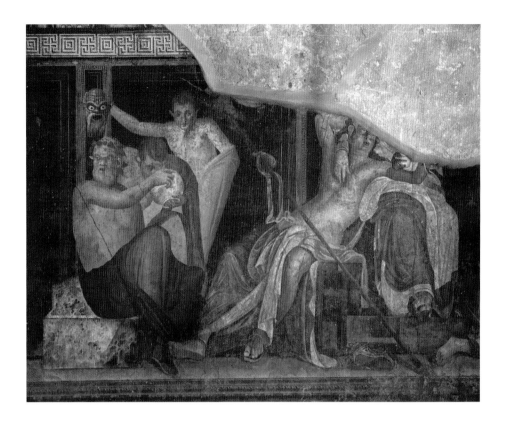

Fig 7.10 Vatican City, Musei Vaticani, Museo Gregoriano Profano 10399/10400 from Rome, Hippolytos sarcophagus, *c.* AD 210–220, marble, H 63cm, L 1.91m, H (lid) 29cm.

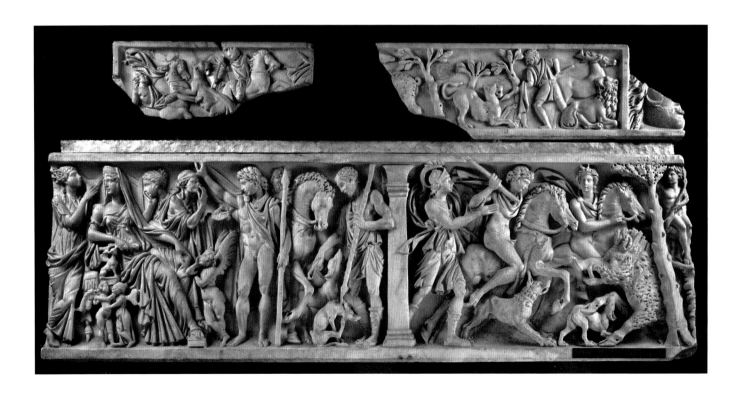

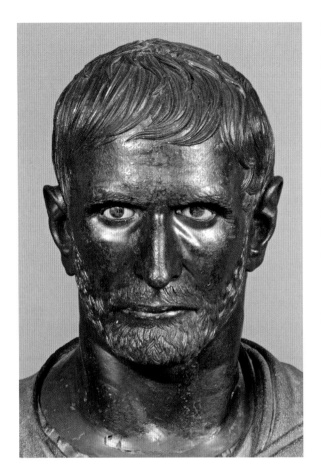

Fig 7.11 Rome, Musei Capitolini, Palazzo dei Conservatori 1183 ("Brutus"), third century BC or Augustan, bronze, H 32cm.

Recycling the past: portraiture

Portraiture, developed in the Greek world during the fourth century BC, became one of the most ubiquitous categories of Roman art. However, it is not completely dependent on Greek prototypes for it had an earlier history in Etruria and Rome in the form of civic honorific portraits. The bronze head (the bust is not ancient) of "Brutus" (the idea that the sculpture represents the founder of the Roman Republic, Brutus, seems wishful thinking) is extraordinary for its fine quality and sensitive treatment of an aging face, stern mouth, and hair (Fig. 7.11). A lifesize bronze depicts an orator (known colloquially as "L'Arringatore"), recognizable by his gesture of *adlocutio*, the hand held out as if addressing

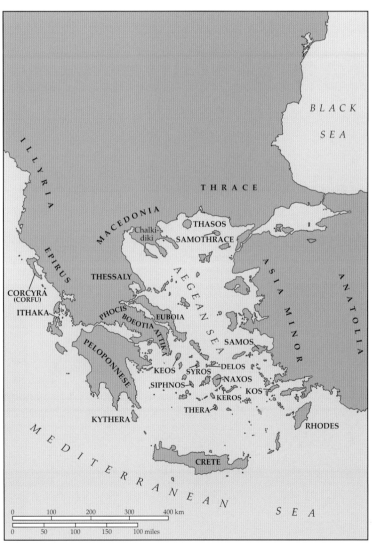

Map of regions of ancient Greece

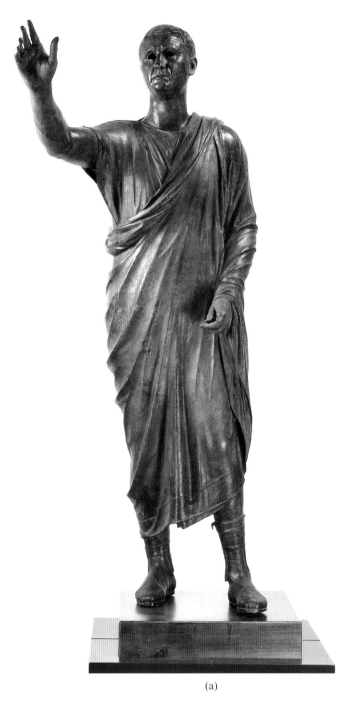

(a)

Fig 7.12a–b Florence, Museo Archeologico ("L'Arringatore"), after 89 BC(?), bronze, H 1.8m.

a crowd (Fig. 7.12a). He wears a *toga praetexta* (a toga marked with a red stripe), tunic, boots, and a ring, markers of a Roman magistrate and of the elite class, perhaps a member of the Senate in Perugia (near where he was found); his Roman name is inscribed in Etruscan script on the lower edge of his garment (Fig. 7.12b).

Imperial Roman portraits certainly rely on this tradition, but also borrow style and motifs from Greek examples, although nudity, a commonplace in Greek art, is far less pervasive in Roman portraiture (images of deities were treated otherwise). A portrait of Augustus from his wife's villa at Primaporta outside Rome deploys the same Classicism used by the Ara Pacis (Fig. 7.13): the adlocutio gesture is already familiar from "L'Arringatore," but the pose and bodily proportions take their inspiration from fifth- and fourth-century B.C. Classical models. (the position of the feet and their disposition to each other are, in fact, *exact* duplications of those of the Doryphoros; Fig. 4.29). Unlike the orator discussed above, Augustus wears military attire, suggesting that he addresses his troops. But curiously, Augustus is barefoot, which has prompted suggestions that he is portrayed as divinized and that therefore, this is a posthumous portrait. Augustus died when he was in his seventies in AD 14, yet the portrayal is of a smooth, unblemished face – in other words, idealized. His soft, full cap of hair, composed of comma-shaped locks, enhances his classicizing appearance. The Eros on the dolphin

(b)

Fig 7.13 Vatican City, Musei Vaticani 2290 from the villa of Livia at Primaporta, Augustus, marble, after 20 BC, marble, H 2.03m.

and the imagery on his cuirass are replete with symbolism pertaining to his genealogy and contemporary politics, a practice that becomes conventional in Roman Imperial art.

In addition, many sculptors of Roman portraits, particularly portraits of the elite, were from Greece and many of their creations were made of Greek marble. Whether these were itinerant craftsmen or the objects were worked in Greece then exported is hard to say in some cases, but it is worth noting just how far afield (that is, how far away from Greece) such portraits appear. For example, two portraits of *c.* AD 160 made of Pentelic marble and carved by Athenian sculptors were uncovered in the Roman villa at Lullingstone, southwest of London (Fig. 7.14).

Fig 7.14 London, British Museum, portrait from Lullingstone, *c.* AD 160, Pentelic marble, H 71cm (54cm without the base).

Stylistic revival

Not surprisingly, Romans adapted Greek styles for their own uses. Marble herms adorned the Horti Maecenatiani (the gardens of Maecenas) in Rome (Fig. 7.15); these figures owe much to sixth- and fifth-century Athenian sculpture, specifically archaic korai. In other words, the figures combine Classical, as well as archaic styles, typical of such

Fig 7.15 Rome, Musei Capitolini 1076, 1095 from the Horti Maecenatiani, Rome, Pentelic marble, H 1.2m.

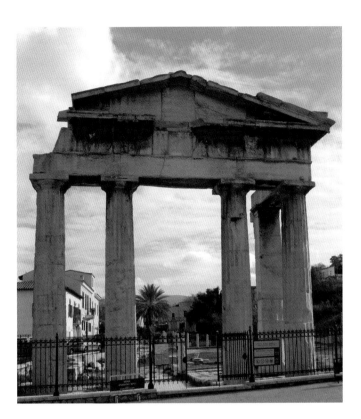

Fig 7.16 Athens, Roman Agora, gate of Athena Archegetes.

"Neo-Attic" works, although korai were not used as herms in Greece.

More specifically, Roman art draws on the Greek Classical style for inspiration, especially during the rule of the emperor Augustus (27 BC–AD 14). Augustan Classicism is pronounced not only in the Ara Pacis but also in other public buildings, both in Rome and in Greece. The Forum of Augustus in Rome included copies of the Erechtheion caryatids, columns, and moldings (see Figs. 4.54, 4.56b), made by Augustus' workmen, who clearly studied the originals or images of them. In Athens itself, Augustus funded a Roman Agora fronted by a gate of Athena Archegetis that faced the "old" Classical Agora north of the Akropolis (Fig. 7.16); a road linked the two locations, making both a physical and metaphorical connection between the old and new. The new Roman Agora usurped many of the commercial functions of the Classical Agora, the center of which was soon filled with cultural civic buildings, such as the Odeion (roofed theater) dedicated by Marcus Agrippa, a capable Roman general and Augustus' son-in-law, in the late first century BC. Around the same time, a fifth-century BC temple to Athena in the Attic countryside was dismantled and transferred to the Classical Athenian Agora, where it was reassembled on new foundations and dedicated to Ares. On the Akropolis, the Athenians themselves dedicated a circular structure to Augustus and the goddess Roma (Fig. 4.31); the building was aligned with the center of the east façade of the Parthenon as if to draw a visual connection between the ruler and Roma, and the images of Athena born from Zeus' head in the center of the Parthenon's east pediment. Augustus also founded the city of Nikopolis in western Greece after his victory at the Battle of Actium in 31 BC (before he held the title "augustus" and was still called Octavian). The regularly planned city, which controlled a large territory, was endowed with numerous buildings, including an odeion, theater, gymnasion, stadion, and a large monument commemorating the ruler's victory.

Augustus' dynastic successors, the Julio-Claudians (the dynasty ruled from the reign of Augustus, beginning in

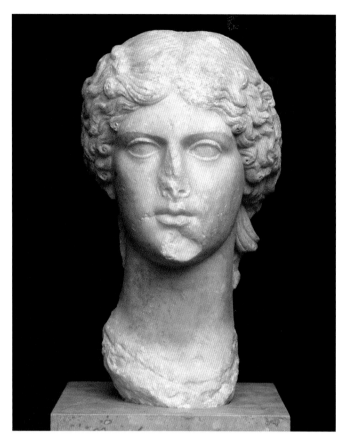

Fig 7.17 Paris, Musée du Louvre Ma3133, Agrippina the Elder from Athens, *c.* AD 37–41, marble, H 44cm.

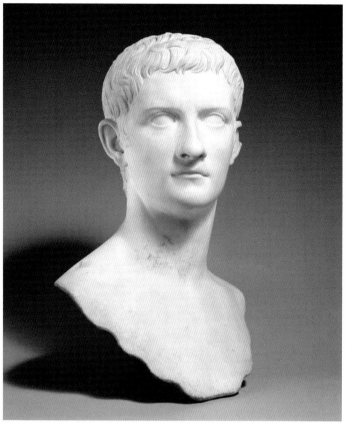

Fig 7.18 New York, Metropolitan Museum of Art 14.37, Caligula, marble, H 50.8cm.

27 BC, until the death of Nero in AD 68), continued to employ the idealism of Classical Greek style as the basis for their portraiture in all media, including cameos and gems, and public monuments: individual likenesses are rendered in an idealized way so that signs of age are diminished or eliminated, skin is flawless, and symmetry prevails (Figs. 7.17–18). And although the portraits of the Flavian emperors (AD 69–96) revert back to Republican style though much subdued (see Chapter 6), they appear on imperial monuments where the style otherwise clearly engages with Greek Classicism, including spatial illusionism and idealism (Figs. 7.19–20).

Greece continued to exert a hold on the Roman imagination. The second century AD ushered in a period of the Second Sophistic, an intellectual movement that focused

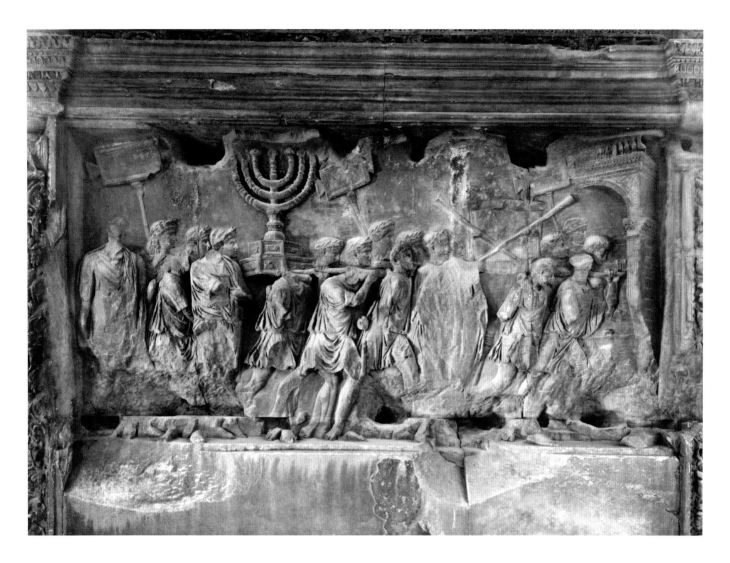

Fig 7.19 Rome, Arch of Titus, triumphal parade relief with spoils from Jerusalem, after AD 81, marble, H 2.39m.

intensely on Classical Greek literature, rhetoric, and art (including the mythological sarcophagi discussed above, see Fig. 7.10). This interest in Greek culture encouraged Roman citizens to travel to Greece, bestow monuments, and build various constructions in the Greek world. Herodes Atticus, for example, a Roman administrator for his native city of Athens, expended his enormous wealth on public monuments in Athens, in Marathon, where he constructed a villa and temple to Egyptian deities, and on a villa in Loukou in the Peloponnese (and his wife installed a magnificent fountain adorned with sculptures at Olympia).

The Philhellenic emperor Hadrian (r. AD 118–138) toured the Greek east and the Greek mainland repeatedly, and bestowed several monuments on Athens, including a library (Fig. 7.21) and honorific arch

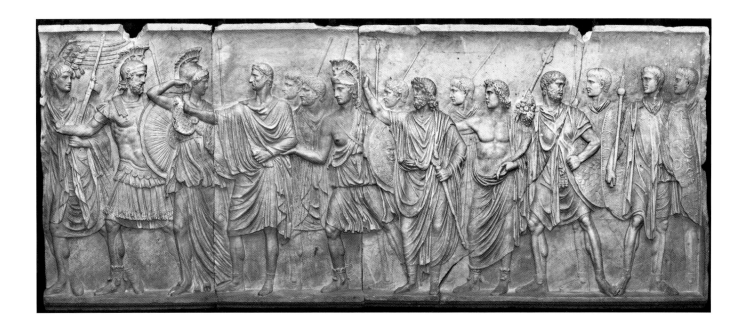

Fig 7.20 Vatican City, Musei Vaticani, Cancelleria relief A, Domitianic, *c.* AD 80–90, marble, H 2.07m.

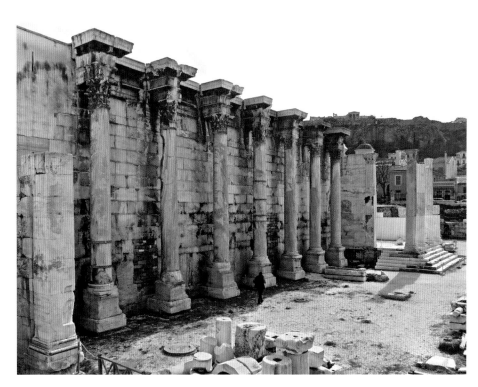

Fig 7.21 Athens, library of Hadrian, façade.

(Fig. 7.22), and he is responsible for (finally) completing the Olympiei-on begun in the sixth century BC (Fig. 3.48). The building was finished in the Corinthian order, and a colossal statue of Hadrian joined that of Zeus in the cella so that the two henceforth shared worship in this space. Roman emperors from the time of Augustus onward were accorded

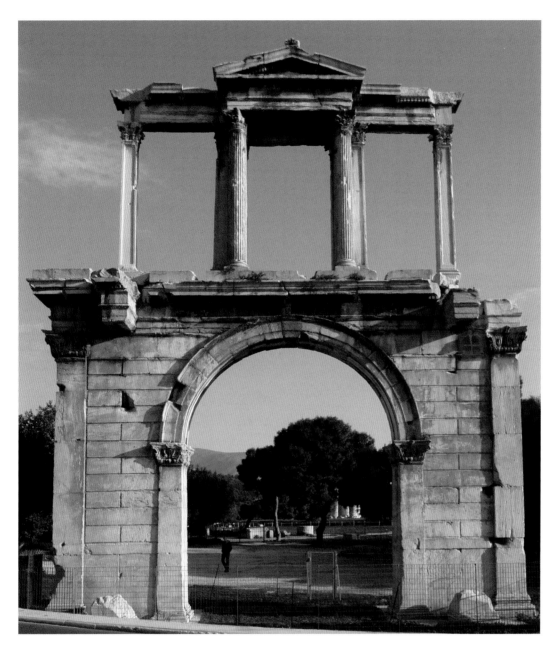

Fig 7.22 Athens, arch of Hadrian.

divine worship after their lifetimes (that is, they received the honors given to deities), and many of them expected it while they were still among the living.

A colossal marble statue of Hadrian – now headless and nearly limbless – found in the Athenian Agora may be a fitting way to end this discussion (Fig. 7.23). Hadrian's foundation of the Panhellenion League of cities in AD 131/132, which also included the Panhellenia festival, may have been the occasion for the erection of the figure, who wears military attire, including a cuirass elaborately decorated with relief figures. It is the cuirass, in fact, that secures the identification based on several other such statues where the portrait heads survive. In the center, the babies

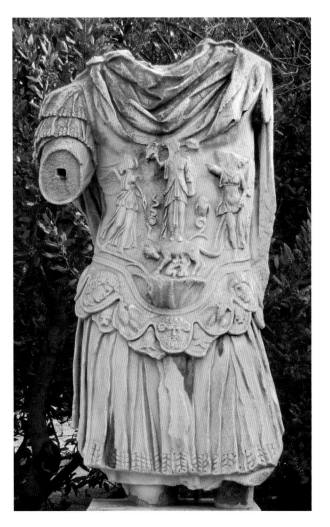

Fig 7.23 Athens, Agora S166 from the Agora, statue of Hadrian, Pentelic marble, H 1.52m.

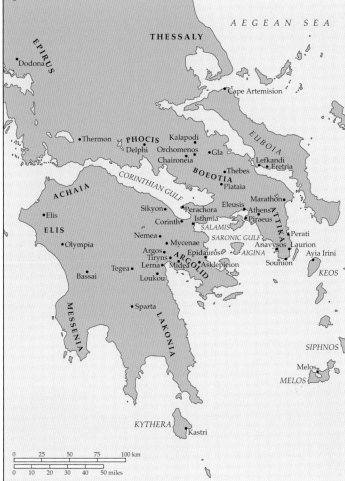

Map of southern Greece and the Peloponnese

Romulus and Remus suckle from the she-wolf, a well-known image in Roman art that symbolizes Rome itself. Standing atop the wolf's back is a large, frontal image of an archaizing Athena, an owl perched nearby on a tendril; she is flanked by two Victories. Here we see the visual embodiment of Horace's comment "Graecia capta ferum victorem cepit."

Epilogue

The preceding discussion has focused almost entirely on works of art produced for the elite, but Greek Classicism also appealed to the middle, merchant, and freedman classes (cf. Figs. 6.60–61) to a more limited degree. Education and the display of erudition were strong

factors in the prevalence of Greek themes and styles, and one did not have to understand the details to covet the effect. Geography was also a critical factor: allusions to Classicism ebb as one moves farther and farther from the urban centers, and are almost non-existent in places, such as the northern provinces, which had little or very limited previous acquaintance with Greek culture (by contrast with the Near East or Egypt, for example).

It is difficult, even misguided, to talk about an end to Greek art. Aspects of Greek art and culture are so deeply embedded in the modern western world in terms of architecture, literary and historical references, mythology, even colloquialisms (e.g., "rich as Kroisos"), to name just a few aspects, that one can justly claim that the ancient Greek world never died. On the other hand, the rise of Christianity in the late antique period led to dramatic changes in cultural priorities, religious practices, governance, and the role of art in Greece under the Byzantine empire (not to mention later Ottoman rule and after Greece's partial independence in AD 1821). It is safe to say that there was a break with the past as Christians regarded pagan art with deep suspicion, even hostility. But the past endured – in literature, in monuments and ruins, and in memory – to be rediscovered, revered, and reviled, again and again.

Glossary

abacus the square portion of a Doric column capital

adlocutio a public address made by a Roman emperor to the army

adyton literally "not to be entered"; a room in a temple behind the cella to which there is restricted access

agalma (pl. agalmata) votive gift that is pleasing to a divinity

agon contest or competition

agora central civic space, usually the locus of commercial activity, but also can be the seat of administrative or governmental bodies and religious activity

akroteria (sg. akroterion) roof sculpture

anastole pertaining to hair: cowlick

anathyrosis a manner of dressing adjoining blocks of stone so as to leave a smooth regular band around the edge for contact with the corresponding area of the next block, while the interior of this perimeter was roughened

andron (pl. androns) literally, a room for men; a room usually designated for the symposion

antae (pl.) the ends of walls

apoikiai (sg. apoikia) colonies

arête excellence

autochthony generated from the earth or sprung from the earth

baitylos a pillar for religious rites

bothros pit

boule governing council in a polis

bouleuterion place where the boule meets

bucrania motif of bulls' skulls, derived from sacrificial practices, used as decoration

caduceus the snake-entwined staff belonging to Hermes

caryatid sculpted female figure serving as a columnar support – functioning either structurally or as decoration

chiton thin linen garment, sometimes pleated

choregos leader or financial sponsor of the chorus

chthonic concerning the area underground, e.g., chthonic deity, hero, or sacrifice

chlamys short cape usually worn tied round the neck or slung over the arm

cire perdu lost wax method of casting bronze

contrapposto counterpoise; position in which one leg is weight-bearing, the other relaxed

demos the deme, a unit of government that corresponds to a topographical region

demosion sema the common burial place in a polis for the war dead

Diadochoi the immediate successors and followers of Alexander the Great

dipinti (sg. dipinto) writing in paint

dipteral an adjective used to describe a building, usually a temple, with a double peristyle

dithyramb a poetic hymn sung (and danced) in praise of Dionysos

dromos literally "road"; manmade path leading up to a structure, such as a tomb

echinus the rounded or conelike molding of a column capital

emporion (pl. emporia) permanent settlement where trade occurred, founded by Greeks outside Greece

entasis swelling of the central portion of a column

ephebe male, eighteen to twenty years old

epinetron object made of terracotta and placed over the upper thigh and knee for carding wool

eschara hearth

exomis a short tunic (worn above the knee), slung over one shoulder and usually cinched at the waist

ganosis a mixture of wax and olive oil applied to painted marble then polished

gravitas dignity, seriousness

gynaikeion literally, a room for women, usually in a domestic setting

hekatompedon literally, "hundred-footer"; a building with a length of one hundred (ancient) feet

heroon (pl. heroa) hero shrine

hetaira (pl. hetairai) hired female companion (courtesan) to provide entertainment at symposia

himation long, heavy, enveloping garment; often worn by females over a chiton

hoplitodromos footrace in which the participants (all male) wear armor and carry weapons, i.e., they are equipped as hoplites

hypaethral an architectural form that is open to the sky, i.e., without a roof

in antis between the antae or wall ends; a term often used of columns placed between wall ends in temple plans

in situ in its original position

insula (pl. insulae) domestic architectural form, usually with multiple dwellings akin to a modern apartment building

kantharos long-handled drinking cup, often (though not always) an attribute of Dionysos

kausiai (sg. kausia) Macedonian wide-brimmed, flat hats made of soft fabric

ketoi (sg. ketos) sea monsters

kline (pl. klinai) couch for reclining at symposia

klismos ornate chair with curved back and curved legs

koilon seating area of a theater

kore (pl. korai) maiden or unmarried girl

kouros (pl. kouroi) young male

kourotrophos child-nurturer, nurse, nanny

kylix (pl. kylikes) drinking cup

lagynos high-necked wine jug used especially for Dionysiac
 festivals in Alexandria

lebetes gamikoi (sg. lebes gamikos) vessels consisting of a lidded
 round kettle upon a tall stand; associated with weddings and
 the female sphere

liturgy a civic financial obligation placed upon wealthy citizens in
 democratic Athens

loculi (sg. loculus) architectural term for niches hollowed into
 walls to hold cinerary urns or sarcophagi

louterion large bowl

loutrophoros cylindrical vessel with high neck existing in both
 terracotta and stone; often (though not always) connected with
 the funerary sphere and weddings

megaron central hearth room preceded by an anteroom and a
 double-columned porch; characteristic feature of Mycenaean
 citadels

metic resident alien

oikemata small buildings (literally, small houses)

oinochoe trefoil-mouthed wine pitcher

omphalos navel

opus caementicum building material, often called "concrete,"
 developed in Italy, consisting of water, a binding agent, and
 filler; like modern concrete, it could be poured into molds

opus vermiculatum literally, 'worm-like work;' mosaic technique
 consisting of thin lines of tiny tesserae

paidotribes physical trainers or coaches in ancient Greek athletics

palladion cult statue of Athena; the most famous in Greek mythology
 is that at Troy on which the safety of the city depended

paradeisoi Persian game parks stocked with animals, often non-
 indigenous, for hunting

peplos heavy woolen garment usually worn by women and belted
 at the waist

periodonike title given to an athlete who had been victorious in
 the four Panhellenic games held at Olympia, Delphi, Isthmia,
 and Nemea

peripteros a temple with an external colonnade

pilos a peaked or rounded hat of soft fabric worn by travelers and
 by Hermes

pinakes (sg. pinax) small painted plaques of wood, terracotta, or
 other material

poloi (sg. polos) cylindrical headdresses often worn by goddesses

propylon monumental gateway

prostyle columns standing in front of a wall

prothesis laying out of the dead

protomes truncated frontal figures used as attachments to other objects, such as cauldrons

prytaneion a civic building used by officials, often housing the sacred flame of the goddess Hestia; in Athens, the government officials comprising the prytany met in the prytaneion located in the Athenian Agora

psychopompos "leader of souls," a term usually applied to Hermes

pyrrhic a dance linked to warfare performed as part of the Panathenaiac festival in Athens

sauroter metal attachment to a spear that terminates in a spike

sekos the central, enclosed portion of a Greek temple

skene the background stage building belonging to a Greek theater

sphyrelaton (pl. sphyrelata) statue made of bronze sheets riveted together

spolia portions of ancient buildings reused in later structures

stadion track for foot races measuring one stade (about 180m)

stoa covered walkway or portico

Stoic a branch of Greek philosophy developed in the Hellenistic period; its name derives from the Athenian stoa in which the philosophers and their followers met

strategos military general

suovetaurilia Roman sacrifice consisting of a sheep, pig, and bull

symposion aristocratic drinking party at which poetry was recited and drinking songs sung to music performed by hetairai and other musicians

synoikismos unification of regions or demes

tainia ribbon

tamiai official title of treasurers

techne art or skill

temenos sacred area or sanctuary

terminus ante quem the date before which X occurred; the opposite is terminus post quem, the date after which X occurred

tesserae (sg. tessera) small squares of glass or stone used to create mosaics

tholos circular covered structure

toga praetexta white garment with a purple border worn by Roman adult citizens to designate their status as magistrates

or priests and by boys before they assumed the toga virilis, the toga worn by adult men

tondo circular interior area of a kylix

tropaia (sg. tropaion) military trophies comprising booty taken from the enemy; initially derives from the place on the battlefield where the enemy turned and fled, which was marked by a tropaion

tufa variety of porous limestone

wanax a term used to designate the ruler or king in Mycenaean culture

xoanon (pl. xoana) early, rudimentary form of cult statue, sometimes consisting only of an unshaped plank of wood or stone

Bibliography

Reference

Hornblower, S. and A. Spawforth. 2012. *Oxford Classical Dictionary*, 4th edition. Oxford. Basic dictionary for the ancient world, arranged alphabetically; entries by name, place, subject, etc.

Jaeger, B., ed. 2005. *Thesaurus Cultus et Rituum*. Malibu. Reference work of ancient Greek and Roman religion.

Lexicon Iconographicum Mythologiae Classicae. 1981–1997. Zurich. Mythological encyclopedia arranged alphabetically by mythological figure; each volume consists of two parts: one comprising text, the other plates.

General

Biers, W. 1996. *The Archaeology of Greece*, 2nd edition. Ithaca.

Pedley, J. G. 2005. *Sanctuaries and the Sacred in the Ancient Greek World*. Cambridge.

——— 2011. *Greek Art and Archaeology*, 5th edition. Upper Saddle River, NJ.

Pollitt, J. J. 1990. *The Art of Ancient Greece: Sources and Documents*, rev. edition. Cambridge.

Sparkes, B. 2011. *Greek Art*, 2nd edition. Cambridge.

Valavanis, P. 2004. *Games and Sanctuaries in Ancient Greece*. Athens.

Whitley, J. 2001. *The Archaeology of Ancient Greece*. Cambridge.

www.latsis-foundation.org/en/92/electronic_library.html

www.propylaeum.de/en/classical-archaeology

Introduction

On artists

Burford, A. 1972. *Craftsmen in Greek and Roman Society*. London.

Pollitt, J. J. 1990. *The Art of Ancient Greece: Sources and Documents*, rev. edition. Cambridge.

Tanner, J. 2006. *The Invention of Art History in Ancient Greece*. Cambridge.

Architecture

Barletta, B. 2001. *Origins of the Greek Architectural Orders*. Cambridge.

Coulton, J. J. 1977. *Ancient Greek Architects at Work: Problems of Structure and Design*. Ithaca.

Hellmann, M.-C. 2002–2010. *L'architecture grecque*, 3 vols. Paris.

Korres, M. 1995. *From Pentelicon to the Parthenon: The Ancient Quarries and the Story of a Half-worked Column Capital of the First Marble Parthenon*. Athens.

Lippolis, E. 2007. *Architettura greca: Storia e monumenti del mondo della polis dalle origini al V secolo*. Milan.

Sculpture

Barringer, J. 2008. *Art, Myth, and Ritual in Classical Greece.* Cambridge.
Brinkmann, V. 2008. "The Polychromy of Ancient Greek Sculpture."
 In *The Color of Life: Polychromy in Sculpture from Antiquity to the
 Present,* edited by R. Panzanelli, 18–39. Los Angeles.
Dillon, S. 2006. *Ancient Greek Portrait Sculpture: Contexts, Subjects, and
 Styles.* Cambridge.
J. Paul Getty Museum. 1990. *Marble: Art Historical and Scientific
 Perspectives on Ancient Sculpture.* Malibu.
Mattusch, C. C. 1988. *Greek Bronze Statuary from the Beginnings through
 the Fifth Century BC.* Ithaca.
Palagia, O., ed. 2006. *Greek Sculpture: Function, Materials, Techniques.*
 Cambridge.
Rolley, C. 1999. *La sculpture grecque,* 2 vols. Paris.
Stewart, A. F. 1990. *Greek Sculpture,* 2 vols. New Haven and London.

Vase and wall painting

Bérard, C. *et al.* 1989. *A City of Images.* Princeton.
Boardman, J. 2001. *The History of Greek Vases.* London.
Clark, A. 2002. *Understanding Greek Vases: A Guide to Terms, Styles, and
 Techniques.* Los Angeles.
Noble, J. V. 1988 (reprint of 1966 edition). *The Techniques of Painted
 Attic Pottery.* London.
Pollitt, J. J., ed. 2014. *The Cambridge History of Painting in the Classical
 World.* Cambridge.
Rasmussen, T. and N. Spivey, eds. 1991. *Looking at Greek Vases.* Cambridge.
Rystedt, E. and B. Wells, eds. 2006. *Pictorial Pursuits: Figurative Painting
 on Mycenaean and Geometric Pottery.* Stockholm.
Schreiber, T. 1999. *Athenian Vase Construction: A Potter's Analysis.* Malibu.
Sparkes, B. 1991. *Greek Pottery: An Introduction.* Manchester.
 1996. *The Red and the Black: Studies in Greek Pottery.* London and
 New York.

Topography and monuments of Athens

Camp, J. 1992. *The Athenian Agora.* New York and London.
 2001. *The Archaeology of Athens.* New Haven and London.
Goette, H. R. 2001. *Athens, Attica and the Megarid: An Archaeological
 Guide.* London and New York.
Hurwit, J. M. 1999. *The Acropolis of Athens.* Cambridge.
Knigge, U. 1988. *The Kerameikos of Athens.* Athens.
www.agathe.gr

Chapter 1

Castleden, R. 2005. *The Mycenaeans.* London.
Cline, E., ed. 2010. *The Oxford Handbook of the Bronze Age Aegean.* Oxford.

Dickinson, O. 1994. *The Aegean Bronze Age.* Cambridge.
　2006. *The Aegean from Bronze Age to Iron Age.* London.
Fitton, J. L. 2002. *The Minoans.* London.
Mazarakis Ainian, A. 1997. *From Rulers' Dwellings to Temples: Architecture, Religion and Society in Early Iron Age Greece (1100–700 BC).* Jonsered.
Pollitt, J. J., ed. 2014. *The Cambridge History of Painting in the Classical World.* Cambridge.
Poursat, J.-C. 2008. *L'art égéen.* Paris.
Rystedt, E. and B. Wells, eds. 2006. *Pictorial Pursuits: Figurative Painting on Mycenaean and Geometric Pottery.* Stockholm.
Shelmerdine, C., ed. 2008. *The Cambridge Companion to the Aegean Bronze Age.* Cambridge.
Snodgrass, A. M. 1971. *The Dark Age of Greece.* Edinburgh.
www.dartmouth.edu/~prehistory/aegean/
Mycenae: www.stoa.org/metis/cgi-bin/qtvr?site=mycenae
Knossos: www.bsa.ac.uk/knossos/vrtour

Chapter 2

Carter, J. 1972. "The Beginning of Narrative in the Greek Geometric Period." *Annual of the British School at Athens* 67: 25–58.
Coldstream, N. 2003. *Geometric Greece: 900–700 BC,* 2nd edition. London.
　2010. *Greek Geometric Pottery.* London.
Gunter, A. 2009. *Greek Art and the Orient.* Cambridge.
Langdon, S. 2008. *Art and Identity in Dark Age Greece, 1100–700 BCE.* Cambridge.
Markoe, G. 1996. "The Emergence of Orientalizing in Greek Art: Some Observations on the Interchange between Greeks and Phoenicians in the Eighth and Seventh Centuries BC." *Bulletin of the American Schools of Oriental Research* 301: 47–67.
Mazarakis Ainian, A. 1997. *From Rulers' Dwellings to Temples: Architecture, Religion and Society in Early Iron Age Greece (1100–700 BC).* Jonsered.
Pollitt, J. J., ed. 2014. *The Cambridge History of Painting in the Classical World.* Cambridge.
Rystedt, E. and B. Wells, eds. 2006. *Pictorial Pursuits: Figurative Painting on Mycenaean and Geometric Pottery.* Stockholm.

Chapter 3

Hall, J. 2006. *A History of the Archaic Greek World.* Malden, MA.
Hurwit, J. M. 1985. *The Art and Culture of Early Greece, 1100–480 BC.* Ithaca and London.
　1999. *The Athenian Acropolis.* Cambridge.
Keesling, C. 2003. *The Votive Statues of the Athenian Acropolis.* Cambridge.

Neils, J. 1992. *Goddess and Polis: The Panathenaic Festival in Ancient Athens.* Hanover, NH.

Pollitt, J. J., ed. 2014. *The Cambridge History of Painting in the Classical World.* Cambridge.

Raaflaub, K. and H. van Wees, eds. 2009. *A Companion to Archaic Greece.* Chichester.

Shapiro, H. A., ed. 2007. *The Cambridge Companion to Archaic Greece.* Cambridge.

Chapter 4

Barringer, J. M. 2008. *Art, Myth, and Ritual in Classical Greece.* Cambridge.

Hurwit, J. M. 2004. *The Acropolis in the Age of Pericles.* Cambridge.

Korres, M. 2000. *Stones of the Parthenon.* Los Angeles.

Neils, J. 2001. *The Parthenon Frieze.* Cambridge.

Neils, J., ed. 2005. *The Parthenon: From Antiquity to the Present.* Cambridge.

Oakley, J. 2004. *Picturing Death in Classical Athens.* Cambridge.

Stewart, A. 2008. *Classical Greece and the Birth of Western Art.* Cambridge.

Tournikiotis, P., ed. 1996. *The Parthenon and its Impact in Modern Times.* Athens.

www.parthenonfrieze.gr/ – /view

Chapters 5 and 6

Bruneau, P. 2005. *Guide de Délos.* Paris.

Bugh, G., ed. 2006. *The Cambridge Companion to the Hellenistic World.* Cambridge.

Burn, L. 2005. *Hellenistic Art from Alexander the Great to Augustus.* Los Angeles.

Dillon, S. 2010. *The Female Portrait Statue in the Greek World.* Cambridge.

Dunbabin, K. 1999. *Mosaics of the Greek and Roman World.* Cambridge.

Erskine, A., ed. 2003. *A Companion to the Hellenistic World.* Oxford.

Grainger, J. 1990. *The Cities of Seleukid Syria.* Oxford.
1991. *Hellenistic Phoenicia.* Oxford.

Green, P. 1990. *Alexander to Actium.* Berkeley.

Gruen, E. 1984. *The Hellenistic World and the Coming of Rome,* 2 vols. Berkeley.

Holt, F. 2012. *Lost World of the Golden King: In Search of Ancient Afghanistan.* Berkeley.

Moreno, P. 1994. *Scultura ellenistica,* 2 vols. Rome.

Pollitt, J. J. 1986. *Art in the Hellenistic Age.* Cambridge.

Schultz, P. and R. von den Hoff, eds. 2007. *Early Hellenistic Portraiture.* Cambridge.

Stanwick, P. 2002. *Portraits of the Ptolemies: Greek Kings as Egyptian Pharaohs*. Austin.

Stewart, A. 1993. *Faces of Power: Alexander's Image and Hellenistic Politics*. Berkeley, Los Angeles, and London.

2004. *Attalos, Athens, and the Akropolis*. Cambridge.

2014. *Art in the Hellenistic World*. Cambridge.

Venit, M. 2002. *The Monumental Tombs of Ancient Alexandria: Theater of the Dead*. Cambridge.

Chapter 7

D'Ambra, E. 1998. *Roman Art*. Cambridge.

Zanker, P. and H. Heitmann-Gordon. 2010. *Roman Art*. Los Angeles.

Picture credits

1.1 Credit: author.
1.2 Photo: Hans R. Goette.
1.3 Plan reproduced and adapted from *To Ergon* 2008: 89 fig. 104.
1.4 Photo: Hans R. Goette.
1.5 Photo: National Archaeological Museum, Athens, photographer: Kostas Xenikakis © Hellenic Ministry of Education and Religious Affairs, Culture and Sports/Archaeological Receipts Fund.
1.6 Photo: Hans R. Goette.
1.7 Photo: Hans R. Goette.
1.8 Photo: © 2012 The Metropolitan Museum of Art/Art Resource/SCALA, Florence.
1.9 Photo: Hans R. Goette.
1.10 Photo: Hans R. Goette.
1.11 Photo by Yiannis Piatrikianos courtesy of Athens, Archaeological Receipts Fund.
1.12 Courtesy: Athens, Archaeological Receipts Fund.
1.13 Plan adapted and reproduced with permission from Poursat, J.-C. 2008. *L'art égéen* 1. Paris, fig. 200.
1.14 Photo from Myers et al. 1992. *The Aerial Atlas of Ancient Crete.* Berkeley and London, pl. 33.4 used with permission of University of California Press, Thames & Hudson.
1.15 Reproduced from Myers et al. 1992. *The Aerial Atlas of Ancient Crete.* Berkeley and London, pl. 33.3 used with permission of University of California Press, Thames & Hudson.
1.16 Photo: Ashmolean Museum/The Art Archive at Art Resource.
1.17 Photo: Hans R. Goette.
1.18 Photo: Hans R. Goette.
1.19 Photo: Hans R. Goette.
1.20 Photo: Hans R. Goette.
1.21 Photo: author.
1.22 Photo: author.
1.23 Photo: Hans R. Goette.
1.24 Photo: Hans R. Goette.
1.25 Photo: Erich Lessing/Art Resource, NY.
1.26 Photo: © The Trustees of The British Museum.
1.27 Photo: Hans R. Goette.
1.28 Photo: Hans R. Goette.
1.29 Photo: Georg Gerster/Panos.
1.30 Plan from Myers et al. 1992. *The Aerial Atlas of Ancient Crete.* Berkeley and London, p. 106 fig. 131 used with permission of University of California Press, Thames & Hudson.
1.31 Photo: Maria Liston.
1.32 Photo: Vanni/Art Resource, NY.
1.33 Photo: Hans R. Goette.
1.34 Photo: Hans R. Goette.
1.35 Photo: Scala/Art Resource, NY.
1.36a–b Reproduced with permission from J. Caskey and E. Blackburn. 1978. *Lerna in the Argolid.* Princeton.

1.37 Photo Hans R. Goette.

1.38 Reproduced with permission of Oxford University Press from D. Preziosi and L. Hitchcock, 1999. *Aegean Art and Architecture*. Oxford. p. 186, fig. 124.

1.39 Photo Hans R. Goette.

1.40 Photo Hans R. Goette.

1.41a–b Photo Hans R. Goette.

1.42 Photo Hans R. Goette.

1.43 Courtesy: The Department of Classics, University of Cincinnati.

1.44a–c Photos: Hans R. Goette.

1.45a Photo: author.

1.45b Reproduced with permission from Y. Tzedakis and H. Martlew, eds. 1999. *Minoans and Mycenaeans: Flavours of Their Time*, Athens, p. 193.

1.46 Photo: Hans R. Goette.

1.47 Reconstruction from A. Wace 1949. *Mycenae*, Princeton, fig. 22 reproduced with permission of the British School at Athens.

1.48 Photo: Hans R. Goette.

1.49 Photo: Hans R. Goette.

1.50 Photo: Hans R. Goette.

1.51 Photo: Hans R. Goette.

1.52a Photo: Hans R. Goette.

1.52b Photo: Hans R. Goette.

1.52c Photo: Hans R. Goette.

1.53 Photo: Hans R. Goette.

1.54 Reproduced with permission from A. Wace 1949. *Mycenae*, Princeton, foldout no. 5.

1.55a Photo: Hans R. Goette.

1.55b Reconstruction of doorway by Mark Bloomfield reproduced by permission.

1.56 Photo: author.

1.57 Photo: National Archaeological Museum, Athens, photographer: Irini Miari © Hellenic Ministry of Education and Religious Affairs, Culture and Sports /Archaeological Receipts Fund.

1.58 Photo: Ingo Pini.

1.59 Photo: Athens, Archaeological Receipts Fund.

1.60 Photo: Hans R. Goette.

1.61 Photo: Hans R. Goette.

1.62 Photo: Hans R. Goette.

1.63a Plan reproduced and adapted with permission from the British School at Athens from M. Popham, P. Calligas, and L. Sackett. 1993. *Lefkandi* 2:2, Athens, pl. 38.

1.63b Reconstruction by J. J. Coulton, reproduced with permission from the British School at Athens from M. Popham, P. Calligas, and L. Sackett. 1993. *Lefkandi* 2:2, Athens, pl. 28.

1.63c Reproduced with permission from the British School at Athens from M. Popham, P. Calligas, and L. Sackett. 1993. *Lefkandi* 2:2, Athens, pl. 13.

1.64 Photo: D-DAI-ATH-Kerameikos-04245.

1.65 Photo: Hans R. Goette.

Box 1.1 Fig 1 Photo: Hans. R. Goette.

2.1 Photo: Hans R. Goette.

2.2 Drawing reproduced with permission from E. Kunze, 1931, *Kretische Bronzereliefs*, Stuttgart, p. 8, Beilage 1.

2.3a–b Photos: D-DAI-ATH-NM-4881 and D-DAI-ATH-NM-4882.

2.4 Photo: Hans R. Goette.

2.5 Photo: DAI-ROM.

2.6 Photo: © 2012 Museum of Fine Arts, Boston.

2.7 Photo: Hans R. Goette.

2.8a–b Photo: L. H. Jeffery Archive at the Centre for the Study of Ancient Documents, Oxford.

2.9 Photo: Hans R. Goette.

2.10a–c Photos: Hans R. Goette.

2.11 Photo: Hans R. Goette.

2.12a–b Courtesy: École suisse d'archéologie en Grèce.

2.13 Courtesy: École suisse d'archéologie en Grèce.

2.14a Plan reproduced and adapted with permission from H. Kyrieleis 1981. *Führer durch das Heraion von Samos*. Athens, p. 65, fig. 42.

2.14b Plan reproduced and adapted with permission from H. Kyrieleis, 1981. *Führer durch das Heraion von Samos*. Athens, p. 65, fig. 42.

2.15a Reproduced with permission from I. Beyer, 1976. *Die Tempel von Dreros und Prinias A*, Freiburg, Taf. 3.

2.15b Reconstruction by A. Mazarakis Ainian, reproduced with permission.

2.16 Photo: Hans R. Goette.

2.17 Photo: Marie Mauzy/Art Resource, NY.

2.18a Reconstruction of exterior reproduced with permission from G. Gruben, 1997. "Naxos und Delos: Studien zur archaischen Architektur der Kykladen." *Jahrbuch des Deutschen Archäologischen Instituts* 112: 265 Abb. 2b.

2.18b Reconstruction of interior reproduced with permission from G. Gruben, 1997. "Naxos und Delos: Studien zur archaischen Architektur der Kykladen." *Jahrbuch des Deutschen Archäologischen Instituts* 112: 264 Abb. 2a.

2.19 Plan reproduced with permission from A. Mazarakis Ainian, 1997. *From Rulers' Dwellings to Temples*, Jonsered, fig. 61.

2.20a Restored plan by F. Hemans reproduced with permission from E. Gebhard and F. Hemans, 1992. "University of Chicago Excavations at Isthmia, 1989: I." *Hesperia* 61: 32 fig. 8.

2.20b Axonometric drawing by F. Hemans reproduced with permission from E. Gebhard, 2001. "The Archaic Temple at Isthmia: Techniques of Construction." In *Archaische griechische Tempel und Altägypten*, edited by M. Bietak, Vienna, p. 42, fig. 1.

2.21 Plan reproduced from *Archaiologike Ephemeris* 1900, p. 175.

2.22 Photo: D-DAI-ATH-Athens Aetolaokarnanien-0155.

2.23a–b Photo: Hans R. Goette.

2.24 Photo: author.

2.25 Photo: Hans R. Goette.

2.26 Photo: Hans R. Goette.

2.27 Photo: Hans R. Goette.

2.28a Photo: author.

2.28b Photo: D-DAI-ATH-Olympia-5042.

2.29 Photo: Hans R. Goette.

2.30 Photo: Hans R. Goette.

2.31a Photo: Hans R. Goette.

2.31b Reproduced with permission from *AM* 74 (1959) fig. 7.

2.32 Photo: Hans R. Goette.

2.33 Photo: DAI Athens Samos 5476.

2.34a–b Photos: Hans R. Goette.

2.35a Plan reproduced with permission from L. Pernier, 1934. "New Elements for the Study of the Archaic Temple of Prinias." *American Journal of Archaeology* 38: 173 fig. 2.

2.35b Reconstruction by Stefani reproduced from L. Pernier, 1914. "Templi arcaici sulla Patèla di Priniàs in Creta." *Annuario della Scuola archeologica di Atene e delle Missioni italiane in Oriente* 1, pl. VI.

2.36 Photo: Athens, Archaeological Receipts Fund.

2.37a–c Photos: Hans R. Goette.

2.38a–c Photos: Hans R. Goette.

2.39 Photo: author.

2.40a–b Photo: Hans R. Goette.

2.41a–b Drawing and photo: American School of Classical Studies in Athens: Agora Excavations.

2.42 Photo: Hans R. Goette.

2.43a–b Photo: © The Trustees of the British Museum.

2.44 Photo: Hans R. Goette.

2.45a Photo: Art Resource.

2.45b Photo: Soprintendenza per i Beni Archeologici dell' Etruria Meridionale.

2.46a–b Photo: RMN.

2.47a–e Photos: Hans R. Goette.

2.48a Photo: DeA Picture Library/Art Resource, NY.

2.48b Photo: Archivo Fotografico dei Musei Capitolini.

2.49a–c Photos: Hans R. Goette.

2.50 Photo: RMN.

2.51a Photo: Athens, Archaeological Receipts Fund.

2.51b Photo: Hans R. Goette.

2.52 Reproduced with permission from the British School at Athens from J. Cook, 1958–1959. "Old Smyrna 1948–1951." *Annual of the British School at Athens* 53/54: 15 fig. 3.

2.53 Reconstruction by J. Coulton reproduced with permission from A. Cambitoglou, 1981. *Archaeological Museum of Andros*, Athens, Figs. 9–10.

Box 2.1 Fig 1 Credit: Hans R. Goette.

Box 2.1 Fig 2 Photo: Hans R. Goette.

Box 2.2 Fig 1 Drawing reproduced with permission from M. Korres, 2001. *From Pentelicon to the Parthenon*, Athens, p. 19.

Box 2.2 Fig 2 Photo: Hans Rupprecht Goette.

Box 2.2 Fig 3 Drawing by A. Claridge reproduced by permission from A. Claridge, 1990. "Ancient Techniques of Making Joins in Marble Statuary." In *Marble: Art Historical and Scientific Perspectives on Ancient Sculpture*, Malibu, p. 141, fig. 6a.

3.1a–b Photos: Hans R. Goette.

3.1c Photo: Hans R. Goette.

3.1d Photo: Hans R. Goette.

3.2 Photo: Hans R. Goette.

3.3 Plan by Hans R. Goette.

3.4a–b Photos: Hans R. Goette.

3.5 Plan by Hans R. Goette after a drawing by D. Mertens.

3.6a–b Photos: Hans R. Goette.

3.7 Reconstruction by G. Rodenwaldt, 1938. *Kerkyra II: Die Bildwerke des Artemistempels*, Berlin, Taf. II.

3.8 Photo: Hans R. Goette.

3.9a Plan by Michael Kerschner, executed by I. Benda-Weber, used with permission of the Österreichisches Archäologisches Institut.

3.9b Restored elevation by Hans R. Goette after a drawing by W. Karnapp.

3.10 Plan reproduced with permission from H. Kyrieleis, 1981. *Führer durch das Heraion von Samos*, Athens, p. 73, fig. 49.

3.11 Photo: Hans R. Goette.

3.12 Reconstruction by E. Hansen reproduced with permission of the École française d'Athènes.

3.13 Adapted by Hans R. Goette from P. de la Coste-Messelière and G. de Miré. 1943. *Delphes*, Paris, 317.

3.14 Photo: Hans R. Goette.

3.15 Photo: Hans R. Goette.

3.16 Photo: Hans R. Goette.

3.17 Photo: Hans R. Goette.

3.18 Photo: Hans R. Goette.

3.19a–b Photos: Hans R. Goette.

3.20 Photo: Foto Marburg/Art Resource, NY.

3.21 Photo: Hans R. Goette.

3.22a Photo: Hans R. Goette.

3.22b Photo: Alison Frantz Archive, American School of Classical Studies in Athens.

3.23 Photo: Marie Mauzy/Art Resource, NY.

3.24 Photo: Hans R. Goette.

3.25 Photo: Hans. R. Goette.

3.26 Photo: Hans R. Goette.

3.27 Photo: Hans R. Goette.

3.28a–b Photos: author.

3.29 Reproduced with permission from H. R. Goette, 2001. *Athens, Attica and the Megarid*, rev., London, 133 fig. 37.

3.30a–c Photos: Florence, Museo Archeologico.

3.31 Photo: Hans R. Goette.

3.32a–b Photos: SCALA.

3.33 Photo: Munich, Antikensammlungen.

3.34a–b Photos: Würzburg, Martin von Wagner Museum.

3.35a–b Photo by Renate Kühling, Munich, Antikensammlungen.

3.36a–b Photos: Soprintendenza per i Beni Archeologici dell'Etruria Meridionale, Roma.
3.36c–d Photos: Hans R. Goette.
3.37a–b Photo by Renate Kühling, Munich, Antikensammlungen.
3.38a–b Photos: Hans R. Goette.
3.39 Plan by Hans R. Goette.
3.40 Photos: Hans R. Goette.
3.41 Photo: Hans R. Goette.
3.42 Photo: Hans R. Goette.
3.43 Photo: Hans R. Goette.
3.44 Photo: Hans R. Goette.
3.45 Plan drawn by Hans R. Goette.
3.46 Photo: Hans R. Goette.
3.47 Courtesy: Agora Excavations: American School of Classical Studies in Athens.
3.48 Courtesy: Agora Excavations: American School of Classical Studies in Athens.
3.49 Photo: Hans R. Goette.
3.50a–b Photo: Karlsruhe, Badisches Landesmuseum.
3.51 Photo: Hans R. Goette.
3.52 Plan by Hans R. Goette.
3.53 Photo: Hans R. Goette.
3.54 Photo: Hans R. Goette.
3.55 Photo: Hans R. Goette.
3.56 Photo: Hans R. Goette.
3.57 Photo: NY/Art Resource.
3.58 Photo: Würzburg, Martin von Wagner Museum.
3.59a–d Photo: Basel, Museum of Ancient Art and Ludwig Collection.
3.60a–b Photo: Hans R. Goette.
Box 3.1 Fig 1 Plan drawn by Hans R. Goette.
Box 3.2 Fig 1 Drawing by Hans R. Goette.
Box 3.2 Fig 2 Drawing reproduced from A. Orlandos, 1994. *Les Matériaux de construction et la technique architecturale des anciens grecs* 2, Paris, fig. 49.
Box 3.2 Fig 3 Drawing reproduced from A. Orlandos, 1994. *Les Matériaux de construction et la technique architecturale des anciens grecs* 2, Paris, fig. 97.
Box 3.2 Fig 4 Drawing by Hans R. Goette.
4.1 Photo: Hans R. Goette.
4.2 Photo: Hans R. Goette.
4.3 Photo: Hans R. Goette.
4.4a–b Photos: Hans R. Goette.
4.5a–b Photos: Hans R. Goette.
4.6 Photo: Hans R. Goette.
4.7 Photo: Hans R. Goette.
4.8 Photo: Hans R. Goette.
4.9 Photo: Hans R. Goette.
4.10 Photo: Georg Gerster/Panos.
4.11 Plan by Hans R. Goette.

4.12a Photo: Hans R. Goette.

4.12b Reconstruction by A. F. Stewart, drawing by C. Smith reproduced with permission.

4.13 Photo: Hans R. Goette.

4.14 Photo: Hans R. Goette.

4.15a Photo: Hans R. Goette.

4.15b Reconstruction by A. F Stewart, drawing by C. Smith reproduced with permission.

4.16 Photo: Hans R. Goette.

4.17 Photo: Hans R. Goette.

4.18 Reconstruction reproduced from *Olympia* 3, Taf. 45.

4.19 Photo: Hans R. Goette.

4.20 Photo: Hans R. Goette.

4.21a–b Photos: Hans R. Goette.

4.22 Photo: Hans R. Goette.

4.23 Plan by Hans R. Goette.

4.24 Photo: Hans R. Goette.

4.25 Photo: SCALA/Art Resource, NY.

4.26 Photo: Nimatallah/Art Resource, NY.

4.27a–b Photos: RMN.

4.28a–b Photos: Hans R. Goette.

4.29 Photo: Hans R. Goette.

4.30 Photo: Hans R. Goette.

4.31 Reproduced and adapted with permission from W. Hoepfner, ed. 1997. *Kult und Kultbauten auf der Akropolis*, Berlin, inside front cover.

4.32a–b Photo: Hans R. Goette.

4.33 Plan by Hans R. Goette.

4.34a–b Photo: Hans R. Goette.

4.35 Reconstruction by E. Berger reproduced with permission from E. Berger, 1977. "Parthenon-Studien: Zweiter Zwischenbericht." *Antike Kunst* 20: Falttafel III.B.

4.36 Reconstruction by E. Berger reproduced with permission from E. Berger, 1977. "Parthenon-Studien: Zweiter Zwischenbericht." *Antike Kunst* 20: Falttafel II.

4.37 Photo: Hans R. Goette.

4.38 Photo: Hans R. Goette.

4.39 Photo: Hans R. Goette.

4.40 Photo: Hans R. Goette.

4.41 Photo: Hans R. Goette.

4.42 Photo: Hans R. Goette.

4.43 Photo: Hans R. Goette.

4.44 Photo: Hans R. Goette.

4.45 Photo: Hans R. Goette.

4.46 Photo: Hans R. Goette.

4.47 Photo: Agora Excavations 2000.02.1143, The American School of Classical Studies at Athens.

4.48 Photo: Hans R. Goette.

4.49 Plan reproduced with permission from H. R. Goette, 2001. *Athens, Attica and the Megarid,* rev., London, p. 18 fig. 8.

4.50 Photo: Hans R. Goette.

4.51a–b Photos: Hans R. Goette.

4.52 Photo: Hans R. Goette.

4.53a–b Photo: Hans R. Goette.

4.54 Photo: Hans R. Goette.

4.55 Plan by Hans R. Goette.

4.56a–b Photo: Hans R. Goette.

4.57 Photo: Hans R. Goette.

4.58 Photo: Hans R. Goette.

4.59 Photo: Hans R. Goette.

4.60 Photo: Hans R. Goette.

4.61 Plan: Agora Excavations, The American School of Classical Studies at Athens.

4.62 Photo: Hans R. Goette.

4.63 Plan by Hans R. Goette.

4.64 Photo: Hans R. Goette.

4.65 Photo: Hans R. Goette.

4.66 Reconstruction reproduced with permission from Papaspyridi-Karouzou, S. 1954–1955. "Alkamenes und das Hephaisteion." *Mitteilungen des Deutschen Archäologischen Instituts, Athenische Abteilung* 69–70: 83 Abb. 3.

4.67 Photo: © The Trustees of The British Museum.

4.68a–b Photos: Hans R. Goette.

4.69 Photo: Hans R. Goette.

4.70 Photo: Hans R. Goette.

4.71a–b Photos: Hans R. Goette.

4.72 Photo: Hans R. Goette.

4.73 Plan by Hans R. Goette.

4.74 Reconstruction of interior by F. Krischen reproduced from F. Krischen, ed. 1938. *Die griechische Stadt: Wiederherstellungen von Fritz Krischen,* Berlin, pl. 40.

4.75 Photo: © The Trustees of the British Museum.

4.76 Photo: © The Trustees of the British Museum.

Box 4.1 Fig 1 Photo: Agora Excavations, The American School of Classical Studies at Athens.

Box 4.2 Fig 1 Photo: National Archaeological Museum, Athens © Hellenic Ministry of Education and Religious Affairs, Culture and Sports/Archaeological Receipts Fund.

Box 4.2 Figs 4.2a–b Photos: Berlin Art Resource/Bildarchiv Preussischer Kul-turbesitz (BPK).

Box 4.5 Fig 1 Photo: Art Resource/Bildarchiv Preussischer Kulturbesitz (BPK).

5.1 Photo: Hans R. Goette.

5.2 Photo: Hans R. Goette.

5.3 Photo: Hans R. Goette.

5.4 Photo: Hans R. Goette.

5.5 Photo: Hans R. Goette.

5.6 Photo: Hans R. Goette.

5.7 Plan adapted by Hans R. Goette from a drawing by G. Kummer and W. Wilberg.

5.8 Reproduced from T. Wiegand and H. Schrader. 1904. *Priene*, Berlin, fig. 199.

5.9 Plan reproduced with permission from D. Robinson, 1938. *Olynthus VIII: The Hellenic House*, Baltimore, pl. 94.

5.10 Photo: Georg Gerster/Panos.

5.11 Reconstruction by E. Busch, reproduced with permission from W. Hoepfner and E. L. Schwandner. 1994. *Haus und Stadt im klassischen Griechenland*, 2nd edition, Munich, Abb. 76.

5.12 Plan reproduced with permission from P. Ducrey, 1993. *Eretria 8: Le quartier de la Maison aux mosaïques*, Lausanne, 32 fig. 25.

5.13 Photo: © Andreas F. Voegelin (Antikenmuseum Basel).

5.14a Photo: Hans R. Goette.

5.14b Photo: Hans R. Goette.

5.14c Photo: Hans R. Goette.

5.15 Photo: Hans R. Goette.

5.16a Elevation reconstruction reproduced with permission from G. Roux, 1961. *L'architecture de l'Argolide aux IVe et IIIe siècles avant J.-C.*, Paris, pl. 39.

5.16b Plan reproduced with permission from F. Seiler, 1986. *Die griechische Tholos: Untersuchungen zur Entwicklung, Typologie und Funktion kunstmässiger Rundbauten*, Mainz, Klapptafel (fig. 80).

5.17 Photo: Hans R. Goette.

5.18 Plan adapted by Hans R. Goette from H.-V. Herrmann, 1972. *Olympia*, Munich, p. 162, Abb. 115.

5.19a Plan drawing by K. Herrmann.

5.19b Elevation reconstruction drawing by K. Herrmann.

5.20 Photo: Hans R. Goette.

5.21 Photo: Georg Gerster/Panos.

5.22 Photo: Hans R. Goette.

5.23 Plan by Hans R. Goette.

5.24 Photo: Hans R. Goette.

5.25a–b Plan and reconstruction of interior elevation from N. Norman, 1984. "The Temple of Athena Alea at Tegea." *American Journal of Archaeology* 88: 182–183, illustrations 8 and 9. Courtesy: Archaeological Institute of America and *American Journal of Archaeology*.

5.26 Photo: Hans R. Goette.

5.27a–c Photos: Hans R. Goette.

5.28 Photo: Hans R. Goette.

5.29 Photo: Hans R. Goette.

5.30 Photo: Hans R. Goette.

5.31 Photo: Hans R. Goette.

5.32 Photo: Hans R. Goette.

5.33 Photo: Hans R. Goette.

5.34 Photo: Hans R. Goette.
5.35a–b Photos: © The Trustees of the British Museum.
5.36 Photo: Hans R. Goette.
5.37a Photo: Hans R. Goette.
5.37b Photo: Hans R. Goette.
5.38 Photo: author.
5.39a–b Photos: American Numismatic Society.
5.40a–d Photos: Gianni Dagli Orti/ The Art Archive at Art Resource, NY and Vanni/Art Resource, NY.
5.41a–b Photos: Hans R. Goette.
5.42 Photo: 17th Ephorate, Hellenic Ministry of Culture.
5.43a Photo: 17th Ephorate, Hellenic Ministry of Culture.
5.43b–c Photos: Hans R. Goette.
5.44 Drawing reproduced with permission from E. Borza and O. Palagia. 2007. "The Chronology of the Macedonian Royal Tombs at Vergina." *Jahrbuch des Deutschen Archäologischen Instituts* 122: pl. 4:2.
5.45 Photo: Art Resource.
5.46 Photo: Art Resource.
5.47a–b Photos: Hans R. Goette.
5.48 Photo by Renate Kühling, Munich, Antikensammlung.
5.49a–b Photos: Hans R. Goette.
5.50 Photo: Hans R. Goette.
6.1 Photo: Hans R. Goette.
6.2 Photo: Hans R. Goette.
6.3 Photo: Hans R. Goette.
6.4a–b Photos: Hans R. Goette.
6.5 Photo: Hans R. Goette.
6.6 Photo: Hans R. Goette.
6.7a–b Photos: New York, American Numismatic Society.
6.8a–b Photo: Hans R. Goette.
6.9a–b Photo: Art Resource.
6.10 Photo: Hans R. Goette.
6.11 Photo: Florence, Museo Archeologico.
6.12 Photo: Hans Rupprecht Goette.
6.13 Photo: Hans R. Goette.
6.14 Photo: Hans-Peter Klut/ Elke Estel, Dresden 2008 © Skulpturensammlung, Staatliche Kunstsammlungen Dresden.
6.15a–b Photos: Hans R. Goette.
6.16a–b Photos: Hans R. Goette.
6.17 Photo: Hans R. Goette.
6.18a Drawn by Alfred Frazer. Courtesy of the American Excavations on Samothrace.
6.18b Drawn by Alfred Frazer. Courtesy of the American Excavations on Samothrace.
6.19a Drawn by John Kurtich. Courtesy of the American Excavations on Samothrace.
6.19b Drawn by John Kurtich. Courtesy of the American Excavations on Samothrace.

6.55　Photo: Athens, Archaeological Receipts Fund.
6.56　Photo: Georg Gerster/Panos.
6.57　Photo: Hans R. Goette.
6.58　Photo: Athens, Archaeological Receipts Fund.
6.59　Photo: Hans R. Goette.
6.60　Photo: Hans R. Goette.
6.61a–b　Photos: Hans R. Goette.
7.1a–b　Photos: Hans R. Goette.
7.2a–b　Photos: Hans R. Goette.
7.3　Photo: Hans R. Goette.
7.4a–b　Photos: Hans R. Goette.
7.5　Photo: Art Resource, NY.
7.6　Photo: author.
7.7　Photo: Scala/Art Resource, NY.
7.8　Photo: Scala/Art Resource, NY.
7.9　Photo: Alinari.
7.10　Courtesy: DAI-ROM-402428.
7.11　Photo: Art Resource, NY.
7.12a–b　Photos: Florence, Museo Archeologico.
7.13　Photo: Hans R. Goette.
7.14　Photo: Hans R. Goette.
7.15　Photo: author.
7.16　Photo: Hans R. Goette.
7.17　Photo: Louvre/Art Resource, NY.
7.18　Photo: Art Resource, NY.
7.19　Photo: Art Resource, NY.
7.20　Photo: Hans R. Goette.
7.21　Photo: Hans R. Goette.
7.22　Photo: Hans R. Goette.
7.23　Photo: Hans R. Goette.

Index